PETRUS CHRISTUS
IN RENAISSANCE BRUGES
AN INTERDISCIPLINARY APPROACH

Edited by Maryan W. Ainsworth

The Metropolitan Museum of Art, New York
in collaboration with Brepols Publishers, Turnhout, Belgium

Library of Congress Cataloging-in-Publication Data

Petrus Christus in Renaissance Bruges: an interdisplinary approach / edited by Maryan W. Ainsworth.
236 p. 297 x 210 cm.
Papers presented at a symposium held June 10-12, 1994, at the Metropolitan Museum of Art.
In collaboration with Brepols Publishers, Turnhout, Belgium.
Includes bibliographical references.
ISBN 0-87099-751-3 (The Metropolitan Museum of Art)
ISBN 2-503-50444-2 (Brepols Publishers)
1. Christus, Petrus, ca. 1410-1475/6-Congresses.
2. Painting, Renaissance-Belgium-Bruges-Congresses.
I. Ainsworth, Maryan Wynn. II. Metropolitan Museum of Art (New York, N.Y.)
ND673.C49P48 1995
759.9493-dc2095-17091
 CIP

Published in the United States of America by The Metropolitan Museum of Art, New York.

Published in Belgium and distributed by Brepols Publishers, Turnhout, Belgium.

Printed in Belgium

PETRUS CHRISTUS
IN RENAISSANCE BRUGES

Foreword

This book is the rich result of collaborative efforts that have continued over the years, principally between American and Belgian scholars. A number of the contributors to the symposium enjoyed their first contacts with each other and with the experience of early Netherlandish art through the aegis of the Belgian American Educational Foundation. We are, therefore, very pleased on the occasion of its seventy-fifth anniversary to dedicate this volume to the Belgian American Educational Foundation and to the continuing efforts of its president, Émile Boulpaep, toward fostering scholarly exchange between Belgian and American students.

The papers in this volume are for the most part those presented at the symposium "Petrus Christus in Renaissance Bruges," which took place at The Metropolitan Museum of Art from 10 to 12 June 1994 in conjunction with the exhibition *Petrus Christus: Renaissance Master of Bruges*. Only Anne van Buren's discussion of the Eyckian workshop in Bruges will be published elsewhere, as part of her commentary for the forthcoming new facsimile of the Turin-Milan Hours. The contributions here have been augmented by three additional ones not presented at the symposium, namely those on the technical examination of the Brussels *Lamentation,* one by Hélène Verougstraete and Roger van Schoute and one by Leopold Kockaert, and my own essay, "Afterthoughts and Challenges to Modern-Day Connoisseurship." The open discussions that took place during the course of the symposium have been transcribed and edited to include the most significant exchanges between our audience and the speakers. This book is intended as a companion volume to the exhibition catalogue *Petrus Christus: Renaissance Master of Bruges* and references to illustrations in the catalogue are indicated by the terms "cat. no." or "cat. fig."

The symposium and the publication of the proceedings have been made possible through the generosity of the National Endowment for the Humanities, the Christian Humann Foundation, the government of Flanders, and the Belgian American Educational Foundation. This volume has been jointly produced by The Metropolitan Museum of Art and Brepols Publishers, in an endeavor that has been coordinated by Barbara Burn, Executive Editor, and Johan Van der Beke, Publisher. I am grateful to Patricia M. Godfrey, who edited the papers. Special thanks are also due to Margaret Koster, art historian intern in the Paintings Conservation Department, who helped with innumerable details in preparing all the papers for publication.

Maryan W. Ainsworth
The Metropolitan Museum of Art

Contents

Approaches to Petrus Christus

Lorne Campbell
Courtauld Institute of Art, London

During the past few decades, admirers of Petrus Christus have been astonishingly fortunate. Unknown or forgotten paintings in the style of Christus have turned up with surprising regularity: in the 1950s, the wonderful Kansas City *Holy Family* (cat. no. 20); in the 1960s, the Birmingham *Christ* (cat. no. 9) and the Bruges *Isabella of Portugal Presented by Saint Elizabeth;* in the 1980s, the Cleveland *Baptist* (cat. no. 3) and the problematic Bruges panels of the *Annunciation* (cat. fig. 21) and the *Nativity* (cat. fig. 23). Nothing, of course, can compensate for the loss, during World War II, of the Dessau *Crucifixion* and the Berlin wing panels of the *Baptist* and *Saint Catherine* (cat. fig. 153). We had to wait until 1974 for the first monograph devoted to Christus, but since then two more books on Christus have been published and important discoveries have been made about his career in Bruges. Now, thanks to Maryan Ainsworth and her colleagues here, we have this truly marvelous exhibition, where we have the privilege of studying more of Christus's paintings than he himself can ever have seen gathered in one place. We also have the handsome exhibition catalogue, in which Maryan Ainsworth has surveyed the work of previous authorities on Christus, in which Maximiliaan Martens has provided a valuable study of Christus's life and times and a most useful edition of all the documents concerning Christus, and in which Maryan Ainsworth has published the infrared reflectograms that she has made of Christus's paintings. Her study of Christus's underdrawings and of his technical procedures constitutes a landmark in the investigation of Early Netherlandish art.

The exhibition catalogue was necessarily written before the exhibition opened. The exhibition itself initiates a new phase in Christus studies and is the ideal beginning. If problems of attribution and chronology are ever to be settled, they must be settled during the exhibition; never again will it be possible to

study so many Christus originals assembled in one place. It is, of course, unfortunate that some panels are too delicate to travel and that four of the nine signed, probably signed, or once signed pictures cannot be here. Especially regrettable, perhaps, is the absence of the Bruges *Annunciation* and *Nativity,* about which art historians have been exceptionally evasive. Of course it would be helpful if the Bruges museum would publish the X-radiographs and detailed condition reports on the two panels.

The exhibition will, I hope, allow us to settle problems of attribution, so that it will no longer be possible to juggle attributions to suit preconceived theories. The most unfortunate victim of such juggling has been the San Diego *Death of the Virgin* (cat. no. 15), to my mind clearly by Christus but often, and without compelling arguments, rejected. If it proves necessary to reject any attribution, I trust that the unlucky rejected work of art will not be forgotten. Ever since connoisseurship went out of fashion, I have been increasingly concerned that works of art perceived as problematic or unattributable are being consigned to a limbo of undeserved neglect. I am thinking, for example, of the grisaille diptych in the Louvre of the *Baptist* and the *Virgin and Child*. First published in 1938, just too late to get into Friedländer's lists, it has occasionally been attributed to Christus but tends to be forgotten.[1] Another painting in the Christus group that is often ignored or treated with excessive caution is the Bruges *Isabella of Portugal Presented by Saint Elizabeth*. This is the left wing of a triptych; the right wing, *Saint Catherine,* is in a private collection. It seems well established that they are the shutters of a triptych of the *Pietà* that was in the collection of Margaret of Austria. Although the Duchess of Burgundy appears as the donatrix and though the triptych belonged to her great-granddaughter, Margaret of Austria did not inherit it but had it as a gift from one of her ladies.[2] It was not necessarily commis-

sioned by Isabella, but it is surely significant in suggesting a connection of some kind between the Burgundian court and Christus's workshop or followers.

Christus is frequently said to have had no following, but that seems patently untrue: the Master of the Baroncelli Portraits, for example, was strongly influenced by Christus and deserves more attention than he normally gets. I would like to suggest that the Baroncelli Master may have painted a *Pentecost,* in a private collection; but I do so with great caution because I have never seen it. It comes from Bruges, from the Rappaert family, and in the last century was still attached to two seventeenth-century wing panels representing Pieter Rappaert, his wife Margareta de Badts, whom he married in 1606, and eight of their children.[3] Christus's son Bastyaen, or Sebastian, Christus should also be investigated. He was good enough for one of his pictures, a *Virgin and Child,* to have found its way by 1491 into the collection of the queen of France, Anne of Brittany. It would appear to have been signed "Sebastian son of deceased Petrus Christus" in a gesture of filial piety similar to that made by Rogier's grandson Goswijn van der Weyden in a signature on a lost triptych of 1535.[4]

After Max Martens's investigations, there is not much chance that anyone will discover more about Christus's career in Bruges; but it may be possible to find out something about his origins. All that is known about his parentage and early life is that his father's name was also Petrus and that he was from Baerle. *Christus* is a strange surname. Weale suggested that it came into being because Petrus the elder was a painter of Holy Faces or a carver of crucifixes.[5] In fact the name occurs with some frequency in the fifteenth and sixteenth centuries in and around Breda, which confirms that the Baerle from which Christus came was the Baerle south of Breda, and further suggests that the ancestor who gave the family its unusual surname belonged to an earlier generation than Petrus's father.[6] Petrus must have been born into a reasonably prosperous family: without financial backing, he could never have become a painter or gone to Bruges to set up a business there.

The most prominent member of the Christus family was indubitably Geryt Christus, who died in 1488. As *his* father's name was Hendrik,

he cannot have been Petrus's brother; he was probably a cousin of some sort. Geryt was involved in property transactions at Breda from 1447, was alderman of Breda on several occasions between 1466 and 1486, and was burgomaster of Breda in 1470 and 1473. During the 1470s and 1480s he also held office in the feudal court of Breda and as deputy of the *drossaard,* or bailiff.[7] His wife Agnes was an illegitimate daughter of the nobleman Dirk van der Merweden, a gallant supporter of Jacqueline of Bavaria, whom he apparently helped to escape from Ghent in 1425. Dirk's wife was related to Jacqueline and to Philip the Good, whose favor he managed to attract; he was his councillor and chamberlain as well as his bailiff and castellan of Heusden, an important fortress controlling the lowest reaches of the Meuse.[8] Dirk van der Merweden bequeathed to Geryt Christus and his wife a considerable annual income.[9] Dirk Christus of Breda, possibly a son of Geryt and perhaps named after his maternal grandfather, Dirk van der Merweden, matriculated at the University of Orléans in 1484. He was a bachelor of civil and canon law, a master of arts and, from 1486, proctor of the German nation at Orléans.[10] Another possible relative of Petrus was Nicholas Christus, from Hoogstraten, just west of Baerle. He matriculated at Louvain University in 1496[11] and was almost certainly the Master Nicolaas Christi recorded at Bergen op Zoom between 1504 and 1526. He was the priest attached to the Béguinage there until, accused of having Lutheran sympathies, he disappeared from Bergen.[12] Petrus Christus seems to have come of a prosperous and well-educated family.

The seal of Geryt Christus shows his coat of arms, a fess embattled couterembattled between three insects.[13] If Petrus Christus was indeed Geryt's cousin, and if he used the same coat of arms, it would be tempting to see some heraldic significance in the famous fly in the *Portrait of a Carthusian* (cat. no. 5): it has settled directly above Christus's name. Other artists, however, included flies in their portraits. In two versions of van der Weyden's *Philip the Good without Headgear,* large flies are crawling upon the backgrounds.[14]

Much remains to be discovered about the patrons of Petrus Christus. The best documented of them is probably Edward Grimston, who, when Christus painted his portrait in

1446 (cat. fig. 65), was very much a young courtier on the make. Little can be added to the exemplary biography published by Franks in 1866;[15] it would be enormously helpful to have similar definitive biographies of Christus's other identifiable patrons. In passing, I should perhaps mention that Franks's article has been consistently misquoted or misrepresented in the subsequent literature on the *Grimston*.

Other Christus sitters should be identifiable: for example the Washington donors (cat. no. 12). They are Genoese: she is a Vivaldi and her name is probably Elizabeth, since there is a woodcut of Saint Elizabeth behind her; he seems to be a Lomellini. It sounds as though it should be easy to track down a Lomellini man who married an Elisabetta Vivaldi and who was involved in trade between Genoa and the Low Countries; but though there were a surprising number of Lomellini-Vivaldi marriages, no obvious candidates, as far as I know, have presented themselves. There was a Battina Vivaldi who married a Domenico Lomellini; they were alive in 1492, but, as her father died only in 1470, they were perhaps too young to have encountered Christus in about 1450.[16] The Copenhagen donor (cat. fig. 8), whose coat of arms was revealed during cleaning in 1984, ought to be identifiable. The arms in the first and fourth quarters of his shield were used by a number of families in the Low Countries and Italy and elsewhere; those in the second and third quarters I have not yet found outside the German-speaking countries. As the picture was acquired in Holland in 1763, and as it was then attached to a *Holy Family* in the style of van Dyck, it seems more likely to have been painted for a Netherlandish than for an Italian patron.[17] A van Hoven and a Ram family used the first coat of arms.[18] It may be possible to pursue the heraldic investigation, to find a reference to the painting when it was on the Dutch art market in the early 1760s, or even to discover when and why it was joined to the *Holy Family*. I offer one piece of unpublished evidence, a copy of the portrait joined to the *Holy Family*. This is, or was, at Rudding Park, near Harrogate, in Yorkshire.[19]

The identity of the Berlin *Lady* (cat. no. 19) is another problem that should be soluble. Waagen, who evidently examined the original frame before it was mysteriously lost, noted that it bore the signature "Opus Petri Christophori" and a second inscription giving the name of the sitter, whom Waagen called "a niece of the famous Talbot."[20] The famous Talbot was John Talbot, first earl of Shrewsbury, an English warrior who was revered not only by the English but also by his enemies the French, and who was so famous that a chapel was built in his honor on the site where he was killed, at the Battle of Castillon in 1453.[21] His only niece, however, died aged about five in 1421 and clearly cannot have been the Berlin sitter, whom Christus must have painted in the 1460s.[22] But the inscription, like the signature, may have been in Latin: *nepos,* the Latin word for niece, can also mean granddaughter, and the famous Talbot had several granddaughters who could have sat to Christus. The two daughters of Talbot's eldest son, the second earl of Shrewsbury, were Anne and Margaret. I find that Margaret's husband, Thomas Chaworth, was born in 1457; Margaret is unlikely to have been much older and is therefore an improbable candidate.[23]

Anne, who married Henry Vernon in 1467,[24] may very well have accompanied her aunt, the duchess of Norfolk, who went to Bruges in 1468 as principal lady to Margaret of York when she married Charles the Bold. Not much is known about Anne, but I have come across an undated letter that she wrote to a London mercer:

> desyring you for to delyver a yerd and a quarter of fyne blak velvet unto Maisteris Langton bunyng [being] in Chepeside for to make me a bonnett of.[25]

Unfortunately, this black velvet bonnet is unlikely to be the hat worn by the Berlin sitter. Anne died in 1493,[26] before her husband, Sir Henry Vernon, who, when making his will in 1515, ordained that her "bones be taken uppe and laid with me when our tombe is made." The tomb, in the Vernon Chapel of the church at Tong in Shropshire, was to be completed within two years of his death, "and the better and the more honorable for the bloode that my wyff is comyn of."[27] The tomb survives, in rather a battered state (Fig. 1); the effigy of Anne, made long after her death, may be compared with the Berlin portrait but cannot be said to confirm that the sitter is indeed she.

The famous Talbot in fact had two other granddaughters, the children of one of his younger sons, Lord Lisle. They were Elizabeth

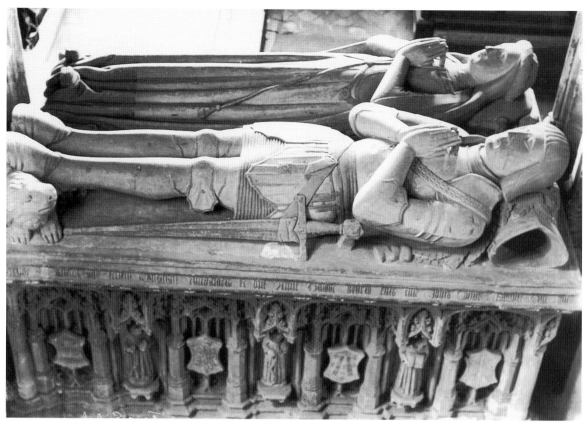

Figure 1. Tomb of Henry Vernon (died 1515) and his wife, Anne Talbot (died 1493), Vernon Chapel, St. Bartholomew, Tong, Shropshire (photo: Canon M. H. Ridgway)

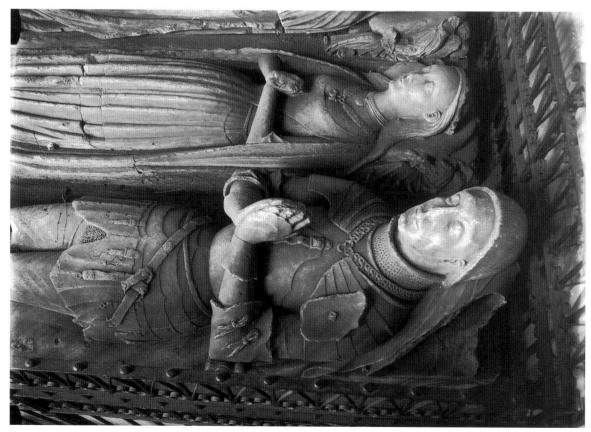

Figure 2. Effigies of Elizabeth Talbot, Lady Lisle (died 1487), and Edward Grey, Lord Ferrers (died 1457), St. Mary, Astley, Warwickshire (photo: Conway Library)

and another Margaret and were aged eighteen and sixteen in September 1470[28]; they too might have gone to Bruges in the entourage of their aunt. Margaret married but died almost immediately.[29] Elizabeth, who died in 1487, had a very grand tomb at Astley in Warwickshire. What is thought to be her effigy survives at Astley (Fig. 2), but it is a generalized image, of little use for comparative purposes.[30]

The X-radiograph of the Berlin portrait, published in the exhibition catalogue (cat. fig. 164), seems to show that there is some sort of heraldic achievement on the reverse. If the reverse is investigated, the identity of the sitter may be at last and definitively reestablished.

The most revealing document that anyone leaves behind is often a will, but no wills of persons who certainly commissioned paintings from Christus have been found, and the will of Christus's possible patron Pieter Adornes does not refer to pictures.[31] It is perhaps worth looking quickly at the will of a contemporary patron, Marie de Pacy, who died in Brussels in 1452.[32] She was painted by the Master of Flémalle or one of his followers; the portrait is known only from copies. Marie was the widow of Barthélemy Alatruye, an important official of the Burgundian financial administration. They came from Lille but moved to Brussels in the 1430s.[33] Marie bequeathed to the Carmelite church in Brussels, where she was buried, her altar table and her large missal, which she kept in the chapel of her Brussels residence. She owned a second missal, also kept in her Brussels house and left to one of her executors. Her other legacies to the Carmelites included "une pierre dautel ou les xij apostres sont"; "un tablet dun crucifix en crois"; two cushions of red cloth of gold; a fine brass chandelier; an altarpiece of black velvet embroidered in Cyprus gold and showing Our Lady holding Christ in her lap and Saints Bartholomew and Mary Magdalen; a painted portrait of herself ("un tablet ou est le visaige de ladite testatresse en painture"); and a pair of sleeves from her best dress. The rest of her best dress, which like the dress in her portrait was red and furred with miniver, she left to her parish church, Saint Géry.

In the bad old days, there seems to have been a general feeling that there was little point in attempting further archival research; that Pinchart, Dehaisnes, Weale, and their colleagues had found and published all that was worth knowing; and that they had published a great deal more that, having no direct bearing on surviving works of art, was best ignored. I am glad to say that attitudes have changed, that art historians are now reading the documents published in the last century and are making important discoveries in Belgian and French archives. One of the most interesting revelations has been Max Martens's, who has found the true date of Christus's death.

Even in places like Tournai and Brussels, where the local archives have been largely destroyed, important discoveries are still being made, and some are not without relevance to Christus. In Tournai, it has emerged that Robert Campin, besides endowing a chapel dedicated to Saint Luke, was paid in 1430–31 for having made and painted a Crucifixion in a new missal made for the church of Saint Margaret.[34] This of course has some bearing on the question of the activity of certain painters as illuminators: Maryan Ainsworth has written in the exhibition catalogue about Christus's possible work as an illuminator. Another Tournaisien discovery, made this time by reexamining the published sources, concerns the painter Louis Le Duc, one of the famous artists listed by Jean Lemaire de Belges in his *Couronne margaritique* of 1504:

> Et de Tournai plein d'engin celestin
> Maistre Loys, dont tant discret fut l'oeil.[35]

Louis Le Duc, it emerges, was Rogier van der Weyden's nephew and was presumably trained in Brussels by his uncle. Louis returned to Tournai, where he became a master in 1453, but in 1460–61 he moved to Bruges, where he must have known Petrus Christus.[36] The presence in Bruges in the early 1460s of Rogier's nephew, himself a famous artist, seems worth remembering.

In van Eyck studies, too, there have been important revelations. Lambert van Eyck, the third brother, appears certainly to have been a painter and to have executed in 1432 a portrait of Jacqueline of Bavaria, now known only from copies. Lambert, who survived his brothers, could have played an important part in winding up Jan's business; he could, perhaps, have taken over Jan's workshop and his stock of patterns.[37] A Lucchese contract of 1480, first published in 1982, seems not to have been given

much attention, but it establishes that Jan van Eyck painted a *Pietà*.[38] No longer can one entertain the idea—which, I confess, I found attractive—that Jan deliberately avoided painting scenes of intense emotion and that because he was so much admired, he could pick and choose his commissions accordingly. The Lucca document concerns Agata, widow of Paolo di Poggio. This must, I think, be the same Paolo di Poggio who was living in Bruges in 1450 and who handled payments from Leonello d'Este to Rogier van der Weyden.[39] The widow Agata was commissioning two local artists to paint a representation of

> Nostra Donna con lo Figliuolo morto in braccio, tutto, con un'altra figura, nel modo che sta in una taula di messer Giovanni di Bruggia in casa di dicta Madonna Agata, et dennola fare in quella forma et in quello acto, la quale taula in mia presenza hanno visto dicti dipintori.

Petrus Christus could very easily have seen this lost *Pietà* before it was taken from Bruges to Lucca.

Other discoveries, in conjunction with the results of technical investigations, can be taken to cast light on the important questions of how paintings were commissioned and executed. A particularly interesting series of extracts from the accounts of the Brussels shoemakers was published in 1991 and concerns a polyptych painted by Aert van den Bossche between 1490 and 1494.[40] It was probably the altarpiece of Saints Crispin and Crispinian, of which the center panel is in Warsaw and some of the wing panels survive in Moscow and in the Musée Communal in Brussels. The painter had a substantial advance; he then prepared a design, for which he was paid. After the design had been approved by the senior members of the corporation, a contract was drawn up—unfortunately the contract itself is lost—and a copy of the original design was made and paid for. The price of the copy was modest, one twentieth of the amount paid for the design itself. Presumably it was a small and schematic copy, made for and preserved by the patrons to ensure that the artist kept to his contract and did not deviate from the approved design. As was customary, the design itself would have remained in the artist's possession.

Such designs must have been elaborate. In 1474 the burgomasters of Bruges went with the treasurers and other members of the administration to the house of the painter Pierre Coustain to have his opinion on the making of a design for a figure of Philip the Good. Presumably, Coustain was himself to make this design, to be used for a stone statue for the Town Hall.[41] When Gossaert died, one of his principal assets was reckoned to be the design, *tpatroen,* for the famous *Middelburg Altarpiece,* which Dürer had admired in 1520.[42] These models or contract designs could have been drawn or painted, according to the patron's needs as well as the artist's usual practice. What is beyond any doubt is that they were carefully scrutinized and highly regarded and that the making of such a design was a vital stage in the execution of an important commission.

The next vital stage was obviously the making of the underdrawing, which of necessity followed very exactly the approved design. In van der Weyden's triptych of the *Nativity* (Berlin), scrolls in the underdrawing were never painted. They reappear, however, in the Cloisters version of the triptych, painted by a later follower.[43] The only reasonable explanation for what seems at first an anomaly is that Rogier provided for his patron a design in which the scrolls were present. The design was then copied onto the panels as underdrawing, but Rogier, his patron, or both together decided against the scrolls, which were never painted. The original design, with the scrolls, remained with Rogier and his heirs, and, with sensible economy, they would have kept it with the other workshop patterns. The painter of the Cloisters polyptych would have examined and copied the original design but he need never have seen Rogier's finished triptych.

The original, approved design was of paramount importance. Transferring this design to the panel was not necessarily a very interesting task and could have been delegated to assistants. There is, then, no guarantee that the underdrawing, especially the underdrawing of a large and expensive commission, was invariably by the head of the workshop. Van der Weyden seems often to have delegated underdrawings to assistants, for instance in the *Columba Triptych,*[44] but no painter need have been totally consistent in his working procedures, and every artist evolves different procedures to suit his own tastes and, if necessary, the requirements of his workshop. As the underdrawings in Christus's large paintings seem consistent in

style, it appears safe to assume that his normal practice was to execute his own underdrawings.

In some pictures in the Christus group—the Cleveland *Baptist* (cat. no. 3), the New York *Lamentation* (cat. no. 8), the *Friedsam Annunciation* (cat. no. 10), and the Exeter *Madonna* (cat. no. 7)—the color is so idiosyncratic as to suggest that unusual pigments may be present. These paintings appear to relate to the signed Christus *Virgin* of 1449 (cat. fig. 12), which I have not seen but where the same brown purple and acid green seem to occur. The greens may well be combinations of lead-tin yellow and copper greens, but I am not sure how the Indian reds and brown purples of these pictures have been created. Red earths may be present.

In the London *Portrait of a Young Man* (cat. fig. 66), the red robe is of course vermilion, red lake, and white, with a red lake glaze. In the robe and in the red object beneath the book, there are in places traces of finely ground lapis lazuli, as well as black, mixed into the glaze. Jan van Eyck also used lapis in the same way in red draperies: this seems not to have been a common practice and may indicate something about Christus's contacts with van Eyck and his followers. In the London portrait, there is much unnecessary detail: for example in the illuminated prayer, where the pins holding the vermilion edging tape to the backing panel are very carefully rendered and the undulations in the tape are most patiently observed and lovingly painted. Jan van Eyck was more sparing of his effort, and painted detail with superb skill and economy; in his devotion to apparently insignificant and minute detail, Christus comes nearer Rogier van der Weyden.

While various scholars have shown much ingenuity in trying to explain the symbolism that may—or may not—be present in Early Netherlandish paintings, we should perhaps take a greater interest in what is actually depicted. The buildings and interiors represented would repay much closer scrutiny. The Kansas City *Virgin* (cat. no. 20), for example, is in a type of room often described in the books as a "bourgeois interior." I am not quite sure how and why this term gained currency and I do not think that anyone has ever tried to justify its use. Perhaps these rooms look fairly like De Hooch's interiors, but, in fifteenth-century rather than seventeenth-century terms, they are palatial. Let us compare a French royal palace

as it is depicted in the *Girart de Roussillon,* a manuscript of about 1450.[45] The Kansas City interior has a less elaborate floor but is otherwise comparable. A carved lion decorates the arm of the chair built into the Kansas City bed and there it may have symbolic importance; but there are carved lions on the bench in the manuscript, where they can have no religious significance. The beds are necessary furniture for grand reception rooms: these are not bedchambers but reception rooms that happen to contain beds. The followers of van der Weyden could use exactly the same setting, a reception room containing a bed, for an *Annunciation* and for a portrait of a count of Edessa.[46] French ambassadors, received by Henry VI of England at Westminster in 1445, were surprised to find the king in a lofty chamber hung with tapestries but without a bed.[47]

Costume is another neglected field. Art historians often use dress to date works of art, but dress can be studied from many other points of view. In Christus's *Lamentation* in Brussels (see Verougstraete and van Schoute essay, Plate 33), for example, the Magdalen is wearing a short-sleeved, tight-fitting dress that has been hurriedly and ineffectively laced up the front. She has laced only every second eyelet; below the waist, she has given up lacing altogether. The garment is in fact not a dress but an underdress, of a type shown by the Master of Wavrin in his *Roman de Girart de Nevers*. There the heroine is unlacing her underdress (which, unlike Christus's Magdalen, she has laced properly through all the eyelets) as she prepares for her bath; her treacherous servant is boring a hole through the wall so that the villain can spy on her. Christus's Magdalen is appearing in public half-dressed. In her distress, she has put on only her underdress, has had no time to lace it properly, and has flung a mantle carelessly about her.[48] Such distraught and disheveled Magdalens appear in van der Weyden's pictures. The Mary on the right of Christus's *Lamentation* is even more strangely dressed, as she appears to have put on her clothes in completely the wrong order, her chemise over her dress. I cannot pursue these points but refer anyone interested to Margaret Scott's book on dress, *Late Gothic Europe*.[49]

Contemporaries would obviously have understood details of costume, of furniture, in ways that we cannot hope to reconstruct comple-

ly, but it is, I think, worth considering what the implications may have been. Contemporaries may have been less good at understanding narratives. An educated Englishman, possibly a herald, who accompanied Margaret of York to her wedding at Bruges in 1468, was puzzled by the *tableaux vivants* that he saw at Sluis:

> the pageauntes were soo obscure, that y fere me to wryte or speke of them, because all was countenaunce and noo wordes.

Conscious of the lack of explanatory inscriptions, he must have asked about the *tableaux,* for he went on to mention that he understood the subjects to have been Jason, Esther, and Vashti.[50]

Christus's attitude to reality is most easily studied in his portraits, where he distorts his sitters in some of the same ways as Jan van Eyck. Christus does not shrink their bodies so drastically as van Eyck, but both tend to diminish the cranium of a man, to extend the forehead of a woman, and to enlarge the features of both sexes. In the *Grimston* (cat. fig. 65), the eyes are seen more or less frontally while the nose, mouth, and ear are turned further into profile. The eyes are viewed slightly from above, so that the linings of the lower lids are visible, whereas the nose is seen from below to reveal much of the near nostril. Such adjustments of viewpoint are usual in Christus, and not just in his portraits; he presumably, and rightly, believed that such slight adjustments heightened the degree of individualization. The line in the cornice marks the center of the panel's height; the tear duct of the near eye is in the middle of its width. Christus's concern for symmetry and pattern becomes increasingly obvious in his later portraits. In the London *Young Man* (cat. fig. 66), the features are distorted like Grimston's, though here the cranium is not shrunken and the near eye is set too low—something that happens fairly often in Christus's work. Its pupil marks the center of the width of the panel, as does the fur cuff of the right sleeve, while the shirt collar and the lion's mouth are at the center of its height.

In the Berlin *Lady* (cat. no. 19), we have a much enlarged forehead and cranium and the usual rearrangement of the slightly enlarged features. The profile ear is rather surprising and is set too high, perhaps to make the neck look longer. Because the nostril is seen from below, one has the sense of looking up at the sitter, although the linings of her lower eyelids are visible. The eyes are completely asymmetrical, the far eye being more or less horizontal but the near eye rising at an angle of 10 degrees. The sitter's expression varies as one concentrates attention on the near, or on the far, side of her face. The cornice marks the center of the height of the panel; at the center of its width are the head of the pin, the middle pearl in the lower row of her necklace, and the corner of her near eye. The important and assertive diagonal of the far side of her hat is approximately parallel to the main diagonal of the support and is at exactly 60 degrees to the horizontal, while the upper contour of the far side of her fur collar again makes an angle of 60 degrees with the horizontal. Christus seems to have developed a great liking, no doubt instinctive, for the 60-degree angle of a perfect equilateral triangle, as well as for the geometric harmonies of symmetrical patterns.

Petrus Christus has been overshadowed by his great contemporaries Jan van Eyck and Rogier van der Weyden. Fifteenth-century Netherlandish painting has been most unjustly overshadowed by fifteenth-century Italian painting. This exhibition gives us a wonderful opportunity to look at Christus and to take him on his own terms. We must make every effort to abandon preconceptions and prejudices. Because Christus shares certain interests, notably in geometric pattern and in mathematical perspective, with some of the great Italians, he is compared, to his disadvantage, with Piero della Francesca. This is simply not fair: the resemblances are probably entirely coincidental and Christus's aims, as a representational painter, were entirely different from Piero's and rather less literal. His paintings look less real than van Eyck's, yet van Eyck's figures are more distorted than Christus's and his detail is sometimes less exact. Christus comes close to van Eyck's supreme command of tone. Thanks to this marvelous exhibition and its splendid catalogue, we are well on the way to rescuing Christus from unjustified neglect and are beginning to view him more positively. If we can recognize, and then abandon, our prejudices, our false preconceptions, the way is open for a reassessment of Petrus Christus as one of the most fascinating of all fifteenth-century artists. The reassessment has begun in the exhibition and continues, over the weekend, at the Symposium.

NOTES

In this lecture I have deliberately avoided mentioning by name living authorities on Petrus Christus—apart from the authors of the exhibition catalogue. As it was clearly impossible to mention all the many contributions made by living scholars to Christus studies, I decided to speak in general terms rather than to attempt a selective critical review.

1. Édouard Michel, *Peintures flamandes du XVe et du XVIe siècle*, catalogue raisonné, Musée du Louvre (Paris, 1953) pp. 64–65; Nicole Reynaud in *Polyptyques: Le Tableau multiple du moyen âge au vingtième siècle,* exh. cat., Louvre (Paris, 1990) pp. 86–87. See Ainsworth and Martens, *Petrus Christus,* p. 35, note 21.

2. Aquilin Janssens de Bisthoven, M. Baes-Dondeyne, and D. De Vos, *De Vlaamse primitieven*, vol. 1 *Corpus ...,* 1, Stedelijk Museum voor schone kunsten (Groeningemuseum) Brugge, 2nd ed. (Brussels, 1981) pp. 85–101.

3. J. Gailliard, *Bruges et le Franc*, 6 vols. (Bruges, 1857–64) vol. 4, p. 279; M. J. Friedländer, *Early Netherlandish Painting*, trans. H. Norden (Leiden and Brussels, 1967–76) vol. 10, pp. 19, 70, plate 13 (14), there attributed to Mostaert.

4. Inventory of the *trésorerie de l'épargne* of Anne Brittany, queen of France, at the castle of Nantes, 12–13 April 1491 (Bibliothèque Nationale, Paris, MS fr. 1364, fol. 4 v): "Item ung autre tableau, ouquel y a une ymage de nre dame laquelle tient son enfant sur son bras destre et y a escript autour missus est angelus gabriel [& c?] et le fist ung nome sebastianus qudam filius petri xpi." The extract was published in a shortened form by W. H. J. Weale, "Peintres brugeois, Les Christus," *Annales de la Société d'émulation de Bruges* 59 (1909) pp. 97–120, p. 113, note 2. For Goswijn van der Weyden's altarpiece of the *Death and Assumption of the Virgin*, once at Tongerlo, see Adrianus Heylen, *Historische verhandeling over de Kempen* (Turnhout, 1837) p. 160.

5. Weale, "Peintres brugeois," p. 100.

6. H. J. J. Scholtens, "Petrus Christus en zijn portret van een kartuizer," *Oud Holland* 75 (1960) pp. 59–72, 59–63.

7. Ibid., pp. 61–62 and references.

8. L. Galesloot, *Inventaire des archives de la Cour féodale de Brabant*, 2 vols. (Brussels, 1870–84) vol. 1, pp. 130–131; G. C. A. Juten, "Burgst," *Taxandria: Tijdschrift voor Noordbrabantsche geschiedenis en volkskunde*, vierde reeks, achtste jaargang, 38 (1931) pp. 113–123, 191–192, 116–117; Dirk's wife Catherine van Ranst was a descendant of Joanna, bastard daughter of John III of Brabant, the great-great-grandfather of Philip the Good. See F. C. Butkens, *Trophées sacrés et prophanes du duché de Brabant*, 2nd ed., 4 vols. (The Hague, 1724) vol. 1, p. 449, vol. 2, pp. 241, 246–247; Galesloot, *Inventaire*.

9. F. F. X. Cerutti, *Middeleeuwse rechtsbronnen van de stad en heerlijkheid Breda*, vol. 3, Werken der Stichting tot uitgaaf der bronnen van het oud-vaderlandse recht, 19 (Zutphen, 1990) p. 27.

10. Hilde De Ridder-Symoens, Cornelia M. Ridderikhoff, and Detlef Illmer, *Premier livre des procurateurs de la nation germanique de l'ancienne Université d'Orléans, 1444–1546*, seconde partie, *Biographies des étudiants*, vol. 1 (Leiden, 1978) p. 120.

11. A. Schillings, *Matricule de l'Université de Louvain*, vol. 3, Commission royale d'histoire (Brussels, 1958) p. 134.

12. G. C. A. Juten, "Het begijnhof te Bergen op Zoom (vervolg)," *Taxandria* 38 (1931) pp. 57–64; 63.

13. W. J. F. Juten, "Noordbrabantsche zegels," *Taxandria* 14 (1909) pp. 290–300; 291, 299; Scholtens, "Petrus Christus en zijn portret," p. 62, fig. 2.

14. Palacio Real, Madrid, and formerly Schlossmuseum, Gotha: Friedländer, *Netherlandish Painting*, vol. 2, plate 127 (125a, 125b).

15. A. W. Franks, "Notes on Edward Grimston," *Archaeologia* 40 (1866) pp. 455–470; see also John Ferguson, *English Diplomacy 1422–1461* (Oxford, 1972) pp. 180, 189.

16. Natale Battilana, *Genealogia delle famiglie nobili di Genova*, vol. 1 (Genoa, 1825) fasc. Vivaldi, p. 10.

17. *Restaureringsbilleder: En udstilling om bevaring og undersogelse af aeldre kunst*, exh. cat., Statens Museum for Kunst (Copenhagen, 1984) pp. 46–52, 105–106.

18. J. B. Rietstap, *Armorial général*, 2nd ed., 2 vols. (Gouda, 1884–87) vol. 1, p. 996, vol. 2, p. 1519.

19. Formerly in the collection of Sir Everard Radcliffe, Bart., M.C.; photograph in the Witt Library, Courtauld Institute of Art, London (negative B72/1117).

20. G. F. Waagen, *Verzeichniss der Gemälde-Sammlung des königlichen Museums zu Berlin* (Berlin, 1834) p. 141; idem, *Handbuch der deutschen und niederländischen Malerschulen*, 2 vols. (Stuttgart, 1862) vol. 1, p. 94, note 3.

21. Hugh Talbot, *The English Achilles: An Account of the Life and Campaigns of John Talbot, 1st Earl of Shrewsbury (1383–1453)* (London, 1981).

22. G. E. C., *The Complete Peerage*, rev. ed., 13 vols. (London, 1910–59) vol. 11, pp. 698–699.

23. Mary A. Renshaw, *Inquisitions Post Mortem Relating to Nottinghamshire, 1437–1485*, Thoroton Society, Record Series, XVII (Nottingham, 1956) p. 60. Thomas Chaworth died in 1483; Margaret married as her second husband, in 1483 or 1484, Ralph Vernon. See George P. Farnham and A. Hamilton Thompson, "The Manor and Advowson of Medbourne, 1086–1550," *Transactions of the Leicestershire Archaeological Society* 13 (1923-24) pp. 91–135, 122–123. She became insane on 21 September 1485 and was still alive in 1513; see J. S. Brewer, ed., *Letters and Papers, Foreign and Domestic, Henry VIII*, vol. 1, i (London, 1920) pp. 755–756.

24. John Nichols, *The History and Antiquities of the County of Leicester*, vol. 3, ii (London, 1804) pp. 985★–986★; Susan M. Wright, *The Derbyshire Gentry in the Fifteenth Century*, Derbyshire Records Society, vol. 8 (Chesterfield, 1983) p. 139 and Appendix 5b.

25. Royal Commission on Historical Manuscripts, *Twelfth Report*, Appendix 4, *The Manuscripts of His Grace The Duke of Rutland*, vol. 1 (London, 1888) p. 14.

26. Nichols, *History and Antiquities*, p. 986★.

27. Will dated 18 January 1515, proved in the Prerogative Court of Canterbury 5 May 1515: Public Record Office (henceforth PRO) London, PROB 11/18, quire 9.

28. PRO, C 140/35, no. 58; see also G. E. C., *Complete Peerage*, VIII, p. 59, where it is wrongly stated that there was a

third sister, Eleanor, who married Sir Thomas Butler and died on 30 June 1468. Eleanor was in fact the aunt and not the sister of Elizabeth and Margaret; she was a daughter of the famous Talbot; see Inquisition post mortem, PRO, C 140/29, no. 39.

29. Margaret married Sir George Vere and died without issue in December 1472; Inquisitions post mortem, PRO, C 140/41, no. 40.

30. Elizabeth married, before August 1472, Edward Grey, viscount Lisle, and died on 8 September 1487; *Calendar of Inquisitions Post Mortem, Henry VII*, vol. 1 (London, 1898) p. 110; G. E. C., *Complete Peerage*, vol. 8, pp. 59–60. For the effigy at Astley, see Philip B. Chatwin, "Monumental Effigies in the County of Warwick," *Birmingham Archaeological Society, Transactions and Proceedings* 47 (1921, published 1924) pp. 35–88, 84–85, and plate *XI* fig. l.

31. Stadsarchief, Bruges, 93/I-32; Susan F. Jones kindly showed me a transcript of this document.

32. Archives générales du royaume, Brussels, de Lalaing 525, dated 2 May and 28 June 1452.

33. On Marie, her husband, and her portrait, see Paul Denis du Péage, *Recueil de généalogies lilloises*, 4 vols., Mémoires de la Société d'études de la province de Cambrai, 12–15 (Lille, 1906–8) vol. 3, pp. 899–901; L. Campbell, *Renaissance Portraits: European Portrait-Painting in the Fourteenth, Fifteenth, and Sixteenth Centuries* (New Haven and London, 1990) pp. 211–213 and references. For the purchase of their house in Brussels, see T. S. Jansma, *Raad en rekenkamer in Holland en Zeeland tijdens hertog Philips van Bourgondië,* Bijdragen van het Instituut voor middeleeuwsche geschiedenis der Rijksuniversiteit te Utrecht, 18 (Utrecht, 1932) p. 157.

34. Jean Dumoulin and Jacques Pycke, "Comptes de la paroisse de Sainte Marguerite de Tournai au quinzième siècle: Documents inédits relatifs à Roger de la Pasture, Robert Campin, et d'autres artisans tournaisiens," in *Les Grands Siècles de Tournai (12ᵉ–15ᵉ siècles): Recueil d'études publié à l'occasion du 20ᵉ anniversaire des guides de Tournai*, vol. 7 (Tournai and Louvain-la-Neuve, 1993) pp. 279–320, 28l, 301.

35. *Oeuvres de Jean Lemaire de Belges,* ed. J. Stecher, vol. 4 (Louvain, 1891) p. 163.

36. Albert Schouteet, *De Vlaamse primitieven te Brugge: Bronnen voor de schilderkunst te Brugge tot de dood van Gerard David,* vol. 1, Fontes Historiae Artis Neerlandicae, vol. 2 (Brussels, 1989) pp. 182–183.

37. J. K. Steppe, "Lambert van Eyck en het portret van Jacoba van Beieren," *Mededelingen van de Koninklijke Academie voor wetenschappen, letteren en schone kunsten van België, Klasse der Schone Kunsten,* 44, no. 2 (1983) *Academiae Analecta,* pp. 53–86.

38. Claudio Ferri, "Nuove notizie documentarie su autori e dipinti del '400 lucchese," *Actum Luce* 11 (1982) pp. 53–72;

Graziano Concioni, Claudio Ferri, and Giuseppe Ghilarducci, *I pittori rinascimentali a Lucca: Vita, opera, committenza* (Lucca, 1988) pp. 16, 51–54.

39. *Le Muse e il principe: Arte di corte nel rinascimento padano, Catalogo,* exh. cat., Museo Poldi-Pezzoli (Milan, 1991) pp. 314–315.

40. A.-M. Bonenfant-Feytmans, "Aert van den Bossche peintre du polyptyque des saints Crépin et Crépinien," *Université Libre de Bruxelles, Annales d'histoire de l'art et d'archéologie* 13 (1991) pp. 43–58.

41. Schouteet, *De Vlaamse primitieven,* pp. 154–155.

42. " 't patroen vander tafel vand' abdye te middelb'," document of 11 April 1536, Gemeentearchief Veere, Archief van de Weeskamer van de stad Veere, Weesboek E (1531–44) fol. 108. A French translation was published in Maurice Gossart, *Jean Gossart de Maubeuge, sa vie et son oeuvre* (Lille, n.d.) p. 143. Peter Blom, archivist at Veere, very kindly sent a photocopy of the original document.

43. Rainald Grosshans, "Infrarotuntersuchungen zum Studium der Unterzeichnung auf den Berliner Altären von Rogier van der Weyden," *Jahrbuch Preussischer Kulturbesitz* 19 (1982) pp. 137–177; J. R. J. van Asperen de Boer, J. Dijkstra, and R. van Schoute, *Underdrawing in Paintings of the Rogier van der Weyden and Master of Flémalle Groups,* Nederlands Kunsthistorisch Jaarboek, 41, 1990 (Zwolle, 1992) p. 162.

44. Ibid., pp. 202–221.

45. Österreichische Nationalbibliothek, Vienna, cod. 2549, fol. 80; Otto Pächt, Ulrike Jenni, and Dagmar Thoss, *Die illuminierten Handschriften und Inkunabeln der Österreichischen Nationalbibliothek, Flämische Schule,* vol. 1, 2 vols. (Vienna, 1983) vol. 2, plate 72.

46. The *Annunciation* is in the Louvre; Van Asperen de Boer et al., *Underdrawing,* pp. 299–302. The miniature of Joscelin II, Count of Edessa (d. 1159) is in the *Chroniques de Jérusalem abrégées,* Österreichische Nationalbibliothek, Vienna, cod. 2533, fol. 15; Pächt et al., *Die illuminierten Handschriften,* plate 118.

47. "Et trouverent le roy en une haute sallet sans lit. . ."; "Relation de l'ambassade de Loys de Bourbon, comte de Vendosme," printed in Joseph Stevenson, ed., *Letters and Papers Illustrative of the Wars of the English in France during the Reign of Henry the Sixth,* vol. 1, Rerum Britannicarum Medii Aevi Scriptores, vol. 22 (London, 1861) p. 103.

48. Bibliothèque Royale, Brussels, MS 9631, fol. 11; reproduced in Margaret Scott, *Late Gothic Europe, 1400-1500,* The History of Dress Series (London, 1980) p. 14.

49. Ibid., pp. 135–136, 149–154.

50. Samuel Bentley, *Excerpta Historica* (London, 1833) p. 229.

The Creative Environment: Incentives to and Functions of Bruges Art Production

Wim Blockmans
Leiden University

The relationship between art and society belongs to the most ferociously debated issues in history. We should not be too surprised at the difficulty of the task of bridging the gap between *ars* and *ratio*, on the one hand rendering artistic freedom, creativity, and taste comprehensible, and on the other giving the emotional and sensitive aspects of mankind their due place within the so-called rational Western society. While it had been commonly accepted that artistic production generally developed during periods of economic well-being, the noted economic historian Roberto Lopez inverted this correlation by stating in a famous lecture at The Metropolitan Museum of Art more than forty years ago that "hard times" furthered "investment in culture."[1] Every detail of his argument has been scrutinized since then. Economic historians diversified their concepts of business trends and abandoned the overall notion of an "age of depression" as applied to the late Middle Ages in Europe at large.[2] Regional developments are now seen as contradictory and often as complementary: shifts of activities created depression in one region but growth in another.

The question of the relationship between economy and culture remains more complex. In a recent evaluation of the matter, the economic historian Wilfried Brulez concluded that the whole discussion rested on a *faux problème*, a question formulated in the wrong way.[3] In this paper, I will argue that, indeed, a solid analysis requires more than a crude correlation between the general business trend and investment in culture. Moreover, the reduction of the problem of artistic production to a shift in investment strategies is unacceptable. Other factors, such as the structure of production and that of demand have to be considered as well. These imply notions of the form and function of the products, which are related to values and taste. Not only economic, but also social, political, and cultural dimensions are required for

an adequate theory of the relationship between art and society. Leaving aside these aspects cripples any discussion of the factors influencing artistic production. The tendency toward such a reductionist approach, as shown by some economic historians or sociologists, explains the limited response they received from art historians.[4] However, since the questions raised are absolutely fundamental, we cannot leave the discussion as its stands now. Historians have refined their questions; art historians have entered into matters of market and patronage. Can we try to bring the two approaches closer to each other, concentrating on fifteenth-century Bruges?

To start with, a full awareness of the social and mental context within which both producers and buyers of works of art operated is fundamental. The productive structure was corporative, authorized by the city government, which bestowed on the crafts a constitution and an organizational model. It provided for the training of apprentices and prescribed entrance fees, which were differentiated by the person's birth as a master's son, a burgher of Bruges, a Fleming, or a foreigner. Prices, wages, production techniques, the duration of the training, and the requirements for the admission to the master's rank were regulated in the same manner as they were for all other crafts. The three-level structure of apprentice, journeyman, and master had to guarantee the quality of the products and enable the craft members to monopolize the market. Besides being governed by the social and economic regulations, the crafts played a role in the political life of the city, its military organization, and the religious and civic festivals.[5]

No special provisions were made for artists. In the universities a similar pattern of three levels and a division into professional sectors was to be found, but the universities were under the particular protection of the pope and thus remained largely independent of local author-

ities. In the fifteenth-century Low Countries, however, artists were by no means distinguished from other craftsmen. They were incorporated in various crafts, together with various other professional groups. In Bruges, the painters belonged to the same craft as the sculptors, cloth painters, glaziers, mirror makers, saddlers, and horse-collar makers. The woodcutters and organ builders were incorporated with the carpenters, who fought bitter competence quarrels with the cabinetmakers, who had a craft of their own.[6] In Ghent, the woodcutters formed a craft with the painters, while the stonecutters were grouped with the masons. All these formations differed locally, making it very clear that no concept was extant of "the artist" as having an occupation different from that of other artisans. Local crafts regulated and meticulously controlled the quality of both the materials and the craftmanship of the products delivered by their members. One contract concluded between an English merchant and the painter Jan van den Heer even contained a provision that the price of the altarpiece he commissioned would be reduced if the inspectors of the craft should declare the finished product of inferior quality in relation to the agreed price.[7] The remark by John Michael Montias that "the idea of the quality of a work of art seems to have been far more precise at the end of the Middle Ages and in the Renaissance than later on" may be explained by the application of craft regulations.

In contemporary Italy, where the word *arte* had equally designated crafts in industry and in the arts and crafts, the fifteenth century saw the evolution of the professional artist trained with ancient models in the academies. This new concept of training went along with the systematic reorientation of the style toward the imitation of classical models and the more sophisticated, self-conscious vision of the role of the artist.[8] Isolated elements of the Italian Renaissance concept, such as the introduction by Petrus Christus of one-point perspective, penetrated the Low Countries in the course of the fifteenth century. Only during the first decades of the sixteenth century did Renaissance concepts, including stylistic features and an outspoken preference for humanistic themes, become prevalent as a coherent system.

In the Low Countries, neither the training nor the self-consciousness of the artist differed from those of craftsmen in general; even their wages were equal to those of other trained craftsmen such as masons or carpenters. In the Bruges tax lists of 1394-96 covering three of the six city quarters, nine members of the image makers and saddlers craft belonged to the lowest tax category, and two belonged to the next lowest, a social stratification very close to that of the total population. Among some 1,200 taxpayers whose professional activities could be traced, 83.14 percent belonged to the lowest and 13.92 percent to the second lowest categories; 2.20 percent and 0.63 percent belonged to the two highest tax categories. Among the latter 2.83 percent of the population no painters and saddlers were found.[9] Admittedly, the central Saint John's quarter, which may have shown a rather different social structure, is missing in the fiscal documentation. It is equally to be observed that the situation may have changed considerably after 1394-96, as a consequence of Bruges's considerable economic growth during the following century. Anyhow, the available documents show the close similarity of the social position of artists with that of other craftsmen in late fourteenth century Bruges. The system of production and training in workshops formed a typical part of this corporative structure. At the beginning of the fifteenth century, however, the Bruges building industry saw the emergence, within the corporative system, of entrepreneurs operating on a larger scale and on a capitalistic basis. Similar exceptionally successful craftsmen breaking through the corporative regulations could be found in other sectors and other cities as well.[10] Some painters obviously were among those exceptions who could take some liberties, unlike dozens of their fellow craftsmen.

The recruitment of the Bruges crafts rather precisely reflected the demand for specific types of labor. The city accounts registered each year the inscription fees of new *poorters*, the fully privileged citizens. Not every new inhabitant could or would afford the payment of the fee, but all new members of the crafts had to comply. During most of the fifteenth century, the amount of the fee was six pounds *parisis* for Flemings and twelve for foreigners, or the equivalent of respectively ten and a half or twenty-one days' wages of a skilled craftsman.[11] In 1441, Duke Philip the Good ordered a sub-

stantial reduction of the inscription fees for both citizens and craft members, as a clear incentive to revitalize the city after the great revolt of 1436–38, the economic blockade, the famine, and the subsequent plague. It is interesting to take a closer look at the text of the duke's ordinance, promulgated on 4 February 1441.[12]

Expounding the motives for his extraordinary measure, the duke declares to have in view the common weal of his city which had been greatly troubled and gone badly astray. Wanting to have it governed correctly, he proposed to put an end to bad customs, especially those concerning the entry fees and admission duties in the mechanical crafts. In his view, the excessive duties imposed by these organizations had discouraged people from moving toward Bruges and becoming incorporated in a craft. This added to the effects of the recent plague and many other troubles that had greatly impoverished and depopulated the city. In order to attract artisans from any nation or place, he reduced the citizenship fee, for four years from that date, to five shillings of Flemish groats[13] and the entry fee in any craft to twenty of the same shillings. He also forbade any of the customary duties, such as offering a dinner, and any distinction as to the place or manner of the apprenticeship. Moreover, the duke granted the new *poorters* freedom from the fine newly imposed after the revolt. At the end of the four-year period, in January 1445, a completely new legislation was imposed on the crafts.[14] It is clear that the four-year reductions were closely connected with the measures concerning the regulation of the crafts in general. A striking aspect is the temporary elimination of the discrimination against foreigners and other outsiders in the craft. During the years 1441 to 1445, all had to pay the same amount of 300 groats for citizenship and craft membership together. This sum was the equivalent of twenty-six and a half days' wages of a master craftsman. From January 1445 onward, the old distinctions were reintroduced, more than doubling the duties for Flemings and more than tripling them for foreigners, who then had to pay as much as eighty-seven days', or nearly four months', wages.[15]

Table 1: Entry fees for citizenship and craft membership in Bruges, in Flemish groats

	Flemings			Foreigners		
	Citizen	Craft	Total	Citizen	Craft	Total
1441–45	60	240	300	60	240	300
1445–	120	506	626	240	746	986

Understandably, the duke's measures had a strong effect on the immigration to Bruges in those years. From 1436 to 1440, an average of 79 new citizens were registered each year. Those were the catastrophic years. From 1441 to 1444, under the reduced fees, a yearly average of 403 persons were registered as new citizens. During the next four years, under the high fees, the yearly average dropped to 158.[16] During the four years' reduction, in all 1,614 new citizens immigrated to Bruges, who, following the text of the ordinance, were to be new craftsmen.

The immigrant Petrus Christus thus obviously belonged to a general trend. He registered on 6 July 1444, during the last year of reduced fees.[17] I would like to stress the fact that the duke's policy was aiming at attracting skilled craftsmen from anywhere, offering the greatest reductions to foreigners—to one fourth for the citizen's fee and to less than one third for the crafts' inscription. Close reading of the *Poorterboek* permits one to observe that the craft of a new *poorter* is mentioned only in some cases, and in such a way as to make clear that it was the immigrant's intention to pursue that particular craft in accordance with the ordinance. The combination of the birthplace with the eventual mention of the craft taught me that the craft was mentioned for two categories of people only: for the immigrants from the *Brugse Vrije*, the rural district around Bruges, who needed permission to leave their village, and for those born outside the county of Flanders. Since the entry concerning Petrus Christus mentions that he purchased citizenship "in order to be a painter," his birthplace, Baerle, can only be the village in Brabant, halfway between Breda and Turnhout.[18] On his journey of about a hundred miles to Bruges, he would have had to pass through Ghent, where he may have seen some of van Eyck's works. We do not, however, need to refer to Jan's reputation to understand why Petrus Christus was one of the 1,614 artisans of every

kind who at that time took advantage of the temporary reduction of fees to move to Bruges.

Table 2: New *poorters* in Bruges: yearly averages per decade[19]

1400-9	81	1450-59	165
1410-19	153	1460-69	159
1420-29	239	1470-79	127
1430-39	132	1480-89	100
1440-49	233	1490-99	66

Looking at the yearly averages of immigration in Bruges per decade during the fifteenth century, one notices that the 1420s and 1440s marked the absolute apex of the attraction of the Bruges labor market. In the 1430s, the economic difficulties with England, the revolt of 1436-38, the blockade by the German Hanse, and the plague struck the city severely.[20] The whole period from 1410 to the early 1470s showed a strong immigration. This coincided with a general tendency toward increasing the wages in the crafts by about 14 percent.[21] After the revolt of the 1480s, the evolution went steadily downward. The proportion of immigrants from outside the county of Flanders or from a distance of more than thirty miles is remarkably high: 53 percent in the peak years 1440–59, 46.5 percent in 1420–39, 44.5 percent in 1460–69, 38 percent in 1390–1419. Thus, the greater the number of immigrants, the farther they traveled. Comparison with the town of Oudenaarde, located some thirthy miles southeast of Bruges, reveals how exceptionally attractive Bruges was. During the fifteenth century, 50 percent of the migrants to Oudenaarde traveled less than six miles, and only 11.6 percent traveled more than thirty miles or came from abroad.[22]

The distribution by occupational sector of the immigrants of Bruges, as it can be computed for the period from 1331 to 1375, shows that the percentage of immigrants engaged in arts and crafts and clothing crafts double the percentage of those in the same occupations in the total population, while, for example, the building industry was underrepresented.[23] And from 1466 to 1496, 31 percent of the new masters of the image makers' craft were immigrants.[24] The specialized crafts thus exerted a special attraction to migrant artisans until the end of the fifteenth century.

Table 3: Professional sectors of the largest groups of immigrants

	% population	% immigrants
	1394-96	1331-75
Textile	15.1	18.7
Building	14.5	11.9
Clothing	12.5	26.2
Arts	7.3	13.4

The effect of the decrease in the immigration figures, which reflects the economic regression after 1475, can be observed in detail from the registration of new members in the craft of the image makers, thanks to the studies by Sosson and Martens.[25]

Table 4: New members of the image makers' craft

	Masters		Apprentices	
		Average		Average
	Number	per year	Number	per year
1454-1475	177	8	215	10
1476-1530	227	4	169	3

The downward tendency of the business trend[26] led to a strong decrease in the registration of new members in the image makers' craft, which fell to half the level during the golden age for the masters, and to even less than one third for the apprentices. While 60 percent of the masters of the 1454–75 period taught at least one apprentice in their workshop, this proportion fell to a mere 23 percent afterward. The obvious effects were (1) the overall decrease by more than 50 percent of the number of image makers active in Bruges after 1475; (2) the near doubling of the workshops consisting of one master only; (3) the concentration of apprentices from an average of two for each master who had apprentices at some time in his career in 1454–75 to 3.25 in 1476–1530. In this picture, the position of the journeymen remains unclear. Following Martens's observation that a large majority of the apprentices did not reach the status of master, one has to note that most masters employed one journeyman. This leads to the conclusion that during Bruges's golden age the typical workshop included besides the

master a journeyman and an apprentice for some years, with about 40 percent of the masters working alone. After 1475, the vast majority of the masters must have remained alone, while less than a quarter employed a journeyman and an apprentice. Considering the high numbers involved, it is very unlikely that all those one-master workshops were owned by painters of the highest talents. Many of them must have formed part of some kind of division-of-labor system, such as functioned in the textile industries, limiting themselves to decorative tasks. It has been shown that carpenters, panel painters, and image painters divided the work for the larger altarpieces typical of the Low Countries in the fifteenth and sixteenth centuries. Ready-made standardized elements were inserted in the finished product. This method allowed artists to save time and deliver larger quantities of products at the moment when demand peaked during the fairs. It did not, however, reduce costs in such a way as to prohibit adaptations to the customers' taste.[27]

The quantitative data presented above obviously offer interesting possibilities for the interpretation of the technical and artistic quality of paintings. It seems plausible to launch the hypothesis that within the same sector of crafts, artisans may have reacted to the pressure of the market in a generally similar way. Or were there any reasons, technical or other, to suppose different procedures among the painters? The increased differentiation between one-master workshops and those including a journeyman and apprentices must be recognizable in the characteristics of their products, and possibly also in their prices. The important results shown by the technical analysis of the wooden panels and of the underdrawings feed the hope that the application of adequate research methods will continue to bring new results.

So far, we have focused on the production side of the process. If we turn now to demand, we have to stress that Bruges was a really exceptional center since it combined the presence of a court with that of a rich commercial bourgeoisie, an exceptionally large community of foreign merchants, and an extraordinarily well-to-do and broad middle class.[28] The role of the court was overwhelming at certain moments, but should not be overestimated in the long run, especially since the dukes spent only limited periods of time in their *prinsenhof*. The continuity of art patronage was to be found among the local elites and institutions.[29] Bruges was one of the largest cities of northwestern Europe, with possibly about 40,000 inhabitants by 1470. It contributed 15.7 percent of the subsidies paid by the county of Flanders to its ruler. Ghent's share amounted to 13.8 percent, while its population was considerably higher, at least in the middle of the fourteenth century, when we have reliable estimates. Moreover, one seventh of the Bruges's indirect taxes on trade flowed into the duke's treasury. All this makes it highly probable that Bruges paid more taxes than that of Ghent, and that it could afford to do so since its individual income was so much higher. That again can be explained by its economic structure, more commercial than industrial, and by the fact that its crafts included so many relatively capital-intensive, specialized activities.[30]

In the fourteenth and fifteenth centuries, Bruges was certainly the most prominent commercial city of northwestern Europe, offering hospitality to hundreds of foreign merchants from all over Europe. The exact number of those of the German Hanse have been traced for the years 1363 to 1380. Throughout these years, forty to fifty Hanse merchants resided in Bruges; several of them owned or rented houses in the city, others lived in the famous inns. During spring, when the fair was held, their numbers doubled.[31] The pattern may well have been the same for all foreign nations: a core group residing for some years, and at least as many sailing in for the fair. This combination of continuity and change meant that a great number of foreign merchants regularly passed weeks, months, or years in the city and thus had occasion to learn of the broad variety of its opportunities. To quote the merchant Pero Tafur from Córdoba, writing in 1437 (quoted by R. Vaughan in *Philip the Good* [London, 1970] pp. 244–45):

> Bruges is a great and very rich city and one of the most important markets of the world.... All nations meet here and one says that on some days more than 700 ships leave the harbour.... Income is very high in Bruges and the inhabitants are very rich. Anybody who has money to spend will find here products from all over the world.

The foreign merchants had corporate buildings belonging to their nations, particular chapels for their religious services, and private

houses. All these were concentrated in a few blocks of houses around three marketplaces north of the Great Market. The Italians were most concentrated around Beurze Square, the Iberians had their quarters beyond the canal around Biscay Square, the Scots and the English were located in the next streets, the Hanse resided one street beyond. The proximity of all these merchants' houses and inns must have facilitated contacts on a purely commercial level as well as on that of conviviality and devotion.[32] In this atmosphere, trade negotiations may well have followed exchanges about artistic products.

There is proof indeed that altarpieces and sculptures in wood were displayed during the three "show days" of the fair, since on that occasion even products from outside Bruges were allowed in for sale. During the fair, which lasted for thirty days beginning the third Monday after Easter, free trade in raw materials for painters was allowed without the intervention of a local broker. An ordinance of 1432 allowed woodcutters and organ builders to work on the eve of festivals and during the night to finish the work when they had a contract with merchants who were eager to sail off. It is unlikely, however, that other products of art than those in wood were offered for sale at the fair. The image makers' craft insisted on having their members exhibit their works in shops and at counters, and it was only in 1482 that the Bruges Saint Nicholas guild had a special *pand* constructed for the exposition of works of art.[34]

Two factors may explain these different selling methods. It may be that the standardization of sculpture in wood allowed production for an anonymous and large market, largely abroad. Even then, the 1432 ordinance for the woodcutters and organ builders suggests that foreign merchants struck contracts during the "show days" in the beginning of the fair, for products to be finished before they sailed—that is, within a month. This implies a direct personal contact between the artist and the buyers, who chose on the basis of the models displayed on the fair, but had the products specially made—during thirty days and nights—to their order. The market may have been anonymous, but the merchants acted through direct personal contact.[35] On the other hand, book production was equally largely standardized for the

external markets but not offered at the fair. One should not forget that, unless stalls in the great city hall could be used, weather conditions from April to early June could be harmful for paintings on oak, cloth, or parchment.

Maximiliaan Martens has convincingly shown that religious confraternities may have been the organizations where the various segments of the Bruges elite, from the court and the nobility to the foreign merchants and the local officials, could meet artists—including Petrus Christus—who were eager to accept their patronage.[36] The same pattern has been revealed for other Flemish cities as well.[37] The richness of the Bruges middle classes allowed them to participate in art patronage. We have to stress that the period from 1440 to about 1470/75 has to be considered exceptionally prosperous, especially in Bruges. That was exactly the time of Petrus Christus's career. Real wages were at their highest level in four centuries, thanks to the advanced economy, wide commercial networks, political and monetary stability, and relatively low taxation. In Bruges, the center of the economy of northwestern Europe, work was abundant in specialized trades, services, arts, and crafts. The immigration of 230 to 240 artisans per year during the 1420s and 1440s may imply that, adding their families and the unregistered immigrants, the yearly influx was about a thousand per year. They were attracted, even from great distances, by high wages: in 1465, a mason in Bruges might earn in real terms 2.4 times as much as his colleague in Haarlem.[38] No wonder that corporations flourished and were prepared to invest in culture.

Jean-Pierre Sosson has shown that during the fifteenth century the Bruges crafts in the building sector went through a process of aristocratization. A small elite combined the political representation of the crafts with large-scale entrepreneurship facilitated by their political power. In other words, they used their representative functions on behalf of fellow craftsmen to undermine corporate solidarity for their own profit. These social climbers may have been very prone to imitate the behavior of the established elites, not only in politics but also in culture.

More generally, a hypothesis could be formulated as follows. The density of the social network at Bruges made possible close con-

tacts between very different social categories, from courtiers to deans of crafts. The social distance between a nobleman and an artisan was in daily practice smaller here than in less populated and less cosmopolitan regions. In this environment, new information and ideas circulated rapidly, as it was of prime importance for merchants to be aware of the latest developments on the markets and trade routes all over Europe. Flemings, and the citizens of Bruges and Ghent in particular, had developed a strong self-confidence through centuries of political struggle in defense of their autonomy. They evidently were aware of their economic assets, which often were at the heart of conflicts. In this environment, where different cultures, languages, political forces, and economic systems met, the expression of one's identity was more relevant than in a less diversified one. Artistic media allow people to express identity and status in a more indirect, more refined way than by a sheer display of power and wealth. The more sophisticated the message, the more impressive it is for a cultivated observer. Following Montias, one could add that the most expensive works of art were those commissioned by patrons who wanted the representation to be personalized, eventually by the inclusion of their portraits.[40] Once the climate has turned to such "cultural" expressions of status and identity, imitations may follow and multiply in turn, until standardized, cheaper copies are produced in large quantities. This in turn degrades the original expression to banality and provokes those having the necessary means at their disposal to stimulate the creation of new forms of expression.

If this hypothesis is accepted, it may offer the answer to a series of deadlocks in the art and society debate. Of course, a high level of capital accumulation is a necessary precondition for any active center of artistic creation. The investment in added value without any direct utility is to be expected only when a sufficient surplus is available. But this certainly is not a sufficient condition: prosperity does not automatically produce art, and the choice of a particular type of product depends on the prevailing ambience. One has to take into account that Bruges had been an international commercial city since the thirteenth century and that investment in culture in that period had primarily been oriented toward building

impressive churches, walls, gates, and trading halls. In that time more capital was probably invested in public buildings than during the next two centuries. Once they existed, however, a further step could be taken. Only when an elite chooses artistic means to express its status will artistic creativity attain momentum. Then striving social groups convert productive capital into symbolic capital. A favorable business cycle helps the middle classes to participate by imitation in the movement toward investment in culture; their very participation enlarges the market for art products and attracts more artists, and thus probably also the best ones. The high concentration of artists enhances the competition between them and thus the search for conspicuous performances. At the same time, large-scale production reduces the distinctive value of the original artistic forms and provokes the taste for innovation among the wealthiest patrons. The best conditions for artistic creation seem thus to be found in the socially most diversified and economically most advanced cities; continuity and stability of social and economic conditions are required, as well as the acceptance in the society of the artistic way of communication.

What about "hard times," then? It is obvious that they reduce the demand for artistic production among the middle classes. Hence the number of producers will have to fall dramatically, as we have seen in Bruges after 1475. This accounts for the drying up of the stream of immigrants, most of whom from then onward preferred Antwerp with its growing opportunities. In the arts and crafts, reactions to the recession were not different from those in other sectors, such as the textile industry.[41] Concentration in fewer workshops, of which some employed cheap labor, allowed for specialization and differentiation of production. A limited high-quality market was thus paralleled by one of cheaper standardized products. It is an accepted view in economic history that some economic functions remained active in bypassed core cities, such as Bruges in the early sixteenth century. Banking especially remained located for some decades in the former metropolis. Moreover, accumulated capital largely stayed in the city, often even concentrated in fewer hands.[42] Here, Lopez's thesis may apply, albeit for different reasons than those he put forward. The former commercial elite will have turned

into a rentier class and preferred, for social rather than for economic reasons, to invest in conspicuous artistic consumption with the aim of enhancing its status, perhaps on its way toward nobility.

The analysis of the identity of patrons, the display of religious and heraldic symbols and references to their personal achievements, the realism of their representation, and their prominence within a given (still mostly religious) subject are essential to understanding the social function attributed to paintings. The precise analysis of painting techniques displayed in the magnificent catalogue of the Metropolitan Museum of Art's Petrus Christus exhibition is to be recommended with a view to attaining an answer to the question of the quality of artistic production, comparing periods of prosperity with those of contraction. Does serial work in larger workshops flatten the quality, since more is done by less-qualified people? Do we have to distinguish split markets, with a continued high-quality production for the reduced, but still very actively patronizing, elite? Does innovation in form and content stagnate as soon as the rivalry between ambitious and fervently interacting patrons slows down? There are still enough questions for stimulating debate between historians and art historians.

* *less than 1% of the total*
● *more than 1%, up to 5%*
● *more than 5%, up to 10%*
● *more than 10%, up to 15%*
● *between 20% and 25%*
● *between 25% and 30%*

Figure 1. Regional origins of the 173 newly registered members of the Bruges building crafts, 1418-50 (from Sosson, *Travaux publics*, p. 334)

NOTES

1. Roberto S. Lopez, "Hard Times and Investment in Culture," Metropolitan Museum of Art, ed, *The Renaissance: Six Essays* (New York, 1962) pp. 29–54.

2. John H. Munro, "Economic Depression and the Arts in the Fifteenth-Century Low Countries," *Renaissance and Reformation* 19 (1983) pp. 235–250.

3. W. Brulez, *Cultuur en Getal: Aspecten van de relatie economie-maatschappij-cultuur in Europa tussen 1400 en 1800* (Amsterdam, 1986) pp. 84–88.

4. For an excellent recent discussion of these problems, see Michael North, *Kunst und Kommerz im Goldenen Zeitalter: Zur Sozialgeschichte der niederländischen Malerei des 17. Jahrhunderts* (Cologne/Weimar/Vienna, 1992) pp. 3–23.

5. An exemplary study is that by J. P. Sosson, *Les Travaux publics de la ville de Bruges XIV*ᵉ*-XV*ᵉ *siècles: Les matériaux, Les hommes* (Brussels, 1977) pp. 131–201.

6. J. P. Sosson, "Une approche des structures économiques d'un métier d'art: La corporation des peintres et selliers de Bruges (XVᵉ-XVIᵉ siècles)," *Revue des archéologues et historiens d'art de Louvain,* 3 (1970) pp. 91–100.

7. John Michael Montias, "Le Marché de l'art aux Pays-Bas, XVᵉ et XVIᵉ siècles," *Annales: Economies—sociétés—civilisations* 48, no. 6 (November–December 1993) pp.1558–1559 (with reference to the unpublished work by Lynn Jacobs).

8. Bram Kempers, *Kunst, macht en mecenaat* (Amsterdam, 1987) pp. 231–247, 326–351; also available in German trans. *Kunst, Macht und Maezenatentum: der Beruf des Malers in der italienischen Renaissance* (Munich, 1989).

9. Ingrid De Meyer, "De sociale strukturen te Brugge in de 14ᵉ eeuw," W. Blockmans et al., *Studiën betreffende de sociale strukturen te Brugge, Kortrijk en Gent in de 14ᵉ en 15ᵉ eeuw: Standen en Landen* 54 (Heule, 1971) pp. 12, 36, 52, 55.

10. J. P. Sosson, "Quelques aspects sociaux de l'artisanat bruxellois du métal," *Cahiers Bruxellois* 6 (1961) pp. 98–122; and idem, "L'Artisanat bruxellois du métal: Hiérarchie sociale, salaires et puissance économique (1360-1500)," ibid. 7 (1962) pp. 225–258.

11. Summer wages were raised from 10 to 12 groats per day for most crafts in the building industry at different moments: in 1429 for the slaters, in 1434 for the pavers, in 1442–50 for the masons, in 1446 for the carpenters, in 1450 for the thatchers. I calculated an average day-wage in the middle of the century on the basis of two-thirds summer and one-third winter wages, resulting in 11 (case fraction1/3) groats; see Sosson, *Travaux publics,* pp. 300–303. My calculation corrects that by Maximiliaan P. J. Martens, "Petrus Christus: A Cultural Biography," in Maryan W. Ainsworth and Maximiliaan P. J. Martens, *Petrus Christus,* exhib. cat. (New York, 1994) p. 20, n. 10.

12. Poorterboek 1434-50, fol. 23–24v, Stadsarchief, Bruges. The text was published with some reading errors by R. A. Parmentier, *Indices op de Brugsche Poorterboeken,* 2 vols. (Bruges, 1938) vol. 2, *Annexes,* pp. 5–8; to be read in connection with the reintroduction of the previous high tariffs by the city aldermen on 25 January 1445, on pp. 8–9.

13. I regret having to correct on this point both E. Thoen, "Immigration to Bruges in the Late Middle Ages," *Le migrazioni in Europa secc. XIII-XVIII: Atti della 20a settimane di studi, Istituto di storia economica Francesco Datini* (Prato, 1993) p. 339, who mentions 12 instead of 3 pounds *parisis* for foreigners in 1441–45; and Martens, "Petrus Christus," pp. 15 and 195. The former mentions 12 pounds *parisis* as the citizenship fee for foreigners in 1441–45, but as the pound *parisis* was equal to only 20 groats, and a shilling was 12 groats, the actual figure was 3 pounds *parisis*. Martens uses the correct figure but assumed that the city accounts were in pounds groats, rather than pounds *parisis;* city accounts were usually made up in pounds groats, but in this case, as in some other instances when goods are mentioned, the archaic pounds *parisis* must have been meant. Thus the citizen fees, for both Flemings and foreigners, for the years 1441 to 1445 amounted to 3 pounds *parisis,* of 20 groats each, equal to the 5 shillings groats mentioned in the ordinance. From 1445–46 onward, the fees amounted to 6 pounds for Flemings and 12 pounds for foreigners. See the city accounts in the Stadsarchief, Bruges, or in the Algemeen Rijksarchief, Brussels.

14. Sosson, *Travaux publics,* pp. 58–60, 136–141.

15. Parmentier, *Indices,* vol. 2, Annexes, pp. 8–9.

16. Calculated from A. Jamees, *Brugse poorters,* 4 vols. (Handzame, 1974–80) vol. 2, 1, p. ii.

17. Ainsworth and Martens, *Petrus Christus,* p. 195.

18. Compare Ainsworth and Martens, *Petrus Christus,* pp. 15, 55–56. To take only one example, fol. 72v of the *Poorterboek* mentioning Petrus Christus lists eleven entries, of which five mention a craft. One man from Moerkerke, in the *Brugse Vrije*. expresses the intention of becoming a tanner and brings an "issue" letter; the four others come from Goes in Zeeland (a tradesman), Borgloon in the Land of Liège (a maker of chasubles), Baerle (a painter) and Dongen near Breda (another tradesman). The six other entries concern people born in parts of the county of Flanders outside the *Brugse Vrije,* and make no mention of their craft. The *Poorterboek* is, from what I have observed, absolutely consistent in making this distinction.

19. Thoen, "Immigration," p. 337.

20. Richard Vaughan, *Philip the Good: The Apogee of Burgundy* (London, 1970) pp. 87–92.

21. To be precise a 20 percent increase of the summer wages, which amounted to 13.8 percent on a yearly basis if the summer wages accounted for two thirds of the total income: Sosson, *Travaux publics,* p. 226.

22. Thoen, "Immigrants," pp. 347–348.

23. Ibid., pp. 348–350, and De Meyer, "Sociale strukturen," p. 36 (with the statistical reservations formulated above after note 9).

24. Albert Schouteet, *De Vlaamse primitieven te Brugge; Bronnen voor de schilderkunst te Brugge tot de dood van Gerard David,* I (Brussels, 1989) p. 9; Maximiliaan P. J. Martens, Artistic Patronage in Bruges Institutions, ca. 1440–1482, (Ph.D. diss., University of California, Santa Barbara, 1992; University Microfilms).

25. Sosson, "Une approche"; Martens, Artistic Patronage

26. W. Prevenier ans W. Blockmans, *The Burgundian Netherlands* (Antwerp-Cambridge, 1985) pp. 191–196.

27. Montias, "Le marché," pp. 1549–1551, 1559.

28. W. Blockmans, "Bruges the European Commercial Centre," in *Bruges and Europe,* ed. V. Vermeersch (Antwerp, 1992) pp. 40–55, and other chapters in this book.

29. Lorne Campbell, "The Art Market in the Southern Netherlands in the Fifteenth Century," *The Burlington Magazine,* 118 (April 1976) pp. 188–198.

30. W. Prevenier, "Bevolkingscijfers en professionele strukturen der bevolking van Gent en Brugge in de 14de eeuw," *Album Charles Verlinden* (Ghent, 1975) pp. 269–303; W. Blockmans and W. Prevenier, *Under the Spell of Burgundy* (in print).

31. W. Paravicini, "Bruges and Germany," in Vermeersch, ed., *Bruges and Europe,* pp. 100–114.

32. W. P. Blockmans, "Urban Space in the Low Countries, 13th-16th Centuries," in *Spazio urbano e organizzazione economica nell'Europa medievale,* ed. A. Grohmann (Perugia, 1994) pp. 170–175.

33. M. Vanroose, "Twee onbekende 15de-eeuwse dokumenten in verband met de Brugse 'beildesniders'," *Handelingen van het Genootschap"Société d'émulation" te Brugge* 110 (1973) pp. 168–178.

34. Martens, Artistic Patronage; Montias, "Le Marché," p. 1555.

35. Ainsworth and Martens, *Petrus Christus*, pp. 17–19.

36. Maximiliaan P. J. Martens, "New Information on Petrus Christus' Biography and the Patronage of His Brussels *Lamentation,"* Simiolous 20, no.1 (1990–91) pp. 5–23; idem, "Petrus Christus."

37. H. Pleij, *De sneeuwpoppen van 1511.* (Amsterdam, 1988) pp. 151–191.

38. W. P. Blockmans, "The Economic Expansion of Holland and Zeeland in the Fourteenth-Sixteenth Centuries," in *Studia Historica Oeconomica: Liber Amicorum Herman van der Wee,* ed. E. Aerts et al. (Leuven, 1993) pp. 47–48.

39. Sosson, *Travaux publics,* pp. 189–202.

40. Montias, "Le Marché," pp. 1545–1546.

41. J. Vermaut, "Structural Transformation in a Textile Centre: Bruges from the Sixteenth to the Nineteenth Century," in *The Rise and Decline of Urban Industries in Italy and in the Low Countries (Late Middle Ages-Early Modern Times),* ed. Herman van der Wee (Leuven, 1988) pp. 187–192; H. van der Wee, "Industrial Dynamics and the Process of Urbanization in the Low Countries from the Late Middle Ages to the Eighteenth Century: A Synthesis," in ibid., pp. 323–347.

42. W. Brulez, "Bruges and Antwerp in the 15th and 16th Centuries: An Antithesis?," *Acta Historiae Neerlandicae* 6 (The Hague, 1973) pp. 1–26.

43. Brulez, in *Cultuur en getal,* p. 57, sampled paintings from the Low Countries and identified 30 religious themes versus 2 secular ones for the period 1450–1500, and 49 versus 36 respectively in 1500–1550. It seems necessary to pursue this line of research and to define the criteria more explicitly.

Fact, Symbol, Ideal: Roles for Realism in Early Netherlandish Painting

Craig Harbison
University of Massachusetts at Amherst

What does it mean when we talk or write about the visual "realism" of early Netherlandish painting? Perhaps no other term—except, of course, the term *symbolism*—is bandied about so freely when present-day observers discuss this art. The purpose of my paper is to be more specific about just what this term *realism* might refer to—what qualities it might encompass when applied to early Netherlandish painting. How was the realism of these images composed? And how was it meant to function?

Obviously this is an enormous, and enormously complex, topic. Clearly, in this brief paper, I have to focus my discussion rather drastically. I will concentrate on the representation of buildings and, at times, of cities, in the backgrounds of several fifteenth-century Bruges paintings. But I will also stray slightly from this emphasis by including a few non-Bruges works, as well as several architectural interiors. I hope to be able to elicit several general principles about Netherlandish painted realism from this admittedly limited, but fascinating, material.

Perhaps the most beautiful background scene in the art of this time and place is that found in Jan van Eyck's painting of the Virgin and Child with the mighty Burgundian chancellor, Nicolas Rolin (now in the Louvre, Paris; Fig. 1). Here we find carefully observed rivers, islands, bridges, towns, and cities with buildings large and small, and hundreds of tiny human figures. What does this view, framed by a triple arcade in the foreground, represent? How "real" is it? What meaning (or meanings) was it meant to convey?

Throughout the centuries since it was produced, early Netherlandish painting has, first and foremost, attracted observers because of its apparent verisimilitude, its ability to capture or mimic truthfully, on a two-dimensional surface, aspects of the visible world. Applied rig-

orously to the Rolin *Virgin,* this presumption has produced the following rather dubious results. Over the years, the city at the right in the background has been identified by different authors as Geneva, Lyons, Prague, Autun, Liège, Maastricht, and Utrecht.[1] Fortunately, I believe that no critic today maintains that van Eyck here meant to paint a portrait of one particular major urban center. But an even more startling suggestion has recently been made. In a brief article in the *Gazette des Beaux-Arts* in 1990, Peter Schwarzmann compared van Eyck's background scene to an aerial photograph of the village of Stein am Rhein—specifically, a photograph credited to Swissair Airlines.[2] For Schwarzmann, the message of this comparison was obvious: van Eyck had been to Stein am Rhein and made a drawing of the surrounding landscape from some height (but not, presumably, from an airplane). It seems as though it is impossible to quell the urge to find the source of van Eyck's art in some literal corner of the visible world.

For authors like Schwarzmann, the realism of early Netherlandish painting in general, and the background scene of the Rolin *Virgin* in particular, has a significant documentary function, recording a particular locale or view. Since the 1950s and the publication of Erwin Panofsky's influential study of early Netherlandish art, what might seem like a quite different role has often been accorded the painting's apparent realism. For Panofsky and his followers, van Eyck's is a totally transfigured reality, minutely and completely adjusted to the demands of a religious program of meaning.[3] For Lotte Brand Philip, for instance, there can be no doubt that many, if not all, of the backgrounds in early Netherlandish art cleverly represent a celestial realm in the guise of a particular man-made earthly town. Thus, she believes, the Rolin *Virgin* presents us with an image of

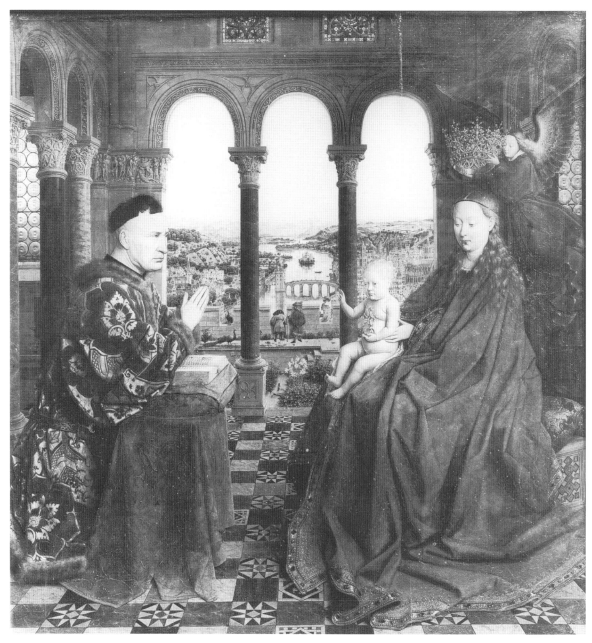

Figure 1. Jan van Eyck, *Virgin and Child with Chancellor Nicolas Rolin,* c. 1435. Oil on panel, 66 x 62 cm. Paris, Musée du Louvre (photo: Réunion des musées nationaux)

the Heavenly Jerusalem—the foreground room is the New Heaven, the background fairy-tale city "unquestionably signifies the New Earth."[4] Incidentally, I should make it clear that for both Schwarzmann and Philip an exacting documentary realism can, and usually does, convey complex religious symbolism; they do not believe that these two positions are mutually exclusive.[5]

In my view, the theories of Schwarzmann and Philip are extreme and are also unsupported by historical evidence. No documenta-

tion from the fifteenth century has been put forth to suggest that artists at the time were that literal, thoroughgoing, or single-minded either in their recording of reality or in their encoding of conscious religious programs of meaning in their art. I would like to stake out a position somewhere between such extremes—a position where realism in fifteenth-century art is considered a highly charged convention, but is still meant to look "real"—where what I would call fragments of identifiable reality are used as the basis for an ideal experience.[6] Above

all, I believe that the fragmentary, emblematic, and propagandistic aspects of early Netherlandish realism are meant to be perceived and appreciated simultaneously—not one element emphasized at the expense of all else.

In order to explain what I mean—and how it is distinguished from those other views I have just enumerated—let me back up and briefly consider some documentary evidence. The question that I am interested in is, quite simply, what evidence do we have that the realism of early Netherlandish painting was commissioned to be painted? What evidence is there that the original viewers of this art consciously articulated a concern for its verisimilitude, its realistic accuracy? The indications here are intriguing. By the middle of the fifteenth century some surviving contracts stipulate that in representations of scenes such as the Annunciation to Mary and the Nativity of Christ, contemporary Flemish furniture was to be included.[7] Thus we know that patrons probably requested the inclusion of certain bourgeois details. These might have been objects like the newfangled reversible bench before which Mary reposes in the *Mérode Triptych* (now in the Cloisters Collection of The Metropolitan Museum)[8] or the lush red bed in Jan van Eyck's *Arnolfini Double Portrait* (National Gallery, London).[9] Therefore, I think we would be historically justified in referring to this as a "descriptive realism of particulars."

To some modern observers, it has seemed logical to extend this sense of verisimilitude to the whole contemporary interior. Thus these images are thought to portray not just actual still-life details but the entire and exact appearance of an existing room.[10] I know of no documentary evidence to confirm this. I believe that the carefully staged, two-dimensional compositions of these paintings strongly argue against taking the overall view as a literal record of the visible world. Other kinds of architectural interiors, church interiors in particular, offer strong indirect support for this as well. This is because almost all the relevant and important churches that might have served as models for these painters have survived, and can be carefully compared with the paintings—something that is simply not possible in the case of domestic interiors, where survival is quite rare.

The critical situation we find in the case of church interior paintings is similar to that found with the background city in the Rolin *Virgin*. At first, the apparent verisimilitude of an interior like that in Jan van Eyck's panel of the *Virgin in a Church* (now in the Gemäldegalerie, Berlin) led many modern scholars to make suggestions that the artist portrayed a specific church—perhaps one in Ghent, Paris, Dijon, Liège, or Cologne.[11] Actually, van Eyck's interior is now generally recognized as an original combination of elements from several churches, especially famous pilgrimage shrines in Flanders like those at Halle and Tongeren.[12] In another interesting case, Rogier van der Weyden's *Seven Sacraments Altarpiece* (Antwerp, Koninklijk Museum voor Schone Kunsten) is clearly indebted to the church of Saint Gudule (now Saint Michael) in Brussels.[13] No doubt Rogier, like van Eyck, could have made a portrait of this, or another, interior if he had wanted to—or been asked to. He chose, rather, not only to alter the proportions of the Brussels cathedral, but also to add new elements in the triforium and clerestory.

Two things seem to be at work here. One is the ultimate production of a stereotypical realism, in this case, the image of a building that is an ideal expression of late Gothic architecture, not limited to one particular time or place. A second important feature of the realism of these works is their fragmentariness—or, what I would like to call their "model-book mentality." What I mean is that these images reveal a reality made up of discrete, carefully observed details, or individual elements, drawn at times from firsthand study, but fit together in a novel, almost puzzle-like fashion. This is an attitude that we more readily associate with works like a late fourteenth-century German panel by Meister Bertram showing the creation of the animals (part of the *Grabow Altarpiece,* now in the Hamburg Kunsthalle).[14] Here a series of pattern-book images like those found in the famous early fifteenth-century Vienna model book[15] were rather awkwardly displayed on either side of God the Creator. Van Eyck and his contemporaries may have become more adroit at combining their models, but, in fact, a version of this "model-book mentality" survived throughout the fifteenth century. We can return to van Eyck's Rolin *Virgin* to see, at least to some extent, how this worked.

Within ten years after van Eyck had completed this image, motifs from its background

were taken up in several other paintings. In the *Virgin and Child with Saints Barbara and Elizabeth and Jan Vos* (now in the Frick Collection, New York; cat. no. 2), an Eyckian workshop artist who, as Maryan Ainsworth has speculated, probably had access to the model drawings of the master, recombined elements of the Rolin landscape in a rather awkward manner.[16] More fragmentary yet are the reflections of van Eyck's model in two miniatures by the early fifteenth-century Parisian manuscript illuminator known as the Bedford Master (Fig. 2).[17] Clearly van Eyck's ideal combination of winding river, bridge, island, and boats was tremendously attractive to his contemporaries. The reception and propagation of this design indicates quite nicely the fragmentary nature of this realistic imagery. It also demonstrates that at least his contemporaries did not immediately perceive van Eyck's landscape as a portrait of reality that should, in any sense, be considered sacrosanct, limited in appeal to a particular client, or preserved though literal repetition. Rather, as van Eyck freely manipulated details of reality to achieve his ideal effects, so could they in turn do the same, now working with and from his model.

Another good example of this model-book mentality embodied in background architectural details is found in the work of Rogier van der Weyden. In the background of the center panel of Rogier's *Nativity Triptych* in Berlin is a representation of a building that has been said to be the newly constructed castle at Middelburg of the Burgundian official Pierre Bladelin.[18] Unfortunately the building itself does not survive today. The chief piece of evidence supporting the theory that Rogier portrayed it is the fact that, when attempting to provide an illustration of Bladelin's castle in his 1641 publication *Flandria illustrata*, Antonius Sanderus copied the building in Rogier's painting.[19] The main thing, I believe, that this teaches us is that in 1641 early Netherlandish realism was already presumed to have a documentary function, as it so often is today as well. In fact, as many have observed, the building in Rogier's painting could not be an exact portrayal of Bladelin's castle, since it is constructed in an earlier, Romanesque style.[20] And what is more, a slightly altered version of the structure is also found at the back of another Rogier triptych, showing the adoration of the Magi in the foreground (this is so-called *Columba Triptych,* now in Munich).[21] Here the building looms over the head of a quite different donor—a fact that leads me to conclude that it could hardly have had strict documentary significance for either patron. Such an appealing, ideal model, creatively varied from image to image, was appropriate for many contexts.[22]

I know of only one fifteenth-century documentary reference to the urban architectural details of these paintings. In 1453 a Carthusian priest commissioned a painting of the coronation of the Virgin from a painter born in Laon but active in the south of France, Enguerrand Charonton (the painting is now in the Musée de l'Hospice, Villeneuve-les-Avignon).[23] Twenty-six paragraphs in the contract for this work specified the numerous details to be included, among which were to be representations, at the bottom, of the cities of Rome, on the left, and Jerusalem, at the right.[24] What I want to stress about this document is the fact that these cities were to be identified, or represented, by a selection of only three or four key monuments: Saint Peter's, the Castle Sant'Angelo, the Church of the Holy Cross of Jerusalem, and so on. In this way, prime structures might be said to form the attributes of the city. In the fifteenth century, the portrayal of an actual or specific city was thus, for the most part, envisioned in terms of a few archetypal buildings—several crucial parts were clearly meant to stand for the whole.

That is the main reason that I find myself in disagreement with Joel Upton's views on the architectural backdrop for a work by Petrus Christus. In a book that provides a very sensitive general interpretation of Christus's art, Upton has tried to identify the city of Bruges in the background of Petrus Christus's *Exeter Madonna* (cat. no. 7).[25] Upton believes that such a view was meant to recall the period that donor, Jan Vos, resided in that city; and he has obviously pored over old maps and views of Bruges, drawn on by the common assumption that what looks so real must be so, literally and exactly. In principle, that is not an impossible claim: at this time buildings represented in a background, above or beside a donor's head, could be specifically related to that individual's life and to the painting's history and commission. Such is the case with Jacques Daret's 1435 *Visitation,* a scene viewed by the donor, Jean

Figure 2. Bedford Master, *King David Praying* (illustration to the Seven Penitential Psalms), from a book of hours. Paris, c. 1440–1450. Malibu, J. Paul Getty Museum, MS Ludwig XI.6, fol. 100r (photo: J. Paul Getty Museum)

du Clerq, abbot of Saint Vlaast in Arras (the panel is now in the Gemäldegalerie, Berlin; Fig. 3).[26] The Abbey of Saint Vlaast itself is represented above and behind the cleric. But this is a major structure associated quite specifically with this individual.

What bothers me about the possible identification of Bruges in Christus's Exeter *Madonna* is the casualness of the view. Joel Upton has not identified a major Bruges monument here, but instead has found something at the panel's far left resembling the Tanners' Square, and something at the center resembling the Minnewater.[27] Neither detail is clearly identifiable because neither is sufficiently distinctive of Bruges alone. In the later fifteenth century when the Minnewater is portrayed in several paintings, it is in conjunction with the unmistakable, major towers of the city.[28] In general, I believe that if any of the realistic details or environments in early Netherlandish art were meant to be identified with a particular time and place, their meaning or reference would not be in any way disguised or hidden, but perfectly open and obvious. Realism in these works was not just an incidental snapshot or casual souvenir from life. It was both more selective and more particular. Specific realistic details identifying an actual location had to be distilled and essential, acting in a sense like the symbolic attributes of a saint.

In fact that is the way two great towers of Bruges, the Belfry and the tower of Notre Dame, were treated in a series of later fifteenth-century Bruges paintings. These include *The Virgin of the Rosegarden* by the Master of the Saint Lucy Legend (now in Detroit; Fig. 4),[29] and another one showing Anna van Nieuwenhove with the Virgin and Child and Saint Anne by the Master of the Saint Ursula Legend (now in the Robert Lehman Collection of the Metropolitan Museum; Fig. 5).[30] Unfortunately, we do not know the exact identity of the artists of these works. Active in Bruges in the late fifteenth and early sixteenth centuries, they have been given *noodnamen*—"emergency names"—after some of their chief works, which often illustrate scenes from the lives of female saints. Partly because of the artists' anonymity, these works have never been rated too highly. Certainly in terms of their technical and artistic quality—in terms of composition, figure style, and oil glazes—they are not the equal of their most famous contemporary, Hans Memling. Critics have emphasized their homeyness, their production for an increasingly open, middle-class market, and their frequent export to southern lands.[31]

Their use of the Bruges towers has been taken as a further sign of the détente often said to characterize later fifteenth-century Netherlandish art. These artists are not felt to have been creative enough to imagine their own contemporary vistas, so they resorted to a rather naive, literal record of actual edifices.[32] And their record was so literal-minded that in these works we can observe the four different building stages that the Bruges Belfry went through between 1483 and 1501. Art historians have, in turn, ingeniously tried to date these works according to the stage of the Belfry's construction, assuming again that a Netherlandish artist would never paint a monument like this except in its exact, contemporary condition.[33] Little allowance has been made for the artist (or patron) who might simply respond to the ideals for which these towers stood.

Certainly these two towers do represent ideals—civic and religious, secular and sacred, side by side. Their frequent combination can hardly be accidental. They are emblematic—medallion-like portraits of the city of Bruges. Why suddenly, about 1480, would these towers be introduced—and their popularity continue through the 1480s and 90s? (More than twenty paintings with one or both towers survive today.) Erwin Panofsky thought that the painters were intent on "flattering the civic pride of their clients."[34] While this is undoubtedly true in a general sense, I believe we can be more specific and pointed in drawing a relation between the paintings and contemporary history.

Several years ago, Christy Anderson drew my attention to the fact that, during the period when these works were painted, the market of Bruges was suffering a serious decline—especially after 1482 and the accession to power of Maximilian I.[35] Maximilian's hostility to Bruges and to its struggle for autonomy culminated in his imprisonment in the city for several months during the spring of 1488. After his release, Maximilian only repeated his demand that all foreign merchants leave the city, thus effectively eliminating Bruges as a formidable economic power.

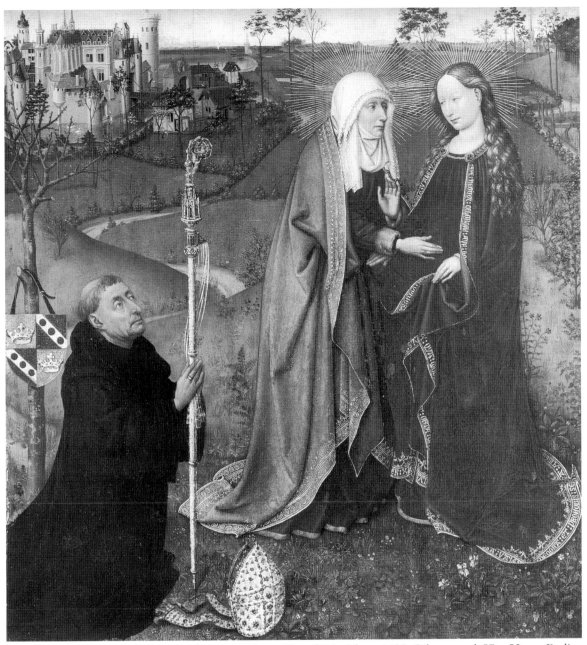

Figure 3. Jacques Daret, *Visitation with Jean du Clerq, Abbot of Saint Vlaast*, 1435. Oil on panel, 57 x 52 cm. Berlin, Gemäldegalerie, 542 (photo: Jörg P. Anders)

The earliest paintings which include the Bruges towers, from the later 1470s and early 80s, do slightly precede this final urban crisis. But the continued popularity of the development was, I believe, undoubtedly related to Bruges's tragic history. Artists and patrons were willfully overcompensating.[36] At a time of great insecurity and economic unrest, the paintings presented a picture of the opposite—paradisial calm and prosperity. Interestingly, Ann Roberts has pointed to an analogous situation in the late fifteenth and early sixteenth century Bruges

painter Jan de Hervy's *View of the Zwin* (the painting is now in the Stedelijk Musea, Arentshuis, Bruges).[37] This is a poorly preserved oil and tempera painting on canvas commissioned in 1501 by the city of Bruges as part of an ambitious campaign to combat, not the political problem of the Holy Roman Emperor, but the ongoing physical problem of the silting up of the Zwin River, which was robbing Bruges of its access to the sea. In de Hervey's painting, Bruges is at the left and an elaborate series of canals, locks, windmills, and waterways occu-

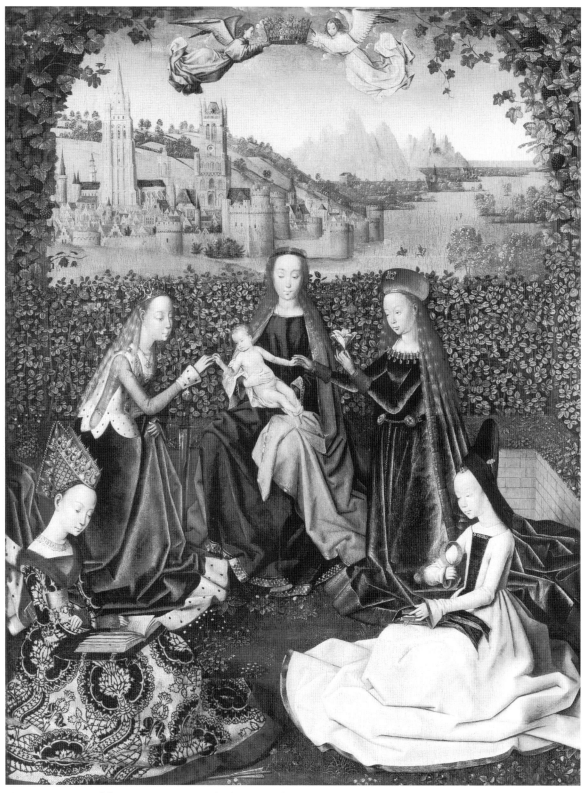

Figure 4. Master of the Saint Lucy Legend, *The Virgin of the Rosegarden*, c. 1480. Oil on panel, 79.1 x 60 cm. Detroit Institute of Arts, 26.387 (photo: The Detroit Institute of Arts)

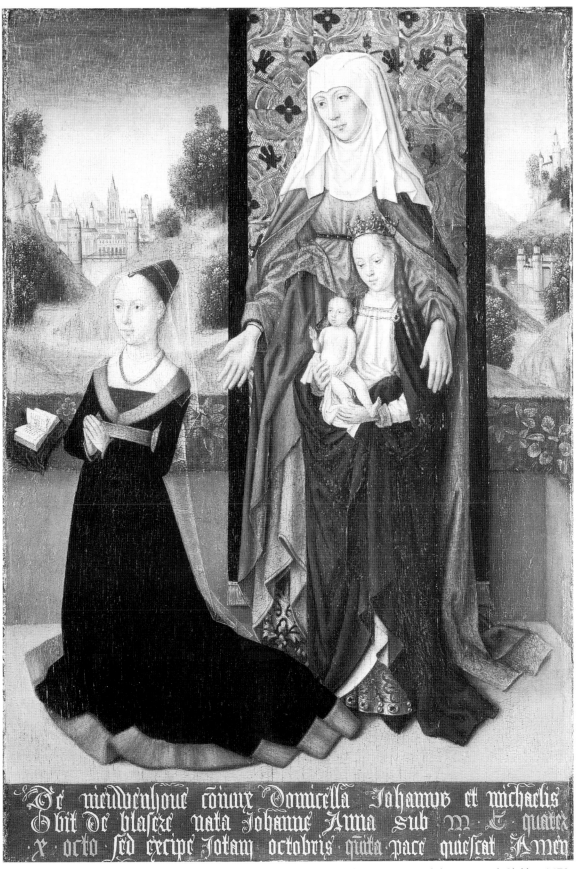

Figure 5. Master of the Saint Ursula Legend, *Anna van Nieuwenhove with Saint Anne and the Virgin and Child*, c. 1479. 19 9/16 x 13 9/16 in., New York, The Metropolitan Museum of Art, Robert Lehman Collection, 1975.1.114 (photo: The Metropolitan Museum of Art)

py the rest of the image. The painting was commissioned when the project was merely under discussion, and thus the numerous boats shown easily sailing through the countryside were an example of wishful thinking, if ever there was one. As Roberts has said, this was not the way Bruges actually looked or felt, but the way "the city hoped it would be."[38]

The same thing can be said about the patrons of the anonymous Bruges panels with the towers of the city in the background. This new realism had a particular urgency or propagandistic punch. It is very tempting to relate this to the individual patrons themselves. Unfortunately, only a very few of the patrons included in these paintings can be identified with certainty. But the example of these few is suggestive. The painting in The Metropolitan Museum by the Saint Ursula Master, executed sometime after 1479, served as an epitaph for Anna van Nieuwenhove. Anna's husband Jan, who must have commissioned the work, was tortured and sentenced to death because of his part in Bruges's revolt against Maximilian in 1488. Jan van Nieuwenhove was a prominent political figure in Bruges throughout the 1470s and 80s.[39] The patron of another work by the Saint Lucy Master, Donas de Moor, was accused (perhaps wrongly) of collaboration with the emperor against the local government of Bruges and because of this was banished from the city in 1483.[40] The triptych by the Saint Lucy Master commissioned by Donas de Moor shows the lamentation over the dead Christ in the center panel (now in the Thyssen-Bornemisza Collection, Madrid).[41] In the background of this work there is a city, but it is not a glowing image of Bruges. Of course, it might seem perfectly understandable that a particularly fierce local civic leader like Nieuwenhove would respond favorably to this artistic development, while a member of another political party or persuasion might not so readily favor it. This does not mean that all strongly Brugeois citizens wanted and got such a view of their city or, conversely, that the absence of such city views signifies, absolutely, a disinterest in or disloyalty to Bruges.[42]

It is also worth noting that many of these paintings with the Bruges towers ended up in Italy and Spain, presumably commissioned by merchants with ties in Flanders. A possible instance of this is the devotional portrait by the Saint Ursula Master, most likely of Ludovico Portinari, identified by the Portinari coat of arms and the initials LP on the reverse (the panel is now in the Johnson Collection in the Philadelphia Museum of Art; Fig. 6).[43] The interesting thing again is that these foreigners were, in a sense, flying in the face of imperial prohibition. They wanted to record and remember their time in that once-prosperous Flemish metropolis, despite Maximilian's edicts. Perhaps they also viewed the towers as a stamp or badge, certifying the authenticity and origins of their painting in one of the great artistic centers of Flanders.[44]

The third principle about early Netherlandish realism that I draw from these late fifteenth-century examples is one concerning political purpose—political purpose in the fullest sense, involving religious, economic, social, and artistic issues on both a broad, as well as on an individual or personal, scale. To repeat my earlier dictum, Netherlandish realism is fragmentary, emblematic, and propagandistic all together—it serves as fact, symbol, and ideal simultaneously. This is a realism, resembling the model books in its focus on the discrete and the particular, emblematic in its use of realistic elements as attributes or symbols; and at the same time, it is a complex, propagandistic negotiating device, intentionally charged with a variety of religious, political, social, and economic meanings.

Let me return to the work I began with in order to apply this dictum *in toto* to an individual painting. In this case, I need to single out one further detail in van Eyck's teeming Rolin cityscape (Fig. 1), and it is the very close rendition of the tower of the Utrecht cathedral just to the left of the Christ Child's head. First of all, I must point out that van Eyck has not painted an exact imitation of the Utrecht tower, however inescapable the relation between painting and actual building may be. As observers before me have indicated, the second story of van Eyck's tower has only two vertical openings per side, while the Utrecht tower itself has three.[45] But the Utrecht tower was a well-known and imposing structure, and surely van Eyck was making some deliberate reference to it here.

The artist has not taken or recorded the city of Utrecht along with its cathedral tower. This is especially apparent when we notice that there

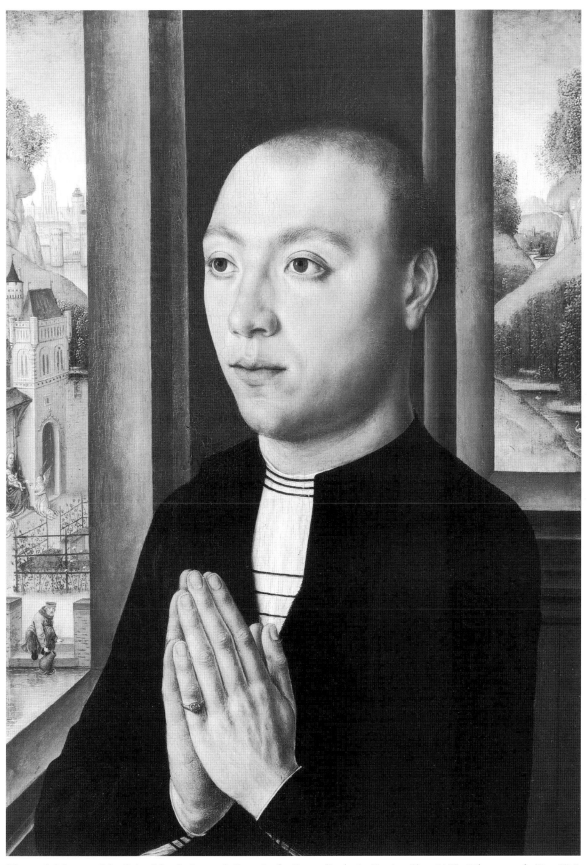

Figure 6. Master of the Saint Ursula Legend, *Portrait of a Donor (Ludovico Portinari?),* c. 1480. Oil on panel, 42 x 29.8 cm, Philadelphia Museum of Art, John G. Johnson Collection, 327 (photo: Philadelphia Museum of Art)

is another, even larger, church or cathedral in van Eyck's city, closest, as one might expect, to the Virgin—Notre Dame. Still, it seems that the Utrecht tower might have brought with it some particular significance or meaning. During the Middle Ages, the plan of the churches of Utrecht was deliberately set out in a cross to reflect the idea of the Heavenly Jerusalem. Utrecht was to be thought of as *een hemel op aarde*—"a heaven on earth."[46] In some later fifteenth century paintings from Utrecht, the cathedral tower is planted in the middle of the city of Jerusalem, viewed behind a representation of the Crucifixion.[47] When local artists portrayed the Utrecht tower accurately, they chose to associate it with Jerusalem, probably referring as well to the New, or Heavenly, Jerusalem that Utrecht was ideally thought to be. I hasten to add that this is not, in my view, a general symbolism or meaning that can be applied indiscriminately to all Netherlandish cities or their artistic portrayals. It was a specific propaganda ploy of the city of Utrecht. The Utrecht tower can thus have a positive and propagandistic religious meaning.[48]

But some people disagreed. Probably in the 1370s, Geert Grote, a leader of the spiritual movement known as *devotio moderna,* wrote a treatise, surviving today in an early fifteenth-century copy, condemning the Utrecht tower as the vain and pompous work of man.[49] The personally devout Grote was here acting like latter-day Saint Bernard of Clairvaux, railing against the material splendor that some claimed would lead the mind to God. Grote might well have felt vindicated when, on the night of 1 August 1674, during a tremendous wind storm, the slender nave (but not the tower) of the Utrecht cathedral collapsed.[50]

In van Eyck's image, Rolin pretended to be engaged in the kind of humble personal and private piety that Geert Grote had recommended. Yet Grote's further exhortation to shun worldly pride and ambition was contradicted by the reality of Rolin's life and the realism of van Eyck's art. Rolin, a very worldly and materialistic individual, wants his piety taken seriously—judged, through the miracle of van Eyck's art, as real.[51] But that devotion cannot, intentionally, be pinned down to a particular time or place—he is not that secure about it. This is what we might call pretension without documentation. Such was the case, I believe, with the vast majority of early Netherlandish images. Early Netherlandish realism was complex and ambiguous; pious, pretentious, and propagandistic; fact, symbol, and ideal—all at once.

NOTES

1. See Elizabeth Dhanens, *Hubert and Jan Van Eyck* (New York, 1980) p. 273; James Snyder, "Jan van Eyck and the Madonna of Chancellor Nicolas Rolin," *Oud-Holland* 82 (1967) pp. 163–171, esp. pp. 164–165; and J. J. M. Timmers, "De achtergrond van de Madonna van Rolin door Jan van Eyck," *Oud-Holland* 61 (1946) pp. 5–10.

2. See Peter Schwarzmann, "La Ville de Stein am Rhein à l'arrière-plan dans *La Vierge au chancelier Rolin* de van Eyck?" *Gazette des beaux-arts* ser. 6, 115 (1990) pp. 104–108.

3. Erwin Panofsky, *Early Netherlandish Painting* (Cambridge, 1953), states on p. 137: "this [Jan van Eyck's] imaginary reality was controlled to the smallest detail by a preconceived symbolical program."

4. Lotte Brand Philip, *The Ghent Altarpiece and the Art of Jan van Eyck* (Princeton, 1971) p. 190.

5. Schwarzmann, "La Ville de Stein am Rhein," p. 106; and Philip, *The Ghent Altarpiece,* esp. p. 194–195.

6. See for instance Craig Harbison, "Visions and Meditations in Early Flemish painting," *Simiolus* 15 (1985) pp. 87–118; and idem, "Religious Imagination and Art Historical Method: A Reply to Barbara Lane's "Sacred vs. Profane," *Simiolus* 19 (1989) pp. 198–205.

7. See Lorne Campbell, "The Art Market in the Southern Netherlands in the Fifteenth Century," *Burlington Magazine* 118 (1976) pp. 188–198, esp. pp. 192-193.

8. See Jozef de Coo, "A Medieval Look at the Mérode Altarpiece," *Zeitschrift für Kunstgeschichte* 44 (1981) pp. 114–132; a good color reproduction is in James Snyder, *Northern Renaissance Art* (New York, 1985) colorplate 19, p. 157.

9. For a good color reproduction see Snyder, *Northern Renaissance Art,* colorplate 18, p. 108.

10. This is, for instance, the opinion of Jan Baptist Bedaux with regard to the *Arnolfini Double Portrait;* see his "The Reality of Symbols: The Question of Disguised Symbolism in Jan van Eyck's *Arnolfini Portrait,*" *Simiolus* 16 (1986) pp. 5–28, esp. pp. 21–22.

11. See Dhanens, *Van Eyck,* p. 328; and James Snyder, "The Chronology of Jan van Eyck's Paintings," in *Album amicorum J. G. van Gelder* (The Hague, 1973) pp. 293–297, esp. p. 296 n. 7; for a good color reproduction of the *Virgin in a Church,* see Snyder, *Northern Renaissance Art,* colorplate 17, p. 107. For a general treatment of the portrayal of contemporary architecture in early Netherlandish painting, see R. Maere, "Over het afbeelden van bestaande gebouwen in het schilderwerk van Vlaamsche primitieven," *De kunst der Nederlanden* 1 (1930–31) pp. 201–212.

12. See Craig Harbison, "Miracles Happen: Image and Experience in Jan van Eyck's *Madonna in a Church,*" in *Iconography at the Crossroads,* ed. B. Cassidy (Princeton, 1993) pp. 157–169, esp. p. 164.

13. See Maere, "Over het afbeelden," esp. pp. 201–203; Panofsky, *Early Netherlandish Painting,* p. 283; and Martin Davies, *Rogier van der Weyden* (London, 1972) p. 196. The *Seven Sacraments* is reproduced as pls. 54–57 in Davies.

14. For a good color reproduction and general discussion of this work, see Paul Portmann, *Meister Bertram* (Zurich, 1963) p. 41–42 and colorplate 5, p. 43.

15. For this model book, see R. W. Scheller, *A Survey of Medieval Model Books* (Haarlem, 1963) pp. 125–132.

16. See Maryan Ainsworth and Maximiliaan P. J. Martens, *Petrus Christus: Renaissance Master of Bruges,* exh. cat. (New York, 1994) p. 76.

17. These two manuscript illuminations are discussed and reproduced in Christopher de Hamel, *A History of Illuminated Manuscripts* (London, 1986) pp. 179–182; one is now in the J. Paul Getty Museum (MS Ludwig XI.6, fol. 100r; reproduced in Fig. 3); the other was in a sale at Sotheby's, London, 13 June 1983, lot 11, fol. 105r (Book of Hours, Paris, c. 1440–1450).

18. See for instance Panofsky, *Early Netherlandish Painting,* pp. 276-277; reproduction in Panofsky, Fig. 337.

19. The illustration from Sanderus's publication is reproduced in Anne Markham Schulz, "The Columba Altarpiece and Rogier van der Weyden's Stylistic Development," *Münchner Jahrbuch der Bildenden Kunst* ser. 3, 22 (1971) pp. 63-116, esp. p. 69, fig. 8.

20. This was pointed out by Schulz, "Columba Altarpiece," p. 65-66. See also Davies, *Rogier van der Weyden,* pp. 201–202, and Lorne Campbell, *Van der Weyden* (New York, 1980) p. 51; both doubt that the building in the back of the Berlin *Nativity* could (accurately) represent Middleburg. Panofsky, in *Early Netherlandish Painting,* p. 276–277 and 286, hypothesized that the *Nativity Triptych* was painted before the castle at Middleburg was completed, and thus Rogier mistakenly inserted Romanesque windows; this argument was refuted by Schulz's pointing out that the castle was in fact inhabited by the time Rogier's triptych was painted.

21. Good color reproduction in J. Snyder, *Northern Renaissance Art,* colorplate 22, p. 160.

22. Lynn Jacobs has pointed out to me that the way northern Renaissance painters copy and adapt architectural fragments bears an interesting analogy to the way medieval architects selectively copied and adapted crucial features from earlier buildings. The medieval situation is outlined by Richard Krautheimer, "Introduction to an "Iconography of Medieval Architecture," *Journal of the Warburg and Courtauld Institutes* 5 (1942) pp. 1–33, esp. pp. 13–20.

23. Good color reproduction in J. Snyder, *Northern Renaissance Art,* colorplate 47, p. 258.

24. The contract is reprinted in its entirety in Wolfgang Stechow, *Northern Renaissance Art, 1400–1600: Sources and Documents* (Englewood Cliffs, NJ, 1966) pp. 141–145.

25. Joel Upton, *Petrus Christus: His Place in Fifteenth-Century Flemish Painting* (University Park, Pa., 1990) p. 18.

26. Good color reproduction in Henning Bock, Rainald Grosshans, Jan Kelch, Wilhelm H. Köhler, and Erich Schleier, *The Gemäldegalerie, Berlin: A History of the Collection and Selected Masterpieces* (London, 1986) p. 129; see also the text p. 128 associated with this reproduction.

27. See the detailed reproductions in Upton, *Petrus Christus,* figs. 7–12.

28. See Maximiliaan P. J. Martens, "The Epitaph of Anna van Nieuwenhove," *MMJ* 27 (1992) pp. 37–42, esp. pp. 37 and 40; the latter is a reference to the *Portrait of a Donor* reproduced in fig. 8 (see note 43 below).

29. For this work, see Detroit Institute of Arts, *Flanders in the Fifteenth Century: Art and Civilization,* cat. no. 41 (Detroit, 1960) p. 168.

30. See Guy Bauman, "Early Flemish Portraits, 1425–1525," *Metropolitan Museum of Art Bulletin*, n.s. 43 (Spring 1986) pp. 1–33; and Martens, "The Epitaph of Anna van Nieuwenhove."

31. See for instance Ann M. Roberts, "North Meets South in the Convent: The Altarpiece of Saint Catherine of Alexandria in Pisa," *Zeitschrift für Kunstgeschichte* 50 (1987) pp. 187–206.

32. See Panofsky, *Early Netherlandish Painting*, pp. 346–347.

33. See Nicole Verhaegen, "Le Maître de la légende de sainte Lucie: Précision sur son oeuvre," *Bulletin de l'Institut royal du patrimoine artistique* 2 (1959) pp. 73–82; and Georges Marlier, "Le Maître de la légende de sainte Ursule," *Jaarboek van het koninklijk Museum voor schone kunsten, Antwerpen* (1964) pp. 5–42.

34. Panofsky, *Early Netherlandish Painting*, p. 346.

35. Christy Jo Anderson, "The Image of Urban Life: A Portrait of Bruges in Late Fifteenth-Century Painting" (unpublished manuscript). See also the articles by J. Marechal, "Le départ de Bruges des marchands étrangers (XVᵉ et XVIᵉ siècle)," *Handelingen van het Genootschap-"Société d'émulation" te Brugge* 88 (1951) pp. 26–74; and J. A. van Houtte, "The Rise and Decline of the Market in Bruges," *Economic History Review* ser. 2, 19 (1966) pp. 29–47.

36. This point is also made by Marc Girouard in discussing the addition of a final octagon to the Bruges belfry tower in 1483–87—he calls it "a piece of desperate window-dressing"; see his *Cities and People: A Social and Architectural History* (New Haven, 1985) p. 100.

37. See Ann Roberts, "The Landscape as Legal Document: Jan de Hervy's *View of Zwin*," *Burlington Magazine* 133 (1991) pp. 82–86; the painting is reproduced as fig. 22, p. 82.

38. Roberts, "The Landscape as Legal Document," p. 86.

39. See Martens, "The Epitaph of Anna van Nieuwenhove," p. 42 n. 20.

40. Colin Eisler, *Early Netherlandish Painting: The Thyssen-Bornemisza Collection* (London, 1989) p. 122, gives the incorrect date of 1481 for de Moor's exile; this is corrected in Maximiliaan J. P. Martens, "Artistic Patronage in Bruges Institutions, c. 1440–1482" (Ph.D. diss., University of California, Santa Barbara, 1992; University Microfilms) p. 264.

41. Good color reproductions in Eisler, *Early Netherlandish Painting*, pp. 117–120.

42. Max Martens has pointed out to me, in a letter of 15 July 1994, that Donas de Moor had been a prominent citizen of Bruges throughout the 1450s, 1460s and 1470s. Martens theorizes that he was falsely accused of collaboration with the emperor, perhaps because he was of a different political party from someone like Jan van Nieuwenhove. There is no evidence that de Moor was seriously disloyal to the city; his wife was allowed to bring his body back to the city after he died in 1483. See also Martens's "Artistic Patronage", pp. 264–266. I am very grateful to Professor Martens for generously sharing this information with me.

43. This portrait is one half of a devotional diptych; the other half, showing the Virgin and Christ Child is now in the Fogg Art Museum, Harvard University, Cambridge, Mass. For this diptych and Ludovico Portinari's possible identification, see Colin Eisler, *New England Museums*, Les Primitifs flamands, I: Corpus de la peinture ... 4 (Brussels, 1961) pp. 101–107, esp. pp. 102–103.

44. An interesting analogy can be drawn here to the use of blind stamps on the back of panels and frames to certify their place of manufacture; see Jill Dunkerton, Susan Foister, Dillian Gordon, and Nicholas Penny, *Giotto to Dürer: Early Renaissance Painting in the National Gallery* (London, 1991) p. 153.

45. See Panofsky, *Early Netherlandish Painting*, p. 433 n. 1.

46. See Marieke van Vlierden, *Utrecht, een hemel op aarde* (Utrecht, 1988) esp. pp. 26–40.

47. The paintings are a *Crucifixion* (Utrecht, c. 1460) now in The Hague, Rijksdienst Beeldende Kunst (inv. no. B 1892); a *Crucifixion* (North Netherlandish, late 15th-early 16th century) in the Rijksmuseum, Amsterdam (inv. no. A2212); and an *Adoration of the Magi* (Jacob van Utrecht, c. 1513) now in the Wallraf-Richartz-Museum, Cologne (inv. no. 355); all are reproduced in van Vlierden, *Utrecht, een hemel op aarde*, cat. nos. 64–66, pp. 70–71.

48. See also the article by Aart J. J. Mekking, "Pro turri Trajectensis: De positieve symboliek van de Domtoren in de stad Utrecht en op de aanbidding van het lam Gods van de gebroeders van Eyck," in *Annus quadriga mundi: opstellen over middeleeuwse kunst opgedragen aan Prof. Dr. Anna C. Esmeijer*, ed. J. B. Bedaux and A. M. Koldeweij (Zutphen, 1989) pp. 129–151.

49. See R. R. Post, *Geert Grootes tractaat contra turrim Traiectensem teruggevonden* (The Hague, 1967); and idem, *The Modern Devotion* (Leiden, 1968) esp. pp. 124–129.

50. See Utrecht, Gemeentelijk Archief, *1 Augustus 1674, De Dom in Puin, Herman Saftleven tekent de stormschade in de stadt Utrecht* (Utrecht, 1974).

51. See for instance my earlier treatment of the role of Rolin's biography in the making of this image in *Jan van Eyck, The Play of Realism* (London, 1991) pp. 100–118.

The Reception of Flemish Art in Renaissance Florence and Naples

Gabriella Befani Canfield
The Metropolitan Museum of Art

The presence of Flemish art in fifteenth-century Italy has been studied extensively in the last hundred years. Great efforts have been made to collect, examine, and evaluate all the literary, documentary, and visual evidence. It would be fair to say, however, that there are still many areas, especially for the first half of the century, that need to be studied more closely. The area that most warrants our attention is the dating of the arrival in Italy of works by Flemish artists. At present, in most cases, we only have tentative *terminus ante quem* dates. I shall investigate this point in my forthcoming book.[1] Another area that has not been fully studied is the dynamics between Italian humanists and patrons and the Flemish art they praised or collected. The purpose of this paper is to discuss the reception of Flemish art among fifteenth-century humanists and patrons in Florence and Naples.

I shall discuss Bartolomeo Facio's *De viris illustribus,* written in 1456 at the request of Alfonso of Aragon, king of Naples, but I shall do so in the context of humanistic discourse on the dignity of man, and his privileged position in the cosmos. Only in this light can we really appreciate the significance of the fact that in writing a historical tract, Facio, a humanist from Genoa and the appointed historiographer at the Aragonese court in Naples, would include Jan van Eyck and Rogier van der Weyden among the most illustrious men in contemporary society.

I shall then examine the five ethical treatises written in 1493 by Giovanni Pontano, the Umbrian humanist who had served the Aragonese court until 1492 as secretary of state. These treatises, published in 1498 yet largely unknown, have not so far received the attention they deserve. They are of great importance for understanding the courtly concepts later developed in *The Courtier* of Baldassarre Castiglione, such as the value placed on art patronage and on collecting in contemporary courtly soci-

ety.[2] Pontano, furthermore, in extolling Alfonso as the patron *par excellence* among all his contemporaries, frequently referred to Alfonso's taste for miniatures and for the works of Jan van Eyck.

The writings of two Florentines, Leon Battista Alberti and Giannozzo Manetti, will also be examined, because they evidence the importance of the arts and the artists in humanistic thought, even though they make no direct references to Flemish art. My paper will end with a brief discussion of Italian works that evidence the profound impact the art from Flanders had on miniatures and paintings commissioned in Naples and Florence during the same century.

The earliest appreciation of Flemish art and the earliest mention of two Flemish artists, Jan van Eyck and Rogier van der Weyden, appear in a historical tract written in 1456 by Bartolomeo Facio, the Genoese humanist and Royal historiographer of King Alfonso of Naples.[3] In his *De viris illustribus*, a collection of biographies of contemporary princes, citizens, humanists, and jurists, he included the lives of four painters: the Italians Gentile da Fabriano and Pisanello, and the Flemings Jan van Eyck and Rogier van der Weyden.[4]

Michael Baxandall, in *Giotto and the Orators,* analyzed Italian literary references to the art of painting and in an illuminating study of Facio's biographies of the four artists, cited the classical literary sources on which Facio based his evaluation of the four painters mentioned in his treatise.[5] As Baxandall "set out to demonstrate the sort of linguistic and literary conditions within which humanists were operating when they made remarks about painting,"[6] Facio's text is evaluated only in this light, and Facio's contribution to the development of the humanist tradition of criticism is fully recognized.[7]

Facio's major contribution lies, in the evidence he supplies for the reception of Flemish

art in Italy. He is the first humanist to apply to Flemish artists the same canons by which Italian artists were judged in humanistic discourses and to establish that Jan van Eyck and Rogier van der Weyden, along with Gentile da Fabriano and Pisanello, exemplify in their art the characteristics of the most famous painters of antiquity.[8]

Facio opened the door to the increasing number of references to these two Flemish painters in Italian sources. Among them are Filarete's *Trattato di architettura* of 1451–64, and Giovanni Santi's *Cronaca rimata,* recounting the great deeds of Federico da Montefeltro and written after his patron's death in 1482.[9] Facio's well-known comments on the art of "Jan of Gaul" must be discussed, however briefly. The first occurs when he is describing a triptych of the Annunciation in the collection of the king of Naples (the lost painting also known as the *Lomellini Triptych*), Facio writes that the remarkable picture is kept *in penetralibus* of King Alfonso, a phrase always loosely translated into English as "private apartments." This translation does not, however, respect the flavor the word has in the original.[10] The term *penetralia* in fifteenth-century humanistic Latin indicated a room not open to all and one with difficult access, a room that one could penetrate only with labor. In elitist societies such as the courts in Italy were, access to the *penetralia* was only granted to the *conoscenti*. The prince and the selected viewer evaluated the precious objects contained in such rooms, according to the values derived from classical literature, and admired the talent and skill of the artists in the perfection of their works. Facio's statement reminds us of a passage in Ciriaco d'Ancona's *Commentarii delle antiche cose* in which he described the *Lamentation* by Rogier van der Weyden, which the learned antiquarian saw in Ferrara on 7 July 1449, when it was shown to him by Leonello d'Este himself. Ciriaco's passage is further evidence that such courtly discussions of art took place and that great value was attached to chosen works of art—in both these cases works by van Eyck and van der Weyden.[11]

Facio's second comment refers to what we call perspective, that is, the art of reproducing a three-dimensional object on a flat surface. Facio described the depiction of Saint Jerome's library in Jan van Eyck's *Lomellini Annunciation*

triptych as having been painted "with rare art: for if you move away from it a little it seems that it recedes and that it has complete books laid open in it, while if you go near, it is evident that just their main features are there."[12] Immediately following, we find the description of the "circular representation of the world" that Jan van Eyck painted for Philip the Good, duke of Burgundy, and the observation that "it is thought that no work has been done more perfectly in our time; you may distinguish in it not only places and the lie of the continents but also, by measurements, the distances between places."[13] In my view, these two passages should clearly put to rest all the questions raised by art historians perplexed by the lack of any reference to the art of Flanders in the writings of Leon Battista Alberti. They suspect that Alberti's silence was motivated by the absence of "mathematical perspective" in van Eyck's works. Alberti's silence does not prove a negative or indifferent attitude toward Flemish art. Rather it shows that all Italian humanistic writings that include references to specific artists mention only those artists who come from the same part of Italy as the writer or those artists who are collected by the patron for whom the humanist is working.

In my opinion, in a humanistic discourse both the empirical and the mathematical perspective would have been deemed equally successful when an artist achieved the representation of nature as realistically as van Eyck did. Even the anonymous scribe who listed the treasures contained in Lorenzo de' Medici's private collection is prompted to comment upon the detail of "uno armarietto di più libri di prospettiva," when describing van Eyck's *Saint Jerome in His Study*.[14]

Scholars from other disciplines find Facio's text reliable and based on firsthand information.[15] Yet art historians seem reluctant to accept another piece of information provided by Facio, this time about Rogier van der Weyden's trip to Italy in 1450, which he mentions in his life of Gentile da Fabriano: "It is said of Gentile that when the famous painter Rogier of Gaul visited San Giovanni in Laterano in 1450 and looked at a picture of Pope Martin, he was taken with admiration and, praising him highly, declared to prefer him to the other Italian painters."[16] I suggest we should accept this account as factual and think that Facio did not use the anecdote to be

provocative, but to further prove that his compilation of lives of illustrious men was, as he claimed, based on firsthand knowledge. He admits that he does not have much direct knowledge of the art of Gentile; thus, he defers to Rogier's judgment of it.

The art of van Eyck is mentioned in other humanistic tracts written in Naples. Giovanni Pontano, a humanist from the Marche, a friend of Facio, and a holder of high positions under the kings of Naples from the 1450s until 1492, in 1493 began to compose five treatises inspired by the ethical writings of Aristotle and written in the form of erudite exemplifications. They deal with the uses to which wealth should be put and with the five virtues necessary to a just and meritorious use of wealth. By the middle of the century the concepts of opulence, wealth, and the uses of wealth had become areas of concern to the humanists. It is in this context that Pontano's ethical treatises are essential to understanding the patronage of the arts in Naples. In his five treatises, *De liberalitate, De beneficentia, De magnificentia, De splendore,* and *De conviventia,* Pontano discussed each virtue and the ways the ruler must follow it in order to maintain his privileged position and to contribute permanently to the state he governs.[17] The duties of the prince and the qualities necessary to a leader of men had been discussed in earlier writings, when Pontano was working for the court. These five treatises, however, were written during his retirement, and he was therefore freer to express his thoughts. His examples are taken with very few exceptions from classical history, and most refer to Alexander the Great. The contemporary figure that dominates is Alfonso of Aragon, the man Pontano had faithfully served in his youth. He is the king who had brought to Naples a new patronage and who had passed into history as the perfect king, one to be exalted for his nobility of soul and the excellence of his courtly nature.

In a passage in *De magnificentia,* Pontano describes the work of art as an object that can fill the mind and soul of the observer, and one whose excellence is demonstrated by the *voluptas* that it gives the observer. An object of art must have *dignitas,* that is "worthiness"—a quality that is shown through the skill with which the object was made and one that generates admiration.[18] Pontano insisted that great expenditures should be made for great works of art, such as the building of churches and temples, because they are permanent, but also for creating libraries, as Cosimo de' Medici had done for Florence.[19]

In another passage of the same treatise, Pontano writes that "art" determines the value of an object and asks rhetorically, "what gift did Alfonso keep with such pleasure as a painting by Jan van Eyck?"[20] For Pontano therefore, and by extension for Naples, Jan van Eyck's painting was the paradigm of a work of art.

In *De splendore,* Pontano defines this particular virtue as being exemplified in the possession of splendid ornaments for one's home and one's person. These were one's most personal possessions, to be enjoyed in private, but by acquiring them one attained permanent glory. In this treatise, we also learn that Alfonso of Aragon, king of Naples, aspired to become the *exemplum* of the patron and to overshadow the duke of Berry, whereas Pope Paul II tried to overshadow both of them.[21]

Jean, duke of Berry, who had died in 1416 but whose wealth and art collection were still unrivalled, had already been referred to as the *exemplum* of a patron by Filarete.[22] It is becoming very apparent that patronage and collecting were ways to compete with other princes. In a document drawn up in Valencia on 2 May 1444, we learn that Johan Gregori acquired for King Alfonso a panel with Saint George on horseback, and other objects, all skillfully rendered.[23] The panel had been painted and designed by "Master John the great painter of the illustrious duke of Burgundy." It seems to me significant that Jan van Eyck is identified as the painter "of the illustrious duke of Burgundy," a sobriquet that seems to render the possession of a panel painted by him still more valuable.[24]

Pontano's treatise thus can be called the first systematic program of patronage as a political expression. That the patronage and the collecting of art had become the most enduring and visible signs of greatness was known even to Florentine citizens such as Giovanni Rucellai, not a humanist himself but definitely the propagator of their ideas.[25] In his *Zibaldone* (1457) we read that works of art give him "the greatest contentment and the greatest pleasure because they serve the glory of God, the honor of the city and the commem-

oration of myself ."[26] With great glee he proceeds to list all the works of art in his possession. Unlike Alfonso's works, all of them are by Florentine artists. This should not come as a surprise to anyone familiar with Florentine humanistic discourses on art and artists. This discourse was initiated in Florence by Filippo Villani in his *De origine civitatis Florentinae et eiusdem famosis civibus*, of 1381. Villani, along with Coluccio Salutati (the chancellor of Florence and editor of Villani's text), was preoccupied with Florence's political standing in relation to the rest of Italy, and he used Florentine art and its creators as further proof of Florence's predestined superiority among all Italian states.[27] Engaging in the same discourse, Leon Battista Alberti in his prologue to *Della pittura* wrote that he used to grieve that "Nature, the mistress of things, had grown old and tired—thus painters, sculptors, architects—and other noble and amazing intellects were rarely found today," but that upon his return to Florence[28] he had found in many men, especially in "Filippo [Brunelleschi] and—Donato the sculptor, and in others like Nencio, Luca, and Maso, there is a genius for accomplishing every praiseworthy thing."[29] He concluded that "for this genius they should not be slighted in favour of anyone famous in antiquity in these arts."[30]

The same concerns about the art and artists of the past and present are evident in a tract dedicated to King Alfonso of Naples by another Florentine humanist, Giannozzo Manetti. Manetti was in Naples on a diplomatic mission from his native Florence when, in 1452, he wrote *De dignitate et excellentia hominis* at Alfonso's request.[31] Alfonso's request for a treatise on the dignity of man and of man's role in the cosmos was provoked by the earliest humanistic work entirely concerned with the dignity of man, Facio's *De excellentia ac praestantia hominis,* of 1448, in which man's achievements in government, civilization, the sciences, and the arts are praised.[32] Alfonso found Facio's position too pessimistic and asked Manetti for his views on the subject. Manetti placed a stronger emphasis on human achievement and creativity in this world (as opposed to the afterworld); he outlined the thesis that the excellence of man revealed itself in works produced by human faculties, and therefore proposed that architects and sculptors could be admired next to poets, astronomers, jurists, historians, and philosophers.[33] When discussing intelligence, which he interprets as the inventive faculty of man, Manetti finds man's ingenuity or inventiveness so great that "man himself should be regarded as a second creator of the human historical world that was superimposed on the original divine creation of the natural world."[34] All towns and buildings are created by man as well as paintings and sculptures, which are of such a nature that they ought to be regarded as the works of angels rather than of men.[35] Manetti, like all other Florentine humanists, cited two Florentines, Brunelleschi and Ghiberti, as proof of the excellence of contemporary artists and as examples of *homo faber,* that is, "man as creator."[36] Manetti, a member of one of the richest commercial families as well as the most renowned orator and most esteemed ambassador of the city of Florence, had no reason to mention artists from outside his city.[37] Again, I want to stress that this does not indicate a lack of interest in or admiration for the new art coming from north of the Alps. Manetti must have known that art very well, since he belonged to the Medici circle and had easy access to the princely courts, whose collections contained works by Jan van Eyck and Rogier van der Weyden. In brief, Manetti speaks for Florence and Facio for Naples.

The political aims of Alfonso of Aragon were completely different from those of the Medici. The Medici, whose close relations with Florentine humanists have been addressed in an earlier study of mine, had always acted upon the principle that the predestined superiority of Tuscany could be proved through its art and its artists.[38] In this context, I will mention the gift sent by Cosimo de' Medici to Alfonso of Aragon: a triptych by Fra Filippo Lippi in which a Flemish flavor appears pronounced.[39] We can only wonder whether the hidden message was that Cosimo's artist could paint in both stylistic idioms; certainly the suggestion is there.

In Naples, the patronage of art is exemplified by René of Anjou, king of Naples from 1435 to 1442, and by Alfonso of Aragon, king of Naples from 1444 to 1458. Their predilection for Flemish paintings and tapestries is well documented. As Federico Zeri observes, fifteenth-century Italy is a mosaic of visual cultures that for the most part coincide with the local political power and its sphere of influ-

ence.[40] René brought from France his painters and his art collection, and Alfonso's patronage is strictly tied to his political ambition to become *emperador de la mediterrania*.[41] As a consequence, the painters were invited or came to Naples from all over Italy and from all the states under the crown of Aragon (Catalonia, Aragon, Valencia, Sicily, and Sardinia). Most of the pictorial works produced during Alfonso's reign have been lost, but those that remain are clearly influenced by Flemish art.[42]

By the end of the century this admiration for Flemish painting, and in particular for Petrus Christus, is evident also in sculpture. For example, the *Death of Saint Zita*, executed by the workshop of Antonello Gaggini for the Church of Saint Zita in Palermo, copies almost exactly Christus's *Death of the Virgin* (Timken Art Gallery, Putnam Foundation, San Diego).[43] After Alfonso's death, the royal court was involved in wars to defend the Aragonese claim to the kingdom, and the state coffers were predominantly used for the erection of public buildings and fortifications, and less was left for paintings.[44]

The Medici, apparently the first among Florentines to appreciate Flemish painting, shared the refined, learned, and courtly taste of other Italian patrons and collectors of Flemish art. They collected art for their private enjoyment and kept their treasures within the confines of their palaces. During the second half of the century, merchants such as Tani, Baroncelli, and Portinari, who represented the Medici bank in Bruges, commissioned Flemish paintings especially to adorn their family chapels.[45] This new "destination" caused a change in the size of the commissioned paintings, from miniature-like panels to large altarpieces. It also made them more easily accessible to contemporary Florentine artists, who produced Flemish-influenced art in various media. A case in point is that of Domenico Ghirlandaio, who was able to satisfy his patrons in different ways: the Medici with miniatures, and the merchant-bankers Sassetti and Vespucci with frescoes and altarpieces.[46]

To conclude: the humanists provided the intellectual reasons for the reception of Flemish art in Italy, and the patrons had the means to acquire the works.[47] But the ones who really recognized the *dignitas* of the new art, to use Pontano's term, were the Italian artists.

ACKNOWLEDGMENTS

This article is dedicated to the late Sir John Pope-Hennessy, a generous and supportive friend and an inspiring intellectual example. I am happy to thank Professor Paul Oscar Kristeller for having read and commented on this paper and for his valuable criticism and support. My thanks go also to Virginia Budney for having improved the English of my text; to Keith Christiansen, Linda Wolk-Simon, Frank Dabell, Maria Pernis, and Paolo Berdini for advice and information; to Philippe de Montebello for his support; and to the staff of the Watson Library. Last but not least, my warmest thanks to Maryan Ainsworth for her constant encouragement through the various stages of the paper.

NOTES

1. My work on this topic began under the guidance of Professor Charles Sterling and was presented as "Quadri fiamminghi in Italia nel '400" (M.A. thesis, Institute of Fine Arts, New York University, January 1972).

2. Baldassarre Castiglione, *Il cortegiano* (Venice, 1528).

3. *Bartolomaei Facii De viris illustribus*, ed. L. Mehus (Florence, 1745). On Facio's life, Paul Oskar Kristeller, "The Humanist Bartolomeo Facio and His Unknown Correspondence," in *From the Renaissance to the Counterreformation: Essays in Honor of Garrett Mattingly*, ed. Charles H. Carter (New York, 1965) pp. 56–74. Three spellings, all acceptable, of the humanist's name have been used. Baxandall (see note 5) used Fazio; Faccio has been used in the *Dizionario biografico degli Italiani*, in references to him in entries on others, but *Facio* is used in vol. 44, 1944, in the entry on Facio by P.Viti; see also *Facio* in the *Enciclopedia Italiana Treccani* by Kristeller.

4. Mehus, *De viris*, pp. 43–51.

5. Michael Baxandall, *Giotto and the Orators* (Oxford, 1971) pp. 98–111.

6. Ibid., p. vii.

7. Ibid., pp. 18–19.

8. On Facio's inclusion of two Flemish artists in his *De viris*, Baxandall writes (ibid., p. 99): "it must certainly have involved certain strong social pressures towards conformity with Aragonese taste." For the influence of Alfonso's taste on Facio's passages and on contemporary local artists, see O. Morisani, *La letteratura artistica a Napoli* (Naples, 1937) pp. 9–24.

9. *Trattato di architettura, (di) Antonio Averlino detto il Filarete*, ed. Anna Maria Finoli and Liliana Grassi (Milan, 1972): Filarete refers to van Eyck and van der Weyden twice, in book 9, p. 265, and book 24, p. 668. For a discussion of its content and comparison with other contemporary treatises see Schlosser Magnino, *La letteratura artistica* (Florence, 1979) pp. 129–133. Giovanni Santi, *Cronaca rimata delle imprese del duca Federico d'Urbino*, ed. H. Holtzinger (Stuttgart, 1893) book 22, chap. 96, 120 for a msot recent edition, see *Giovanni Santi: la vita e ligesta di Federico di Montefeltro duca di Urbino*, ed. Luigi Minchelini Tocci, 2 vols. (Vatican City, 1985).

10. Facio, *De viris*, quoted in Baxandall, *Giotto*, pp. 165 (in Latin) and 106 (in English).

11. The passage is transcribed in Erwin Panofsky, *Early Netherlandish Painting* (Cambridge, 1958) pp. 361, 2 n. 4. For the purpose of this paper, it is interesting to note that Ciriaco was a close friend of Alfonso of Aragon as well as the author of the history of the battle between the Aragonese and Genoese fleets near Ponza; Paul MacKendrick, "A Renaissance Odyssey: The Life of Cyriac of Ancona," *Classica et Medievalia* 13 (1952) pp. 131–145. On Ciriaco's knowledge of ancient monuments and inscriptions, see Bernard Ashmole, "Cyriac of Ancona," in *Art and Politics in Renaissance Italy*, British Academy Lectures (Oxford, 1993) pp. 41–57; originally delivered as a lecture at the British Academy, 1957.

12. Facio, *De viris*, quoted in Baxandall, *Giotto*, p. 106.

13. Ibid., pp. 106–107. On van Eyck's spatial constructions, see Thomas Martone, "Van Eyck's Technique of the 'Trompe-l'intelligence' Applied to the Deesis of the Ghent Altarpiece," *Versus* 37 (1984) pp. 71–82.

14. The inventory of the Medici Palace in the Via Larga compiled in 1492 is known to us in a copy of 23 December 1512, kept in the Archivio di Stato, in Florence: *Archivio Mediceo avanti il Principato*, filza 165, fol. 1–127; it was transcribed and published by Eugene Muentz, *Les Collections des Médicis au XVᵉ siècle* (Paris/London, 1888) p. 78. The unabridged transcription of the document has been curated by M. Spallanzani e G. Gaeta Bertelá, *Libro d'inventario dei Lorenzo il Magnifico* (Florence, 1992), p. 58. For the fame of this painting see Annʹarosa Garzelli, "Sulla fortuna del Gerolamo mediceo di Jan van Eyck nell'arte fiorentina del Quattrocento," in *Scritti di storia dell'arte in onore di Roberto Salvini* (Florence, 1984) pp. 347–353.

15. Kristeller, "The Humanist Facio," pp. 56–74.

16. Facio, *De viris*, quoted in Baxandall, *Giotto*, p. 105.

17. Giovanni Pontano, *I trattati delle virtù sociali*, ed. Francesco Tateo (Rome, 1965); all five treatises are examined in Tateo, *L'umanesimo etico di Giovanni Pontano* (Bari, 1972) pp. 121–185.

18. Pontano, *De magnificentia*, 19, pp. 126ff. For a discussion of the treatise see Tateo, "La poetica di G. Pontano," *Filologia e letteratura*, 6 (1959) pp. 363ff.

19. Pontano, *De magnificentia*, 11, pp. 126ff. On Costimo de'Medici see A. D. Fraser Jenkins, "Cosimo de'Medici's Patronge of Architeture and the Theory of Magnificence," *Journal of the Warburg and Courtauld Institutes* 33 (1970), pp. 162–170.

20. Ibid., 19, pp. 117, 260.

21. Pontano, *De splendore*, 7, pp. 135, 276.

22. Filarete, *Trattato di architettura*, book 24, p. 680, where particular mention is made of the duke's chalcedony cameo depicting the apotheosis of Augustus, now in Vienna and described in Salomon Reinach, *Pierres gravées* (Parish, 1895) pp. 2–3, ill. 1. On the duke's collection, see *Inventaires de Jean duc de Berry (1401–1416)*, published and annotated by Jules Guiffrey (Paris, 1894–96); Millard Meiss, introduction to *The Belles Heures de Jean, Duke de Berry*, by Meiss and E. H. Beatson (New York, 1974) pp. 9–18.

23. J. Sanchis y Rivera, *Pintores medievales en Valencia* (Barcelona, 1914) pp. 69-70; the document is kept in Barcelona, Arxiu de la Corona d'Arago', Registro 2901, fol. 153v and 154r. For the fate of this van Eyck and of the *Lomellini Triptych*, also in Alfonso's collection, see Roberto Weiss, "Jan van Eyck and the Italians" *Italian Studies* 11 (1956) p. 9ff.

24. Sanchis y Rivera, *Pintores medievales*, p. 69.

25. On Giovanni Rucellai's position in humanistic thought see Gabriella Befani Canfield, "The Florentine Humanists' Concept of Architecture in the 1430s and Filippo Brunelleschi," *Scritti di storia dell'arte in onore di Federico Zeri* (Milan, 1984) p. 112 and n. 16–20; for links between the humanists and the oligarchy in Florence, Lauro Martines, *Power and Imagination: City-States in Renaissance Italy* (New York, 1979) pp. 191–240.

26. Baxandall, *Painting and Experience in Fifteenth Century Italy* (Oxford, 1972) p. 2.

27. Villani's text, with Salutati's corrections, is kept in the Biblioteca Laurenziana, Florence, MS Ashburnham 942, and is discussed in Giuliano Tanturli, "Le biografie di artisti prima del Vasari," *Atti del Congresso internazionale nel IV centenario della morte*, Arezzo-Florence, 2–8 September 1974 (Florence, 1976) pp. 275–298.

28. Alberti's father had been exiled, and Alberti himself was born in Genoa, raised in Venice and Padua, attended university in Bologna, traveled with Albergati through Germany and

France, spent two years in Rome, and came to Florence in 1434, although it is possible that he visited there briefly in 1428. See C. Grayson, *Dizionario biografico degli Italiani,* s.v. L. B. Alberti; and idem, "Leon Battista Alberti: Vita e opere," in *Leon Battista Alberti,* ed. J. Rykwert and A. Engel, exh. cat. (Milan, 1994) pp. 28–37.

29. Leon Battista Alberti, *De pictura,* vol. III of *Opere volgari,* ed. C. Grayson, (Bari, 1973) pp. 7–8. For a discussion of the prologue's date (17 July 1436) and for the dedication to Brunelleschi of the *De pictura* in the vernacular, see ibid., p. 305 and n. 2. Of the artists mentioned in the prologue, Filippo, Donato, Nencio, Luca, and Maso have traditionally been identified respectively as Brunelleschi, Donatello, Ghiberti, Luca della Robbia, and the painter Masaccio. The identification of "Maso" with the bronze caster Maso di Bartolomeo, rather than with the painter Masaccio, was first proposed by H. Janitschek, "Leone Battista Alberti's Kleinere Kunsttheoretische Schriften," *Quellenschriften für Kunstgeschichte,* 11 (1877) pp. 257–261, followed by R. Oertel, in a review of *Masaccio,* by K. Steinbart, *Zeitschrift für Kunstgeschichte,* 14 (1951) pp. 170ff. Kenneth Clark, "Leon Battista Alberti on Painting," *British Academy Proceedings,* 30 (1944) pp. 287ff., and Richard Krautheimer, *Lorenzo Ghiberti* (Princeton, 1970) p. 319, n. 20, disagree completely with this identification and follow the traditional one that holds that "Maso" refers to the painter Masaccio. This controversy was kindly brought to my attention by Keith Christiansen and Linda Wolk-Simon, when they read the draft of this paper. I tend to agree with Janitschek's identification, but not for the reasons brought by him; my findings, based on a close reading of Italian humanistic tracts containing references to artists or the visual arts, will be published in Res in the fall of 1995, in an essay tentatively titled "A New System of the Arts in Italian Humanistic Tracts."

30. On the Renaissance concepts of the art of antiquity, see Canfield, "The Florentine Humanists," p. 115; Eugenio Garin, *Medioevo e Rinascimento* (Bari, 1954) p. 282. For Alberti's dependence on rhetorical formulations, see John K. Spencer, "Ut rhetorica pictura," *Journal of the Warburg and Courtauld Institutes* 20 (1957) pp. 24ff; E. H. Gombrich, "A Classical Topos in Alberti's *Della pittura,*" ibid., p. 173. On the topos of the ancients being outdone by contemporaries, Baxandall, *Giotto,* p. 72 n. 50, with a reference to E. R. Curtius, *Europaische Literatur und latinisches Mittelalter* (Bern, 1948) pp. 162–166. On the revival of the arts, P. O. Kristeller, *Renaissance Thought: The Classic, Scholastic and Humanistic Strains* (New York, 1961) pp. 92 and 150 n. 3 for bibliography. On the close links among the visual arts, the sciences, and literature: Kristeller, "The Modern System of the Arts," *Journal of the History of Ideas* 12 (1951) pp. 496–527; Eugenio Garin, "Brunelleschi e la cultura fiorentina del Rinascimento," *Nuova Antologia* (June-July-August 1977) pp. 11–23. Sir John Pope-Hennessy, in *An Introduction to Italian Sculpture,* Part 2, *Italian Renaissance Sculpture* (London, 1958) p. 57, rightly remarks on Alberti's *Della statua*: "Here we seem to sense the current of thought which culminates thirty years later in Pico della Mirandola's *De hominis dignitate.*"

31. *Janoi Manetti: De dignitate et excellentia hominis,* ed. Elisabeth Leonard (Padua, 1975).

32. Facio links man's dignity and happiness with the pursuit of heavenly joys and with the rejection of earthly and secular values. The scrutiny of the essence of the dignity and the happiness of man developed into a battle between advocates of *vita contemplativa* and those of the *vita activa.* All this is referred to, with bibliography, in Canfield, "The Florentine Humanists," p. 118, note 15; see also *"Vita contemplativa" and "vita activa,"* ed. B. Vickers (Zurich and Stuttgart).

33. *Manetti: De dignitate,* book 2, fol. 20v–22v.

34. Ibid., book 2, fol. 27r–28r.

35. Ibid., book 2, fol. 27v.

36. Ibid., books 2 and 3. For Manetti's view of man as a doer and creator and this new philosophy of *homo faber,* see Charles Trinkus, *"In Our Image and Likeness": Humanity and Divinity in Italian Humanistic Thought* (Chicago, 1970) pp. 231–258. On this new concept of man and its influence on later humanistic tracts see E. Cassirer, *Individuo e cosmo nella filosofia del Rinascimento,* Italian trans. (Florence, 1935) pp. 135–155; G. Gentile, "Il concetto dell'uomo nel Rinascimento," in *Il pensiero italiano del Rinascimento* (Florence, 1940) pp. 47–113; G. di Napoli, *L'immortalità dell'anima nel Rinascimento* (Turin, 1963) pp. 89–97; idem, " 'Contemptus mundi' e 'dignitas hominis' nel Rinascimento," *Rivista di filosofia Neo-Scolastica,* 48 (1956) pp. 9–41. In general, see P. O. Kristeller, *Renaissance Concepts of Man and Other Essays* (New York, 1972). The importance of these treatises on the dignity of man and the position of man in the cosmos in the development of the concept of the artist as "creator," as opposed to that of the artist as "craftsman," will be the subject of a paper to be presented at the Annual Congress of the Renaissance Society of America in Bloomington, Indiana, in April 1996.

37. Lauro Martines, *The Social World of the Florentine Humanist, 1390–1460* (Princeton, 1963) pp. 131–138.

38. Canfield, "The Florentine Humanists," p. 115 and nn. 61 and 62 with bibliography, in connection with Ambrogio Traversari; Federico Zeri, "Premessa," in *La pittura in Italia: Il Quattrocento,* ed. Zeri et al. (Milan, 1987) p. 12.

39. The wings of the triptych, *Saint Anthony Abbot* and *Saint Michael,* are in the Cleveland Museum of Art, Cleveland, Ohio, while the central panel, representing a kneeling Madonna adoring the Christ Child, is lost; see The Cleveland Museum of Art, *European Paintings Before 1500* (Cleveland, 1974) pp. 81–83, plate *XVI.* The wings are also discussed and illustrated in Jeffrey Ruda, *Filippo Lippi* (New York, 1993) pp. 194–199, pls. 113–114, pp. 442–444 (cat. 49). On the gift and the prevailing taste in the South of Italy, see Fausto Navarro, "La pittura a Napoli e nel Meridione," in *La pittura in Italia,* pp. 446–476, esp. p. 455.

40. Zeri, "Premessa," p. 12.

41. Françoise Robin, *La Cour d'Anjou-Provence: La Vie artistique sous le regne de René* (Paris, 1985). On the influence of Alfonso's expansionistic aims on his artistic patronage, see Roberto Pane, *Il Rinascimento nell'Italia meridionale* (Milan, 1975) pp. 5–18 and 63–95; G. L. Hersey, *The Aragonese Arch at Naples, 1443–1475* (New Haven, 1973) pp. 11–28. On Alfonso's political ambitions, see Jaime Vicens i Vives, *Els Trastamares* (Barcelona, 1956) pp. 132–136.

42. A case in point is the woman wiping her tears in Colantonio's *Deposition,* painted for the Church of San Domenico Maggiore in Naples; this woman is the mirror image of the figure in Christus' *Lamentation* in the Musées Royaux des Beaux Arts, Brussels. both illustrated in Liana Castelfranchi-Vegas, *Italia e Fiandra nella pittura del Quattrocento* (Milan, 1983) p. 81 and fig. 44–45, and discussed in Canfield, "Quadri fiamminghi," n. 319. The effect that the art of Petrus Christus had on the South of Italy had been stressed by Roberto Longhi, "I fiamminghi e l'Italia," *Paragone* 25 (1952) pp. 47–50. The motif of Christ supported by angels in his *Christ as the Man of Sorrows* (Birmingham Museums and Art Gallery) seems to have been known in Spain as well as in Italy; see Federico Zeri, "An Exhibition of Mediterranean Primitives," *Burlington Magazine* 94 (1952) p. 321. Additional Italian examples have been found by the author in recent years; some are listed in Canfield, "Quadri fiamminghi," pp. 172–174 and nn. 428–433. See also F. Bologna, *Napoli e le rotte marittime nella pittura di Alfonso d'Aragone e Ferdinando il Cattolico* (Naples, 1977), and R. Filangeri di Candida, "La Peinture flamande à Naples pendant le XVᵉ siècle," *Revue belge d'archeologie et d'histoire de l'art* 1 (1932) pp. 128–143.

43. Discussed and illustrated by Maryan Ainsworth in Ainsworth and Martens, *Petrus Christus*, p. 152, pl. 15, fig. 156.

44. George L. Hersey, *Alfonso II and the Artistic Renewal of Naples, 1485-1495* (New Haven, 1969) esp. pp. 1–17.

45. Raymond de Roover, *The Rise and Decline of the Medici Bank* (Cambridge, Mass., 1963).

46. Domenico Ghirlandaio's shepherds in the *Adoration of the Shepherds* of 1485, for the Sassetti Chapel in the Church of the Holy Trinity, Florence, hark back to those in the triptych of the same subject painted by Hugo van der Goes for Tommaso Portinari and his family, which hung on the high altar in the Church of Sant'Egidio, Florence, and is now in the Uffizi. Ghirlandaio's *Deposition from the Cross*, for the Vespucci Chapel in the Church of Ognissanti, Florence, is based on a Flemish composition. Everett Fahy's book on Ghirlandaio will explore this dependence further. Sir John Pope-Hennessy alerted me shortly after this *Deposition* was "rediscovered," and suggested I study its Flemish predecessors. Annarosa Garzelli, "Roger van der Weyden, Ugo van der Goes, Filippo Lippi nella Pagina di Monte," *Studi di storia dell'arte in memoria di Mario Rotili* (Naples, 1984) pp. 321-330, discusses and illustrates the influence of Flemish art on Florentine miniatures.

47. On the collecting of and predilection for Flemish art: André Chastel, *The Myth of the Renaissance* (Geneva, 1969) pp. 117–122.

Discussion

Maximiliaan P. J. Martens
Groningen University

In my response to the previous lectures, I would like to single out some specific issues raised by the three speakers and conclude with some reflections on the title of the present exhibition.

Response to Wim Blockmans:

By discovering that in the Bruges *Poorterboeken* (burghers' registers) the place of origin is mentioned only for applicants from the Brugse Vrije and from outside the county of Flanders, Wim Blockmans has resolved a long-standing matter of debate. It is now an established fact that Petrus Christus came from the Brabantine village Baerle, and not from the hamlet with the same name in Drongen near Ghent.[1]

Blockmans further discussed fluctuations in the immigration pattern into Bruges, which show that Petrus Christus moved to the city during a period when this migration was at its height. Since the fourteenth century, many specialized craftsmen who produced luxury articles were attracted to the metropolis. This tendency continued during the fifteenth century. We know by name many immigrant artists who relocated their activity to Bruges. Jan van Eyck, Petrus Christus, Hans Memling, Jean de Hervy, Gerard David, Willem Vrelant, Loyset Liédet, and Philippe de Mazerolles are the best-known examples.[2]

The membership lists of the corporation of image makers also confirm this tendency for the fifteenth century. From 1466 on, these lists mention whether newly accepted masters were sons of members, whether they were "half-free" (*i.e.,* if they had been apprenticed in Bruges), or whether they were foreigners. For the period 1466–99, the distribution is as follows: 24 percent were sons of masters, 40 percent half-free, 31 percent foreigners, and 5 percent unknown.[3] The high percentage of foreigners confirms the tendency of artists and artisans as a professional sector to be well represented among the immigrants who moved to Bruges.

Jean-Pierre Sosson has attempted, as I also did later, to interpret the lists of members and apprentices of the corporation of the image makers in Bruges through statistical analysis.[4] I concluded that there must have been a decrease in the number of workshops after about 1475, but that the size of workshops simultaneously grew larger. Here, Wim Blockmans has refined this interpretation. A coherent view now emerges of the development in the size of artists' workshops in fifteenth-century Bruges. His main conclusion is that after 1475 the number of workshops decreased, but proportionally more people worked alone and the medium-sized enterprises grew in size.

In the second half of the fifteenth century, nearly 70 percent of the apprentices never attained the status of master, but remained journeymen.[5] This considerable number of artists, about whom all documentary trace is lost, has to be included in any attempt to reconstruct the average workshop size.

Before 1475, about 40 percent of the artistic workshops were one-man businesses, and 60 percent were small ateliers, perhaps of about two or three persons at any given moment.[6] After 1475, about 75 percent were one-man businesses, and 25 percent were larger enterprises perhaps employing about four people at once.

How are these statistics to be related to the concrete reality of artistic production in fifteenth-century Bruges? They must be considered within the framework of following known historical facts. Famous masters apparently had few apprentices: Petrus Christus only had one pupil, his bastard son Bastyaen.[7] Hans Memling only trained two apprentices after 1480: Hannekin Veranneman and Passcharis Van der Meersch.[8] Unlike these famous masters, most artists were involved mainly in purely decorative and heraldic work.[9] Recent studies have shown that workshop procedures were rationalized and adapted to the changing demands of the open market from about 1475 on.[10]

Figure 1. Pieter Claeissens the Elder, *Seven Wonders of Bruges,* c. 1550. Bruges, Béguinage (photo: Béguinage)

Combining these facts with the statistics, I propose the following hypotheses:

1. One-man businesses throughout the second half of the fifteenth century comprised both the important masters whose work is still known to us and the humble decorators who could not afford to employ assistants.

2. The small workshops active before 1475 were engaged mainly in decorative, routinelike tasks. This allowed a rational distribution of labor under the supervision of one master who was responsible for the final product.

3. Most likely, methods of rationalizing distribution of labor and workshop procedures were first introduced in the larger workshops active after 1475. This allowed for an increasing compatibility with the demands of the newly developing open market.

Only systematic research of workshop procedures through technical investigation of known Bruges paintings may confirm these hypotheses.

Response to Craig Harbison:

In his contribution to the present colloquium, Craig Harbison has proposed the challenging view that cityscapes in the backgrounds of early Netherlandish paintings are simultaneously fragmentary, emblematic, and propagandistic.

He asked whether there is evidence that the realism in early Netherlandish paintings was commissioned. Perhaps a hint of such documentary evidence is provided by a clause that is frequently found in Flemish contracts of the fifteenth century. The clause *alsoet behoort,*[11] which can be translated as "as it should be," or "as is becoming," suggests that there was a certain degree of consensus about artistic quality between contracting parties, and also that the artist had to make the work according to the very best of his abilities.

Parenthetically, I believe that Jan van Eyck's famous motto *Als Ich Xan* alludes to this traditional stipulation in contracts. Since Flemish paintings of the fifteenth century do show a great emphasis on verisimilitude, and because artists were forced by contract to follow carefully the stipulation *alsoet behoort,* one may infer that the implicit meaning of this clause may have been "with the proper degree of realism."

I am very much tempted to follow Harbison's view that background cityscapes were largely constructed as puzzles consisting of fragments taken from model books or reality. In the *Epitaph of Anna van Nieuwenhove* in the Robert Lehman Collection (see Harbison essay, Fig. 5), the specific configuration of the three towers with the Belfry at the right, the Church of Our Lady in the middle, and at the left, a third tower, which is probably that of Saint Savior's Church, can only be seen when viewing the city from north by northeast, *i.e.,* somewhere in between the Ghent Gate and the Catherina Gate.[12] When the city is seen from the side of the Minnewater with its two towers, as it appears in the picture—a view that is from farther toward the east of the city—the tower of the Belfry should appear in the middle. In other words, the painter did indeed idealize the city view, by showing the city simultaneously from different angles.

Perhaps the tradition of Bruges cityscapes that seems to have been popular from the late 1470s on was the nucleus from which the so-called Seven Wonders of Bruges evolved. This became a topos in sixteenth-century Renaissance Bruges art and literature, as is exemplified in a painting from about 1550 by Pieter Claeissens the Elder in the Béguinage (Fig. 1). This entirely imagined cityscape features the towers of Our Lady's Church, the Belfry, the Water Halls, the Burghers' Loggia, the Loggia of the Easterlings, the House with the Seven Towers, and the aqueduct near the Bouverie Gate.

Concerning the method of dating paintings by followers of Memling on the basis of the four building stages of the Belfry, which appears in the background of several of their paintings, the following remarks can be made. Although Harbison is right in pointing out that the idealistic connotations of such representations have been neglected, I do believe that this does not necessarily mean that the dating method would

be invalid. It was first introduced by Georges Hulin de Loo in a seminar on the followers of Memling at the University of Ghent in 1925.[13] As these masters painted the tower very precisely in its different building stages, it is simply logical that they represented the tower of the Belfry the way it appeared at that particular moment.

One could argue that the building phase of the Belfry is not necessarily a reliable indication for the date of pictures in which the tower appears. Theoretically, these cityscapes could have been copied from older sketches. Nevertheless, it would have made little sense for a Bruges painter to represent a Bruges building the way it looked some years earlier. Besides, why then would the Master of the Saint Ursula Legend and the Master of the Saint Lucy Legend have represented the Belfry in its later building phases as well? The validity of this dating method is also supported by the possibility of applying it to works of artists in other artistic centers, such as the Brussels Master of the View of Saint Gudule.[14]

Is there documentary evidence for assuming that buildings may have been represented with propagandistic intentions? Contemporary chronicles seem to suggest that sometimes the powerful and imposing nature of the Bruges Belfry was utilized indeed in a politically charged context.

On 3 July 1468, the celebrations for the wedding of Charles the Bold and Margaret of York started with the triumphal entry of the new duchess into the city.[15] The rhetorician Antoon de Roovere, one of the main figures in Flemish literature of the fifteenth century, devised a scaffold that was constructed on the northeastern side of the Belfry. De Roovere is most probably also the author of the rather elaborate description of this pageant in the famous chronicle the *Excellente chronicke.*[16] The scene showed

> an extraordinary beautiful girl, very lavishly dressed, with costly jewels on her head and around her neck, and above her head hung a golden lily, and on her lap lay a lion and a leopard, as if they had embraced each other, and there was written in golden letters "The Lion and the Leopard have embraced each other on the lap of the blossom, under the lily."[17]

Behind the lion and the leopard were more lions, and on either side of the stage stood a

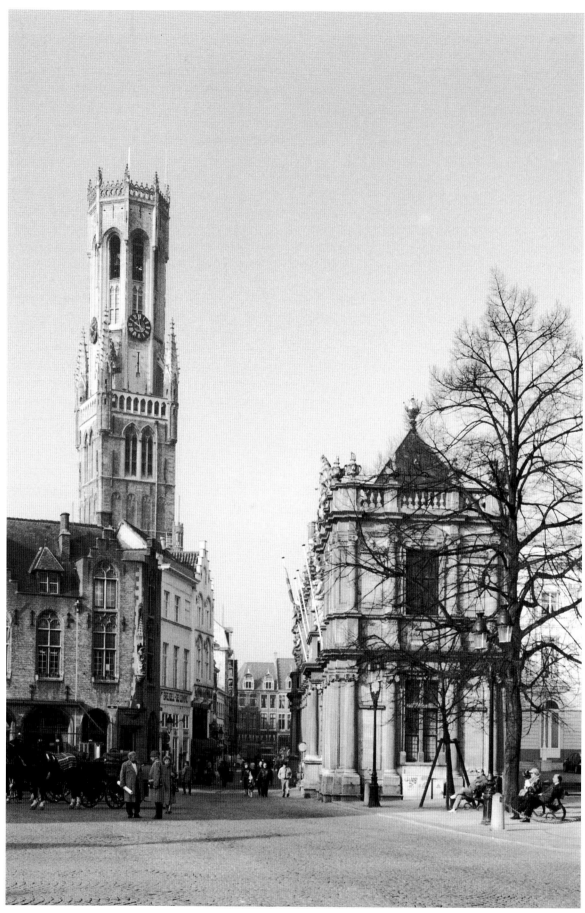

Figure 2. Belfry, seen from the Breidelstraat (photo: Hugo Maertens)

woman, one holding the arms of Flanders and a book showing a pierced-through heart, the other holding the arms of Bruges and an illustration of a golden crown.

The author explained the iconography of this scene. The political allegory is presented here in purely heraldic form. The girl represented is, of course, the duchess. The black lion and the leopard embracing each other on her lap stood for the friendly relations between Flanders and England, strengthened through marriage. The golden lily symbolized the house of Valois, while the other lions represented the lands ruled by the Burgundian dukes (Brabant and Luxembourg) and domains claimed by the English crown (Aquitaine and Normandy).

It was, of course, no coincidence that this tableau was installed at the foot of the Belfry, the most impressive symbol of civic pride and power. The alliance between Flanders and England, symbolized by the *tableau vivant,* placed against a backdrop of local civic power embodied in the architecture of the Belfry, must have fostered a powerful visual association.

Especially for the honored guests who proceeded from the Burg to the Market through the narrow Breidelstraat, which is overshadowed by the Belfry, the dramatic use of civic architecture as a bearer of political meaning must have been overwhelming (Fig. 2).

In this context, it should be remembered how vital a good relationship with England was for the Flemish cities. The main pillar of their economy, the textile industry, was largely dependent upon the import of English wool. For centuries this issue has determined Flemish politics. It is, therefore, no surprise that it was precisely Margaret's role in assuring this bilateral bond that was chosen by the city of Bruges as the central theme for the main *tableau vivant* in 1468.

The placement of this *tableau vivant* in front of the Belfry proves Harbison's suggestion that buildings could be used in an artistic context as a means of propaganda.

Response to G. Canfield:

Gabriella Canfield discussed the role of humanistic discourse in the reception of Flemish painting in fifteenth-century Florence and Naples. The speaker stressed the importance of regional diversification in this reception, linked to the different political attitudes of the humanist authors. Particularly noteworthy is the observation that it was first and foremost Italian artists who recognized the qualities of Flemish painting, while the humanists attempted to provide an ethical foundation for the taste of contemporary collectors.

Petrus Christus: A Renaissance Artist?

Blockmans questions the categorization of Christus as a Renaissance artist on the basis of economical and social-historical grounds. Petrus Christus's functioning as a craftsman was determined by the social and economic regulations of the late medieval corporative structure.

As Gabriella Canfield pointed out, Manetti considered Brunelleschi and Ghiberti as examples of *homines fabri,* a term she translated as "men as creators." However, a more literal translation for *faber* is "craftsman." It is significant that literary humanists in Italy, such as Manetti, also still considered artists craftsmen, a conception entirely rooted in the medieval tradition.

The strictly art historical arguments hardly need to be summarized here. Is the *ars nova* of Jan van Eyck, and more specifically the use of oil painting and the resulting verisimilitude of the representation, a typical northern equivalent of the Italian *renovatio*? And more restricted to Petrus Christus himself, can his remarkable search for a correct application of linear perspective, and from 1457 on his exceptional success in this matter, be considered the preoccupation of a Renaissance artist? And how should we evaluate his attempts at bridging the distance between the pictorial space and the "actual" space of the beholder?[18]

A comparison between his *Portrait of a Man* in the Los Angeles County Museum and Antonella da Messina's *Portrait of a Man* in the National Gallery in London clearly demonstrates that the distinction between late medieval and Renaissance in Christus's case is highly problematic.[19]

A crucial question in the northern context is, of course, whether a "re-naissance" of classical antique culture did occur and when? How widespread was the knowledge of and the interest in antiquity in fifteenth-century Bruges? Most classical texts that were popular in Flanders at this time, such as, for instance, Valerius Maximus' *Facta et dicta memorabilia,* had been read throughout the Middle Ages.

The categorization of early Netherlandish painting as late medieval art, which is current at European universities, is indebted largely to the Groningen historian Johan Huizinga, who wrote in his *Waning of the Middle Ages:*

> The naïve, and at the same time refined, naturalism of the brothers van Eyck was a new form of pictorial expression; but viewed from the standpoint of culture in general, it was but another manifestation of the crystallizing tendency of thought which we noticed in all the aspects of the mentality of the declining Middle Ages. Instead of heralding the advent of the Renaissance, as is generally assumed, this naturalism is rather one of the ultimate forms of development of the medieval mind...."[20]

Today, Huizinga's interpretation of the Burgundian era as a period of cultural decline is considered idiosyncratic.[21] Even Fazio's description of works by Jan van Eyck was interpreted by Huizinga as typical of late medieval culture:

> The terms he [sc. Fazio] uses to vent his enthusiasm betray merely a naive curiosity, losing itself in the unlimited wealth of details, without arriving at a judgement on the beauty of the whole. Such is the appreciation of a medieval work by a mind which is still medieval...."[22]

Not only Huizinga's art historical approach, but perhaps also his cultural-historical arguments, have to be reconsidered in the light of new evidence. For instance, it is important to take into consideration some cases of emerging humanistic thought in fifteenth-century Bruges when reassessing the artistic production of Bruges in general, and the art of Petrus Christus in particular. In defining northern humanism, I would certainly advocate the inclusion of philologists who specialized in editing classical and early Christian authors. By purifying the texts of antiquity from later additions and corruptions, they discovered the anthropocentric ethical values that appealed to them.

Thus, Vasco da Lucena, the Portuguese translator of classical texts for Charles the Bold, can hardly be considered a humanist *pur-sang*.[23] He did use the Latin version by Poggio Bracciolini of Xenophon's *Cyropaedia* for his own French translation,[24] but as in his most famous work, the *Histoire d'Alexandre* (a translation of Quintus Curtius Rufus), Lucena had no humanistic

intentions whatsoever of publishing a noncorrupted classical text. At the contrary, as he stated in the introduction of the latter text, he reinterpreted the work by considering it a stimulus for Charles the Bold to undertake a new crusade.[25] Not only this interpretation, but the intention with which the author has made a new edition of the text, is entirely rooted in the medieval tradition.

This adherence to tradition seems to have been the mainstream of the intellectual climate and cultural life of Bruges in the fifteenth century. The contents of the library of Louis of Gruuthuse, with its 147 known titles the largest at this time in Bruges, amply demonstrate this: it included almost exclusively vernacular texts, and very few in Latin.[26] More than 40 percent of his library consisted of moralizing, devotional, and didactic literature. Gruuthuse possessed treatises on hunting and on tournaments; he had copies of the popular medieval encyclopedias by Vincent of Beauvais, Bartholomeus Anglicus, and Brunetto Latini; he owned Romance literature and many chronicles and other historical treatises. And of course the works of classical authors like Julius Caesar, Flavius Josephus, Valerius Maximus, and Quintus Curtius Rufus were represented in his library, but all in French editions.

Besides this predominant current of traditionally rooted culture, there seems to have existed in Bruges a small and undoubtedly marginal milieu of proto-humanists. Most of them were clerics. Perhaps the most prolific among them was Jan Crabbe, abbot of the Cistercian Abbey of De Duinen between 1457 and 1488.[27] He collected glossed texts by Latin authors like Virgil, Cicero, and Sallust, by early Christian authors like Boethius and John Chrysostom, and by Italian proto-humanists like Petrarch, Boccaccio, and Guarino da Verona. He seems to have maintained close contacts with Georgius Hermonymus, a Greek scholar who established a scriptorium in Bruges for some years in the 1470s, before he was appointed as the first professor of Greek at the University of Paris.[28] Unquestionably, Hermonymus played a prominent role in the initial dissemination of humanistic ideas in the Netherlands.

Jan Crabbe's manuscripts differ notably from those made for the dukes or for Louis of Gruuthuse. The texts are often written in a

careful *littera humanistica textualis,* instead of the typical Burgundian *littera bastarda* that appears in ducal and Gruuthuse manuscripts.

The first manuscript written in a humanistic script in the Netherlands was copied by Joris van Oedelem, a scribe from Bruges, in 1438.[29] It was a text by Sallustius, commissioned by Antonius Haneron, a Bruges scholar who became a teacher of Charles the Bold, a professor at Louvain University, and later the provost of the Chapter of Saint Donatian in Bruges.

Another important humanist was Raphael de Mercatellis, bastard son of Philip the Good, and abbot of the Benedictine Abbey of Saint Bavo in Ghent from 1478 to 1508. His library contained mainly humanistic texts.[30]

Obviously some Italians residing in Bruges also had humanistic interests. Carlo Gigli, a Genoese who was already in Bruges during the first half of century, maintained correspondence with Enea Silvio de' Piccolomini, later Pope Pius II.[31] Domenico Albergati, a Bolognese, resided in Bruges as apostolic nuncio about 1470-75. During his stay in 1475, he commissioned a text by Marsilio Ficino from a Bruges scriptorium.[32]

The most important secular humanists in Bruges were undoubtedly the Adornes family.[33] Pieter Adornes planned to establish a public library, modeled after the example of Cosimo de' Medici's in Florence.[34] From Anselmus Adornes's library, only one manuscript can be identified with certainty, namely a copy of the Breviarium by the Roman author Rufus Festus, written in a proto-humanistic imitation type of the Carolingian minuscule.[35] The oration that Anselmus presented during his first diplomatic mission to Scotland in 1468 is considered a rare example of early Netherlandish humanistic discourse.[36]

Another significant indication of this humanistic interest is found in the inventory of Jan Adornes's library, in which the Latin grammar of Lorenzo Valla figures.[37] Valla was a friend and colleague of Bartolomeo Fazio at the Neapolitan court. In his Latin grammar, Valla strongly opposes the usage of the older medieval grammar of Alexander de Villa Dei. A copy of the latter manuscript was indeed removed from the Adornes library, and its parchment used in the binding of family archives.[38] More attention should be given to clarifying *disjecta membra* of this sort.

Petrus Christus's contacts with the Adornes family are documented. Anselmus Adornes and Christus were both board members of the prestigious Confraternity of Our Lady of the Dry Tree.[39] I have proposed that two seventeenth-century engraved portraits of Pieter Adornes and his wife are probably copies of lost works by Christus.[40] I have also suggested that two figures at the right of Christus's Brussels *Lamentation* may be identified as Anselmus Adornes and his wife, Margaretha van der Banck.[41]

In about 1455-60, Petrus Christus became acquainted with linear perspective. He may have learned about it through humanistic writings. As he maintained contacts with the Adornes family, the most prolific humanists in Bruges at that time, it seems probable that he may have consulted Italian treatises on perspective in their library.

Having established the probable contacts between Petrus Christus and the humanist milieu in Bruges, could we not consider him a "Renaissance artist" in a predominantly late-medieval civic culture? *Non possumus non loqui.*

NOTES

1. For a survey of this discussion, see Joel Upton, *Petrus Christus: His Place in Fifteenth-Century Flemish Painting* (University Park/London, 1990) p. 8, and Martens, "Petrus Christus: A Cultural Biography," in Maryan W. Ainsworth and Martens, *Petrus Christus: Renaissance Master of Bruges,* exh. cat. (New York, 1994) p. 15. I also agree with Blockmans on the obsolete use of Parisian pounds in the items of the Bruges municipal accounts relative to the purchases of citizenship, even after the monetary reform of 1433. This implies following corrections: the currency used in the entries published under Doc. 2 in Appendix 1, "Archival Documents and Literary Sources," of the catalogue, pp. 195 is lb.[par.] instead of lb.[gr.]. Furthermore, Martens, "Bruges during Petrus Christus's Lifetime," in the catalogue, p. 15, col. 2, lines 8–10, should read "the sum of £3 par., approximately the total wages made by a skilled master craftsman in about a week."

2. M. Martens, "Bruges during Petrus Christus's Lifetime," pp. 6–7.

3. M. Martens, "Artistic Patronage in Bruges Institutions, ca. 1440–1482" (Ph.D. diss., University of California, Santa Barbara, 1992) p. 29.

4. J.-P. Sosson, "Une approche des structures économiques d'un métier d'art: La Corporation des peintres et selliers de Bruges (XV⁴–XVI⁴ siècles)," *Revue des archéologues et historiens d'art de Louvain* 3 (1970) pp. 91–100; Martens, "Artistic Patronage in Bruges," pp. 44–49.

5. M. Martens, "Artistic Patronage in Bruges," pp. 45–46. This percentage is obtained by subtracting 40 percent of the masters (i.e. the percentage of half-free masters) from the total number of apprentices trained between 1454 and 1490. The remainder is the number of apprentices who never obtained mastery, and must have remained journeymen. The latter figure can be expressed as a percentage of the total number of apprentices for the same period.

6. For the percentages, see the essay by Blockmans in this publication. Workshops always included one master, one pupil, and a number of journeymen at a time. The number of journeymen given here is an estimate based upon the assumption that masters who frequently accepted pupils ran the larger workshops, and thus must have employed more journeymen than others.

7. M. Martens, "Archival Documents," p. 209, Doc. 26.

8. D. De Vos, *Hans Memling: Het volledige oeuvre* (Antwerp, 1994) pp. 410–411, Docs. 16, 24.

9. M. Martens, "Artistic Patronage in Bruges," pp. 86–150; idem, "Bruges during Petrus Christus's Lifetime," p. 8.

10. See ibid., p. 10, n. 47–48.

11. See for instance in contracts published in E. de Busscher, *Recherches sur les peintres gantois des XIV⁴ et XV⁴ siècles: Indices primordiaux de l'emploi de la peinture à l'huile à Gand* (Ghent, 1859) pp. 28-32 (n. 1), 45-46 (n. 1), 68 (n. 1), and 73 (n. 1).

12. M. Martens, "The Epitaph of Anna van Nieuwenhove," *Metropolitan Museum Journal* 27 (1992), p. 37.

13. P. Bautier, "Le Maître brugeois de la légende de sainte Ursule," *Bulletin koninklijke Musea voor schone kunsten van België* 5 (1956) p. 3.

14. L. Ninane, *Primitifs flamands anonymes: Maîtres aux noms d'emprunt des Pays-Bas méridionaux du XV⁴ et du début du XVI⁴ siècle,* exh. cat., Groeningemuseum (Bruges, 1969) p. 253.

15. For a more detailed account of this event, see Martens, "Artistic Patronage in Bruges," pp. 79–85, 146–150 (with complete bibliography).

16. J. Van Mierlo, *De Middelnederlandse letterkunde van omstreeks 1300 tot de Renaissance,* in *Geschiedenis van de Letterkunde der Nederlanden,* 9 vols., ed. F. Baur et al. (Antwerp/Brussels/'s Hertogenbosch, 1939-83), vol. 2 (1950) p. 312.

17. *Dits die Excellente Cronike van Vlaenderen,* Antwerp, Willem Vorsterman, 1531, fol. 138.

18. For Petrus Christus's representation of space, see Ainsworth, "The Art of Petrus Christus," in Ainsworth and Martens, *Petrus Christus,* especially pp. 37–49.

19. Ibid., p. 61–63.

20. J. Huizinga, *The Waning of the Middle Ages: A Study of the Forms of Life, Thought, and Art in France and the Netherlands in the Fourteenth and Fifteenth Centuries,* trans. F. Hopman (London, 1990) pp. 251–252.

21. See among others F. Haskell, *History and Its Images: Art and the Interpretation of the Past* (New Haven/London) 1993, pp. 431–495; B. Ridderbos, *De melancholie van de kunstenaar: Hugo van der Goes en de Oudnederlandse schilderkunst* (The Hague, 1991) pp. 64–65; M. Kuiper, *De vaas van Huizinga: Over geschiedenis, verhaal en de betekenis van de dingen die voorbijgingen* (Amsterdam, 1993) pp. 120–132.

22. Huizinga, *The Waning,* p. 253. Michael Baxandall already pointed out that this view is problematic; see M. Baxandall. "Bartolomaeus Facius on Painting," *Journal of the Warburg and Courtauld Institutes* 27 (1964) p. 91.

23. On Vasco da Lucena, see C. Samaran, "Vasco de Lucena à la cour de Bourgogne," *Bulletin des études portugaises et de l'Institut français au Portugal* (1938) pp. 13-26; D. Gallet-Guerne, *Vasque de Lucène et la Cyropédie à la cour de Bourgogne, 1470: Le Traité de Xénophon mis en français....* (Geneva, 1947)

24. R. Walsh, "The Coming of Humanism to the Low Countries: Some Italian Influences at the Court of Charles the Bold," *Humanistica Lovaniensia* 25 (1976) p. 180.

25. A. von Euw and J. M. Plotzek, *Die Handschriften der Sammlung Ludwig* (Cologne 1979-85) vol. 4, p. 248.

26. Martens, "De librije van Lodewijk van Gruuthuse," in idem et al., *Lodewijk van Gruuthuse, Mecenas en Europees diplomaat, ca. 1427-1492* (Bruges, 1992).

27. N. Geirnaert, "De bibliotheek van de Duinenabt Jan Crabbe," in *Vlaamse kunst op perkament: Handschriften en miniaturen te Brugge van de 12de tot de 16de eeuw,* exh. cat., Gruuthusemuseum (Bruges, 1981) pp. 176–206; N. Geirnaert, "Bruges and European Intellectual Life in the Middle Ages," in *Bruges and Europe,* ed. V. Vermeersch (Antwerp, 1992) pp. 246–248.

28. On Georgius Hermonymus, see Geirnaert, "De bibliotheek van Jan Crabbe," pp. 182–190; idem, "Bruges and European Intellectual Life," p. 248; idem, "Classical Texts in Bruges around 1473: Cooperation of Italian Scribes, Bruges Parchment-Rulers, Illuminators and Book-Binders for Johannes Crabbe," in *Fifteenth-Century Flemish Manuscripts in Cambridge Collections: Transactions of the Cambridge Bibliographical Society* 10, no. 2 (1992) pp. 173–181.

29. Geirnaert, "Bruges and European Intellectual Life," p. 239.

30. A. Derolez, *The Library of Raphael de Mercatellis* (Ghent, 1979); A. Arnould, The Art Historical Context of the Library

of Raphael de Mercatellis (Ph.D. diss., University of Ghent, 1991).

31. Geirnaert, "Bruges and European Intellectual Life," p. 236.

32. F. Saxl, "A Marsilio Ficino Manuscript Written in Bruges in 1475 and the Alum Monopoly of the Popes," *Journal of the Warburg and Courtauld Institutes* 1 (1937) pp. 61–62; Geirnaert, "Bruges and European Intellectual Life," p. 236.

33. Idem and A. Vandewalle, *Adornes en Jeruzalem: Internationaal leven in het 15de- en 16de-eeuwse Brugge*, exh. cat., Jeruzalemkapel (Bruges, 1983); N. Geirnaert, "Adornes," in *Nationaal Biografisch Woordenboek* 12 (Brussels, 1987) col. 2–25; and idem, *Het archief van de familie Adornes en de Jeruzalemstichting te Brugge*, 2 vols. (Bruges, 1987–88).

34. On this planned library, see A. Derolez, *Corpus catalogorum Belgii: De middeleeuwse bibliotheekscatalogi der Zuidelijke Nederlanden*, I: *Provincie West-Vlaanderen*, Verhandelingen koninklijke Vlaamse Academie voor wetenschappen, letteren en schone kunsten, klasse der letteren, 28/61 (Brussels, 1966) pp. 9-10; idem, "Vroeg humanisme en middeleeuwse bibliotheken: De bibliotheek van de Adorne's en van de Jeruzalemkapel te Brugge," *Tijdschrift voor Geschiedenis* 85 (1972) pp. 161–170;

Walsh, "The Coming of Humanism to the Low Countries," pp. 173–175; A. Derolez, "Middeleeuwse bibliotheken in Brugge," in *Vlaamse kunst op perkament*, exh. cat., Gruuthusemuseum (Bruges, 1981) pp. 51–54.

35. Brussels, Koninklijke Bibliotheek Albert I, MS 4659; see P. Thomas, *Catalogue des manuscrits de classiques latins de la Bibliothèque royale de Bruxelles* (Ghent, 1896) p. 15, no. 34 (erroneously dated as 13th century); see also Geirnaert and Vandewalle, *Adornes en Jeruzalem*, p. 127, no. 43.

36. Ibid., p. 23; Geirnaert, "Bruges and European Intellectual Life," p. 235.

37. Derolez, *Corpus catalogorum Belgii*, Doc. 5, no. 21.

38. N. Geirnaert, "Het archief van de familie Adornes en de Jeruzalemstichting: Mogelijkheden voor verder onderzoek," *De Leiegouw* 28, no. 3–4 (1986) p. 296.

39. M. Martens, "Archival Documents," Doc. 16, pp. 200–203.

40. M. Martens, "Artistic Patronage in Bruges," pp. 294–296.

41. M. Martens, "New Information on Petrus Christus's Biography and the Patronage of His Brussels *Lamentation*," *Simiolus* 20 (1990–91) pp. 5–23.

PETRVS.XPI.ME.FECIT:
The Transformation of a Legacy

Joel M. Upton
Amherst College, Massachusetts

The modern scholarly characterization and assessment of Jan van Eyck's art and of Petrus Christus's response to the Eyckian legacy may have obscured a fundamental human debate that resides within the very paintings of these two artists.[1] This exhibition provides an opportunity for us to stop talking as it were, in order to look silently and to hear what Petrus Christus and Jan van Eyck say visually to each other. From a vantage point within this exhibition we might come to accept and share Christus's legacy to us all. Summarized, his art might propose that sensory perception independent of ordered ratiocination can be a potent basis of spiritual wisdom.

The assembly in The Metropolitan Museum of Art of seventeen paintings and several drawings by Petrus Christus reaffirms vividly the activity of an artist who ceased working more than five hundred years ago. As one more step in the slow rediscovery of fifteenth-century Flemish painting, this exhibition literally transforms the obscurity of the nineteenth-century references to Christus as a "completely unknown" artist and the initial confusion about his name—Crista, Christophori, Christophsen—into the relative clarity and solid presence of his now familiar inscription, "PETRVS. XPI.ME.FECIT."[2] Although this inscription is verbally comparable to the inscription "Iōhes de Eyck Me Fecit," which Jan included in some of his paintings a few years earlier, these relatively rare "signatures" disclose, in the particular ways they are integrated with their respective images, contrary pictorial values amounting, in the case of Petrus Christus, to a transformation of the tradition he discovered on his arrival in Bruges.[3] By replacing Jan van Eyck's accomplishment of artistic remoteness with specific occasions for self-conscious awareness inspired by a dynamic interaction between the beholder and the painting, Christus, I believe, altered the Eyckian legacy at its core. At its best, Christus's art redirects our attention from perception

absorbed by order to immediate experience within a context of shared conventions.[4]

In 1953 Erwin Panofsky left behind an important descriptive marker to which he never, to my knowledge, returned. He called Petrus Christus's *Portrait of a Carthusian* in New York (Fig. 1) a "corner space" portrait, acknowledging its essential iconographic departure from contemporary pictorial practice.[5] With the inclusion of a specific space in place of the flat, undifferentiated ground or undefined darkness that were typical of Flemish portraiture around mid-century, Christus, according to Panofsky, "in admitting the beholder to the intimacy of the sitter's domestic surroundings … placed their relationship on an entirely new psychological basis."[6] We are now able, some forty years later, to look directly at the related questions of artistic and art historical legacies embedded in this observation. That is, by returning to the origin of Panofsky's provocative words we may pick up his thread to see where it might lead.

Panofsky's primarily iconographic rather than visual point of view emerges in his subsequent conclusion that Dieric Bouts's *Portrait of a Young Man* in London, painted sixteen years after Christus's *Portrait of a Carthusian,* should be characterized as a *Stimmungsporträt* or, roughly, a psychologically atmospheric portrait.[7] Panofsky's emphasis in both instances on the sitter's and the beholder's implied psychological interaction, however, limits our recognition of Christus's artistic accomplishment by pictorial means. In visual fact, the definition of the space surrounding the Carthusian monk is only one of several interrelated transformations realized in this revolutionary portrait. Equally important are the apparent changes in the relationship of the trompe l'œil frame to the painted image and in the pictorial role of the artist's inscription on the lower border of this frame.

In the "corner space" of the *Portrait of a Carthusian,* Christus did not simply add a pas-

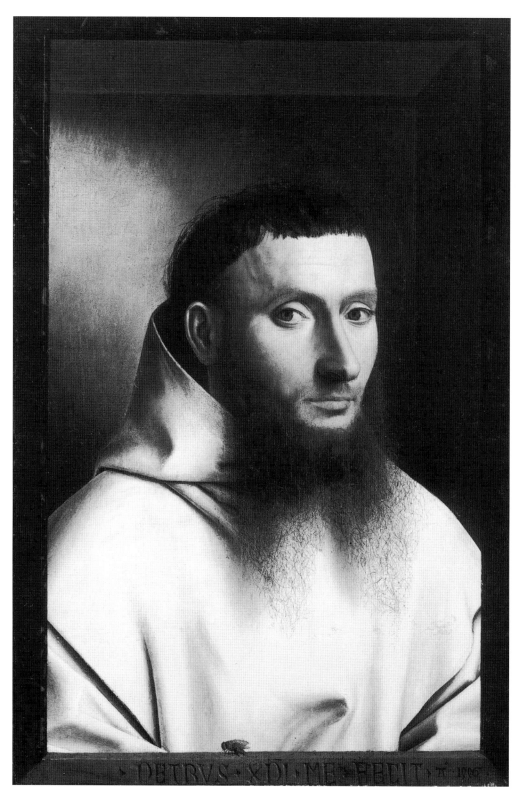

Figure 1. Petrus Christus, *Portrait of a Carthusian*, 1446. Oil on oak, 29.2 x 20.3 cm. The Metropolitan Museum of Art, Jules Bache Collection, 1949, 49.7.19.

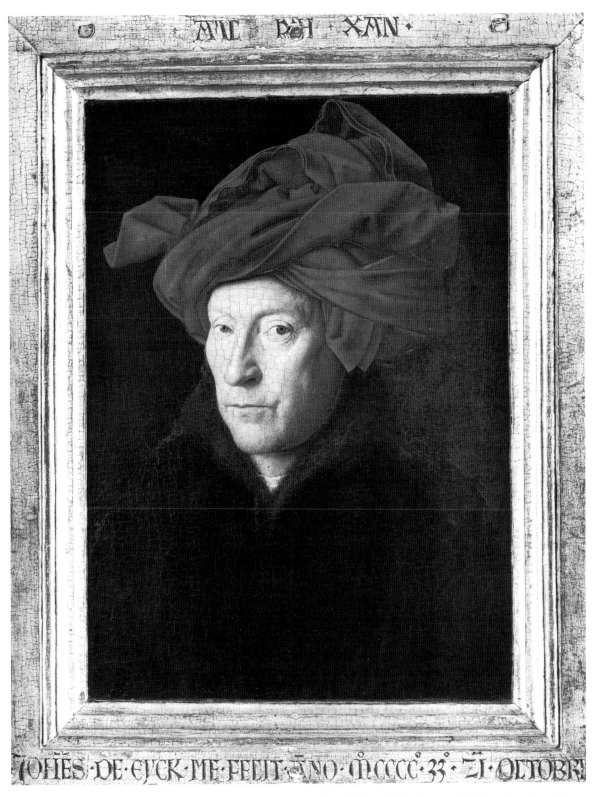

Figure 2. Jan van Eyck, *Man in a Turban*, 1433. Oil on oak, (33 x 25.8 cm) The National Gallery, London (photo: Courtesy of the Trustees; The National Gallery)

sive background enclosing the sitter within an environment. He created a pictorially affective relationship with the frame. Taken as a visually integrated part of the whole image, this "corner space" continues the linear and color accents of the surrounding frame, translating its dark neutral and brighter red color values into the geometric architecture of the room and the organic ambiguity of ambient light. In this painting, the image of the frame as window and the illusory presentation of the figure in space are deliberately combined. Pictorial space and the acknowledged surface of the image merge so that the visual conceit of the trompe l'œil frame quite literally bridges the conceptual distance between us and the sitter. Our world, the frame, and the Carthusian's world are, on one level at least, the same.

It is, likewise, pictorially intentional that the illusion of a diffuse light from an unseen window behind the sitter complements the "external" light from outside the painting, behind us, that illuminates both the sitter's face and the frame, including its inscription. Highlights on the frame itself and on the presumed engraved letters of the inscription confirm both the direction and the consistency of this second light, as do the subtly observed and recorded points of luminous convergence within the illusory space. Note especially the monk's right shoulder and the contours of his folded cowl. By this pictorial logic or structure, the beholder's relationship to this painting goes beyond the abstract formulation of "admission to the intimacy of the sitter's domestic surroundings." The *Portrait of a Carthusian,* in the pictorial context of its era, redefines the connection between the illusory world of the painting and the material efforts of the artist by joining them at the precise point in space of our perception of the painted image—at the picture surface. The extraordinary placement of a trompe l'œil fly on the ledge of the lower border of the tromp l'œil frame creates a second, reinforcing occasion, along with the conflation of "interior" and "exterior" pictorial light, of making visually palpable the beholder's explicit relationship with the image. Christus's deliberate confusion of actuality and illusion, implied by our term *trompe l'œil,* only focuses the location of our "entry" into the reality of this painting. The frame, the room, the light, the inscription, and the fly all seek to identify our perception of the

material forms that constitute this image and our recognition of the subject. Together, these devices foster our intimate association with the painting itself.

The dramatic and convincing recent removal of the allusive golden halo from the *Portrait of a Carthusian* takes away any lingering doubt, in my mind, about Christus's determination to concretize the connection between the fabric of the painting and its illusion.[8] The "entirely new psychological basis" Panofsky spoke of turns out, it seems, to implicate the physical presence of the painted object at least as much as, if not more than, the beholder's association with the sitter.

Jan van Eyck, on the other hand, seems equally determined to enclose the pictorial event, the illusory world, within both a conceptual and a literal frame. The figure in this portrait (Fig. 2), the man wearing a red turban, is, after all, very precisely pictorially positioned inside the frame and ground of this always-startling painting in London. The figure extends outward from the center of the composition toward the borders of the image, but each point of potential contact with the frame has been left either untouched or obscured. Darkness finesses the lower border, while a tense compression of figure, frame, and ground on the remaining edges isolates the sitter in pictorial space. For all of its seeming psychological confrontation with the beholder, the person remains, as so many have noted, hauntingly remote, as though a nanosecond separated this illuminated vision from the impenetrable black that surrounds it. The man's sudden glance toward us just as he turns his head away, and the detailed plastic definition of his face in the raking light, remain visible because they are pictorially suspended before us. No contact with our world, physical or psychological, bridges the distance between him and us. The frame around this image gives no ground to its being anything other than a device for distinguishing actual and pictorial realities. Even though the inscription "Iōhes de Eyck Me Fecit" is painted, like the inscription on the *Portrait of a Carthusian,* to resemble engraved letters, its illumination bears no resemblance to the vivid intensity of light within the portrait. Contrary to Christus's unifying efforts, the very unaccountability of the difference between "interior" and "exterior" pictorial light in the

Man in a Turban, despite their common direction from our left, creates two utterly distinct worlds. In one the light is fragmented, abbreviated, limited. In the other it is sharply focused, complex, and alive.

Despite the apparent superficial similarities of the three-quarter-face, bust-length pose, the extensive modeling, and the arresting, direct gaze of the sitters, these two portraits could hardly be more dissimilar as images. And it is at the picture surface, in the frames surrounding these images, that the essential change occurs. Where Christus connected the actual and the illusory, the frame and the portrait, Jan van Eyck disconnected them. While the fly on the lower border of the *Portrait of a Carthusian* might well be defined as that portrait's center of pictorial gravity, animating our relationship with the image, the figure of the man in a red turban finds its conceptual focus in the exquisite fragment of white color positioned like the man's head in the midst of surrounding darkness. If Christus's fly joins the experiential space and moment of viewing with the material presence of the painting, Jan van Eyck's starched white collar fixes the image within and behind its invisible surface. The true emblematic counterpart to Christus's elusive insect, however, must be Jan van Eyck's famous motto on the upper border of the *Man in a Turban*. Painted as though they too were engraved in the frame, the words of this motto, *als ich xan* ("as [best] I can"), stand as the Eyckian artistic credo. Combined with the artist's signature on the lower border, these simple words signal the idealist's self-conscious intention to distinguish and separate lasting order from fleeting and, therefore, limited experience.[9] The exactness of the date included in the inscription on the frame of the *Man in a Turban*—21 October 1433—and, of course, the unshaved stubble of the sitter only make the instant preserved all the more precious for its precision.

The compositional role of the inscriptions in Christus's *Saint Eligius* in New York (cat. no. 6) and Jan van Eyck's *Portrait of Giovanni Arnolfini and His Wife, Giovanna (Arnolfini Double Portrait)* in London (cat. fig. 94) will illustrate how Christus transformed a vividly natural, even coherent, space that is decisively removed from the viewer into the interactive space apparent in the *Portrait of a Carthusian*. The location of Christus's "signature" on the front edge of the goldsmith's working counter conflates an implied pictorial frame with the beholder's position in front of the master's shop. The visible—even pronounced—conjunction of the horizontal plane or shelf of the counter where it intersects the window jamb in the right corner of the painting, and the curling wedding belt draped over the front edge of the counter, establish a deliberate two-way bridge to the beholder's world. And while the central axis of this composition focuses our attention on the psychological narrative occurring before us, the inconspicuous shadow across the word *Petrus* in the inscription reasserts our place before the painting, reminding us of its author.[10]

By comparison, Jan van Eyck's most famous inscription, whose very meaning is vague, is preserved on the rear wall of a room in a painting that is compositionally closed to the beholder. The *Arnolfini Double Portrait* may seem unrelated to the impenetrable world of the *Man in a Turban* because of its absolutely convincing visual impression of an accessible space enveloping the figures. Jan van Eyck clearly adumbrated a possibility of pictorial entry. But he also subtly, implacably, blocked that entrance. Implied by the outside shoes that have been appropriately removed within this "interior" or pictorial space, the enclosure of this painting is achieved by a visual logic at its four borders no less convincing or effective than the separating frame and ground of the *Man in a Turban*. The points of spatial contact with the world beyond the painting on the lateral and upper borders are undefined, and the orthogonal perspective of the room overlaps multiple vanishing points.[11] The brass chandelier that hangs behind the figures is also associated visually with the upper border of the painting as the dominant accent of a series of forms, including the mirror and the dog on the lower border, that delineates the bilateral surface pattern of the composition. Uncannily, the chandelier serves its opposed purposes by remaining perceptually impalpably suspended in space. To see the remarkable spatial ambiguity created in the *Arnolfini Double Portrait* compare the "location" of this chandelier to the tangibly situated chandelier in Christus's *Holy Family in a Domestic Interior* in Kansas City (cat. no. 20).

Above all, however, Jan van Eyck's inscription exists within a virtual pictorial reliquary because of the conceit of the mirror just below

it. As is well known, two men are plainly visible in the reflection of this mirror; one wears a red turban and the other a blue, and they are shown standing in the doorway. They are, in effect, present in the room, thereby corroborating the literal truth of the inscription, *Johannes de Eyck fuit hic*—"Jan van Eyck was here." Accordingly, Jan was there, as the man in the red turban perhaps, to witness the event portrayed as Panofsky first suggested.[12] But the pictorial world that encloses that event, whatever it is, remains beyond our experience except for its separated illusory representation. At no point (physically or conceptually) are we given pictorial access. In visual fact we are denied it. The frontally placed mirror that will never reflect us, as it should, explicitly confirms a pictorial "distance" appropriate for a second, artistic rather than legalizing, translation of the inscription: "Jan van Eyck was here [in the room attending this ceremony]" might become, in addition, "Jan van Eyck was this one"; in other words, the artist who made this painting, who was alive, is no more, but is, of course, still "here" in the painted image itself. As if to assure this memorializing intimation, the mirror's closest visual analogue in the painting, the round beady eyes of the dog, who is also unreflected in the mirror, stare out directly at us, as though he were a Flemish Cerberus protecting the sanctuary of the painting at the one point where the actual and the illusory do meet.[13]

Christus's mirror in the *Saint Eligius* is both unambiguous and conceptually accessible. It is placed at an angle in the corner of the goldsmith's service counter, where it leans against the vertical support of the window. Its reflection reveals two obliquely located figures whose position in the street logically defines rather than denies our imaginal existence in front of this shop and this painting. By placing his inscription on the frontal plane of the illusory space of his painting rather than on the back wall of a pictorially enclosed room and by conflating it with the open conceit of a craftsman's service counter rather than the ambiguity of a reflected image, Christus convincingly articulated an eloquent experiential alternative to Jan van Eyck's naturalized icon. Where van Eyck suggested entry but blocked it, Christus allowed us full access while connecting us sensually to the pictorial moment.

The monogram to the right of the inscription on the *Saint Eligius* may help to clarify Christus's artistic intent. As a form, this monogram is reasonably associated with traditional goldsmiths' marks used to identify a master's work. Such a mark would be especially appropriate on this painting, arguably done for the goldsmith's guild in Bruges and representing the patron saint of goldsmiths.[14] The particular shape or precise design of this unusual monogram, however, may also be significant in another, rather different but nonetheless suggestive, way. Composed of a vertical heart-shaped stem and an articulated horizontal bar, this monogram resembles remarkably closely the escapement mechanism of a verge and foliot clock.[15] Although measuring and keeping time may have become for us the essential symbol of modern, secular technological culture, the verge and foliot clock in the fifteenth century served the purpose of monastic or spiritual regulation. It awakened the person who was responsible for ringing the bells that would alert everyone else to the actual moment for prayer.[16] As a device, this monogram, like the verge and foliot clock, might alert us to the spiritual value of immediate temporal and sensory experience as compared to the remote abstraction of the canonical hours, labors of the month, and zodiacal signs. That is, without pursuing here the question of Christus's literal involvement in clockmaking or the role and symbolism of timekeeping in his era, it may be useful to refocus our view of his art by seeing his paintings as precisely engineered instances of moral awakening through direct sensory appeal.[17] While I believe all of Christus's paintings meet this test in a variety of compelling ways, let me suggest two moving examples from this exhibition.

On the far left of the *Nativity* in Washington, D.C. (cover illustration), a shepherd seems to cock his ear, as if straining to hear something. At the far right in the same painting, a second shepherd stares blankly forward, unfocused but also straining to see. Uncommonly specific in their gestures of sensory response, rather than the more typical attitude of confirmed prayer, these shepherds may embody our human capacities to see and to hear. The men in red, on the right of each of the pair, await the result of their brothers' perception. With these shepherds, we occupy the horizon of pictorial sight

whose orthogonals focus on the center of the panel at the location of several distinctly described plants that presumably possessed medicinal powers, possibly even for deafness or failing eyesight.[18] The geese, far off but vivid against the blue sky, might recall the familiar experience of a distant sound made audible by our sudden awareness of the silence around us—like the remote trumpets of Verdi's *Requiem,* or Nathaniel Hawthorne's sound of the train whistle affirming the peace of his pastoral reverie. It is the sheer radiance of an early morning light, however, that unifies and intensifies all other sensory experience before this painting. For it is this light that informs our perception of the moment by transforming the plant in the shattered stump of the king post of the Nativity shed into an illuminated and tangible instance of renewal. Set in the center of the base of an equilateral triangle starkly silhouetted against the dawn, this plant becomes the sensory equivalent of the transubstantiated host.[19] To my eye, the recent overpainting of the golden paten by the conservator of the National Gallery of Art allows the purely sensory association of the frail figure of the Child, protected by the hem of his mother's dress, and the rising of the *sol invictus* to have its full, uncluttered impact.[20]

In the painting's restored state, the color of the sky, as it moves from the intense cerulean blue at the summit to a pale, cool neutral at the horizon, forms the true sensory foil against which this image assumes its meaning. Delicate variations in the shape and intensity of this radiant blue press through the structure of the Nativity shed, outlining both the sturdy and the broken elements. This blue illuminates the most distant hills, highlights an angel's wing, and models the light and shade of the foreground angel's alb beneath the decorated green and gold cope. Reassembled and neutralized, this same blue appears in the luminous frame around the Nativity, especially in the blue and green upper surface of the portal threshold, but also in the delicate harmony of warm and cool in the sculpted arch. Distinctly different from the dark, impenetrable blue of Mary's dress, Joseph's hat, or the clothing of the perceiving shepherds, this celestial blue, in its very elusive pervasiveness, complements, in the grandest sense, the more earthbound local tonalities of blue, green, and red-orange located through-

out the painting. More immediately, this recently refreshed blue argues that the halo on Mary and the golden paten beneath the figure of the Child were pictorially superfluous, later additions. The holiness of Christus's painting resides less in its iconography than in the sacral light of its color.[21]

A comparison of the Washington *Nativity* with a work by Hans Memling, one of the masters whose life overlapped Christus's in Bruges, may suggest that Christus left a legacy of his own. In the *Diptych of Maarten van Nieuwenhove* (Fig. 3), a relatively iconic, fixed, and idealized portrait of Mary and the Child, with generalized features and an imperturbably demure expression, competes with the felt, even sensual presence of the donor's unique character. Taken together as two parts of a larger whole, this diptych joins the particular experiential reality of the donor, Maarten van Nieuwenhove, to the moral order within which he resides. But the source of the pictorial unity of this image must be the envelope of air suggested by the variation of blue throughout the painting. Visible everywhere once it is noticed, ranging from the most stable blue in the stained glass to the most ephemeral blue in the neutral violet of the donor's jacket and the reflected light from the window frame behind him, this celestial color complements and fulfills its chromatic, corporeal partner which is, of course, the red-orange of Mary's robe and the fruit she offers the Child. As in Christus's Washington *Nativity,* no gold is necessary to assure or define the spiritual reach of this image.

Petrus Christus's *Madonna of the Dry Tree* in Madrid (cat. no. 18) works because a sequence of sensory perceptions summons memories of spiritual renewal.[22] Having most likely been commissioned by a member of the Confraternity of Our Lady of the Dry Tree, for which its iconography was emblematic, this painting might once have evoked the smell of rose water used in the initiation ceremony of the confraternity. The thorns of the leafless tree seem to scratch the very edges of a painting meant to be held—not unlike a rosary. Mary's delicate touching of the Christ Child's foot near the center of the image reiterates the tactile immediacy and passional meaning of these thorns. The dominant red color of the painting, amplified by its complementary green and accentuated by the black ground and dark blue of

Mary's dress, might have suggested the floral association with a rose. And like the honking of the geese in the Washington *Nativity,* the implied sound of the word *Ave,* invoked by the fifteen Gothic letter *a*'s turning silently in an invisible breeze, might echo the music of true spiritual harmony, reversing the discord of Mary's historical counterpart, Eva. Holding this painting, any viewer alert to the life of the senses must have been especially moved by the recollection of Mary as the rose without thorns.[23]

Petrus Christus projected the tree and its rotating letters into the darkness that surrounds this image, collapsing the "interior" and "exterior" realities of the *Madonna of the Dry Tree,* eliminating the last barrier between art and perception. As subtle in its own way as the revolutionary "corner space" and trompe l'œil fly and frame in the *Portrait of a Carthusian,* this shadowy border converts the Eyckian legacy of immaculate separation into the immediacy of unmediated sensory convergence. By joining the illusory world of the painting and the actual experience of the beholder, this transparent, "open" frame distinguishes the sensate reality of this painting from Jan van Eyck's equally rich sensual construction of the Berlin *Madonna* (cat. no. 7), in which Mary and the Child are triply framed or enclosed—first within a painted marble border, then by the intricately imagined architecture of faith, and finally by the poetically ambiguous, rationally elusive "natural" light. The point is, where Jan van Eyck transformed and enshrined sensory experience in order to elevate it, Christus, by provoking it, democratized it.[24]

Lest anyone doubt Christus's determination to draw the beholder into a direct association between art and the world we inhabit, finding meaning in the uninterpreted, precognitive joy of sensory delight, look again at the *Portrait of a Carthusian* and the material shadow cast by his wispy beard and even by the fly! Or look closely at the figure in the *Portrait of a Lady* in Berlin (cat. no. 19) and the inarticulable gossamer veil around her shoulders. It is a shame that the original frame of this portrait, which was inscribed, has been lost, as it prevents us from examining the pictorial role of that inscription.[25] Nevertheless, it is plain that the "exterior" pictorial light from behind the viewer to our left, which illuminates the face of the young lady, also accounts for the distinct inte-

rior shadow she casts on the wall behind her to our right.

It is my understanding that Erwin Panofsky used to warn students in seminars, "If you want to prove something, for God's sake don't illustrate it."[26] On one level this ironic counsel surely meant simply that if you illustrate your idea, someone in the audience will see your evidence otherwise, or see something different in the critical comparison you have made—another detail, relationship, or allusion. On another level, Panofsky's charming warning might recall an idealist's perspective that rejects individual phenomena, including direct, uninterpreted sensory perception, as anything more than fragmentary data that point to the larger, fixed, and independent whole or idea—hence the inadequacy of proof in illustration. More specifically his wry admonition to his students might recall the second commandment of the Decalogue in Exodus: "thou shalt not make unto thee any graven image." To do so, of course, would be to construct an imperfect image of God. Panofsky's words, "for God's sake don't illustrate it," were in this sense very possibly meant literally.

Although it is obvious that Panofsky himself rarely took his own advice, his heavily illustrated iconographic proofs sought to confirm his own very clear sense of the hierarchical superiority of ideas over sensory experience. Accordingly, Jan van Eyck and Rogier van der Weyden became Flemish exemplars of ideas revealed through disguised symbolism or emotional emblems. Together they served Panofsky's purposes by representing the abstract polarities of light and space on the one hand and surface, line, and texture on the other. Petrus Christus in this equation worked in the thrall of alternately Jan and Rogier, ultimately forming a synthesis of the two. Along with Dieric Bouts, Hugo van der Goes, and Hans Memling, Christus was included in an epilogue entitled "The Heritage of the Founders" to the main text of Panofsky's idea of artistic attainment in early Netherlandish painting.[27] With this exhibition of Christus's works as the ultimate illustration before us, we may wish to reassess our understanding of this argument. For the accumulated effect of Petrus Christus's art calls into question the fundamental definition and evaluation of his achievement. His paintings, when confronted directly and sympathetically, might

become palpable for us again in their very contrast to the deliberate and purposeful serene remoteness of his most famous predecessor. From this perspective we might even wish to reinterpret the closing words of Panofsky's *Early Netherlandish Painting,* "this too high for my wit I prefer to omit," as the deeply humble counterpoint to its rationalist introduction, recalling Jan van Eyck's own motto, "als ich xan."[28]

By setting aside idealist preferences that have obscured Christus's voice, we might hear again his gentle sensory awakening and push away the coverlets of orthodoxy and collective authority. In a paraphrase of Panofsky's own moving observation about the shepherds in Hugo van der Goes's *Portinari Altarpiece,* we might hear the varied voices, often discordant ones, of individual perception and experience bursting into the classical order of the human symphony.[29] Like the exuberant sound of the cock whose crowing renewed Saint Peter's moral wholeness, the affective character of Christus's paintings may come to resemble the sound of the morning bell calling each of us to matins. If so we may also hear again John Donne's words, "And therefore never send to know for whom the bell tolls; It tolls for thee."[30] Where the poet may have intended to celebrate in his era the crucial importance of immediate sensory perception, a perception charged with spiritual wisdom, perhaps a newly discovered art of Petrus Christus can do the same for us in our own time.

NOTES

1. For a review of the scholarship relating Jan van Eyck and Petrus Christus since Christus's "rediscovery" by Gustav Waagen in 1825, see Joel Upton, "Petrus Christus," (Ph.D. diss., Bryn Mawr College, 1972) pp. 1–55, and *Petrus Christus: His Place in Fifteenth-Century Flemish Painting* (University Park/London, 1990) pp. 1–19. The suggestion by Maryan Ainsworth in her review of this scholarship (Ainsworth and Martens, *Petrus Christus*, pp. 25–26) that my dissertation maintained the traditional view, reiterated and expanded by Erwin Panofsky (*Early Netherlandish Painting* [Cambridge, 1953], vol. 1, pp. 308–313), that Christus later looked to Campin and Rogier and finally, after about 1450, merged the two prevailing influences," misstates my work (see "Petrus Christus," 1972, pp. 17–24). Beginning with my argument that normal citizenship rules in Bruges most likely precluded Christus's supposed association with Jan van Eyck ("Petrus Christus," 1972, pp. 36–55; *Petrus Christus*, 1990, pp. 7–19), my purpose has been to characterize Christus's art in its own right. By raising the interrelated questions of attribution, chronology, iconography, form, style, perspective, structure, and function within the context of fifteenth-century Flanders, I have sought both factually and figuratively to unhinge Christus's art from the automatic assumption of inferiority based on presumed relationships and invidious comparisons with the work of Jan van Eyck and others that emerged from the essentially idealist art-historical bias of the nineteenth century. My comments in this symposium seek again to distinguish Christus's artistic vision for its own sake and to propose a larger critical perspective than the primarily rationalist, scientific one that continues to limit our view. By valuing both the affective and the analytical, the artist's (and the viewer's) sensory contact with the world (and art), as well as the need to give shape to that contact, artistic attainment may be found within a paradoxical tension somewhere between order, beyond time and sensory response, and experience, undiminished by thought. From this inclusive and dynamic perspective, in which Christus's unique art shares a common goal of aspiration, we might push our "rediscovery" of his art back to its true origins in the human condition.

2. Upton, *Petrus Christus,* pp. 2–3.

3. For a full catalogue of existing inscriptions in 15th-century Flemish painting, see J. Folie, "Les Oeuvres authentifiées des primitifs flamands," *Bulletin de l'Institut royal du patrimoine artistique,* 6 (1963) pp. 183–256. For Christus's inscriptions, see Ainsworth and Martens, Petrus Christus, pp. 27–33.

4. The complex discussion of the beholder's relationship with and response to the image, fabric, and meaning of Flemish paintings—a discussion that began with Michelangelo's putative commentary recorded by Francisco da Hollanda (see R. Klein and H. Zerner, *Sources and Documents in the History of Art Series, Italian Art 1500–1600*, ed. H. W. Janson [New York, 1969] p. 34) was recently refocused by J. Marrow in "Symbol and Meaning in Northern European Art of the Late Middle Ages and the Early Renaissance," *Simiolus*, 16 (1986) pp. 150–169; response by C. Harbison, pp. 170–172. See also Harbison, "Realism and Symbolism in Early Flemish Painting," *Art Bulletin*, 66 (1984) pp. 588–602 and "Visions and Meditations in Early Flemish Painting," *Simiolus*, 15 (1985) pp. 87–118. For a fundamental study of this issue see S. Ringbom, *Icon to Narrative: The Rise of the Dramatic Close-up in Fifteenth-Century Devotional Painting,* 2nd ed., rev. (Doornspijk, 1984); idem, "Devotional Images and Imaginative Devotion: Notes on the Place of Art in Late Medieval Private Piety," *Gazette des beaux-arts*, 6th series, 73 (March 1969) pp. 159–170.

5. Panofsky, *Early Netherlandish Painting,* vol. 1, p. 310. Although Jan van Eyck's *Portrait of Isabella of Portugal* (1429), possibly reproduced in an anonymous 17th-century copy, appears to have shown the figure in a recognizable space with her hand resting on a foreground parapet, the entire image is set within an elaborate frame unrelated to the illusory view; see K. Bauch, "Bildnisse des Jan van Eyck," *Studien zur Kunstgeschichte* (1967) pp. 79–122; and C. Sterling, "Jan van Eyck avant 1432," *Revue de l'art*, 33 (1976) pp. 7–59).

6. Panofsky, *Early Netherlandish Painting*.

7. Ibid., pp. 316-317; vol. 2, fig. 422.

8. Ainsworth and Martens, *Petrus Christus*, p. 93 and note 5. Jan van Eyck's supreme use of trompe l'œil in his *Annunciation Diptych* (Thyssen-Bornemisza Collection, Madrid), by comparison, brilliantly confuses the borderline between art and actuality.

9. Jan van Eyck's motto *als ich xan*, literally translated "as I can," has been variously interpreted to imply an essentially idealist aspiration to perfection ("as best I can," Panofsky, *Early Netherlandish Painting*, p. 179, or "as I can, but not as I would" (M. Davies, *National Gallery Catalogues, Early Netherlandish School,* 3rd. rev. ed. [London, 1968] p. 53). See also R. W. Scheller, "Als Ich Can," *Oud Holland*, 83 (1968) pp. 135–139; Upton, Petrus Christus, p. 25 note 7, and 28 note 17.

10. For a full discussion of the iconography of this panel and its relationship to compositional form see Upton, *Petrus Christus*, pp. 32–34. See also P. Schabacker, "Petrus Christus's *Saint Eloy*: Problems of Provenance, Sources and Meaning," *Art Quarterly*, 35 (Summer 1972) pp. 103–120; idem, *Petrus Christus* (Utrecht, 1974) pp. 86–93; Ainsworth, *Petrus Christus*, pp. 96–101.

11. See Upton, *Petrus Christus*, pp. 36–38, fig. 26; D. L. Carleton, "A Mathematical Analysis of the Perspective of the *Arnolfini Portrait* and Other Similar Interior Scenes by Jan van Eyck," *Art Bulletin*, 64 (March 1982) pp. 118–124 and subsequent discussion by J. Ward and Carleton, *Art Bulletin*, 65, (December 1983), pp. 686–690; J. Elkins, "On the *Arnolfini Portrait* and the *Lucca Madonna*: Did Jan van Eyck Have a Perspectival System?" *Art Bulletin*, 73 (March 1991) pp. 53–62; L. Seidel, *Jan van Eyck's Arnolfini Portrait, Stories of an Icon* (Cambridge, 1993) p. 99.

12. Panofsky ("Jan van Eyck's *Arnolfini Portrait*," *Burlington Magazine*, 64 [1934] pp. 119–128) first associated this inscription with Jan van Eyck's literal presence at the ceremony represented. For detailed recent interpretation of this inscription and its relationship to the meanings of this image see Seidel, *Jan van Eyck's Arnolfini Portrait*, pp. 127–41 and C. Harbison, *Jan van Eyck: The Play of Realism* (London, 1991), pp. 33–47.

13. Colin Eisler, review of *Icon to Narrative*, by S. Ringbom, *Art Bulletin*, 51 (June 1969) pp. 186–188, in referring to Ringbom's discussion of the frame as window, notes the "reliquary quality" of the Eyckian frame, pointing out the relationship of the "physical enclosure of the work of art" to the "sacred container." In the case of the *Arnolfini Double Portrait*, the watchdog assures a similar memorial separation from ordinary life at the picture's border, suggesting the mythological role of Cerberus of preventing anyone from leaving Hades to return to the world of the living or, conversely, from entering Hades to take someone back.

14. Schabacker, "Petrus Christus' *Saint Eloy*," pp. 103–20; Ainsworth, *Petrus Christus*, p. 96.

15. The association of this monogram with a verge and foliot clock was first suggested by G. Szabó, *The Robert Lehman Collection: A Guide*, New York, 1975) pp. 79–80. See Ainsworth and Martens, *Petrus Christus*, p. 101, note 31.

16. For the role of clocks and timekeeping in medieval Europe see D. Landes, *Revolution in Time: Clocks and the Making of the Modern World* (Cambridge, Mass./London, 1983) pp. 53–84, and L. White, "The Iconography of *Temperantia* and the Virtuousness of Technology," in *Medieval Religion and Technology* (Berkeley, 1978), pp. 181–204.

17. Although the dual problem of portraying sensory phenomena and engineering viewer response in Flemish painting has not yet, to my knowledge, received due attention, Ringbom's *Icon to Narrative* and J. Marrow's *Passion Iconography in Northern European Art of the Late Middle Ages and Early Renaissance* (Kortrijk, 1979) both address the self-conscious response to objects and events. Most recently, R. Falkenburg, in *The Fruit of Devotion: Mysticism and the Imagery of Love in Flemish Paintings of the Virgin and Child, 1450-1550,* (Philadelphia, 1994), examines the iconography of "taste" and the use of fruit and flowers as sensory symbols of love. M. Miles, *Image as Insight: Visual Understanding in Western Christianity and Secular Culture* (Boston, 1985), defines and traces the explicit role of sensory perception, especially vision, in Christian devotional art and architecture.

18. The thistle to the right of center is a well-known plant with medicinal properties.

19. For a full discussion of the liturgical iconography and form of the Washington *Nativity*, see Upton, Petrus Christus, pp. 89-108.

20. For the argument that the golden disk beneath the Christ Child, and Mary's halo, were later additions to the Washington *Nativity* see the essay by Catherine Metzger in this volume.

21. The reasonable possibility that the golden disk and Mary's halo were added to the Washington *Nativity* after it arrived in Spain, presumably in order to adjust it to local religious pictorial and iconographic expectations, indirectly discloses an evolution of religious imagery in Christus's art that had advanced beyond more conservative Spanish preferences.

22. For a full discussion of the interrelated form and iconography of the *Madonna of the Dry Tree* see Upton, *Petrus Christus*, pp. 60–65 and Ainsworth and Martens, *Petrus Christus*, pp. 162–165.

23. Saint Ambrose, *Hexameron*, in *The Fathers of the Church*, trans. J. J. Savage (Washington, 1961) vol. 42, pp. 102–103: "Mingling formerly with the flowers of the earth and without thorns, the rose, most beautiful of all flowers, displayed its beauty without guile...."

24. The marbleized frame currently enclosing the Berlin *Madonna* replaces the original frame, stolen during the 19th century, which was wider and more substantial (see E. Dhanens, *Van Eyck* [New York, n.d.] p. 390). Although many writers have attempted to identify the specific church represented in the Berlin *Madonna*, none has succeeded convincingly. The very structure of the building, with its unlikely choir raised well above the level of the nave and the variety of Gothic "styles"

incorporated, argues for the imagined reality of this church and against the tempting notion proposed by Harbison (*Jan van Eyck*, pp. 172–75) that it recalls one of several actual structures in Tongeren and Tournai; the orientation of those structures, in turn, qualifies Panofsky's well-known suggestion (*Early Netherlandish Painting*, vol. 1, pp. 147–148) that the light in the Berlin *Madonna* is northern or supernatural, divine light. Like the memorializing frame, the church structure, and the scale of the Virgin, the unusually complicated, sparkling light of this painting defies certain identification beyond its metaphorical life-giving radiance preserved within a painted reliquary. Conversely, Petrus Christus's portrayal of a particular site, Bruges, in his Exeter *Madonna* (Upton, *Petrus Christus*, pp. 17–18 and Ainsworth and Martens, *Petrus Christus*, pp. 102–106) offers explicit evidence of the fundamental conceptual difference between his and Jan van Eyck's art proposed in this paper. The reader may wish to compare Harbison's contrary view (see his essay in this volume) that the Exeter *Madonna* is essentially "Eyckian" because its landscape is idealized or abstracted from nature. But surely the particular view comprising a town square seen obliquely to the left (Bruges, Huydevetters Plaetse?) and a body of water with a sluice to the right (Bruges, Minnewater?) as it is portrayed in the Exeter *Madonna* can only be that of Bruges seen from the famous Belfry itself—a view visible to this day. Unless, of course, the similarity of two distinctive landmarks observable both in the town and the painting was, even for an artist working in Bruges for a patron about the leave Bruges, coincidental. Unlike Jan van Eyck's purposefully imaginary constructions, including his landscapes and the visionary building in the Berlin *Madonna*, Christus's landscape in the Exeter *Madonna* is not only manifestly actual but—perhaps even more important—is also shown from an actual, identifiable vantage point, the bell tower on the southern side of the Groote Markt. This direct association of the viewing subject and its object (an association explicitly focused in the perspective structure of the Exeter *Madonna*; see Upton, *Petrus Christus*, p. 18) makes the Exeter *Madonna* unique in its fundamental transformation of the underlying spatial anonymity typical of Flemish painting at mid-century. On the other hand, Petrus Christus's deliberate figuration of the viewer in the Exeter *Madonna* and in his work generally points toward critical pictorial and psychological developments in the art of Hans Memling (see above in my text), Hugo van der Goes, and others at the turn of the century (see Upton, *Petrus Christus*, pp. 109–114).

25. See Upton, *Petrus Christus*, p. 29.

26. James Snyder and Robert Koch related this well-known story to me.

27. Panofsky, *Early Netherlandish Painting*, vol. 1, pp. 303-358.

28. Ibid., vol. 1, p. 358.

29. Ibid., vol. 1, p. 332.

30. John Donne, *Devotions upon Emergent Occasions*, ed. A. Raspa (Montreal, 1975) p. 87.

Petrus Christus's Berlin Wings and the Metropolitan Museum's Eyckian Diptych

Stephanie Buck
Free University, Berlin

Few compositions by Petrus Christus are so closely connected with Eyckian works as his *Last Judgment* in Berlin (cat. fig. 9) is to the Eyckian *Last Judgment* in New York (cat. fig. 20).[1] Both paintings are parts of larger ensembles: the Eyckian picture—neither signed nor dated—is the right wing of a diptych, which shows the *Crucifixion* on the left. Despite the paintings' transfer from panel to canvas in 1867, the most significant parts of the original frame are still preserved.[2] Christus's composition was the right wing of a triptych, the center portion of which is unknown. The left wing, showing the *Annunciation and Nativity,* came to Berlin together with the *Last Judgment* in 1850, supposedly from Burgos in Spain.[3] The original frames are lost.[4]

An inscription in pastiglia on the bottom of the panels reads "petrus christus me fecit" on the left wing and "anno domini mcccc lii" on the right, and was separated by framing elements from the rest of the paintings in an unusual scheme for a Flemish picture.

Throughout the literature, from Kaemmerer to Belting and Eichberger,[5] this "pair" of *Last Judgments* has been used as the example *par excellence* of the relatively minor qualities of Christus's art compared to van Eyck's. Unsatisfied with this approach, Joel Upton more positively reevaluated the Berlin *Last Judgment* by focusing on the painting's devotional character. Furthermore, Upton did not accept the Eyckian picture as Christus's model. Instead he proposed, as Georg Troescher had already done in 1966, that both compositions were based on a lost prototype, which is also reflected in a monumental fresco in Notre-Dame-des-Fontaines near La Brigue, Savoy, from 1492.[6]

At first this solution seems to make life easier: it enables the art historian to view both Christus's and van Eyck's compositions as dependent on an unknown third, and thus avoid the question of the relation between the two works. If, however, the fresco faithfully reflects an earlier prototype, it only shows that certain individual motifs of the *Last Judgments,* such as a small deesis, the apostles seated in choir stalls, Saint Michael, and the skeleton, were known before the New York composition. The iconographical parallels between the fresco and both Flemish paintings, however, are rather vague, while Christus's composition is very close to van Eyck's: in the fresco the judge does not lift both hands in order to show his wounds; the choir stalls have armrests and high backs; Saint Michael is equipped with lance and scale, instead of a sword; and the hellmouth is separated from the wingless skeleton, which consequently does not have the same impact as it does in the panel paintings.

All the motifs mentioned above, as well as the superposition of Christ and Saint Michael, were common around 1400, especially in French book illumination.[7] The most striking stylistic similarity between the Berlin and New York paintings is that the vertical compositions are divided into three zones of heaven, earth, and hell. There is no hint of this separation in the widespread composition in La Brigue. Thus it is highly unlikely that Christus conceived his composition without having known the Eyckian work, and so a comparison between the two paintings cannot be avoided.[8]

The Eyckian Diptych

In the literature on the New York diptych the question of attribution has always been of major interest. As there are no documents that can be related to the diptych, stylistic analysis has been particularly important. Since Passavant first published the paintings as a work by Hubert and Jan van Eyck in 1841, the close connection to the brothers has never been seriously doubted.[9] Panofsky, however, had already mentioned in 1935 the difference in quality between the two panels of the diptych, an

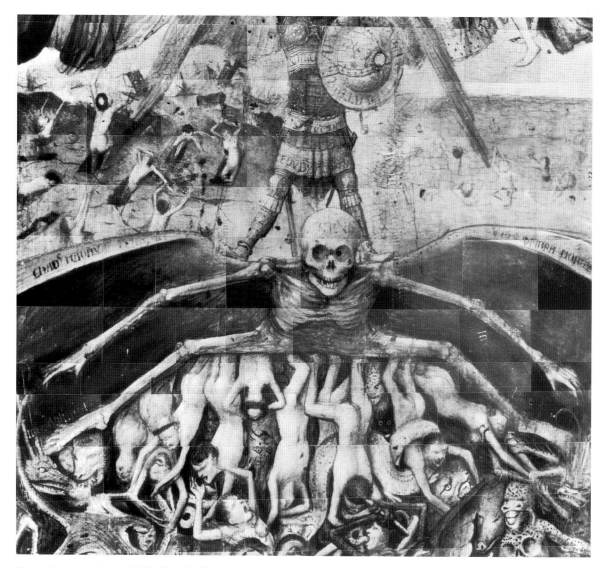

Figure 1. Jan van Eyck, IRR, Detail of *Last Judgment* (skeleton with bodies and arrows and resurrecting souls) (photo: M. Ainsworth)

observation that lead him to attribute parts of the *Last Judgment* in particular to a collaborator of Jan van Eyck.[10] A recent examination of the panels under the microscope has confirmed this suggestion, as two distinctly different treatments can be detected: the far more accomplished technique of the *Crucifixion* points to van Eyck as the artist. He also painted the iconographically important or unusual parts of the *Last Judgment,* such as hell with the skeleton and the figures of Christ and Saint Michael. Most of the upper part of the *Last Judgment,* however, is more crudely executed and was probably not painted by van Eyck himself.

A comparison between the Erythrean Sibyl standing at the lower right of the *Crucifixion* (Plate 1) and Saint John the Baptist, kneeling to Christ's left in the *Last Judgment* (Plate 2),

shows the characteristic differences between the two painters: Saint John's head and hands are not modeled with light and shadow; his eyes, brows, and nose are drawn in with harsh, dark lines. The reddish brushstrokes that indicate the cheekbones are visible as single lines daubed with impasto touches on an unmodulated opaque layer of rose color for the face. This painter does not blend glazes carefully, as Jan van Eyck typically did and as can be seen in the face of the Sibyl.[11]

Other comparisons, like that between the row of apostles in the *Last Judgment* (Plate 3) and the vicious, grimacing crowd standing under the cross in the *Crucifixion,* demonstrate the same differences in painting technique and artistic quality. The rather crudely executed rose-colored drapery of the left angel holding the cross

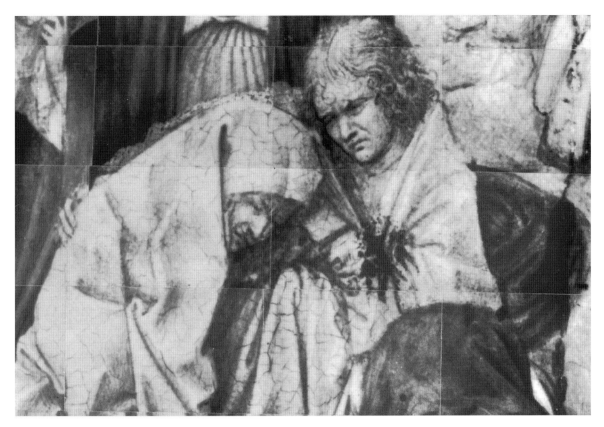

Figure 2. Jan van Eyck, IRR, Detail of *Crucifixion* (Virgin and St. John the Evangelist) (photo: M. Ainsworth)

in the *Last Judgment* also lacks the subtle transitions between dark and light areas, a fact that supports the attribution of the upper parts of the *Last Judgment* to an assistant (Plate 4).[12]

The technique of this unknown artist seems to be characteristic of manuscript illumination, where color is applied relatively thickly in an additive way. This has primarily nothing to do with a work's quality, as even in the most accomplished and extremely refined miniatures, like works of the Limbourg brothers, the lack of blending colors is obvious.[13]

The distinction between the two artists who executed the New York diptych cannot be made in the underdrawing, despite minor differences in quality. Infrared reflectography shows that both compositions are fully underdrawn in a liquid medium, probably with a very fine brush, and that one artist, most probably Jan van Eyck, was responsible.[14] The outlined forms in the two compositions are modeled with narrow parallel hatching, which does not primarily describe the volumetric form but does indicate shadow. The length of the brushstrokes differs according to the function of the lines: contour lines, which define the design,

are long and vigorously placed; modeling strokes are much shorter and blend together in a washlike effect. Crosshatching is reserved for the depressed and thus dark areas of the draperies, as well as for indicating a figure in relief. The overlapping layers of parallel hatching are placed diagonally, forming a dense grid of parallelograms .

These features closely link the underdrawing to Jan van Eyck's work. As in the relatively small-scale, unfinished *Saint Barbara* in Antwerp (cat. fig. 89), all parts of the diptych, from foreground to background, are underdrawn. Even the little resurrecting figures in the *Last Judgment* are quickly sketched in (Fig. 1).[15] The foreground figures are similarly outlined with continuous strokes; narrow parallel hatchings and crosshatchings are placed rectangularly around these contours to bring the figures into relief and to indicate shadow. Long strokes with a thicker, roundish end which clearly divide the folds,[16] and fine parallel hatchings that follow the direction of the ridge, characterize the modeling of elaborate draperies, such as Barbara's skirt or the Virgin's mantle in the *Crucifixion* (Fig. 2).[17] The quick

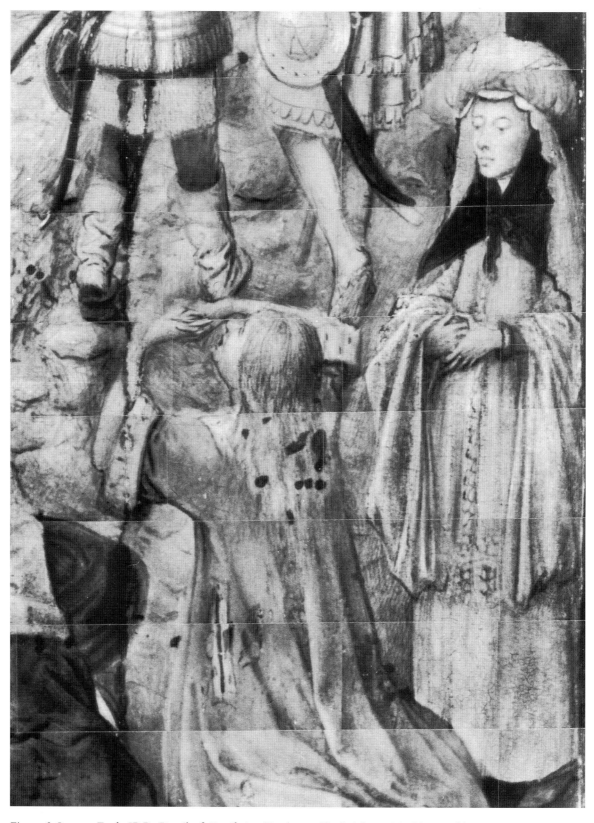

Figure 3. Jan van Eyck, IRR, Detail of *Crucifixion* (Erythrean Sibyl) (photo: M. Ainsworth)

Figure 4. IRR, Detail of *Last Judgment* (trumpets, left angel holding the cross) (photo: M. Ainsworth)

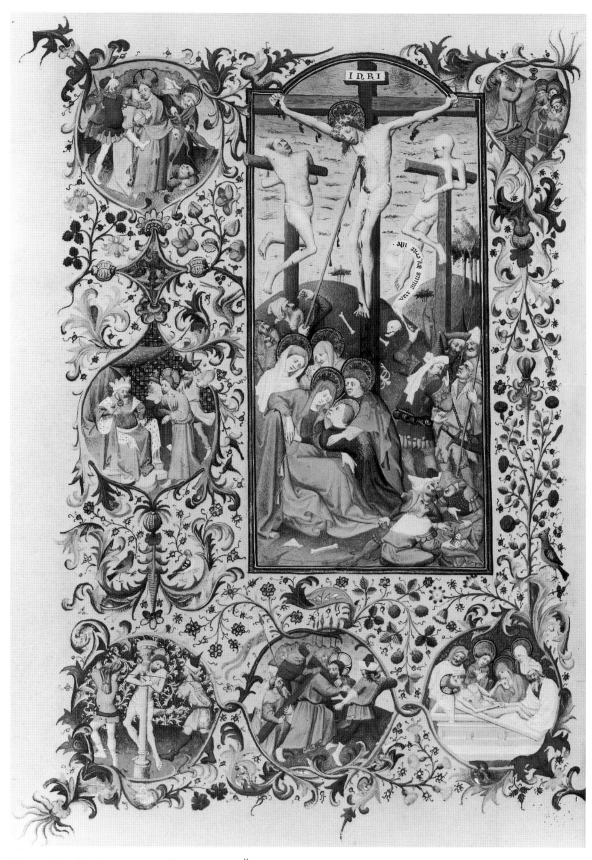

Figure 5. Bedford Master, *Crucifixion*. Vienna, Österreichische Nationalbibliothek, MS 1855, fol. 137v (photo: Osterreichische Nationalbibliothek)

and summary indication of Barbara's right hand, without a detailed description of each finger, can be compared with the Magdalen's or the Sibyl's hands (Fig. 3). Such features contribute to the underdrawing's and painting's generally spontaneous appearance, which is characteristic for Jan van Eyck's art.[18]

His lively hand is also evident in the definition of Saint John the Evangelist's curls in the *Crucifixion* (Fig. 2). They are built up with long curved strokes that end in a large, rather coarse circle that encloses a smaller one. Saint John the Baptist's hair in the *Last Judgment* shows similar characteristics. This not particularly refined, even crude, definition is also characteristic of the curly hair of the singing angels in the *Ghent Altarpiece,* which supports the attribution of the diptych's underdrawing to Jan van Eyck.[19]

Infrared reflectography supports Eichberger's interpretation of the diptych as a work where text and image are interacting components that together build up the meaning of the picture.[20] The arrows attached to the apocalyptic words right and left of Saint Michael had already been sketched in in the underdrawing, as were the inscriptions on the skeleton's wings (Fig. 1). The position was changed, however, in the paint stage. In addition, *MORO* was inscribed on the forehead of the skull in the underdrawing but suppressed in the final painting.[21] Still, its inclusion in the underdrawing points out the didactic basis of the imagery.

Changes between underdrawing and execution that are iconographically crucial have been noted in many of Jan van Eyck's panels; like the hands of both the Virgin and the Child in the Rolin *Virgin* or the position of Giovanni's gesturing hand in the *Arnolfini Double Portrait*.[22] Aside from minor alterations, like the placement of the angel's trumpets and the change in the drapery of the angel holding a cross in the *Last Judgment* (Fig. 4), and the position of the sponge and the size of the hat of the rider shown under the cross of the bad thief in the *Crucifixion,* van Eyck made one important change in the *Crucifixion:* Saint John the Evangelist's right arm is not underdrawn but painted over the already finished figures of two standing women behind him (Fig. 2). By changing this detail van Eyck emphasized Saint John's supporting gesture, and thus strengthened the link between Christ's mother and the apostle.

This powerful emotional quality links the group to the Bedford Master, active in Paris from c. 1410 to 1435. In the *Crucifixion* from a book of hours in Vienna datable c. 1420 (Fig. 5) the comfort rendered to Christ's mother is extremely important; none of the figures who support the Virgin look up to the cross or out of the picture, but concentrate their attention fully on Mary.[23] This is unusual in the iconographic tradition. In paintings such as the so-called *Kleine* and *Grosse Kalvarienberg,* both of which were executed in the first decades of the fifteenth century in Cologne and Westphalia[24] and have been interpreted as iconographic models,[25] the group of the Virgin is isolated as in van Eyck's *Crucifixion,* but lacks the dramatic qualities.[26] Drama characterizes both the New York *Crucifixion* and the French miniature. The Bedford composition may well have inspired van Eyck. In the New York *Crucifixion,* however, the artist further dramatizes the figures' expressions and emphasizes the compositional idea of encircling the Virgin: instead of Magdalen, who in the miniature, distracts the spectator's attention from the Virgin and Saint John, van Eyck depicts a mourning figure viewed from the back.[27]

Dagmar Eichberger has already related the iconography of the New York *Last Judgment* to the Bedford illuminations.[28] The picture on fol. 218v of the book of hours at Vienna, in particular, is compositionally very similar. This similarity is evident in the division into horizontal zones, reserved for the deesis, the twelve apostles sitting on two foreshortened benches, the resurrecting souls, and a depiction of hell in abbreviated form in the border. The heightened drama of the subject also connects van Eyck's painting to the miniature.

Although Eichberger does not suggest a collaboration between van Eyck and a member of the French workshop, it should be seriously considered, since the *Crucifixion* and the *Last Judgment* are closely linked to Bedford compositions. Moreover, judging from the technique, the assistant who painted the upper parts of the New York *Last Judgment* seems to have been trained as an illuminator.[29]

It would not be surprising if this artist was in fact a member of the Bedford workshop who came to Flanders hoping to find new commissions in a region where book illumination was flourishing. Scholars of both Dutch and

French manuscript illumination, like Marrow, Smeyers, Cardon, Avril, and Reynaud, have recently drawn attention to the lively connections between French and south and north Netherlandish art throughout the fifteenth century.[30] Eberhard König even identified a painter of the Bedford workshop as the minor artist Hand F, of the Turin-Milan Hours, and suggested that this painter worked on the illumination of the Turin-Milan Hours shortly before Jan van Eyck started with his decoration of the book in the mid-1430s.[31]

Thus, it might be possible that members of the French workshop came to Flanders. They would have brought workshop patterns that Jan van Eyck could have seen. One of these illuminators might have painted the parts of the *Last Judgment* that cannot be attributed to van Eyck himself. This would suggest a collaboration within a workshop of which Jan van Eyck was the acknowledged teacher.

The underdrawing found in the diptych is stylistically close to Jan van Eyck's works from the 1430s, and does not support an early dating of the paintings. A relatively late date, in the mid-1430s, seems more reasonable with regard to Christus's *Last Judgment* as well.[32] When Christus came to Bruges in 1444 he probably had access to a post-Eyckian workshop, where he might well have seen workshop drawings for the diptych on which he based his own composition of 1452.

Petrus Christus's Berlin Wings

Christus's *Last Judgment* has usually been criticized for depending too closely on van Eyck's model. Panofsky's famous statement, "If you take an Eyckian picture and deflate it by means of an airpump, the result is a Petrus Cristus,"[33] characterizes the general assessment of Christus, marking him as an eclectic minor artist.

While clearly based on van Eyck's composition, the Berlin *Last Judgment* offers a different interpretation of the subject: it serves a different function, is much larger in scale, and was probably commissioned by a patron who must have had very different expectations than van Eyck's patron.

Eichberger drew attention to the original frames of van Eyck's paintings, which indicate that the *Crucifixion* and the *Last Judgment* were

meant to be juxtaposed as two wings of a devotional, portable diptych. Christus's *Last Judgment,* on the other hand, was the right wing of a triptych, the centerpiece of which is no longer preserved. The Berlin panels' large scale and the most unusual juxtaposition of two scenes on the left and one on the right preclude a reconstruction similar to van Eyck's diptych, a fact that is obscured by the side-by-side hanging of the Berlin panels.[34]

A major factor in distinguishing Christus's composition from his predecessor's work is the relative size of the paintings. The small Eyckian diptych was painted for a knowledgeable patron who would have been able to decipher the inscriptions on the frame and within the picture at close range. Christus's massive wings, on the other hand, were never meant to be studied so closely; they were intended to have their greatest impact on the worshiper at a considerable distance. In order to make the subject in his composition immediately comprehensible, Christus clarified van Eyck's composition, thus simplifying the model.[35] For the art historian, the multitude of details in van Eyck's composition is fascinating; they demonstrate the artist's sensitive observation of the natural world, and his ability to faithfully capture these observations pictorially. Christus or his patron or both perhaps considered this overwhelming density of natural details inappropriate, as it distracts the eye from the most important figures and their meaning, namely the judge, the skeleton, and Saint Michael.

Christus achieved this clarification by two fundamental means: He built up a strict central axis, and thus stressed the representation's hieratic character.[36] Furthermore, he divided heaven and hell into clearly demarcated horizontal zones. The diagonals of the foreshortened benches are emphasized while Christ is framed by the column, cross, and four decoratively placed angels, so as to further reinforce the rigidly geometric design. Verticals, horizontals, and the half circle of the rainbow predominate, conveying the static, eternal permanence of heaven. The dynamism of the Eyckian model is sacrificed for the sake of solemnity and iconic power.

This interpretation of a biblical subject is typical of Christus. He depicts his holy figures in clearly organized settings, constructed according to the principles of perspective and

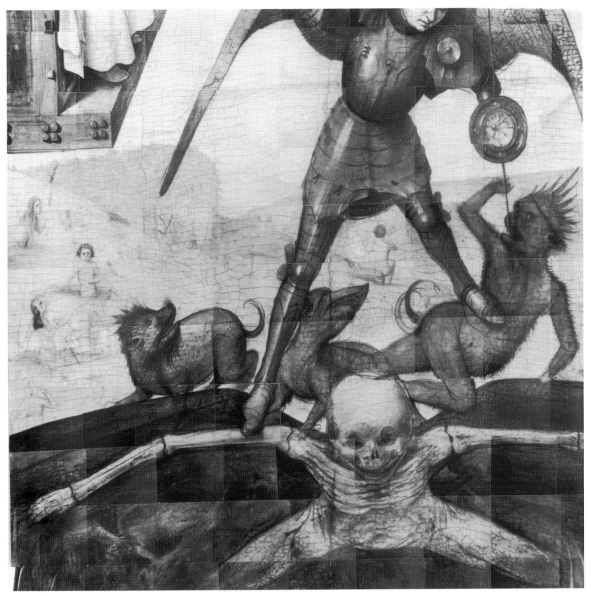

Figure 6. Petrus Christus, IRR, Detail of *Last Judgment* (resurrecting souls left and Saint Michael's left foot) (photo: M. Ainsworth

geometry in order to monumentalize the subject.[37]

Not only are the major compositional lines clearly defined, so too are the figures and objects, which are rendered as compact forms mostly in primary colors. Thus, the eye can rest on individual features without being distracted.

Christus understood hell as heaven's counterpart: he represents it as an imaginary location, a giant place where the rules of perspective do not exist, and where human proportions are irrelevant. The concrete tortures shown in van Eyck's underworld are not a vital part of Christus's idea. In his image, the frightening and threatening aspect of hell is expressed through

the absence of a clear geometrical organization and through the introduction of a generally dark and gloomy atmosphere, which prevents individual forms from being easily distinguished.[38]

In the Berlin *Last Judgment*, Christus gives special importance to Saint Michael. Joel Upton admired this figure because the spectator can identify himself with the fighting saint in his own battle against sin. Compositionally, Saint Michael serves as a mediator between the upper and lower zones. Standing in the picture's central axis, silhouetted against the sky and the landscape, the figure clearly belongs with the heavenly saints. His placement in the composition indicates that the fight against the devil

will be successful. As in his depiction of hell, Christus does not follow van Eyck's model, in terms of both the motif and the color scheme. He copies the gesture of Saint Michael's right arm, as well as the position of his head and torso. Unlike van Eyck, however, whose angel draws his sword, ready to hit, but has no enemy, Christus decided that a traditional Saint Michael, who actually fights against the devil, made more sense.[39] Consequently he depicts him in a more durable, battle-ready armor. Similarly the colorful wings featured in his representation of Gabriel in the *Annunciation* are changed to dark ones, more suited to a warrior. Using color, Christus creates a bridge between the two zones of heaven and hell: like the globe under Christ's feet, Saint Michael's armor reflects the light while the dark browns and greens of his wings link him with the skeleton. Saint Michael is thus the center of the composition, a figure that must fight and will surely win, and is ideal for the viewer's self-identification.

Christus was aware of the compositional difficulties posed by creating an intermediary zone between heaven and hell. The underdrawing shows that it was only in this area that changes were made between the drawing and painting stages: during the painting process, Christus placed a stronger emphasis on Saint Michael and the three creatures from hell by omitting four figures who are being resurrected on the left (Fig. 6). The underdrawn figures were rendered in more expressive postures than the ones that were finally painted. In regard to the dramatic interpretation, the first drawing was closer to van Eyck's model. The female figure on the left is, for example, no longer seen en face but in profile, and it is only in the painted execution that she turns to the center and prays.[40] Christus obviously wanted to stress the picture's devotional character and consciously refocused van Eyck's interpretation.

Other important changes were made in Saint Michael's posture and in the placement of the demons: in this regard, Christus must have known the iconographic tradition in which Saint Michael stands on the devil and kills him with a sword, a lance, or a procession cross.[41] This motif allowed the artist to demonstrate his skill in depicting a figure in action standing on an unstable base. This demanded that the figure's limbs be foreshortened and that the body be twisted and bent. Christus worked on this challenging problem; this is perceptible in the change of Saint Michael's left foot, which Christus foreshortened more strongly in order to stabilize the posture (Fig. 6).[42]

Jan van Eyck's art was not the only source of inspiration for Christus's Berlin wings. As has often been pointed out, the *Annunciation* and *Nativity* are indebted to compositions by the Master of Flémalle and Rogier van der Weyden.[43] However, looking at panel painting alone is not enough. Book illumination seems to have played an important role in the artist's interpretation, especially of the *Last Judgment*.

Arguing from Petrus Christus's technique and from the generally higher quality of his small-scale panels, compared with the large works, Maryan Ainsworth has suggested that Petrus Christus started his career as a miniature painter. The *Trinity* miniature on fol. 155v in Pauwels van Overtvelt's book of hours, which has convincingly been attributed to the artist, indicates that he was, in fact, active in the medium (cat. no. 20).[44] This miniature also documents the collaboration between Christus and an active workshop of manuscript illuminators in Bruges, who were responsible for most of the decoration in the book, including the borders and initial of folio 155v. This type of decoration is commonly associated with Willem Vrelant, an illuminator who emigrated from Utrecht to Bruges c. 1454, and whom Christus knew personally, as both men were members of the Confraternity of Our Lady of the Snow.[45]

The closest parallels to Christus's interpretation of the *Last Judgment,* however, cannot be found in Bruges book illumination but in the oeuvre of the north Netherlandish miniature painter known as the Master of Catherine of Cleves.[46] On page 204 in his major work, the *Hours of Catherine of Cleves*, from c. 1440, Saint Michael is shown fighting with his sword against devils (Fig. 7).[47] In earlier depictions of the scene, the archangel usually stands on only one devil, while here, as in Christus's depiction, three demons are represented; even more are hiding in caves in the rocks behind the angel but seem to be ready to get out and attack. Saint Michael's fight, which represents the struggle for eternal life, is understood as a dramatically threatening event, reinforced by the flames emanating from the rocks. The subject is considered as very important in the Cleves *Hours*, as

Figure 7. Master of Catherine of Cleves, Hours of Catherine of Cleves, *Saint Michael*. New York, The Pierpont Morgan Library, MS M. 917, p. 204 (photo: The Pierpont Morgan Library)

Figure 8. Master of Catherine of Cleves, Hours of Catherine of Cleves, *Gate to Hell*. New York, Pierpont Morgan Library, MS M. 945, fol. 168v (photo: The Pierpont Morgan Library)

it is represented on three more folios.[48] The subject may have been equally significant for Christus or his patron: in an attempt to stress this importance in his *Last Judgment,* Christus rejects van Eyck's interpretation of Saint Michael as an inactive guardian angel. The dramatic composition of the Cleves Master might well have influenced Christus in his representation of the figure.

Another illumination in the Cleves *Hours* supports this suggestion. On fol. 168v, the illuminator created an image of Hell of unrivaled power (Fig. 8).[49] It shows the gate to hell as the enormous, frontally viewed throat of a monster in which a second, smaller mouth appears. This second mouth is the entrance to a dark building, which is crowned by another similar head. Small demons appear in the surrounding darkness, which is extended right to the picture borders and thus confronts the spectator with great power. The impact of the image is achieved not through the devils, who are no larger than the tiny tortured human bodies, but through the giant proportions of the gate and the dark and gloomy colors. These features evoke a very similar atmosphere in Christus's hell. Furthermore, the same unusual motif of a small mouth in a bigger one can be found in the lower right corner of the Berlin *Last Judgment* (Plate 5).

The Berlin *Last Judgment* is not the only composition linked to the Cleves Master: Ursula Panhans-Bühler has drawn attention to the *Death of the Virgin* in the Hours of Catherine of Cleves (see Ainsworth essay, Fig. 2).[50] Here, as in Christus's *Death of the Virgin* (see Ainsworth essay, Fig. 1),[51] the baldachin of the very broad bed extends right to the picture border, whereas the bed itself is pushed well back into the room and thus leaves space for three apostles sitting or standing on the tile floor. The postures of the two apostles sitting in the corners in front of the bed, in particular, link the miniature with Christus's apostle sleeping in the lower left corner. However, the *Death Scene* on page 180 in the same manuscript (see Ainsworth essay, Fig. 3)[52] seems to be even more important with regard to the organization of the corner-space room, with its receding wall on the right with a door, an open window with a landscape view on the back wall, and a comparatively high ceiling. The en-face placement of both the female figure sitting in front of the

bed with a book on her knees and the man who steps into the room from the right also seems to be related to similar figures in Christus's painting.

Painting technique also links Christus to the Cleves Master, and to Utrecht illuminators around the Masters of Zweder van Culemborg in general.[53] One of the most striking features of Christus's technique, the dark pink underpainting of his figures, is paralleled in this group of miniaturists.[54] In the *Missal of Eberhard von Greiffenklau*, MS W. 174 in the Walters Art Gallery, from c. 1435, on which the Zweder and the young Cleves Masters collaborated, all the flesh tones of the figures and other white areas are undermodeled in pink.[55] Much of the final white layers have flaked off, and the pink underpaint is thus exposed. This is clearly visible on fol. 8, where the white fur of the dog standing in the foreground has flaked off, and the pink underpainting is left visible (Plate 6). The technique is atypical of Franco-Flemish book illumination, where gray or beige seems to be more common. Another typical feature of the Utrecht illuminators, the extensive use of thickly applied white highlights—especially for the modeling of the faces and hands—is also characteristic of Christus's small-scale works, in particular the early Exeter *Madonna* (cat. no. 7).[56]

Finally, Christus's typical color combination of saturated green and varying shades of red, ranging from bright vermilion to delicate salmon red, is also paralleled in the oeuvre of the Cleves Master, but can hardly be found in Flemish panel painting.

This suggests that Christus's art is closely linked with contemporary Dutch book illumination of the highest quality, despite the obvious differences in the figures' physiognomies and the painters' temperaments. As Christus was probably a miniature painter himself, and Utrecht and Bruges were closely connected,[57] his *Last Judgment* may well have been inspired by depictions of the Master of Catherine of Cleves. It may even be considered a possibility that Christus, like Vrelant, was trained in Utrecht before he became a master in Bruges.[58]

Analyses of the New York diptych and the Berlin wings both point toward close artistic relations between France and the southern and the northern Netherlands in the first half of the fifteenth century. Whether workshop drawings

alone can explain this phenomenon should be questioned. Pattern drawings belonged to the workshop and were guarded as precious capital.[59] As there are no documents pointing to a free market where such drawings could have been acquired, some kind of direct personal contact between the artists must be assumed.

Through comparison with manuscript illuminations I have tried to broaden the traditional view that Christus was only indebted to Flemish panel painters, and in particular to van Eyck. Although Christus was greatly dependent on van Eyck, he should not be labeled an eclectic imitator of van Eyck but perhaps a "critical admirer."[60]

Christus reinterpreted the Eyckian model by taking the different function of his commission into account. The patron's expectations were probably also important during this creative process. A number of Christus's panels are first mentioned in Spain, the *Portrait of a Carthusian* (cat. no. 5), the Madrid *Virgin and Child Enthroned on a Porch* (cat. no. 14), and the Washington *Nativity* (cover illustration)[61] among them. The Berlin wings, too, are included in this group. Though there is no documentation to confirm their Spanish provenance, first mentioned by Passavant in 1853, when the panels were already part of the royal collection of the Prussian king in Berlin for some years, certain features of the paintings make it seem likely that they were commissioned by a Spanish patron.[62] The figure of Saint Michael, in particular, seems to have been influential for Spanish artists. In 1468, Bartolomé Bermejo, a master from Valencia, had already painted a similar Saint Michael, which seems to have been inspired by Christus's figure.[63]

Whether the Berlin wings were commissioned by a patron in Spain or came there only later is a question that requires further archival research. It is interesting to note, though, that Christus's composition could easily have satisfied a Spanish patron and might have been planned with Spanish taste in mind: in fifteenth- and sixteenth-century Spain the number of pictures showing Saint Michael is striking. The importance of the Apocalypse in Spanish devotion might explain this phenomenon.[64] This is apparent, for example, in the Italian painter Dello da Niccolï Delli's huge decoration of the apse in Salamanca Cathedral (1445), where over fifty single panels with scenes from the life of Christ are crowned by an enormous *Last Judgment* decorating the half dome of the apse.[65]

Typical of Spanish paintings of the middle of the fifteenth century is a clear, iconic rendering of the main saints. The tendency to stress contour lines and to simplify complex forms, like the human body, or to reduce surface details can be found both in Christus's works and in those of Spanish painters. Finally, a Spanish commission could also help to explain the division of the left Berlin wing into two, providing space for two separate depictions, of the *Annunciation* and the *Nativity*. This feature is relatively old-fashioned for an early Flemish painting dated 1452.[66] This is especially so for Petrus Christus, an artist who was primarily concerned with the opening of the picture space by means of perspective, and the integration of outer and inner space. In Spain at this time, however, the altarpiece was still being formed by grouping many single panels showing different scenes. A Spanish patron might well have insisted on a number of painted scenes from Christ's life, perhaps flanking a sculpted shrine.[67] Although this is only a suggestion, Christus should not be blamed too quickly for the compositional difficulties of the wings because they are only fragments of the original overall conception.[68]

If the Berlin wings were commissioned by a Spanish patron who expected to receive a devotional altarpiece, he was certainly well served. Considered in the light of a Spanish commission, we may come to appreciate more fully the peculiar qualities of Christus's work.

ACKNOWLEDGMENT

I would like to thank Maryan Ainsworth for having proposed this paper to me, for her encouraging support, and for allowing me to publish her infrared reflectogram assemblies of the Eyckian diptych here for the first time. The IRR pictures were produced in the Sherman Fairchild Paintings Conservation Department of The Metropolitan Museum of Art, where the archive of this documentation resides. Jacob Wisse helped me very much with the editing of the English text, as did Peggy Pizza. I am also grateful to Eberhard König, who discussed questions relating to manuscript illumination with me.

NOTES

1. Jan van Eyck and assistant, *Crucifixion and Last Judgment,* c. 1435. Oil on canvas transferred from wood, each painting 56.5 x 19.7cm. Provenance: Spanish convent; Russian ambassador D. Tatistcheff, Vienna (by 1841); Hermitage, St. Petersburg (1845); Knoedler, New York (1933). New York, The Metropolitan Museum of Art (since 1933), 33.92A and B. Petrus Christus, *Annunciation and Nativity* and *Last Judgment,* 1452. Oil on oak, each panel 134 x 56cm. Provenance: Burgos Cathedral; cloister in Segovia; purchased by M. Frasinelli, Frankfurt; private collection, Augsburg; Kaiser Friedrich Museum (since 1850); Berlin, Gemäldegalerie, Staatliche Museen Preussischer Kulturbesitz, 529A and B.

The literature on the Eyckian diptych is extensive; a good summary until 1947 is provided in H. Whele and B. Salinger, *The Metropolitan Museum of Art: A Catalogue of Early Flemish, Dutch, and German Paintings* (New York, 1947) pp. 1–12. For later publications see A. Châtelet, *Early Dutch Painting* (New York, 1981) cat. no. 20, pp. 196-197; H. Belting and D. Eichberger, *Jan van Eyck als Erzähler* (Worms, 1983); and D. Eichberger, *Bildkonzeption und Weltdeutung im New Yorker Diptychon des Jan van Eyck* (Wiesbaden, 1987), with bibliographies and color illustrations.

For Christus's Berlin wings see Joel M. Upton, "Petrus Christus" (Ph.D. diss., Bryn Mawr College, 1972) cat. no. 2, pp. 264–271; L. B. Gellman, "Petrus Christus" (Ph.D. diss., Johns Hopkins University, 1970) cat. no. 5, pp. 392–395; B. Richter, "Untersuchungen zum Werk des Petrus Christus" (Ph.D. diss., University of Heidelberg, 1974) pp. 295–301; P. H. Schabacker, *Petrus Christus* (Utrecht, 1974) cat. no. 10, pp. 98-101; Upton, *Petrus Christus: His Place in Fifteenth-Century Flemish Painting* (University Park/London, 1990) pp. 37–40; Maryan W. Ainsworth and Maximiliaan P. J. Martens, *Petrus Christus: Renaissance Master of Bruges,* exh. cat. (New York, 1994). The Berlin wings were not included in the exhibition, but the exhibition catalogue reveals the most comprehensive and thorough analysis of Christus's style and painting technique.

2. The Russian restorer A. Cugopoff signed and dated the canvas on the back when he transferred the paintings. The grisaille figures on the exterior of the panels which were mentioned by Passavant must have been lost during the transfer (J. D. Passavant, "Beiträge zur Kenntniß der altniederländischen Malerschulen des 15. und 16. Jahrhunderts," *Kunstblatt,* 3 [12 January 1841] p. 9).

According to Dr. Hubert von Sonnenburg and George Bisacca, who examined the diptych in the Sherman Fairchild Paintings Conservation Department at The Metropolitan Museum in Feb. 1994, most parts of the frames are original. For a discussion and the reconstruction of the function of the paintings see also Eichberger, *Bildkonzeption und Weltdeutung,* pp. 112–114. Before this finding, the original function of the paintings was discussed controversially in the literature. Among the possible contexts suggested were a diptych, a triptych (J. Weale and M. W. Brockwell, *The Van Eycks and Their Art* [London, 1912] pp. 153–157, and Whele and Salinger, *Early Flemish Dutch and German Paintings,* p. 4), and the doors of a tabernacle (H. Peters, "Zum New Yorker 'Diptychon' der 'Hand G'," in *Munuscula Discipulorum: Kunsthistorische Studie Hans Kauffmann zum 70. Geburtstag,* ed. T. Buddensieg and M. Winner [Berlin, 1968] pp. 235–246; L. Brand Philip, *The Ghent Altarpiece and the Art of Jan van Eyck* [Princeton, 1971] pp. 141–150).

3. For the provenance, see J. D. Passavant, *Die christliche Kunst in Spanien* (Leipzig, 1853) pp. 75, 123–124, 129; W. H. J. Weale, "Pierre et Sebastien Cristus," *Le Beffroi,* 1 (1863) p. 236; *Picture Gallery Staatliche Museen Preussischer Kulturbesitz Berlin, Catalogue of Paintings, 13th–18th Century* (Berlin-Dahlem, 1978) p. 105.

4. G. F. Waagen, in "Bermerkungen über eine Anzahl von Gemälden, welche seit den letzten acht Jahren für die Bildersammlungen des Königlichen Museums zu Berlin erworben sind," *Deutsches Kunstblatt,* 5, no. 7, p. 65, mentions two grisaille figures on the exterior wings which showed the apostles Saint Peter and Saint Paul. In the 19th century both panels were cradled. As there is no trace of the grisailles left, it cannot be determined today if they were painted by Christus or if they were added later.

5. L. Kaemmerer, *Hubert und Jan van Eyck* (Bielefeld/Leipzig, 1898) p. 56; Belting and Eichberger, *Jan van Eyck als Erzähler,* pp. 109–112.

6. G. Troescher, *Burgundische Malerei: Maler und Malwerke um 1400 in Burgund, dem Berry mit der Auvergne und in Savoyen mit ihren Quellen und Ausstrahlungen* Berlin, 1966) pp. 336–337 and pls. 698–708; Upton, "Petrus Christus" (1972) p. 270; and idem, *Petrus Christus* (1990) p. 39 and n. 48.

7. For example the Boucicaut workshop's *Last Judgment* in Saint Augustine, *De civitate dei* (Walters Art Gallery, Baltimore, MS 770, fol. 203, cited in L. M. Randall, *Medieval and Renaissance Manuscripts in the Walters Art Gallery,* vol. 1 [Baltimore/London, 1989] cat. no. 96, pp. 270–273; and in M. Meiss, *French Painting in the Time of Jean de Berry: The Boucicaut Master,* vol. 3 of the National Gallery of Art, Kress Foundation Studies in the History of European Art [London/New York, 1968] fig. 341) or different versions of the *Last Judgment* by the Bedford Master and his workshop (see illustrations in Eichberger, *Bildkonzeption und Weltdeutung,* figs. 16–19). Further research exploring possible connections to illustrations of the *City of God* might be especially interesting because of the iconographical links between the New York *Last Judgment* and Augustine's text, as Panofsky pointed out (Erwin Panofsky, *Early Netherlandish Painting: Its Origins and Character,* 2 vols. [Cambridge, Mass., 1953] p. 238). See also Belting and Eichberger, *Jan van Eyck als Erzähler,* p. 76–82, where the relation to Augustine's text is discussed. See also the *Fall of the Rebel Angels,* fol. 64v in the *Très Riches Heures,* where choir stalls with armrests and high backs are depicted (for a color illustration see R. Cazelles and J. Rathofer, *Illuminations of Heaven and Earth: The Glories of the Très Riches Heures du Duc de Berry* [New York, 1988] pp. 104–105). Only the skeleton in La Brigue is a specific parallel to the Eyckian *Last Judgment.*

8. Brand Philip, *The Ghent Altarpiece,* p. 32, thinks that the 16th-century author Marcus van Vaernewyck was correct when he mentioned a depiction of hell as a part of the *Ghent Altarpiece.* In this context Brand Philips reconstructs an antependium for the *Ghent Altarpiece* which has been destroyed. Even if this picture existed and showed hell, this lost Eyckian prototype was composed for a horizontal format. The specific similarities between Christus's *Last Judgment* and the Eyckian composition in New York would still exist.

9. Passavant, "Beiträge zur Kenntniß," p. 9. Attributions to either Hubert or Jan or a close follower were considered possibilities. A listing of the different attributions is in Châtelet, *Early Dutch Painting,* cat. no. 20, p. 197.

10. Panofsky, "The Friedsam Annunciation and the Problem of the Ghent Altarpiece," *Art Bulletin,* 17, no. 4 (December 1935) p. 471; Eichberger (*Bildkonzeption und Weltdeutung,* p. 35) and Châtelet shared this view, which he expounded in "Un Collaborateur de Van Eyck en Italie," in *Relations artistiques entre les Pays-Bas et l'Italie à la Renaissance,* vol. 4 of Études d'histoire de l'art publiées par l'Institut historique Belge de Rome, Études dédiées à Suzanne Sulzberger (Brussels and Rome, 1980) p. 51 n. 23. In *Early Dutch Painting* (cat. no. 20 p. 196), Châtelet attributes the *Last Judgment* to "perhaps Master H, or more

probably hand I of the *Turin-Milan Hours*." Eichberger thinks that the deesis, however, in the *Last Judgment* is painted by Jan van Eyck, while Châtelet attributes the whole composition to the assistant.

11. Parts of the *Last Judgment* were painted by Jan van Eyck: Saint Michael's head is modeled with the same mastery as the Sibyl's face; the different paint layers that build up the naked bodies tortured in hell are as subtle and as carefully painted as the crucified Christ's skin. The red drapery of the judging Christ, too, is as volumetric and vigorously modulated as the Magdalen's cloak.

12. The different handling of paint is even evident in the skies: the blue in the *Crucifixion* has different shades, and a variety of clouds animate the sky. Although it might be partially due to the iconography and condition, the homogeneous blue paint of the sky in the *Last Judgment*, which is thickly applied with broad brushstrokes, lacks all the atmosphere that defines the air in the *Crucifixion*.

13. For many color illustrations of the *Très Riches Heures* see Cazelles and Rathofer, *Illuminations*. The additive manner in which color is applied is also evident in the lack of a reserve area for the figure of Saint John the Baptist, who is simply painted over the blue sky. This mannerism can also be found in miniature painting, although not enough comparative material has yet been gathered to enable us to call the technique typical for book illuminators. For examples see the *Annunciation*, on fol. 26 of the *Très Riches Heures*, where the Virgin's right hand was painted over her blue drapery (color illustration in ibid., p. 75) or the *Nativity of the Virgin*, fol. 60 of MS W. 289, a French book of hours from about 1425–35 by a follower of the Bedford Master, in the Walters Art Gallery (illustration in L. M. Randall, *Medieval and Renaissance Manuscripts in the Walters Art Gallery*, vol. 2, 2 [Baltimore and London, 1992] fig. 204, p. 585). Here the female figure holding a water jar is painted over the bed's brownish underpaint, which has become visible because the surface is badly abraded.

14. It is hard to tell precisely which drawing media were used because of the painting's small scale. For the difficulties in detecting the media of underdrawings see J. Jennings, "Infrared Visibility of Underdrawing Techniques and Media," in *Le Dessin sous-jacent dans la peinture: Dessin sous-jacent et pratiques d'atelier*, ed. R. van Schoute and H. Verougstraete-Marcq (Louvain-la-Neuve, 1993) pp. 241–252.

15. For color illustrations, see E. Dhanens, *Hubert and Jan van Eyck* (New York, 1980) p. 255, 257, 260, 261, and 263.

16. These thin underdrawn lines must not be confused with the thicker ones in the paint layers.

17. J. R. J. van Asperen de Boer, "Over de techniek van Jan van Eycks *De heilige Barbara*," *Jaarboek van het koninklijk Museum voor schone kunsten Antwerpen* (1992) pp. 9–18.

18. Jan van Eyck's economy in his painting technique was also pointed out by Lorne Campbell in his keynote address, published as the first essay in this volume.

19. Asperen de Boer, "A Scientific Re-examination of the Ghent Altarpiece," *Oud Holland*, 93, no. 3 (1979) pp. 141–214, esp. figs. 20g1, 29. For the attribution of the Ghent underdrawing to Jan, Hubert, or an assistant see ibid., p. 205–213.
Similarities between the underdrawing detected in the *Virgin of Chancellor Rolin* and the New York diptych also support the suggested attribution to Jan van Eyck (Asperen de Boer and M. Faries, "La *Vierge au chancelier Rolin* de Van Eyck: Examen au moyen de la réflectographie à l'infrarouge," *Revue du Louvre et des musées de France*, 40, no. 1 [1990] pp. 37–49).

20. Belting and Eichberger, *Jan van Eyck als Erzähler*, pp. 103–107; Eichberger, *Bildkonzeption und Weltdeutung*, pp. 85–90.

21. The second *O* might also be read as *G*; Eichberger, *Bildkonzeption und Weltdeutung*, reads the word *MORO* and connects its meaning with *mors*, "death." The exact meaning, however, has not yet been identified.

22. Asperen de Boer and Faries, "La *Vierge au chancelier Rolin*, figs. 3, 12; J. Dunkerton, et. al. *Giotto to Dürer: Early Renaissance Painting in the National Gallery* (New Haven/London, 1991) fig. 223, p. 168.

23. Österreichische Nationalbibliothek, Vienna, MS 1855, fol. 137v. For the Bedford Master see J. Backhouse, *The Bedford Hours*, (The British Library, London, 1990) with bibliography, and most recently F. Avril and N. Reynaud, *Les Manuscrits à peinture en France 1440–1520* (Paris, 1993) pp. 23–24.
MS 1855 in Vienna is discussed in H. Hermann, *Beschreibendes Verzeichnis der illuminierten Handschriften in Österreich*, N.F.VII, Part 7, 3, *Französische und iberische Handschriften der ersten Hälfte des XV. Jahrhunderts* (Leipzig, 1938) cat. no. 19. For a color reproduction of the Bedford *Crucifixion*, see E. Trenkler, *Livre d'Heures, Handschrift 1855 der Österreichischen Nationalbibliothek* (Vienna, 1948) p. 19.

24. Both paintings are in the Wallraf-Richartz-Museum, Cologne. The *Kleine Kalvarienberg* is attributed to the Master of Saint Veronica; see G. Zehnder, "Katalog der altkölner Malerei," *Kataloge des Wallraf-Richartz-Museums*, XI (Cologne, 1990) cat. no. 11, pp. 323–327 and fig. 208; for the *Große Kalvarienberg*, attributed to an anonymous Westphalian painter, see ibid., cat. no. 353, pp. 543–550 and fig. 321.

25. C. Sterling, C. "Jan van Eyck avant 1432," *Revue de l'art*, 33 (1976) pp. 46, 48 and note 116; and Brand Philip, *The Ghent Altarpiece*,, nn. 312 and 314 and fig. 169. Brand Philip takes the two Calvaries as examples of a "pre-Eyckian tradition now lost."

26. Jan van Eyck follows the type of the *volksreiche Kreuzigung*. For the development of this iconography, see E. Roth, *Der volkreiche Kalvarienberg in Literatur und Kunst des Spätmittelalters* (Berlin, 1958) p. 44ff. The three crosses are surrounded by riders and foot soldiers; the Virgin—usually accompanied by two or three other women (the Marys), and by Saint John the Evangelist—is either standing or has fainted under Christ's cross. If she has fainted, she is supported either by Saint John or by the women alone. In the latter case the grieving evangelist stands apart or behind the female group, often looking mournfully at the spectator, perhaps allowing him to identify with the Passion scene. Much closer to the New York *Crucifixion* than the examples from Cologne are depictions of the scene that were invented by Franco-Flemish book illuminators. About 1416 the Limbourg brothers interpreted the *Crucifixion* in the *Très Riches Heures* as a dramatic scene at night—the specific moment from the Passion when Christ died and the sky darkened to reflect his passion. The figures do not address the spectator; they are depicted reacting to what happens within the scene. This can also be found in Italian Crucifixions from the *trecento*, which may have inspired the Limbourg brothers, and this important feature also links the *Crucifixion* of the *Très Riches Heures* with van Eyck's painting. In the illumination two women clearly support the Virgin, and Saint John seems to shelter the whole group as he puts his arm around the women. Similar to the New York *Crucifixion* is the lively support of Christ's mother and the resulting close link between the figures. The illuminator, however, tried to connect the two iconographic centers, the cross and the Virgin: Saint John and one of the women both look up to Christ while they take care of his mother. The Bedford Master develops the Limbourg tradition further by making the care of Christ's mother the exclusive subject.

27. The looping piece of black drapery behind Saint John neither is a part of the standing woman's mantle nor does it belong to the kneeling figure in the front. It does not fall realistically according to the movements of the figures and only

makes sense, in fact, as a compositional and coloristic device used to create the impression that Saint John and the Virgin are completely enclosed.

28. Eichberger, *Bildkonzeption und Weltdeutung,* p. 53–56; for a color reproduction see Trenkler, *Livre d'Heures,* p. 24. For the relationship between book illumination and panel painting see also Belting and Eichberger, *Jan van Eyck als Erzähler,* pp. 143–164; for the link with the Bedford group esp. pp. 152–153.

29. For the influence of the Bedford Book of Hours, MS 1855 in Vienna, on later artists see also Martha Wolff, "Some Manuscript Sources for the Playing-Card Master's Number Cards," *Art Bulletin* 64 (December 1982) pp. 587–600.

30. J. H. Marrow, "Dutch Manuscript Painting in Context: Encounters with the Art of France, the Southern Netherlands and Germany," in *Masters and Miniatures,* Proceedings of the Congress on Medieval Manuscript Illumination in the Northern Netherlands, 10–13 December 1989, ed. K. van der Horst and J.-C. Klamt (Utrecht, Doornspijk, 1991) pp. 53–88; M. Smeyers and B. Cardon, "Utrecht and Bruges—South and North: 'Boundless' Relations in the Fifteenth Century," in *Masters and Miniatures,* pp. 89–108; F. Avril and N. Reynaud, *Les Manuscrits à peinture,* cat. no. 47. pp. 97, 70–103. The Mansel Master (pp. 73–75) is especially interesting, as his compositions are close to both the Bedford tradition and early Netherlandish painting, in particular the Master of Flémalle.

31. E. König, "Ein Pariser Buchmaler in den eyckischen Partien des Turin-Mailänder Stundenbuchs: Hand F," *Wiener Jahrbuch für Kunstgeschichte* (1994) pp. 303–310 and figs. on pp. 449–452. According to König (*Pariser Buchmaler* [1994], pp. 308–309), this painter was involved in the decoration of the duke of Bedford's breviary, the so-called Salisbury Breviary, MS lat. 17294, in the Bibliothèque Nationale in Paris, where he was responsible for painting some borders. For the Salisbury Breviary, see E. P. Spencer, "The Master of the Duke of Bedford: The Salisbury Breviary," *Burlington Magazine* 108 (1966) pp. 607–612; C. Reynolds, "The Salisbury Breviary, Paris, Bibl. nat. lat. 17294, and Some Related Manuscripts" (Ph.D. diss., London University, 1986); Avril and Reynaud, *Les Manuscrits à peinture,* cat. 3, p. 24. See ibid., pp. 35–37.

32. When attributed to Jan van Eyck, the diptych is "traditionally" dated rather early in his oeuvre: for example P. Durrieu, "Les Tableaux des collections du Duc Jean de Berry," *Bibliothèque de l'école de chartes,* 79 (1918) pp. 265–290, attributes it to Hubert and Jan and dates it before 1413;
Max J. Friedländer, *Early Netherlandish Painting,* vol. 1 (Leiden, 1967) p. 94 dates it c. 1424; Sterling, "Jan van Eyck," p. 43, dates it to 1426; Eichberger, *Bildkonzeption und Weltdeutung,* p. 34, dates it to the first half of the 1420s. An early date is, of course, also assumed when an attribution to Hubert van Eyck is suggested, as for example Whele and Salinger, *Early Flemish Dutch and German Paintings,* pp. 1–9. For an extensive listing of opinions in the literature see ibid., pp. 9–12.
Some authors, however, date the diptych late in Jan van Eyck's oeuvre: Peters ("Zum New Yorker 'Diptychon'," p. 237) even thought that the diptych is generally dated in the 1430s, and he was writing his text in 1968. Brand Philip (*The Ghent Altarpiece,* p. 141) and J. Snyder, *Northern Renaissance Art: Painting, Sculpture, the Graphic Arts from 1350 to 1575* (New York, 1985) p. 118, also date the diptych late, *i.e.,* after the *Ghent Altarpiece.* This dating is also in conformity with König's dating of Hand G in the Turin-Milan *Hours* (König, *Die Blätter im Louvre,* pp. 54–56). L. Baldass, *Jan van Eyck* (Leicester, 1952) pp. 95–96, attributes the New York diptych and the miniatures of Hand G to a Dutch painter who worked in the 1430s, while Smeyers thinks that the Hand G miniatures in the Turin-Milan *Hours* are by a follower of Jan van Eyck from the mid-15th century. The problem of the attribution of Hand G and Hand H cannot be discussed here; however the arguments for a late date

seem to be more convincing than the ones for the traditional early date in the 1420s. For a discussion of the attribution see M. Smeyers, "Answering Some Questions about the Turin-Milan Hours," in *Le Dessin sous-jacent dans la peinture: Géographie et chronologie du dessin sous-jacent,* ed. R. van Schoute and H. Verougstraete-Marcq (Louvain-la-Neuve, 1989) pp. 55–70. For the most recent discussion of the miniatures in the Turin–Milan Hours, see A van Buren, *Das Turin–Mailänder Stundenbuch Hs. Inv. No. 47.* Museo Civico d'Arte Antica, Turin (Luzern, 1994).

33. Panofsky, "The Friedsam Annunciation," p. 434.

34. Rogier's diptych in Philadelphia is very large in scale, but here the wings are not divided into separate picture spaces, and the paintings could never be closed as Christus's Berlin wings could. This is proven by the documented grisailles on the exterior of the panels. See note 4.

35. Panofsky, "The Friedsam Annunciation," p. 309.

36. For an analysis of the picture as a devotional painting, see Upton, *Petrus Christus* (1990) pp. 39–40.

37. For a discussion of Christus's use of perspective, see Ainsworth and Martens, *Petrus Christus,* pp. 41–49.

38. Upton, *Petrus Christus* (1990) p. 40. Contrary to this Belting and Eichberger, (*Jan van Eyck als Erzähler,* p. 111), strongly criticized Saint Michael as a warrior who fights with anecdotal verve against some monsters.

39. See also Upton, "Petrus Christus" (1972) p. 269; Gellman, "Petrus Christus," p. 120
Christus and his patron were not the only ones who must have had such objections; in fact no other *Last Judgment* is known where Saint Michael's posture was copied exactly.

40. None of the underdrawn figures, however, were copied exactly from the Eyckian *Last Judgment.*

41. An illumination in the famous *Book of Hours of the Maréchal Boucicaut* (Musée Jacquemart-André, Paris, MS 2, fol. 11v) from the first decade of the 15th century, and a Valencian panel dating from the first quarter of the 15th century in The Metropolitan Museum of Art (12.192), may serve as two examples among many. For illustrations, see Meiss, *French Painting in the Time of Jean de Berry,* fig. 2 and pp. 131–133; for an illustration of MMA item 12.192, see K. Baetjer, *European Paintings in the Metropolitan Museum of Art by Artists Born in or before 1865,* 3 vols. (New York, 1980) vol. 1, p. 179, and vol. 2, p. 193.

42. The placement of the creatures also offered a difficult problem for the artist, as the changes between the underdrawing and the execution show: at first the devil's left leg was planned in front of the dog, but in the final stage it was overlapped by the dog.

43. W. Burger, *Die Malerei in den Niederlanden, 1400–1550* (Munich, 1925) p. 34; R. A. Koch, "A Rediscovered Painting by Petrus Christus," *Connoisseur,* 140 (1957) p. 275; Upton, "Petrus Christus" (1972) p. 270; Gellman, "Petrus Christus," p. 394; Schabacker, *Petrus Christus,* p. 101; Upton, *Petrus Christus* (1990) p. 38.

44. Ainsworth and Martens, *Petrus Christus,* cat. no. 21, pp. 176–180. For Christus's relationship to miniature painting see ibid., pp. 33–35, 56–59, 81–83, 104–105, 115–116, 164.

45. Although no work can be attributed to Vrelant on a documentary basis, a huge group of manuscripts are connected with his name. For Vrelant's vita and a reconsideration of his oeuvre see J. D. Farquhar, *Creation and Imitation: The Work of a Fifteenth-Century Manuscript Illuminator* (Fort Lauderdale, Fla., 1976); Smeyers and Cardon, "Utrecht and Bruges," pp. 99–104.

46. For the Master of Catherine of Cleves, see F. Gorissen, *Das Stundenbuch der Katharina von Kleve: Analyse und Kommentar*

(Berlin, 1973); Châtelet, *Early Dutch Painting,* pp. 203–208; W. C. M. Wüstefeld, "The Masters of Catherine of Cleves, ca. 1430–1460," in J. H. Marrow et al., *The Golden Age of Dutch Manuscript Painting* (New York, 1990) pp. 123–128, 146–164.

47. Pierpont Morgan Library, New York, MS M. 917; for a color illustration, see Plummer, *Die Miniaturen,* fig. 101. This composition must have been successful, as the Master of Catherine of Cleves also depicted it in another book of hours (Rijksmuseum Meermanno-Westreenianum, The Hague, MS 10 E 1), dated 1438. See Wüstefeld, "The Masters of Catherine of Cleves," cat. no. VI 44, pp. 150–151, and fig. vi 44, p. 127. The same figure of Saint Michael is depicted in a contemporary book of hours in the University Library in Glasgow (MS Gen. 288, fol. 84v). The composition is first found in a book of hours from c. 1430–35 in the Walters Art Gallery, Baltimore (Walters MS 281, fol. 230), from either northern France or Tournai. (R. S. Wieck, *Time Sanctified: The Book of Hours in Medieval Art and Life* (Baltimore, 1988) cat. no. 35 pp. 186–187 and pl. 33 p. 141; Plummer and Clark, *The Last Flowering,* cat. no. 12, p. 9; Smeyers and Cardon, "Utrecht and Bruges," p. 103, and figs. 12 and 13 p. 108.

Smeyers, like Châtelet (*Early Dutch Painting,* p. 207), suggested that the Cleves Master's composition and the illumination in Walters MS 281 are based on a lost Eyckian model. The artist of the Walters manuscript seems, however, to be indebted to compositions of the Boucicaut Master (see the *Saint Michael* in the Book of Hours of the Maréchal Boucicaut, Musée Jacquemart-André, Paris, MS 2, fol. 11v, where figure and landscape are similar to the later compositions). The reconstruction of a lost Eyckian model does not seem necessary.

48. MS M. 917, paginated, pp. 29, 44, 206; Plummer, *Die Miniaturen,* figs. 50, 68, 102, the *Mass of the Dead,* the *Wednesday Hours of All Saints,* and the *Suffrages. Saint Michael Fighting against Devils* (p. 204) also illustrates the suffrages; Saint Michael is the first saint named and the only one who is shown twice in the suffrages. This proves his extraordinary role.

49. Pierpont Morgan Library, New York, MS M. 945; for a color illustration, see Plummer, *Die Miniaturen,* fig. 99; for a discussion, see Wüstefeld, "The Masters of Catherine of Cleves," p. 156 and color illustration pl. 45b p. 123.

50. MS M. 917, p. 156; Plummer, *Die Miniaturen,* fig. 14; and Ursula Panhans-Bühler, *Eklektizismus und Originalität im Werk des Petrus Christus,* Wiener kunstgeschichtliche Forschungen 5 (Vienna, 1978) pp. 128–129 and fig. 79. The author reconstructs a lost model on which Christus's panel and the miniature are based and does not consider any kind of direct relationship. For a discussion of different suggestions for compositional sources of Petrus Christus's *Death of the Virgin* in the literature, see Ainsworth and Martens, *Petrus Christus,* cat. no. 15, pp. 147–148.

51. Timken Art Gallery, Putnam Foundation, San Diego; Ainsworth and Martens, *Petrus Christus,* cat. no. 15, pp. 146–153.

52. For a color illustration, see Plummer, *Die Miniaturen,* fig. 41, and Châtelet, *Early Dutch Painting,* p. 55.

53. For the workshop of the Masters of Zweder van Culemborg, see W. C. M. Wüstefeld, "The Masters of Zweder van Culemborg, ca. 1415–1440," in *The Golden Age of Dutch Manuscript Painting,* by J. H. Marrow, *The Golden Age,* pp. 89–117.

54. For Christus's use of pink underpainting, see Ainsworth and Martens, *Petrus Christus,* pp. 34–36 and figs. 29 and 30.

55. Wüstefeld, "The Masters of Zweder van Culemborg," cat. no. 35, pp. 110–112, and pl. 35. For the pink underpainting and the white modeling, see also ibid., pls. 42–47 which illustrate illuminations by Utrecht Masters, especially the Cleves Master. The pink flesh tone is also typical of miniatures attributed to Vrelant and his workshop.

56. Gemäldegalerie, Staatliche Museen Preussischer Kulturbesitz, Berlin; Ainsworth and Martens, *Petrus Christus,* cat. no. 7, pp. 102–106 and figs. 91, 117.

In this context Klingelschmitt's suggestion is interesting in that Petrus Christus's *Madonna in Half-length,* in the Bentinck-Thyssen Collection, Luxembourg, signed and dated on the frame 1449, was painted for Eberhard von Greiffenklau, "a prebendary at Utrecht from 1446 and later a canon of the Cathedral of Mainz" (Wüstefeld, "The Masters of Zweder van Culemborg," p. 110. See also F. T. Klingelschmitt, *Mainzer Goldgulden auf dem Eligiusbild des Petrus Christus in der Sammlung Baron Albert Oppenheim, Köln* (Wiesbaden, 1918). Klingelschmitt based his suggestion on the provenance of the Bentinck-Thyssen painting, as it is first mentioned in the possession of Count Matuschka-Greiffenklau (Schabacker, *Petrus Christus,* cat. no. 7 p. 92) a descendant of Eberhard von Greiffenklau. Although the suggestion was not accepted in the literature, no scholar did refute it. Sterling's categorical rejection (in "Observations on Petrus Christus," *Art Bulletin* 53, March 1971 p. 9, note 38) of this hypothesis on the basis of missing connections between Christus and Utrecht may be too rash.

57. See notes 30 and 31.

58. Vrelant contributed a number of illuminations to the *Book of Hours of Willem van Monfoort,* dated 1450, in the Österreichische Nationalbibliothek at Vienna, Cod. S.n. 12878. The Master of Catherine of Cleves worked on the illumination of this manuscript, too. Smeyers and Cardon, "Utrecht and Bruges," pp. 102–103; and Wüstefeld, "The Masters of Zweder van Culemborg," p. 148 and cat. no. 49, pp. 161–162.

59. Lorne Campbell, "The Early Netherlandish Painters and Their Workshops," in *Le Dessin sous-jacent dans la peinture: Le Problème de Maître de Flémalle-van der Weyden,* ed. D. Hollanders-Favart and R. van Schoute (Louvain-la-Neuve, 1981) p. 53–54.

60. Belting and Eichberger (*Jan van Eyck als Erzähler,* p. 110) have also suggested that Christus may have criticized van Eyck's composition, but the authors limit this interpretation to Christus's simplification of the New York composition.

61. Ainsworth and Martens, *Petrus Christus,* cat. no. 5, 14, 17, pp. 93-95, 142-145, 158-162.

62. See note 1.

63. Wernher Collection, Luton Hoo, England. J. A. Gaya Nuño, *La pintura española fuera de España* (Madrid, 1958) p. 43, cat. 332, p. 112, and fig. 64; E. Young, *Bartolome Bermejo—The Great Hispano-Flemish Master* (London, 1975) pp. xii, 17, 36.

64. P. K. Liss, *Isabel the Queen: Life and Times* (New York, 1992).

65. M. Chamoso Lamas, *Catedrales de España: Santiago de Compostella, Orense, León, Valladolid, Salamanca* (Spain, 1981), pp. 362–365.

66. Bouts's *Tüchlein* altarpiece (Brussels, Musée des Beaux Arts), which depicts a Crucifixion in the center, is an exception. In Dieric Bouts's *Last Supper* altarpiece, the division of the wings into separate scenes is due to the type of the altarpiece, which is a *Heilsspiegelaltar.*

67. This suggestion was also made by Belting and Eichberger, *Jan van Eyck als Erzähler,* p. 109, and by Rainald Grosshans (Curator of Early Netherlandish Paintings, Gemäldegalerie, Staatliche Museen Preussischer Kulturbesitz, Berlin) in a conversation in January 1994. In the literature a painted center panel, which supposedly showed a scene from Christ's Passion, is usually reconstructed. Upton ("Petrus Christus" [1972] p. 267) refers to painted and sculpted shrines as possible centers. See also Gellman, "Petrus Christus," p. 394; Schabacker, *Petrus Christus,* p. 99–100; *Picture Gallery,* p. 105; Upton, *Petrus Christus,* pp. 40 n. 49.

Saint Michael was a very common saint, to whom Spanish churches were dedicated, as for example Santa Maria de la Encarnación (Liss, *Isabel the Queen,* p. 19). The iconographical program of the Berlin wings—besides depicting Saint Michael—focuses on the Incarnation by including the *Annunciation* and *Nativity.* Although Isabella of Castile's will, written in October 1504, is too late a source to be linked with the question of Christus's patron, it supports the suggestion that the Berlin wings were connected with a Spanish commission. The will refers to Saint Michael as "that very excellent Prince of the Church and *Cavallería angelical*" and to Saint Gabriel as "the glorious celestial messenger" as of first rank. Besides Saint John the Baptist, Isabella singled out Saints Peter and Paul, with all the other apostles, particularly the very blessed saint *Juan Evangelista,* beloved disciple of our Lord Jesus Christ and great and shining eagle, to whom He reveals his very high mysteries and secrets" (Liss, *Isabel the Queen,* pp. 343–144). Saint Michael, Saint Gabriel, and the Last Judgment are important parts of the wings; additionally Saints Peter and Paul were formerly depicted on the exterior wings (see note 4). Thus the program would have met Spanish iconographical standards.

68. Friedländer, *Early Netherlandish Painting,* vol. 1, p. 84, thinks that the "lack of symmetry in scale and composition between the two shutters remains a puzzle." A positive revaluation is already found in Schabacker, *Petrus Christus,* p. 100.

The *Virgin of Nicholas van Maelbeke* and the Followers of Jan van Eyck

Susan Jones
Courtauld Institute of Art, London

A painting by Jan van Eyck was recorded by reliable sources in the Church of Saint Martin in Ypres from the sixteenth century to the eighteenth century. The most important descriptions of it are in three works by Marcus van Vaernewyck, written between 1563 and 1568.[1] The author describes the painting as representing the Virgin and Child with an abbot or provost kneeling before them, and as having wings, which are unfinished, with images in two registers referring to the purity of the Virgin Mother: the Burning Bush, Gideon's Fleece, Ezekiel's Gate, and Aaron's Rod. He is certain that the painting is by Jan van Eyck, whose work seems more heavenly than human, and says that this work stands above all other paintings.

The painting was seen in the choir of the church in the seventeenth and eighteenth centuries by Antonius Sanderus, who was a canon of the cathedral; the French traveler Sieur Nomis; and the monks Martène and Durand.[2] Before the creation of the diocese of Ypres in 1559, the collegiate church was the center of a community, or provostship, of canons regular of the order of Saint Augustine. Van Vaernewyck seems to refer to this community in 1563 when he says that the painting is in the *proostie* (provostship) in Ypres, without naming the church itself. During the iconoclasm in Ypres in 1566 and 1578 the painting would certainly have been hidden, but apart from this it seems to have always been kept in the choir.[3]

In the eighteenth century the painting hung on the south wall of the choir, to the right of the high altar, next to the tomb of the first bishop of Ypres, Martin Rithovius.[4] It would have hung in an arched blind niche, such as decorate the lower level of the choir walls.[5] The outstanding feature of the design of this painting was the rib vault, which made an apselike setting for the figures; in this way both the arched shape of the panel and the type of pictorial representation seem closely linked to its physical location in the choir. The painting may have been designed in accordance with the intended setting and usage.[6]

The painting by Jan van Eyck is said to have been taken to the bishop's palace in about 1757, when the lower part of the choir walls were being covered with black-and-white marble decoration.[7] After that it disappears. If it stayed in the bishop's palace, it might have been sold in the public sale of the effects of the bishop on 2 March 1795.[8]

The only reference to the painting which includes the name of its patron, its location, and its function is that by Petrus Martinus Ramaut, a schoolmaster of Ypres who lived from 1719 to 1783, and who therefore knew the work attributed to Jan van Eyck in the choir. He wrote two chronicles of Ypres, and included in both a passage describing the events of 1445. It states that Jan van Eyck painted the picture in Ypres for Nicholas Malchalopie and that it was hung in the choir over his tomb as his epitaph. One of the chronicles is still in the town library of Ypres and is dated 1768; the other was acquired by Jean Jaques Lambin, the town archivist, but has now been lost.[9]

In 1825, Lambin gave the information about the painting to Liévin De Bast for his article on the van Eycks.[10] Lambin believed that the Ramaut extract came from a fifteenth-century source, a chronicle of the Gray Friars of Ypres. This was said to have been acquired and copied by Thomas de Raeve, a sixteenth-century chronicler of Ypres, and then in turn by Petrus Ramaut.

The existing chronicle by Ramaut contains a list of his sources, which does include Thomas de Raeve, as well as other Ypres chroniclers and archives from old monasteries. It does not seem impossible, therefore, that the passage about the painting represents a transmission of some local tradition, probably from a written source. There seem to be no examples of the chronicle of Ypres by Thomas de Raeve in existence, so the

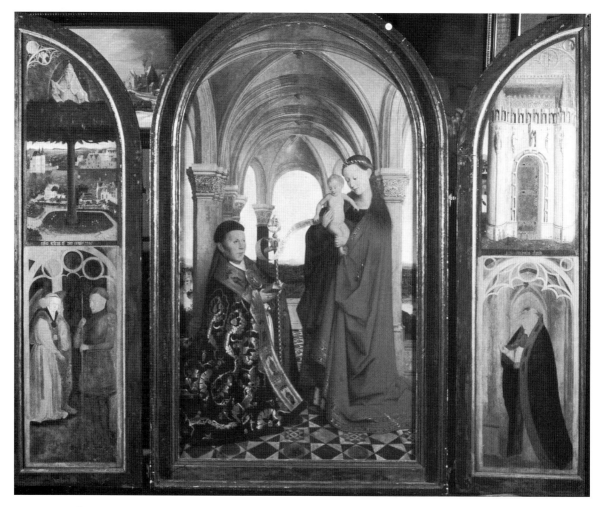

Figure 1. Follower of Jan van Eyck, *Triptych of Nicholas van Maelbeke*. Oil on oak, center (without frame) 177.2 x 99.7 cm, wings (without frame) 177.2 x 41 cm. Private collection

information cannot be traced back any further. The fifteenth-century Gray Friars chronicle is unlikely to be the original source, because a copy of such a chronicle, running from 1405 until 1580, does not mention the painting.[11]

The name given to the patron, Nicholas Malchalopie, does seem likely to be a corruption of Nicholas van Maelbeke, the provost of the church and monastery of Saint Martin's in Ypres. He is documented from 1425 until 1445, dates that coincide well with Jan van Eyck's residence in the southern Netherlands. The name van Maelbeke is not a common one in Ypres, and it completely disappears from the surviving records after the first half of the fifteenth century.[12]

The date 1445 in Ramaut's town chronicle, which is associated with the painting, seems likely to refer to a local historical event. It corresponds exactly to the date of death of Nicholas van Maelbeke, and it seems logical that the date should be taken as that of the installation of the painting above the provost's tomb in the choir.

Nicholas van Maelbeke was a canon of the chapter of Saint Martin's by 1425, when he represented the provost Nicholas Zoudelin at the General Synod of Thérouanne, and he was mentioned as curate of the church in 1428.[13] The post of provost was conferred in Rome on 25 February 1430.[14] At his entry into Ypres the same year he was presented by the magistrates with a silver cross engraved with a bell tower, symbol of the municipality of Ypres.[15] Nicholas van Maelbeke died in 1445, on or shortly before the 28 September.[16]

The provost of Saint Martin's came into contact with the court in the event of ducal visits to Ypres. It is possible that Jan van Eyck formed part of the retinue of Philip the Good or Isabella of Portugal on one or more of these occasions. The first visit of the duke and duchess

Figure 2. *Triptych of Nicholas van Maelbeke* before it was cleaned in 1929

of Burgundy to the town occurred in February 1431, following the suppression of a revolt in Cassel, which had taken van Maelbeke to Hazebrouck to negotiate with the rebels.[17] Philip the Good and Isabella of Portugal stayed for two nights in the monastery of Saint Martin's, which was still used as a lodging for visiting princes later in the century.[18] A particularly interesting visit was that by Isabella of Portugal, who along with the chancellor of Burgundy, Nicholas Rolin, was given wine on 2 June 1441.[19] This date could be close to that of the commission of the painting, which has often been considered a late one. In view of this it is possible that when the members of the court met van Maelbeke, the subject of Jan van Eyck might have arisen, as at least two, and perhaps three, of those present had had their portraits painted by him.

It is also possible, however, that the commission was given during a visit of the provost

to Bruges. Van Maelbeke came into contact with the dean and chapter of Saint Donatian's in Bruges in his capacity as provost, because the two chapters shared tithes on various lands around Ypres.[20]

A belief often found in the literature is that Jan van Eyck died before the painting was completed and that it was installed in the choir in an unfinished state.[21] This idea was largely based on the sixteenth-century descriptions of the painting as being incomplete.

An existing triptych in a private collection, usually called the *Triptych of Nicholas van Maelbeke,* exactly corresponds to van Vaernewyck's descriptions of the painting by Jan van Eyck, including the unfinished paintings of Old Testament subjects in two registers on the wings.[22] For this reason it was often taken to be the original painting (Fig. 1).

This opinion seemed to be backed up by the existence of two drawings from the fifteenth

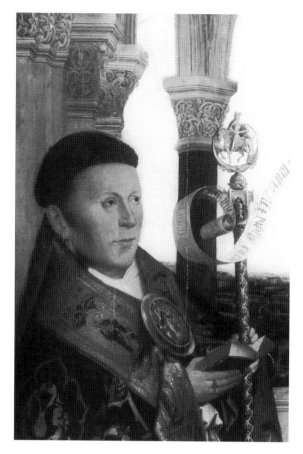

Figure 3. Detail of Figure 1 (the patron)

century (cat. fig. 173; cat. no 22),[23] which appear to have been copied from a single model showing the central composition in an incomplete or preparatory state. James Weale was influential in seeing them as indicators of the extent of Jan van Eyck's personal involvement in the execution of the center panel of the triptych.[24] In 1933, however, Émile Renders convincingly demonstrated that they were closer to each other than to the triptych, both in the details and in the relative scale of the figures, and that the three works seem to have a common source in a lost painting by Jan van Eyck.[25]

A second feature of the triptych which seemed to prove its authenticity was the appearance during cleaning in 1929 of a second head below that of the original patron, who with his beard and moustaches had looked distinctly sixteenth- or seventeenth-century (Fig. 2). The uncovered head was taken by some to be that of Nicholas van Maelbeke, but as Friedländer noted it exists mainly in outline and lacks individual form.[26] After the cleaning, it was heav-

ily restored, but a second and more thorough cleaning of 1960-61 revealed the face as flat and featureless (Fig. 3). The most significant thing about the uncovered head is that it cannot be attributed to Jan van Eyck.

A number of authors believed that the painting was a copy of later date than the fifteenth century, and not an overpainted original.[27] The center panel of the triptych underwent a series of scientific examinations between 1951 and 1974. The last and most thorough examination points to the probability that the triptych is a copy of the late sixteenth or early seventeenth century.[28]

The scientific evidence fits in remarkably well with the idea that the existing painting is a copy commissioned by the canon and cantor of Saint Martin's cathedral Petrus Wyts, who died on 11 October 1629.[29] Ramaut describes this copy in his 1768 chronicle as an epitaph for Wyts's tomb near the altar of Our Lady.[30] He calls it a copy of the excellent painting in the choir, and notes that although it is artfully painted, it is only a shadow by the light compared to the original. The existence of this painting in the Lady Chapel seems to be the basis of the idea, begun by James Weale, that when the painting by Jan van Eyck was removed from the choir, it was replaced by a copy.[31]

Petrus Wyts was cantor of Saint Martin's from 1605 until his death.[32] He was the eldest son of Jan Wyts of Bruges and his wife Marie de Boodt.[33] Pieter Pourbus painted Jan Wyts and his brother Gillis, with other members of the Confraternity of the Holy Blood in Bruges, in 1556, and the Wyts coat of arms appears twice on the frame of that painting.[34] There is no such coat of arms on the existing triptych, but the staff held by the patron seems to support the identification of Petrus Wyts. A fifteenth-century provost would have carried a crozier, as is shown in the seal of Nicholas van Maelbeke,[35] but this staff appears to be that of a cantor.[36] At the top of the shaft a statue of Saint Peter is shown prominently in a niche.

The paintings on the interior of the wings appear to be copies of the unfinished paintings seen by van Vaernewyck, and to be of the same date as the center panel. The rather messy painting technique of the scenes on the inner wings is not like that of the fifteenth century, and the costume of the figures in the scene of the Burning Bush looks late, as the men in the town

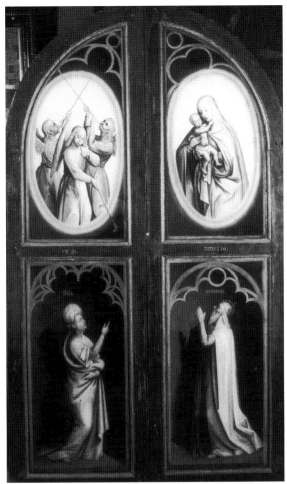

Figure 4. *Triptych of Nicholas van Maelbeke,* wings closed

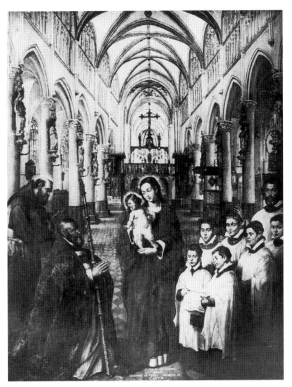

Figure 5. Jan Thomas, *Virgin and Child with Canon Franciscus de Mamez,* dated 22 June 1645. Oil on panel. Lost 1914-18 (photo: Antony, Ostend)

Figure 6. Circle of Hieronymous Wierix?, *Virgin and Child in a Church,* 16th century. Engraving, 171 x 114 mm. New York, The Metropolitan Museum of Art, Harris Brisbane Dick Fund, no. 53.601.18.(192) (photo: The Metropolitan Museum of Art)

in the background appear to be wearing breeches. The grisaille paintings on the exterior (Fig. 4), representing the Tiburtine Sibyl showing the Vision of the Christ Child to Octavian, are comparable in style to a group of paintings from Ypres of the late sixteenth and early seventeenth century, probably from the circle of the painter Frans Denys.[37] They share the unusual tracery patterns of the borders with the paintings on the interior of the wings, and therefore seem to belong to the same phase of execution. This would date the wings, and indeed the entire triptych, to the early seventeenth century.

A second seventeenth-century copy of the painting by Jan van Eyck was commissioned from the Ypres painter Jan Thomas by the canon and cantor Franciscus de Mamez (Fig. 5).[38] It is dated 22 June 1645 and can be associated with three endowments given by De Mamez to provide for the singing of the antiphon Salve

Regina in the nave of the church after Vespers and before Compline upon various days, including certain feastdays of the Virgin.[39] The composition of the van Maelbeke *Virgin* is adapted to show the nave with its contemporary furnishings, and it was kept in the church at the same time as the Wyts copy of about fifteen years earlier.

The two drawings of the composition of the van Maelbeke *Virgin* show that the work was widely copied in order to preserve the composition. The Nuremberg drawing has grooves over all the main lines, showing that it has been traced over to make a copy.[40] The figure of the Virgin in a print of the sixteenth century[41] (Fig. 6, The Metropolitan Museum, Harris Brisbane Dick Fund), a direct copy of the van Maelbeke one, is exactly the same height as the figure in the Nuremberg drawing.

The drawings are unlikely to show the state of the painting as it left the workshop, for the figure of the patron is not fully finished, which would have been essential for a memorial panel. Van Vaernewyck, the most reliable source of information about this work, never calls the painting as a whole unfinished but refers specifically to the wings.[42] None of the later witnesses refer to it as unfinished, and indeed visitors to the church were told that it was a fifteenth-century painting and that it was the first picture to be painted in oil paint.[43] Furthermore, all of the copies are of the center panel.

This would mean that the original unfinished paintings on the wings were additions to van Eyck's van Maelbeke *Virgin*, which left the workshop in Bruges either with no wings or with blank wings. The unusual compositions of the interior wings are evidently unrelated to Jan van Eyck's work.[44] The original paintings could have been begun by a painter from Ypres in the later fifteenth century. The Old Testament subjects are often found in German paintings of the fifteenth century, such as the *Epitaph of Dr. Friedrich Schön* (Lorenzkirche, Nuremberg) of about 1465, attributed to the Master of the Wolfgang Altar.[45]

The center panel of the existing triptych is important evidence in itself that the original painting was finished. To cite only one feature belonging to a completed painting, the inscriptions are entirely in keeping with those found in paintings by Jan van Eyck, in their position, types of lettering, and textual sources. In the

only painting by Jan van Eyck in which the Christ Child holds a scroll, the *Dresden Triptych* (Staatliche Kunstsammlungen, Gemäldegalerie Alte Meister, Dresden), the inscription on it is exactly the same.[46] The quotation on the hem of the Virgin's mantle, which ends "Et sic in Sion firmata sum," is from Ecclesiasticus, Chapter 24, and this line of it is in the Little Office of the Blessed Virgin Mary for Matins.[47] This is a strong link to paintings like the *Virgin of Chancellor Rolin* (see Harbison essay, Fig. 1), (Musée du Louvre, Paris), in which the hem inscription also includes those words, and comprises all of the Matins text.[48] It has been noted that Honorius of Autun explained the words "And in Sion was I established" as referring to Sion as a tower and as the church and to the Virgin as a column supporting the church.[49] The appropriateness of this interpretation for the van Maelbeke composition, and the physical appearance and position of the Virgin within it, make it likely that this inscription is part of the original conception.

Further evidence that the original painting was completed rests in the *Virgin and Child with Saint Barbara and Jan Vos* (Exeter *Madonna;* cat. no. 7, Gemäldegalerie, Staatliche Museen Preussischer Kulturbesitz, Berlin), attributed to Petrus Christus, which uses the van Maelbeke *Virgin* as a source.[50] As the triptych copy was painted two centuries after Christus did his painting, and relies closely on the original, any similarities between them must stem from the painting by Jan van Eyck. These similarities extend to details not present in the copy drawings, such as the landscape background, the tiled floor, and the Virgin's red mantle and blue robe with ermine edging. The triptych copy also had a very fine cloth around the Christ Child, which was described in 1847 as a gauze as transparent as crystal, but this has been cleaned off.[51]

The original painting by Jan van Eyck, henceforth called the *Virgin of Nicholas van Maelbeke* may have been a large painting.[52] The center panel of the copy, with the frame, measures 120.7 x 197.5 cm, comparable to the *Virgin with Canon George van der Paele* (Stedelijk Museum voor Schone Kunsten, Bruges) on its side.[53] This sort of scale would be appropriate for its location in the choir of the church. Moreover, the original painting was often spoken of in the sixteenth century in connection with the large paintings in Ghent and Bruges.[54]

The *Virgin of Nicholas van Maelbeke* was certainly delivered to Ypres by 1445 at the latest, and the detailed knowledge that Petrus Christus had of the painting would have come from his having established a connection with an Eyckian workshop in Bruges on his arrival in the town in 1444. If the painting was a late commission left unfinished by Jan van Eyck at his death, shortly before 23 June 1441, it would have been completed by a member of the workshop, and it is conceivable that Christus saw the original painting. It should be noted, however, that it is not clear whether the drawings depict the painting as left at the death of Jan van Eyck or copy an early stage in the design process of the picture.

Evidence of the activities of the Bruges workshop after the death of Jan van Eyck is provided by the *Virgin and Child with Saints Barbara and Elizabeth and Jan Vos* (cat. no. 2); (Frick Collection, New York). It was painted after 30 March 1441 and before it was blessed by Martin, bishop of Mayo, on 3 September 1443.[55]

The general composition is linked to that of the van Maelbeke *Virgin,* with a similar relationship between the kneeling patron and the standing Virgin holding the Child, and the figures standing before a distant landscape. The arches are open to the sky, which continues across the painting from edge to edge. The lost van Maelbeke *Virgin* is the only known work of Jan van Eyck with this composition. There is a general similarity in the way the Virgin holds the Child, the flattened left sleeve of her mantle, and the fall of the rucked-up drapery beneath the Child. The ermine-trimmed robe of the Virgin is taken from the van Maelbeke *Virgin;* and in the detail of the loose left sleeve of the robe, the Frick *Virgin* is closer to the two copy drawings of the original painting than is either the Exeter *Virgin* or the triptych copy.

A good case can be made for the Frick *Virgin*'s being a pastiche created later in the workshop, and it shares motifs with a large number of Eyckian paintings. It is possible to discern the use of workshop drawings in its creation.[56] One example of this is the bridge in the landscape of the Frick *Virgin,* which is on the same scale as the one in the Rolin *Virgin* (Figs. 7, 8).[57] The artist has used a drawing of the left-hand side of the *Rolin* bridge, extending to just beyond the wayside cross, and reversed it. This is demonstrated by comparing the relative posi-

Figure 7. Detail of Workshop of Jan van Eyck, *Virgin and Child with Saints Barbara and Elizabeth and Jan Vos,* between 1441 and 1443. Oil on panel, transferred to canvas, transferred to Masonite presswood, paint surface 61.4 x 47.4 cm. New York, Frick Collection, no. 54.1.161 (photo: The Frick Collection)

Figure 8. Jan van Eyck, *Virgin of Chancellor Rolin,* ca. 1436. Detail of the landscape in reverse. Oil on panel, whole painting 66 x 62 cm. Paris, Musée du Louvre (photo: Réunion des musées nationaux)

tions of the wayside cross and the shrine standing upon the two bridges. One possible source for the copyist's drawing is the underdrawing of the Rolin *Virgin,* which could have been traced over. This is supported by the fact that the Christ Child in the Frick painting makes exactly the same gesture as the one in the Rolin *Virgin,* as this motif was a change made at the underdrawing stage of that painting.[58]

Jan Vos, perhaps before he left Bruges in 1450, commissioned Petrus Christus to paint a work similar to the one he had ordered from the workshop of Jan van Eyck. Christus had access to the Frick *Virgin,* or to drawings related to it, when he painted the Exeter *Virgin.*[59] He reused the figures of the patron, Saint Barbara, and the Christ Child, and the idea of the figure standing out before the landscape background under a rounded arch. Christus created, however, a new and informed synthesis of Eyckian motifs. His use of Eyckian vocabulary was not purely additive or decorative, but demonstrates that he understood the compositional purpose behind the use and juxtaposition of the motifs he borrowed.

Christus keeps the same physical relationship between the kneeling patron and the Virgin, but uses the figure of the Virgin from the van Maelbeke painting. He copies from van Eyck the subtle relationship between the figures and the setting, in which the figures completely obscure the lower parts of the architecture and the arches visually connect them from above. The way in which the sky and the landscape continue across the picture from edge to edge, is again repeated. Christus follows the van Maelbeke *Virgin* in cutting across the mantle of the Virgin, who therefore appears to stand slightly behind the frame. The left wall receding in space is like an expanded version of the one in the Lucca *Madonna* (Städelsches Kunstinstitut, Frankfurt am Main), and makes the architecture in the foreground very three-dimensional, which is the most striking compositional feature of the van Maelbeke *Virgin.*

The pattern of one of the floor tiles is from the Rolin *Virgin,* and Christus uses a row of such tiles to separate the two figures, mark out the two sides of the composition, and lead the eye into depth—just the way the device is used by Jan van Eyck.

The Exeter *Madonna* combines Eyckian motifs from the Rolin *Virgin,* the Lucca *Madonna,* and the van Maelbeke *Virgin,* all of which were also sources for the painter of the Frick *Virgin.* This seems to be a direct reaction to the commission from Jan Vos, who wanted his second, more personal painting to closely resemble his first. Of all Petrus Christus's existing paintings, the Exeter *Madonna* seems to have the most subtle combination of Eyckian motifs, and to draw upon the greatest number of purely Eyckian sources.

Christus doubtless acquired his thorough knowledge of Eyckian motifs by a number of different routes, but it seems likely that he copied or perhaps acquired a number of drawings from the workshop of Jan van Eyck and then had recourse to those drawings during the rest of his career. In the case of the van Maelbeke *Virgin* he evidently copied the composition, perhaps from drawings like those in Nuremberg and Vienna. It is worth noting, however, that he knew the colors of the robe and mantle of the Virgin, and it is possible that his source was a colored or annotated drawing kept in the workshop. There is also the possibility that he could have seen the original finished painting before it was delivered to Nicholas van Maelbeke.

The *Virgin of Nicholas van Maelbeke* was an important commission in the workshop of Jan van Eyck, and like other works by the master, it was the basis for the creation of a number of other paintings. The compositional and stylistic links between the van Maelbeke *Virgin,* the Frick *Virgin* and the Exeter *Madonna* show how close the connections were between the painters working in Bruges after the death of Jan van Eyck.

NOTES

1. Marcus van Vaernewyck, *Nieu tractaet en curte bescrijvinghe van dat Edel Graefscap van Vlaenderen* (Ghent, 1563) section 24, stanza 126; idem, *Den Spieghel der Nederlandscher Audtheyt* (Ghent, 1568), book 4, chap. lxi, fol. cxxxiij. This work was finished on 1 March 1561 and revised and extended in March and April, 1565. It was reprinted as *Die historie van Belgis* in Ghent in 1574; idem, *Van die Beroerlicke tijden in die Nederlanden en voornamelick in Ghendt 1566–1568,* ed. M. F. Van Der Haeghen (Ghent, 1872-81) pp. 74–75.

2. Antonius Sanderus, *Flandria illustrata,* 3 vols. (Amsterdam, 1641–44) vol. 2, p. 357; Alexandre Eeckman, "Un Voyage en Flandre, Artois et Picardie en 1714 publié d'après le manuscrit de sieur Nomis," *Annales du comité Flamand de France,* 22 (1895) pp. 337–572, 455–456; E. Martène et U. Durand, *Voyage littéraire de deux religieux bénédictins de la Congregation de Saint Maur* (Paris, 1717) p. 189.

3. In 1566 the church masters, altar keepers, and monks of the monasteries in the town removed the principal treasures and ornaments of the churches and concealed them in secret places, "Cort Verhael van 't ghonne binnen de stadt van Ypre . . . tzydert Juny 1566 tot omtrent half Ougst 1567," Bibliothèque Royale Albert Ier, Brussels MS II 4870, fol. l0r.

4. The position of the painting can be worked out from the information given by Sieur Nomis in 1714 and that in a lost manuscript by Petrus Martinus Ramaut, "Beschryving der vermaerde, oud beroemde en schoone stad Ypre," for which see note 9 below. The information from the lost manuscript was published by L. De Bast, "Série inférieur de la grande composition peinte, pour l'église de S. Jean à Gand, par Jean van Eyck," *Messager des Sciences* (1825) pp. 168–169; the passage giving the position of the painting is on p. 169, n.1.

5. For the architecture of the choir see Hugo Constandt, "De collegiale en kathedrale kerk Sint-Martinus: verminking, verwoesting en verrijzenis," in *De Sint Maartenskathedraal te Ieper. Een bundel studies* (Ypres, 1990) pp. 27–80, 31–42.

6. That would not be unusual in a painting by Jan van Eyck; for example, the *Virgin of Chancellor Rolin* has an arcade motif that may allude to the arcade of the north wall in the Chapel of Saint Sebastian in the Church of Notre-Dame-du-Chastel in Autun, where the painting hung. See Anne Hagopian van Buren, "The Canonical Office in Renaissance Painting—Part II: More about the Rolin Madonna," *Art Bulletin,* 60 (1978) pp. 617-633, 632-633, fig. 15.

7. I have not found a source for the information that the painting was taken to the bishop's palace, which first appears in De Bast, "Série inférieur," p. 169.

8. L. Preneel, "Kathedraal en parochie in de Franse tijd, 1792–1804," in *De Sint Maartenskathedraal te Ieper: Een bundel studies,* (Ypres, 1990), p. 175.

9. There are differences between the lost chronicle of Ypres by Ramaut and the existing one, the main differences being that 1) in the existing manuscript the painter is called "joannes van eijk" and not "Iosannes van Eycken"; 2) the existing manuscript does not say that the painting was made in Ypres; 3) it discusses van Eyck's invention of oil painting and copies van Vaernewyck's description of the painting by Jan van Eyck; and 4) it names Petrus Wyts, gives the date of his death, and describes the copy painting as being above his tomb. The surviving manuscript is Petrus Martinus Ramaut, *Historie ofte Beschrijving der vermaerde Stadt van Ipre, Hoofdstadt van Westvlaender,* 1768, Vijfde Cronicke (Stadsbiblioteek, Ieper); the lost manuscript was read in the town library of Ypres by Weale before 1908; he called it *Beschryving der vermaerde, oud beroemde en schoone stad Ypre,* MS no. 85, part 2, book 2, dated 1794 (See

W. H. J. Weale, *Hubert and John van Eyck* [London, 1908], p. 102, n. 1). As Ramaut died in 1783, the date 1794 is not that of the chronicle. The passage dated 1445 from the lost manuscript was first published by L. De Bast, "Série inférieur," p. 168, n. 2. Lambin owned the lost manuscript and divided it into four parts, each of two volumes, adding a fifth part to cover the period 1781 to 1833. A combination of the accounts in both the lost and the extant manuscripts is found in MS II 4888, *Chronyke beginnende van t'jaer 1250 tot het jaer ons heeren 1400,* fol. 104, Bibliothèque Royale Albert 1er, Brussels. The chronicle runs up to 1521; it was copied by G. F. D. Vandemeulen in Roesbrugge, and the relevant passage can be dated to June 1784 (see fol. 145r).

10. De Bast, "Série inférieur," pp. 168–169.

11. "Beschrijvinge van het clooster der grauwe broeders van sinte Fransois door de broeders P. de Roode ende Jan de Hane, 1405-1580," Bibliothèque Royale Albert Ier, Brussels, MS II 4881, vol. 5, fols. 152–171.

12. I have found references in the remaining town archives to eight 15th-century citizens of Ypres called van Maelbeke. The last member of the family is Jeanne van Maelbeke, the abbess of the Benedictine abbey of Nonnenbossche, near Ypres, who died on 12 April, 1455. There is good evidence that she was related to Nicholas van Maelbeke, and was probably his sister. N. Huyghebaert, "Abbaye de Sainte-Marie a Nonnenbossche," in *Province de Flandre occidentale,* Monasticon Belge, Centre National de Recherches d'Histoire Religieuse, tome III, fasc. 1, ed. A. De Meyer et al. (Liège, 1960), pp. 270–281, 276 (Jeanne van Maelbeke); Léopold van Hollebeke, *L'Abbaye Nonnenbossche de l'ordre de saint Benoit, près d'Ypres, 1101–1796, suivi du cartulaire de cette maison* (Bruges, 1865) p. 53, no. 17.

13. E. Feys and A. Nélis, *Les Cartulaires de la prévôté de Saint-Martin à Ypres, précédés d'une esquisse historique sur la prévôté,* Société d'Émulation de Bruges (Bruges, 1880–87) pp. 628–629, no. 783, 28 September 1425; ibid., pp. 664–68, no. 802, 26 May 1428; J. Pycke, "La Prévôté de Saint Martin à Ypres," in *Province de Flandre occidentale,* Monasticon Belge, Centre National de Recherches d'Histoire Religieuse tome III, vol. 3, ed. L.-E. Halkin et al. (Liège, 1974) pp. 932–989, 977–978 (Nicholas van Maelbeke).

14. H. Dubrulle, "Les Bénéficiers des diocèses d'Arras, Cambrai, Thérouanne, Tournai, pendant le pontificat de Martin V d'après les documents conservés aux Archives d'État, à Rome," *Analectes pour servir à l'histoire ecclésiastique de la Belgique,* 31, ser. 3 (1905) p. 297, no. 518; Pycke, "La prévôté," p. 977.

15. Olivier van Dixmude, *Merkwaerdige Gebeurtenissen, vooral in Vlaenderen en Brabant, en ook in de Aengrenzende Landstreken, van 1377 tot 1443,* ed. J. J. Lambin (Ypres, 1835) p. 181.

16. "Martyrologium met necrologium, lectionarium en regel van Saint Augustine" (Sainte-Marie de Voormezele), Bisschoppelijk Archief, Bruges, Fonds Voormezele, C217, fol. 56.

17. Herman vander Linden, *Itinéraires de Philippe le Bon, duc de Bourgogne (1419-1467) et de Charles, comte de Charolais (1433–1467)* (Bruxelles, 1940) p. 90. Town Accounts of Ypres, 1 January 1431 (n.s.)—31 December 1431, Bibliothèque Royale Albert Ier, Brussels, Fonds Merghelynck no. 32, vol. 3, Comptes originaux et cahiers 1406–1450 (1890), no. 38655, fol. 160.

18. Oliver van Dixmude, *Merkwaerdige gebeurtenissen,* p. 138; J. J. Lambin, *Tydrekenkundige Lyst* (Ypres, 1829) p. 41: Archduke Philip of Austria lodged in Saint Martin's in 1497.

19. Town Accounts of Ypres, Bibliothèque Royale Albert Ier, Brussels, fols. 233–4 (see note 17).

20. Feys and Nélis, *Les Cartulaires,* no. 815, 26 September 1431; E. Hautcoeur, *Cartulaire de l'église collégiale de Saint-Pierre de Lille,* 2 vols (Paris/Lille, 1894) vol. 2, p. 950, no. 1377; Feys and Nélis, *Les Cartulaires,* no. 858, no. 815, pp. 148, 636–642, no. 788.

21. For example, M. Héris, "Notice sur le célèbre triptyque de Jean van Eyck, qui ornait autrefois l'église collégiale de Saint Martin à Ypres, et qui fait aujourd'hui partie de la galerie de feu Monsieur Van den Schriek à Louvain," *Journal des beaux-arts,* 1 (1859) pp. 45-46, 53-54; James Weale, "Les Peintures de Jean van Eyck restées inachevées," *Revue de l'art chrétien,* 10, ser. 5 (1899) pp. 408-410; F. Winkler, "Jan van Eyck's Madonna von Ypern," *Pantheon,* 4, pp. 490–494.

22. I have not been able to get access to the triptych, but there are good photographs of it in the photograph library of the Institut Royal du Patrimoine Artistique/Koninklijk Instituut voor het Kunstpatrimonium in Brussels.

23. Fig. 1: Germanisches NationalMuseum, Nuremberg, inv. no. Hz 279; Fritz Zink, *Kataloge des Germanischen National-museums Nürnberg: Die Deutschen Handzeichnungen* vol. 1, *Die Handzeichnungen bis zur Mitte des 16. Jahrhunderts* (Nuremberg, 1968) p. 53, cat. no. 38; Dr. Rainer Schoch, *Meister der Zeichnungen: Zeichnungen und Aquarelle aus der Graphischen Sammlung des Germanischen Nationalmuseums* (Nuremberg, 1992) no. 6. Plate A: Albertina, Vienna, inv. no. 4841; Otto Benesch, *Beschreibender Katalog der Handzeichnungen in der graphischen Sammlung Albertina,* vol. 2, *Niederländischen Schule des XV und XVI Jahrhunderts* (Vienna, 1928) p. 3, cat. no. 13.

24. Weale, "Les Peintures," pp. 408–410.

25. Émile Renders, *Hubert van Eyck, personnage de légende* (Paris/Brussels, 1933) pp. 149, 151.

26. Max J. Friedländer, "Jan van Eycks Altar aus Ypern," *Der Cicerone* 21 (1929) p. 432.

27. In a report of the church council of Saint Martin's of 1824, the council was unclear about when the existing triptych left the church, and call it by "Jan van Eyck ofte andere." See A. Deschrevel, "Verdwenen kunstschatten uit de Sint Maartenskathedraal te Ieper," in *Studies voor M. English* (Bruges, 1952) pp. 114–116. Also see J. D. Passavant, *Kunstreise durch England und Belgien* (Frankfurt, 1833) p. 367; A. Michiels, *Les Peintures brugeois,* Histoire de la peinture flamande et hollandaise (Brussels, 1846) pp. 139–146; J. A. Crowe and G. B. Cavalcaselle, *The Early Flemish Painters,* 2nd ed. (London, 1872) p. 116; L. Kämmerer, *Hubert und Jan van Eyck* (Leipzig, 1898) pp. 98–99; Renders, *Hubert van Eyck,* pp. 147-155. Renders proposed that the entire triptych was by a Ypres painter of the sixteenth century, copying a lost Jan van Eyck.

28. For details of the scientific examination and the report of a 1975 commission on the painting see R. H. Marijnissen, *Schilderijen—Echt, fraude, vals* (Brussels/Amsterdam, 1985), pp. 389–398. A thesis dedicated to the *Maelbeke Triptych* was written in 1977 by Mme. L. Verheyden-Van Overstraeten, "De *Madonna met de proost Nicolaes van Maelbeke:* al dan niet het werk van Jan van Eyck?" (Katholieke Universiteit Leuven, Faculteit Letteren en Wijsbegeerte, Departement Archeologie en Kunstwetenschappen; Central Library, THL19515, 104 pp.) This work examines the authenticity of the triptych in detail and includes the results of most of the scientific examinations of the painting, including that of 1974.

29. The date October 12 recorded in the obituary of the cathedral chapter is that of the memorial founded by Wyts. A low requiem mass was said for him, probably at the altar of Our Lady, near which he was buried and of which he was a benefactor. See Brussels, Bibliothèque Royale Albert Ier, MS 4881, vol. 5, fol. 4v, fol. l9v; Brussels, Bibliothèque Royal Albert Ier, Fonds Merghelynck, no. 66, vol. 1, fol. 40 (Reg. aux Fondat. Saint Martin). The masters of the Table of Saint Peter in Ypres

30. This is the only time that Ramaut gives the name of the patron of the copy. The extract was first published by Daniel Masure, "De Madonna van Ieper" *Iepers Kwartier,* 10 (1974) no. 3, pp. 81–99. For Wyts as the probable patron of the triptych, see E. Dhanens, *Hubert and Jan van Eyck* (Antwerp, 1980) p. 313, and Verheyden—Van Overstraeten, "De *Madonna,*" pp. 101–102.

31. Weale, *Hubert and John van Eyck,* p. 99.

32. "Necrologium sive Liber obituum Sancti Martini Yprensis," Bibliothèque Royale Albert Ier, Brussels, MS II 4881, vol. 5, fol. 4v.

33. Jean Jacques Gailliard, *Bruges et le Franc, ou leur magistrature et leur noblesse,* 5 vols. plus supplement (Bruges, 1857–64), vol. 2, p. 416; L. Gilliodts-van Severen, *Coutume de la ville de Bruges,* Recueil des anciennes coutumes de la Belgique, Commission Royal pour la publication des anciennes lois et ordonnances de la Belgique, vol. 1 (Bruges, 1900), p. 146; W. van Hille, "Histoire de la famille van Hille," *Tablette des Flandres,* recueil 4 (Bruges, 1954) pp. 120–121, 303–310, and, for Petrus Wyts, 304.

34. Paul Huvenne, *Pierre Pourbus, peintre de Bruges, 1524–1584* (Bruges, 1984) cat. no. 4. The wings are signed and dated 1556. The arms of the Wyts family are described in Gilliodts—van Severen, *Coutume,* p. 147.

35. There is a well-preserved seal of Nicholas van Maelbeke on a document of 6 May 1436; Rijksarchief, Bruges, Inventaire des chartes et autres documents isolés sur parchemin provenant de l'ancienne abbaye de Nonnenbossche lez Ypres, no. 76. The provost is shown standing, bareheaded and tonsured, and holding a book in his left hand and a pastoral staff in his right. The staff rises above the level of his chin and has a crook top.

36. Feys and Nélis, *Les Cartulaires,* p. 165, n.5; Verheyden—Van Overstraeten, "De *Madonna,*" p. 71–73 and n. 20.

37. A. Deschrevel, *Schilderwerken van de Pseudo-Karel van Ieper (Frans Denys?) en zijn school* (Ypres, 1962) pp. 25–27. For example, cat. no. 12, a triptych wing with the Death of the Virgin and the Annunciation, from the Church of Our Lady in Poperinge. The painting is comparable in style, although not by the same hand, and is dateable to 1607.

38. Cantor of the cathedral 1642–48 ("Necrologium.. Yprensis," Bibliothèque Royale Albert ler, Brussels, MS II 4881, vol. 5, fol. 4v). The painting was lost 1914–18. There is a watercolor copy of the original in the Town Museum of Ypres (no. 436). Jan Thomas was born in Ypres on 5 February 1617 and died in Vienna in 1678. See Alphonse Vandenpeereboom, "Jean Thomas, peintre Yprois," *Annales de la Société historique, archéologique et littéraire de la ville d'Ypres et de la west-Flandre,* 1 (1861) pp. 3–8; Alfred von Wurzbach, *Niederländisches Künstler-Lexikon,* 2 vols (Vienna, 1910) pp. 709–710.

39. Rekeningen van de kerkfabriek van Sint-Maarten 1760–66, Bisschoppelijk Archief, Bruges, Fonds van het Bisdom Ieper, Y41, fol. 50. The cantor is presented by Saint Francis; also present are six choristers, as well as the choirmaster Judocus Thumaisnil.

40. Schoch, *Meister der Zeichnungen,* no. 6.

41. Attributed to the circle of Hieronymous Wierix (Antwerp, 1553?-1619), The Metropolitan Museum of Art, New York, Harris Brisbane Dick Fund, 1953, 53.601.18 (l92). George C. Williamson, ed., *Bryan's Dictionary of Painters and Engravers,* 5 vols. (London, 1905) vol. 5, pp. 369–370: Hieronymous Wierix, The Virgin with the Crown, after Jan van Eyck; Verheyden—van Overstraeten, "De *Madonna,*" p. 40 and plate 12. Not mentioned in M. Mauquoy-Hendrickx, *Les Estampes des Wierix conservées au Cabinet des estampes de la Bibliothèque royale Albert Ier: Catalogue raisonné,* 3 vols (Brussels, 1978–82).

42. Van Vaernewyck, *Den spieghel,* cap. lxi, fol. cxxxiij: "de Deuren zijn onvuldaen." See also Verheyden-van Overstraeten, "De *Madonna,*" p. 98; Marijnissen, *Schilderijen,* p. 398.

43. Eeckman, "Un voyage de Sieur Nomis,", p. 455; Ramaut, "Historie," Vijfde cronicke, anno 1445; Martène and Durand, *Voyage littéraire,* fol. 189.

44. See also Renders, *Hubert van Eyck,* p. 154; L. Baldass, *Jan van Eyck* (London, 1952) p. 279, n. 1; Verheyden—van Overstraeten, "De *Madonna,*" p. 103.

45. Joel M. Upton, *Petrus Christus* (University Park, Pa./London, 1990) fig. 88.

46. Weale, *Hubert and John van Eyck,* p. 136: "Discite a me quia mitis sum et humilis corde iugum enim meum suave est et onus meum leve." From Matt. 11: 29–30, "[Take my yoke upon you, and] learn of me; for I am meek and lowly in heart: [and ye shall find rest unto your souls]. For my yoke is easy, and my burden is light."

47. Carol J. Purtle, *The Marian Paintings of Jan van Eyck* (Princeton, 1982) p. 184.

48. Purtle, *Marian Paintings,* p. 67 and n. 32; van Buren, "The Canonical Office," pp. 617–620.

49. Purtle, *Marian Paintings,* p. 147; van Buren, "The Canonical Office," p. 622.

50. J. Bruyn, *Van Eyck Problemen* (Utrecht, 1957) p. 120.

51. J. de Mersseman, "Hubert, Marguerite et Jean van Eyck," in *Biographie des hommes remarquables de la Flandre occidentale,* vol. III (Bruges, 1847) p. 196.

52. For a small painting of the size of the drawings, see Renders, *Hubert van Eyck,* p. 154; Verheyden—van Overstraeten, "De *Madonna,*" p. 65.

53. Dirk De Vos, *Catalogue des tableaux 15ᵉ et 16ᵉ siècles: Brugge, Musées communaux* (Bruges, l982) p. 224: the *Vierge au chanoine Georges van der Paele,* with the original frame, is 141 x 176.5 cm.

54. Lucas de Heere, "Ode to the 'Agnes Dei,'" 1559, strophe 19 (in Weale, *Hubert and John van Eyck,* p. lxxx); van Vaernewyck, *Den Spieghel,* fol. 133; Ludovico Guicciardini, *Descrittione di tutti i paesi bassi,* 2nd ed. (Antwerp, 1588) p. l28.

55. H. J. J. Scholtens, "Jan van Eyck's 'H. Maagd met den Kartuizer' en de Exeter-Madonna te Berlin," *Oud Holland* 55 (1938) pp. 49–62. Jan Vos was the prior of the Carthusian monastery of Genadedal near Bruges after 30 March 1441 and until 1450. Martin of Mayo was suffragan bishop of Utrecht from c. 1433 and died before 12 August 1457. See J. F. A. N. Weijling, *Bijdragen tot de geschiedenis van de wijsbisschoppen van Utrecht tot 1580* (Utrecht, 1951) pp. 219–225.

56. I am currently writing my Ph.D. dissertation on the workshop and followers of Jan van Eyck.

57. Dr. Bernice Davidson of the Frick Collection kindly measured the bridge in the Frick painting, which is exactly 3.0 cm from one side to the other. The same portion of the *Rolin* bridge in the illustration in Giorgio T. Faggin, *L'opera completa dei Van Eyck* (Milan, 1968) pls. xliv–xlv, which is called actual size, measures between 3.0 and 3.2 cm. A mathematical calculation based on the photograph of the Rolin *Virgin* in Purtle, *Marian Paintings,* fig. 30, gave a result for the relevant part of the *Rolin* bridge of between 3.27 and 3.46 cm.

58. J. R. J. van Asperen de Boer and Molly Faries, "La Vierge au chancelier Rolin de Van Eyck: examen au moyen de la réflectographie à l'infrarouge," *La Revue du Louvre et les musées de France,* 40, no. 1 (February 1990) pp. 37–49; fig. 3.

59. Christus may have copied the entire painting, because he reused other parts of it, *e.g.* for the Virgin and Child in his *Virgin and Child in an Archway* in Budapest (cat. no. 11; Szépmüvészeti Múzeum, Budapest).

Discussion

Colin Eisler, Institute of Fine Arts, New York University, and Thomas Kren, The J. Paul Getty Museum

Colin Eisler:

The single major issue that this valuable seminar has failed to confront is the question: Did Petrus Christus go to Italy? Dr. Ainsworth's excellent catalogue contains a discussion of the pertinent literature on this topic in her essay "The Art of Petrus Christus" and in individual catalogue entries. Her work has itself made certain, through infrared reflectograms and X-radiographs, just how Petrus Christus used one-point perspective to construct space,[1] while also closely discussing aspects of the possible Italian connections.[2] Someone at this symposium must now go out on a limb and state a firm belief, or equally convinced disbelief, in an Italian journey.

I'm astride the bough that argues *for* such a southern trip. Documents credit the presence of a "Piero di Burges" in Milan in 1457. Many of his paintings were recorded in, and purchased from, Italy. The "Piero di Burges" was active at the Sforza court, working with "Antonello da Sicilia"—presumably Antonello da Messina.[3] Adolfo Venturi, the first to publish Christus's *Death of the Virgin* (now Timken Art Gallery, San Diego; cat. no. 15), ascribed it to a Sicilian "Maestro della metà del '400" when he reproduced it in his *Storia dell'arte italiana*. Antonello was identified as the author of almost every Memling male portrait when these were first published upon their rediscovery in the last 150 years!

Between the ease and economy of pilgrimage travel and the richness of trade among Bruges, Genoa, Venice, Florence, and Naples, an Italian journey for a successful early Netherlandish artist may have been the rule rather than the exception. Evidence points to Jean Fouquet, Rogier van der Weyden, Hieronymus Bosch, and possibly Gerard David as just a few of the many northern European artists to have traveled south of the Alps in the fifteenth century. Dr. Ainsworth has suggested that Gerard David had information about the site for his major altarpiece on the Ligurian coast,[4] and the same reason for travel may have held true for Hugo van der Goes. Such a study trip could have been undertaken before he painted the great *Portinari Altarpiece* (now in the Uffizi) for the Chapel of Sant'Egidio in the Florentine hospital church of Santa Maria Nuova.

Several paintings now or formerly attributed to Christus were listed in Venice and Florence (two in the Medici collection – the *Lady,* now in Berlin, and the *Saint Jerome,* Detroit; cat. nos. 19 and 1). Two recently discovered panels by our artist (Bruges, Groeningemuseum) have strikingly Italianate motifs.[5] Their style and content indicate that Christus may have studied Northern Italian Romanesque architecture and sculpture, while also examining recent painting in Ferrara, Bologna, and Florence.[6]

A star of this show, the Nelson-Atkins Museum *Holy Family* (cat. no. 20), was in Venice, in the collection of the duchess of Berry, in the early nineteenth century.[7] The *Nativity* (formerly Wildenstein and Company, New York, now in a private Spanish collection) was purchased in Genoa; the Kress *Donors* (National Gallery of Art, Washington, D.C.; cat. no. 12) depict members of the Vivaldi and Lomellini families—prominent Genoese families—possibly painted in Bruges.[8] Charles de Tolnay's pioneering article noted striking parallels in the roles that Petrus Christus and Piero della Francesca each played in his own country in terms of the use of light and space[9]. Though Christus could have learned one-point perspective in the north, it seems unlikely. He probably acquired this skill in Northern Italy, in the same fashion as Jean Fouquet did, most probably from Jacopo Bellini.[10]

The *Portrait of a Man* (Los Angeles County Museum; cat.a no. 16), so much improved by a recent cleaning, suggests direct consultation of Italian bust-length sculpture formulae more than it does a continuation of an Eyckian approach. This formula was very well known throughout Italy by the mid-fifteenth century, especially in Florence, as evidenced by portrait busts by Mino da Fiesole, among others.

So many of Christus's panels have warm reds and strong greens that have very little to do with early Netherlandish, or any other northern European pictorial tradition (though one of our participants saw similarities to the tonalities of Utrecht manuscript illumination); such coloring is closer to that of Venice or some other Italian region. For all of the above reasons, *aperçus,* and interpretations, I for one wish to cling, unabashedly, to the concept of Christus as a sophisticated traveler to several centers of present-day Italy, where he went to acquire learning and to sell his art.

Response to Joel Upton

Let's fly on to another subject, to that insect perched on the Carthusian's ledge (cat. no. 5). Might this not be a humanistic conceit, one very possibly based upon the many references in Pliny to trompe l'œil elements in ancient painting? In antiquity, many contests between artists were resolved by the ways in which the viewer—or Nature—accepted illusion for reality. Birds are described as pecking at painted fruit or viewers as trying to pull back painted curtains. Pliny was extremely widely read in the later Middle Ages and in the fifteenth century, and was of special interest to painters and sculptors both for his lives of the artists of classical times and for his nature studies.[11] Carlo Crivelli painted a similarly placed fly on the ledge of his wonderful *Madonna and Child* (Bache Collection, The Metropolitan Museum of Art).[12] In this, among Crivelli's very finest works, the possibility that the fly may be a classical reference is suggested by the Latin form of the artist's signature.

Response to Stephanie Buck

I want now to move on to Stephanie Buck's discussion, a comparison of the Christus Berlin wings and the Eyckian diptych (MMA). I must admit, even though it is obviously a very erudite and well-reasoned talk, to not being very much convinced by the suggestion that Jan van Eyck would have needed many prototypes from manuscript illumination—if I understood her correctly—to arrive at his own compositional discoveries. Every great artist is, in the words

of the great ghost of this meeting, Erwin Panofsky, a "parasite of the past," the degree of parasitism determined by many factors. I'd like also to point out that we don't know exactly where the Bedford Master comes from, though his atelier is first known in Paris. Could he have originated in the Netherlands and then gone to Paris, perhaps to come back north once again? There is a *Last Judgment* by the Bedford Master or his studio (Musée des Arts Décoratifs, Paris) with certain correspondences to Jan's work.

I'd also like to point out that the Jan van Eyck Saint Michael is based on a Byzantine model: the armor is Eastern in every regard. Christus has certainly updated this and given him an expensive new armor, possibly in the French or German style.

Thomas Kren:

May I offer one more question for Stephanie Buck? I was most intrigued by the discussion of the two hands in the *Last Judgment* panel by van Eyck. I think you distinguish between the technique of the upper and lower portions, which I think was called "blended" and which is the Eyckian technique of painting in oil glazes, and the other technique, which is more akin to a manuscript illuminator's, and which I think was called "additive"? In the catalogue it is argued that Christus's technique is sometimes more additive than blended. I have two questions: would one always say that everything that van Eyck painted had this fundamentally blended technique, and would one always say that Christus's technique was fundamentally an additive technique?

Stephanie Buck:

No, you cannot generalize about this issue too much. I think first of all there is the question of scale and of date. In the tiny Thyssen *Madonna of the Dry Tree,* which is late, the glazes are blended, much further than in the small early works, like the Exeter *Madonna.*

Kren:

Are you saying that van Eyck's technique was one that was always blended?

Buck:

Well, if you look at the Antwerp *Virgin and Child at the Fountain,* for example, which is very

small in scale, and blow it up in size, you have individually applied highlights—clearly not blended. But in other areas, like the draperies, there are blended zones. The hand (in the Eyckian *Last Judgment*), that I said might be by a book illuminator; the artist does not blend his strokes, even in areas necessitating subtle tonal transitions.

Kren:

OK, thanks very much. Actually, I thought it was a very interesting and suggestive paper. Should we proceed to the last paper, on the Maelbeke triptych? I have little to say except that I thought it was extremely clear and cogently argued and persuasive.

Yvette Bruijnen:

Could I just react to Mr. Eisler's remarks on Christus's presumed stay in Italy? I think the reason it is not so extensively treated in the catalogue is that the arguments that you give for his Italian sojourn can also be used against it. We know that there were many Italians coming to Bruges who could commission art. That would afford a marvelous opportunity to communicate information about perspective or could account for the way a client would want to be portrayed, like the Los Angeles portrait sitter. So it's quite a complex matter.

NOTES

1. See Maryan W. Ainsworth and Maximiliaan P. J. Martens, *Petrus Christus: Renaissance Master of Bruges,* exh. cat. (New York, 1994) pp. 43–49.

2. Ibid., pp. 60–62.

3. This is believed to be the case by F. Malaguzzi Valeri, *Pittore lombardi del Quattrocento* (Milan, 1902) p. 89, but denied by P. S. Schabacker, *Petrus Christus* (Utrecht, 1974) pp. 69–70, and disputed by G. Consoli, "Ancora sull 'Antonello de Sicilia': Precisazioni su alcuni documenti sforzeschi," *Arte lombarda* 21, no. 1 (1967) pp. 109–112, esp. p. 111, doc. I, among others.

4. Ainsworth, review of *Gerard David,* by Hans van Miegroet, *Art Bulletin* 72 (December 1990) pp. 649–654, esp. pp. 652–653.

5. See Colin Eisler, "A Nativity Signed PETRUS XPI ME FECIT 1452," in *Liber Amicorum Herman Liebaers,* ed. F. Vanwijngaerden et al. (Brussels, 1984) pp. 451–469.

6. Ibid., pp. 464–465.

7. F. Zanotto, *Nuovissima guida di Venezia e della isole della sua laguna* (Venice, 1856) p. 359.

8. Schabacker, *Petrus Christus,* p. 114.

9. Charles de Tolnay, "Flemish Paintings in the National Gallery of Art," *Magazine of Art* 34 (1941) pp. 174–200.

10. Otto Pächt detected the role of Bellini for Fouquet. See his "Jean Fouquet: A Study of His Style," *Journal of the Warburg and Courtauld Institutes* 4 (1941) pp. 85–102. Arthur Rosenauer has recently discovered documentary evidence of Fouquet's residence in Ferrara, which will soon be published.

11. This important topic has been investigated by Professor L. Armstrong of Wellesley College. Among her Pliny studies is "The Illustration of Pliny's *Historia naturalis* in Venetian Manuscripts and Early Printed Books," in *Manuscripts in the Fifty Years after the Invention of Printing,* ed. J. B. Trapp (London, 1983) pp. 97–106.

12. This detail is very well reproduced, but without any commentary, by Pietro Zampetti, in *Carlo Crivelli* (Milan, 1961) pl. 69.

Two Lost Portraits by Petrus Christus

Lola B. Gellman
Queensborough Community College, The City University of New York

In 1907 the city of Bruges was host to an important exhibition celebrating the order of the Golden Fleece, which Philip the Good founded in January 1430.[1] Among the paintings exhibited was a portrait of a woman from the collection of Leo Nardus of Suresnes, near Paris (Fig. 1). The painting was attributed by the owner to Hans Memling and the subject was identified as Margaret of York, who was married in 1468 to Charles the Bold. Even at the exhibition and in the publications associated with it, however, questions were raised about the painting's attribution and subject.[2]

In one of the exhibition catalogues, mention is made of a pendant portrait said to represent Margaret's husband, also owned by Nardus but not exhibited.[3] It is not known exactly when the portraits left the Nardus collection, but photographs of them are on file at the Frick Art Reference Library with the stamp of the Parisian art dealer Demotte and the date 3 November 1922.[4]

Subsequently, the paintings were sold at the auction of the Arnold van Buuren collection in Amsterdam in 1925 as portraits of Margaret of York and Charles the Bold, attributed to a Franco-Flemish Master of about 1470; the sales catalogue included descriptions and color notes (Figs. 2, 3). The catalogue entry reads: "Deux tableaux se faisant pendant. Ils sont vus en buste, lui de trois quarts à droite, coiffé d'une calotte terre cuite pâle et vétu d'un manteau bleu vert, garni de fourrure et à col rouge indien clair. Yeux baissés. Elles est réprésentée de trois quarts à gauche et porte, un costume décolleté bleu vert, bordé de rouge-orange. Autour du cou un collier en or serti de joyaux. Elle est coiffée d'un hennin tressé avec de l'or et muni d'un voile blanc, descendant dans le cou. Elle regarde le spectateur."[5]

The sales catalogue also reveals that the paintings had been transferred from panel to canvas in 1908, and includes an illustration of the male portrait. Differences between the 1907 and the 1925 photographs of the woman's portrait suggest that the paintings were not only transferred

to canvas, but were restored in 1908 or at some later date. This restoration seems to have altered certain passages, so that the collar, described as red in 1907, is red-orange in the sales catalogue, and its pattern is clearly visible. The woman's dress, earlier called blue, becomes blue-green. A comparison of the two photographs shows that the shaded modeling of the face appears to be much reduced, but most striking is the reduction of volume in the neck area, not only in the modeling, but in the width of the neck itself. This has produced the illusion of a thinner, longer, more elegant neck and face. There are other differences visible in the later photograph, including the virtual disappearance of the neck gauze and some details in the head veil. It is impossible to know if any change had occurred in the male portrait, since we lack an earlier photograph. There is no further trace of the paintings after the Amsterdam sale of 1925, except for a handwritten notation in the files of the Institut Royal du Patrimoine Artistique in Brussels, stating that the works were in a Swiss private collection in 1955.[6]

Let us now consider if the sitters are indeed Margaret of York and Charles the Bold. Margaret was twenty-two when she arrived in Bruges in 1468 to marry Charles in a political and economic alliance between England and Burgundy. Comparisons of the photograph of the lost painting with known portraits of Margaret reveal very little similarity. Such portraits include miniatures in manuscripts commissioned by the duchess and one anonymous panel painting convincingly identified as Margaret by the emblematic elements of her jewelry (Fig. 4).[7] These portraits show Margaret with a long, almost gaunt, face, prominent nose, and very slender body, features that are remarkably different from those of the woman in the Nardus painting.[8]

In his 1959 book on Margaret of York, Luc Hommel rejects the identification of the Nardus portrait as Margaret and suggests that she is actually Elisabeth Braderyck, wife of Pieter Adornes of Bruges. He refers to an engraving

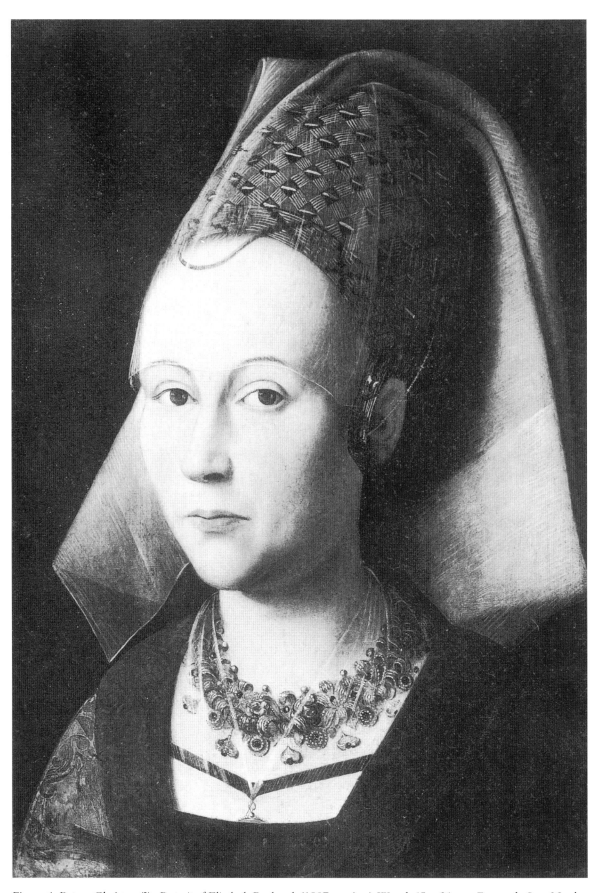

Figure 1. Petrus Christus (?), *Portrait of Elisabeth Braderyck* (1907 version). Wood, 45 x 31 cm. Formerly Leo Nardus collection, Suresnes; present location unknown (photo: by permission of the British Library, shelf mark 7807.5.10)

by Pieter I de Jode that reproduces the painting, set in an oval frame and having an inscription below giving her name, her husband's name, and her coat of arms.[9] Hommel does not mention the accompanying engraving of Pieter Adornes, similarly framed and identified (Figs.5a, b).[10] The inscription below the man's portrait reads: "Petrus Adornes, from the duchy of Genoa, mayor of Bruges, after the death of his wife and (after having) constructed Jerusalem in Bruges, he was made a Carthusian in 1445 and died in 1465," with his motto, Prepare Safely.[11]

Even without the de Jode engraving, we would reject the identification of the man as Charles the Bold. As a grown man, Charles is usually portrayed with a full head of wavy hair, and since he was made a member of the order of the Golden Fleece at his baptism in 1433, he always wears the collar of the order. This can be seen in the Berlin portrait, a workshop replica of Rogier van der Weyden's painting of about 1454, as well as in other examples.[12] Neither of these two features is found in the Nardus painting.

The discovery of these prints effectively eliminated the problem of the identity of the sitters but did not resolve the question of the authenticity of the paintings, which has been doubted by some who have seen the photographs. In the files at the Brussels Institut Royal du Patrimoine Artistique, the photographs are labeled *Faux*. Some believe that the paintings are nineteenth-century forgeries based on the engravings, with imaginary seventeenth-century costumes, jewelry, and headdress; and in the case of the woman, with somewhat altered proportions.[13] It is clear, however, that the engraving and the 1907 painting agree in these details, and that the garments and headdresses are authentic for fifteenth-century Flanders.

The Adornes family originated in Genoa and was part of the extensive Italian population resident in Bruges. Pieter and his brother Jacob are known as the founders and builders of the Jerusalem Chapel.[14] They were active in commercial trade and banking, held municipal posts, and belonged to religious organizations and confraternities. The family achieved a prominent and powerful position and had close ties with the Burgundian court. Both Pieter and Jacob Adornes supported Philip the Good during the uprising against the duke in 1436–38.[15]

Pieter Adornes was born about 1395 and married Elisabeth Braderyck, of a prominent Flemish family, in 1421. In 1452, he wrote his testament, in which we learn that he belonged to at least nine religious confraternities, including that of Our Lady of the Dry Tree, to which Petrus Christus also belonged. Adornes's wife, Elisabeth, died later that year, and we may suppose that the portraits were painted sometime before that date.[16] In 1454, Pieter Adornes entered the Carthusian cloister of Genadedal, near Bruges, and remained there until his death in 1464.

The garments they wear in the paintings reflect their affluence and position, but also suggest a general conservatism in the fashions they chose. Pieter Adornes wears a brocade, organ-pleated jacket with dark fur trim at the neck and a closed front, with a suggestion of padding at the top of the sleeve. The stand-up collar of the pourpoint, worn under the jacket, is visible above the fur trim, as is the white chemise worn underneath. He wears a close-fitting cap, with the lower edge turned up slightly toward the back, and his hair is just visible at the edges.[17]

Elisabeth wears a brocade robe with patterned collar that covers her shoulders and is open to her high-belted waist. The resulting décolletage is partially filled in with a dark cote worn under the robe, and a very light, transparent gauze under both cote and robe. As noted before, the gauze is almost invisible in the photograph of the cleaned painting. Her elaborate gold necklace, set with gems, is visible through the gauze, and below it is a partly hidden pendant hung on a ribbon. The headdress is a short cone woven with gold threads, and a white semi-transparent veil is draped over it. The hat is anchored on her head by the dark loop on her forehead.

A number of examples from manuscripts, tapestries, and panel paintings dating from the middle of the century will help to place the costumes worn by the Adornes couple in the proper time and context. In a depiction of the customs of the Romans from a manuscript of Valerius Maximus (mid-fifteenth century), the feasting and cavorting couples on the right are rather elegantly dressed in the Burgundian court fashion. The women wear short cone

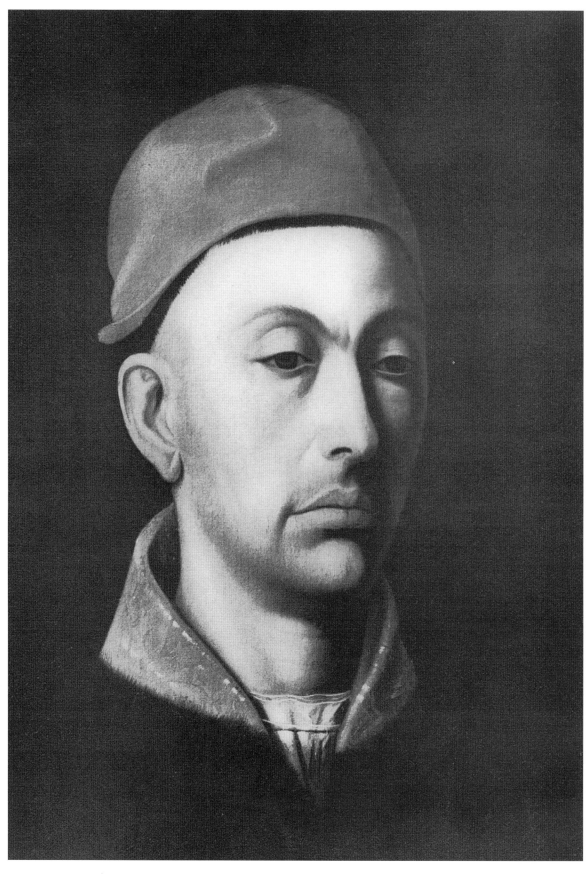

Figure 2. Petrus Christus (?), *Portrait of Pieter Adornes* (1925 version). Canvas transferred from wood, 47 x 34 cm. Formerly Leo Nardus collection; present location unknown (photo: R.K.D., The Hague)

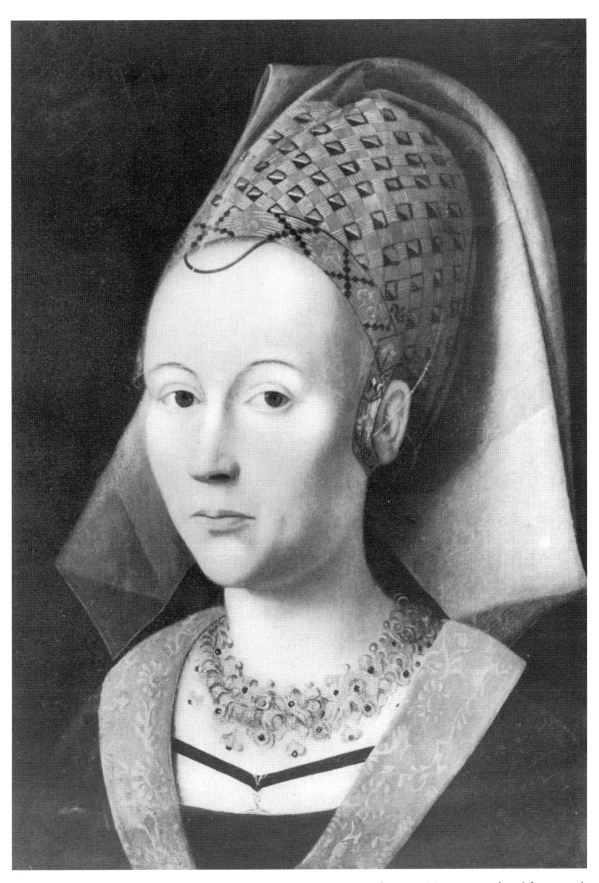

Figure 3. Petrus Christus (?), *Portrait of Elisabeth Braderyck* (1925 version of Figure 1). Canvas transferred from wood, 47 x 34 cm (photo: Witt Library, Courtauld Institute of Art, University of London)

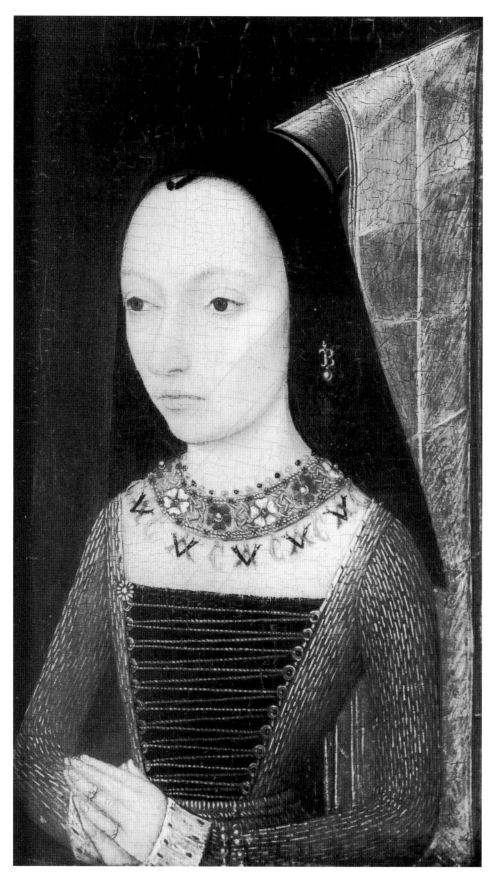

Figure 4. Anonymous, *Portrait of Margaret of York,* c. 1468. Oak, 20.5 x 12.4 cm, Paris, Musée du Louvre (photo: Réunion des musées nationaux)

Figure 5a. Pieter I de Jode, *Elisabeth Braderyck*, engraving, 15.6 x 11.5 cm. Brussels, Bibliothèque Royale Albert Ier (photo: Biblioteca Regia)

Figure 5b. Pieter I de Jode, *Pieter Adornes*, engraving, 15.6 x 11.5 cm. Brussels, Bibliothèque Royale Albert Ier (photo: Biblioteca Regia)

headdresses and veils, and their dresses are like Elisabeth's, but are arranged to be more revealing. The men wear jackets with closed and pleated fronts and padded shoulders, and standing pourpoint collars at the neck.[18]

In a more solemn scene of the death of Alexander from *L'Histoire d'Alexandre* (1448) (Fig. 6), two mournful women at the foot of the bed wear headdresses and modest outfits that resemble Elisabeth's. The woman to the right wears a dark robe with a light collar, and the woman to the left a light robe with a dark collar similar to the engraving and 1907 photograph of Elisabeth.[19] In the Bréviaire de Philippe le Bon (before 1460), the duke and duchess kneel before the Holy Sacrament.[20] Her costume is a more courtly version of Elisabeth's, while the short cone hat with veil is almost identical, although slightly taller.

In the presentation page of the *Chroniques de Hainaut* (c. 1446) made for Philip the Good, we find a range of costume worn by the men, depending on their age and station (Fig. 7).[21] Among these, the duke wears the stylish short jacket with brown fur trim. His pourpoint collar, cords, and white chemise are visible, as in the 1925 photograph of the Pieter Adornes portrait. The costumes in the presentation page

of another manuscript, that of the *Débat sur l'honneur* of about 1450, are of a later style. However, two courtiers to the right wear small caps with slightly turned-up side brims, like that of Pieter Adornes.[22] Pieter Adornes's garments seem to fall somewhere between the most elegant, courtly style and the most conservative. He has the rich brocade fabrics and substantial fur trim, but his organ-pleated jacket is closed down the front and not as tight on the body as some courtly attire.

Comparable fashions in costume can also be seen in fragments of a tapestry at The Metropolitan Museum of Art: *Figures in a Rose Garden*.[23] They are currently considered to be of southern Netherlandish manufacture, and to date from between 1450 and 1455.[24] The women wear brocade robes very similar to Elisabeth's, two with light collars and the other two dark, like the collar in the engraving.

Comparable examples of costume in panel painting are provided by Petrus Christus works of the period around mid-century: the 1449 *Saint Eligius* (cat. no. 6), and the Washington *Donors* (cat. no. 12).[25] The young man standing in the goldsmith shop is wearing the latest fashion for men of the court. The young woman's gown is very like Elisabeth's in style

Figure 6. Anonymous Flemish Illuminator, *Death of Alexander,* tempera on vellum. From *Histoire d'Alexandre,* 1448. Paris, Bibliothèque Nationale de France, MS fr. 9342, fol. 210v (photo: Bibliothèque Nationale de France)

and fit, with a similar transparent gauze at the neck. The handling of the veil over the head-dress seems very comparable in the two works, keeping in mind that in one case we are work-ing from a photograph. We might also note here that the color descriptions we have from the catalogues are close to the colors in the *St. Eligius*: blue or blue-green, red or red-orange, and terracotta.

The Washington *Donor* panels also offer sig-nificant features for comparison. The coats of arms displayed identify the couple as Genoese, and woman's name is probably Elisabeth, but the suggestion that they are identical with the engraved couple has been justifiably rejected.[26] The man's costume cannot be compared to

Pieter Adornes's, but the woman's garment is very similar to Elisabeth's, if somewhat less bulky in fit. The short cone headdress with veil is extremely close, except for the decoration and the fact that the loop is drawn straight across the forehead. It seems clear then, that the cos-tumes worn by the Adornes pair fit easily into the period around the middle of the fifteenth century.

The distinctive necklace that Elisabeth wears has no specific counterpart in other works of art or surviving jewelry. There are many wide necklaces set with gems, with and without pen-dants, to be seen in works throughout the fif-teenth century, but there are no examples of this particular design, with its exuberant, curv-

Figure 7. Attributed to Rogier van der Weyden, *Jean Wauquelin Presenting His Book to Duke Philip the Good*, tempera on vellum. From Jacques de Guise, *Chroniques de Hainaut*, ca. 1446. Brussels, Bibliothèque Royale Albert Ier, MS 9242, fol. 1 (photo: Bibliothéque Nationale de France)

Figure 8. Roundel, English or Flemish, 15th cent. Gold set with sapphire surrounded by white enamel beads. From the Fishpool (Nottinghamshire) Hoard London, The British Museum, no. 9 (photo: British Museum)

Figure 9. Pendant-Brooch, German, 15th cent. Silver, silver-gilt, enamel, with stones. Cologne, Museum für Angewandte Kunst, W. Clemens Collection (photo: Rheinisches Bildarchiv)

ing flower forms. The portrayal of foliage in jewelry is known from descriptions and surviving examples, and gem settings of the type found in Elisabeth's necklace appear in many known pieces (Figs. 8, 9).[27] We must therefore conclude that the necklace worn by Elisabeth is unlike any extant example of the period, but that such workmanship was possible.

There are some suggestions that can be made to explain the necklace, which does not appear in other engravings by Pieter de Jode the Elder (or the Younger).[28] It was surely a piece of jewelry worn by the patron in order to enhance her appearance, and perhaps to serve an emblematic purpose as well. The gold leaves of the necklace form a sequence of lilies, with a gemstone at the center of each (compare the lilies in Christus's Birmingham *Man of Sorrows,* cat. no. 9). They are not stylized but natural-looking and free-flowing in form. The lilies of the necklace might very well be references to the name Elisabeth, which is written *Lysebette* and *Lijsbette* in the two documents prepared for

Pieter Adornes in 1452 and 1454.[29] Across the lower band of Elisabeth's hat are stylized lilies in the form of a fleurs-de-lis decoration. It is possible that a reference to Burgundy and to the Adornes family's allegiance to the duke was intended. On the other hand, it may have been meant as a purely decorative element or another emblematic reference to the name Elisabeth.

Having established the identity of the sitters, let us now turn to the question of the attribution to Petrus Christus. Similarities in costume to the Washington *Donors* have already been noted, and it is also true of the general modeling of the heads and specifically the features, here lit from the left in a comparable manner.

The London *Portrait of a Young Man* (cat. fig. 66) is even closer in facial type, features and modeling to the portrait of Peter Adornes. We see again the similar type and handling of eyes, nose, cleft chin, and especially the mouth, which is full and slightly parted in both portrayals. The costume, however, is not particularly similar and does not suggest the same date. The parallels

here, and in other examples, can rather be seen as the kind of general likeness that an artist's portraits might share, as a result of a consistent tendency to idealize in a particular manner.[30]

Certain similarities to the portrait of Elisabeth can be seen in the pose of the Berlin *Portrait of a Lady* (cat. no. 19) and her averted face, with eyes that engage the viewer's. However, the very tight-fitting costume of the *Lady* has been shown to date from the 1470s, and the subtle modeling and pared-down forms contribute to a compelling psychological presence that is very different in effect from Elisabeth's.[31]

Except for the Los Angeles *Portrait of a Man* (cat. no. 16), the Adornes paintings are unusual for their plain setting.[32] There are, however, many examples of portraits with plain backgrounds in Flemish art from the periods before, during, and after Petrus Christus. In surviving pendant portraits of about 1430, the Master of Flémalle painted a man and wife of modest status against a plain dark background (National Gallery, London), as did Jan van Eyck, Rogier van der Weyden, and Hans Memling in various works.[33] Despite Christus's evident interest in placing figures in defined settings, in this case he may have been following the instructions of a patron.[34] The paintings may have had some modulation of light in the background corresponding to the direction of the light source from the left. This is suggested by the cast shadow in the engravings, but it is not visible in the photographs. The cast shadow suggests a setting; this may have been true of the paintings in their original condition.

The identification of the sitters in the engravings may have depended on now-lost information on the original frames or on the backs of the panels (as is the case with the coat of arms of Edward Grymeston, cat. fig. 65), or on inscriptions on frames in other works. Any of these would have provided the basic information for the engraver to include in his print.[35]

The evidence presented here for considering the lost paintings authentic works by Petrus Christus is primarily circumstantial. The possibility that the paintings were later copies after the Pieter I de Jode engravings certainly remains open. This is complicated by the evident cleaning and alterations of the paintings after 1907, at least as can be seen in the woman's portrait. In my opinion, however, the identification of the sitters and the close relationship of the painting (as seen in the 1907 photograph) to the engraving of Elisabeth Braderyck have provided a basis for considering the paintings authentic, or possibly copies after lost originals by Petrus Christus.

The known facts of the lives of Elisabeth and Pieter Adornes suggest a date of around 1450 for the portraits. The costumes are authentic for that date, as shown by comparisons with other known and dated works. They are also appropriate for the position the couple held in Bruges society at that time. Petrus Christus was then the most important and successful painter in Bruges, and he evidently enjoyed the patronage of members of the foreign population resident in Bruges and visiting from abroad.[36] Admittedly, it is difficult to compare color without the actual works, but the color descriptions from the catalogues are entirely consistent with the colors used by Christus about mid-century. Comparisons with Christus's figures, in the description and modeling of features, and in the psychological attitude and demeanor, seem to suggest the same hand.

It would be most fortunate if the renewed attention paid to the entire body of Christus's work in general, and to these two portraits in particular, were to result in their reappearance. They could then be examined technically in order to determine if they exhibit the characteristic handling and execution of Petrus Christus and whether they date from the mid-fifteenth century. Only in this way can the question of authenticity be finally settled. If the portraits should prove to be authentic, they would be important additions to the artist's production.

ACKNOWLEDGMENTS

I would like to acknowledge with special thanks the contributions of my research assistant, Patricia Anton, for all her efforts in the course of the research and preparation of the talk and article. I am also very grateful to Osvaldo Marti for his time and technical assistance, and to Stanley Weed, who worked under his supervision. This research was supported in part by a grant from The City University of New York PSC-CUNY Research Award Program.

NOTES

1. Several publications appeared in connection with this exhibition: Pol de Mont et al., *Exposition de la Toison d'or à Bruges,*. exh. cat. (Brussels, 1907); J. M. B. C. Kervyn de Lettenhove, *La Toison d'or: Notes sur l'institution et l'histoire de l'ordre (depuis l'année 1429 jusqu'à l'année 1559),* Exposition de la Toison d'or (Bruges, Juin-Septembre 1907), exh. cat. (Brussels, 1907); and idem et al., *Les Chefs-d'oeuvres d'art ancien à l'exposition de la Toison d'or à Bruges en 1907* (Brussels, 1908). The exhibition included almost three hundred paintings, most of them portraits, but also historical and religious paintings and miniatures, along with documents, arms and armor, collars of the order and other jewelry, sculpture, and ceramics.

2. In *Exposition* (p. 19, no. 17), de Mont lists the work as by Hans Memling (misspelled as *Menlinc*): "Portrait d'une Dame (Marguerite d'York?). Panneau, h. 45, l. 31 cm." The description reads: "Coiffée d'un escouffion, surmonté d'un voile retombant sur le front, en robe de brocart bleu à revers rouge, elle porte un collier d'or, enrichi de pierreries." Collection, Leo Nardus, Suresnes. Kervyn de Lettenhove (*La Toison d'or,* p. 38) calls the work a portrait of Margaret of York by Hans Memling. In idem et al., *Les Chefs-d'oeuvres* (p. 16, 17), Pol de Mont attributes the painting to an unknown Franco-Flemish painter of about 1470 and identifies the subject as Margaret of York, third wife of Charles the Bold.

3. *Les chefs-d'oeuvres,* p. 16, n. 1.

4. At that time George-Joseph Demotte had a gallery at 27, rue de Berri, Paris 8, and by 1930 Demotte Inc. occupied a gallery at 25 East 78th Street in New York.

5. A. Mak Van Waay, *Collections Arnold van Buuren, "'T Loover," Naarden: Tableaux anciens, antiquités,* Vente Publique les 26–27 Mai 1925, Amsterdam, p. 26, no. 71. "Toiles, H. 47, L. 34 cent. Ces tableaux ont été transportés de panneaux sur toiles en 1908." Prices were recorded in "Versteigerung der Sammlung Arnold van Buuren bei A. Mak," *Der Cicerone,* 17, (1925) pp.129-30: "Die flämische Schule glänzte durch die beiden Bildnisse von Karl dem Kühnen und seiner Gattin Margarethe von York, die in der Toison d'Or Ausstellung Brügge 1907 zu sehen waren und die man Hans Memlinck zuschreibt." The price was listed as "(holl. Gulden) 85000" for the pair. Unfortunately, there is no record of the buyer.

6. Visit of 30 July 1993.

7. For a discussion of the portraits of Margaret of York in manuscripts, see J. van den Gheyn, "Contributions à l'iconographie de Charles le Téméraire et de Marguerite d'York," *Annales de l'Académie royale d'archéologie de Belgique,* ser. 5, vol. 6 (1904) pp. 384–405, and idem, "Encore. . . " (1907) pp. 275–294. Also Jeffrey Chipps Smith, "Margaret of York and the Burgundian Portrait Tradition," in T. Kren, *Margaret of York, Simon Marmion, and "The Visions of Tondal"* (Malibu, 1992), pp. 47–56. For the panel painting, see Hélène Adhémar, *Le Musée national du Louvre;* Les Primitifs flamands. I. Corpus de la peinture des anciens pays-bas méridionaux au quinzième siècle, no. 5, vol. I (Brussels, 1962) pp. 11–18, cat. no. 79, pls. *V–IX.* The author believes it dates from c. 1468, shortly after the marriage of 13 July.

8. Luc Hommel, *Marguerite d'York ou La duchesse Junon* (Paris, 1959) p. 53. Hommel notes that according to the Burgundian chronicler Jean de Haynin, Margaret had an oval face and gray eyes, was tall and slender with narrow shoulders, and had an air of intelligence and a strong will. See also Christine Weightman, *Margaret of York, Duchess of Burgundy, 1446–1503* (New York, 1989) p. 51.

9. Hommel, *Marguerite d'York,* pp. 343–344. Hommel, however, mistakenly dates the engraving to the 18th century, p. 344, n. 1.

10. The two engravings are pasted together in a book in the Manuscript Room of the Royal Library, Brussels: *Grafschriften van Brugge: Versamelinge van grafschriften van verscheyde kerken, cloosters, abdyen van Brugge, veele door meesters de Hellin en Weemaer, priesters en genealogisten, en van andere daer by gevoegd, met curieuse schilderingen, alles sig refererende aen hun wercken en die van P. Beaucourt, etc.* (Bruges, n.d.), nos. 5 et 6.: "Pierre Adornes, bourgmestre de Bruges, mort en 1465, et sa femme, Isabelle Bruderyck. Le premier est signé: *Petr. de Jode sculpsit;* le second ne porte pas de souscription, et la planche semble ne pas avoir été terminée." Each print measures 15.6 x 11.4 cm. There is another example of the man's print in the Brussels Print Room. In addition, the engraving of Elisabeth with the inscription below prepared for printing, but still unfinished and with her name given as "ELISABETH" instead of the written "Isabella," along with two additional and identical versions of the Pieter Adornes engraving, is found in a work in the Stadsarchief of Bruges. The written inscription on her print reads: "Isabella Braderyck uxor nobilissimi D. Petri adornes ex ducubus de genua;" the printed legend is "ELISABETH BRADERYC() Uxor pronobilis Domini Petri Adornes, illa obiit j4()." The book in the Bruges Stadsarchief is P. Le Doulx, "Levens der geleerde ende vermaerde mannen der stad van Brugge," 2 vols. This handwritten work dates from about 1800, according to Noël Geirnaert, *Inventaris van de handschriften in het Stadsarchief te Brugge* (Bruges, 1984) p. 9, no. 18. In vol. 1 of the Le Doulx book, one of the prints of Pieter Adornes is on the page opposite p. 78; prints of the couple face each other two pages later. All of the prints are pasted onto the pages. The text gives some biographical information. There are other prints by Pieter de Jode and other engravers included in these two volumes, most displaying the same format and frame or with slight variations. I am very grateful to Mr. Geirnaert and his staff for their assistance in locating these additional prints of the Adornes family.

11. Maximiliaan P. J. Martens, "Artistic Patronage in Bruges Institutions, ca. 1440–1482" (Ph.D. diss., University of California, Santa Barbara, 1992) p. 294, nn. 506-509. Martens gives the correct reading of the Adornes motto *Para Tutum,* as well as the inscriptions and their translations. He notes that the dates given are both wrong.

12. *Portrait of Charles the Bold,* Gemäldegalerie, Staatliche Museen Preussischer Kulturbesitz, Berlin; see also the gold and enamel reliquary, 1468–71, in the Treasury of Saint Paul's Cathedral, Liège, in Walter Prevenier and Wim Blockmans, *The Burgundian Netherlands* (Cambridge/New York/Melbourne, 1986) fig. 278.

13. Martens, "Artistic Patronage in Bruges," p. 294, and n. 510. I have found no evidence for his assertion that the paintings had appeared on the art market with attributions to Petrus Christus. Friedländer knew the portrait from the 1907 catalogue. He thought it a copy and not like other portraits of Margaret. However, he considered the style and expression so Eyckian that the original could not have been painted after 1468 and might be considered a possible work of Jan van Eyck: M. J. Friedländer, *Die altniederländische Malerei* (Berlin, 1924), vol. 1, pp. 11–12.

14. On the Adornes family see Noël Geirnaert, "De Adornes en de Jeruzalemkapel: Internationale contacten in het laatmiddeleeuwse Brugge," in idem and A. Vandewalle, *Adornes en Jeruzalem: Internationaal leven in het 15de–en 16de–eeuwse Brugge,* exh. cat. (Bruges, 1983) pp. 11–49; N. Geirnaert, "Adornes…," in *Nationaal Biografisch Woordenboek,* Koninklijke Academiën van België (Brussels, 1987), vol. 12, col. 2–25; and idem, *Het archief van de familie Adornes en de Jeruzalemstichting te Brugge,* 2 vols. (Bruges, 1987–89).

15. Geirnaert and Vandewalle, *Adornes en Jeruzalem,* p. 17; *Woordenboek,* col. 22.

16. The Testament of 1452 is in the Bruges Stadsarchief; the 1454 document is on deposit at the Rijksarchief, Bruges. I would like to acknowledge the cooperation and assistance I received from the staff at both archives.

17. In the photograph of the painting, one cord is laced across the chemise to the underside of the pourpoint collar. The engraver shows a second one below it, but both cords are incorrectly attached on one side. Since the engraving of Elisabeth accords so well with the 1907 photograph of the painting, we may conclude that the engraver made an error in describing the attachment of the cords, as this style would no longer have been known to him a century and a half later. He may have been correct in showing two cords—one may have disappeared in cleaning. For material on costume I was fortunate that Roger S. Wieck, Associate Curator of Medieval and Renaissance Manuscripts at The Pierpont Morgan Library, was willing to share information on work done with Anne van Buren in an early stage of her costume-dating project, and to advise me on matters relating to the manuscripts referred to here. Anne van Buren was very helpful, offering suggestions on costume and jewelry, and examples of comparative manuscripts.

18. Anonymous Flemish Illuminator, *Customs of the Romans,* in Valère Maxime, "Faits et dits mémorables," mid-15th century, tempera on vellum, Bibliothéque Nationale de France, Paris, MS fr. 6185, fol. 51. L. M. J. Delaissé, *La Miniature flamande: Le Mécénat de Philippe le Bon,.* exh. cat., Palais de Beaux-Arts (Brussels, 1959) p. 39, cat. 34, pl. 17.

19. Anonymous Flemish illuminator, *Death of Alexander,* in an MS of *L'Histoire d'Alexandre,* 1448, tempera on vellum, Bibliothèque Nationale de France, Paris, MS fr. 9342, fol. 210v. Delaissé, *La Miniature,* p. 51, cat. 40.

20. Willem Vrelant, *Philip the Good and the Duchess of Burgundy Adoring the Holy Sacrament,* in Bréviaire de Philippe le Bon, before 1460, tempera on vellum, Bibliothèque Royale Albert Ier, Brussels, MS 9026, fol. 258; Victor Leroquais, *Le Bréviaire de Philippe le Bon,* 2 vols. (Brussels, 1929), p. 125, pl. XLVIII; Frédéric Lyna, *Les Principaux Manuscrits à peintures de la Bibliothèque royale de Belgique,* ed. Christiane Pantens, tome III, 2 vols. (Brussels, 1989) pp. 305–311, 462–463.

21. Attributed to Rogier van der Weyden, *Jean Wauquelin Presenting His Book to Duke Philip the Good,* in an MS of Jacques de Guise, *Chroniques de Hainaut,* c. 1446, tempera on vellum, Bibliothèque Royale Albert Ier, Brussels, MS 9242, fol. 1. For the possible attribution of the design of this page to Rogier van der Weyden, see Erwin Panofsky, *Early Netherlandish Painting,* 2 vols. (Cambridge, 1964) p. 268 and n. 3; and L. M. J. Delaissé, "Les *Chroniques de Hainaut* et l'atelier de Jean Wauquelin a Mons, dans l'histoire de la miniature flamande," in *Miscellanea Erwin Panofsky* (Brussels, 1955) pp. 21–56, esp. p. 21. See also Lyna, *Principaux manuscrits,* pp. 9–15, 409–412, pls. I, IA; on p. 12 it is stated" . . .le volume était décoré, du moins la première page en 1446." The general date for the first volume of the *Chroniques* is given as 1448 (p. 409).

22. Jean de Tavernier, *Jean Mielot Presenting His Book to Duke Philip the Good,* in an MS of Bonus Accursius (attrib.), *Débat sur l'honneur,* c. 1450, tempera on vellum, Bibliothèque Royale Albert Ier, Brussels, MS 9278, fol. 1. P. Cockshaw et al., *Charles le Téméraire,* exh. cat., Bibliothèque Royale Albert Ier (Brussels, 1977) pp. 175–176, cat. no. 75; *Trésors de la Toison d'or,* exh. cat., Palais des Beaux-Arts (Brussels, 1987) p. 112, cat. no. 31, illus. p. 113; Lyna, *Principaux manuscrits,* pp. 302–305, 462, pl. LXXXV; the title given for the complete manuscript here is *Recueil didactique*; fol. 1 is one of many variations of the Presentation page of the *Chroniques de Hainaut.*

23. Rogers Fund 1909, 09.137.3.

24. Adolfo Salvatore Cavallo, *Medieval Tapestries in the Metropolitan Museum of Art* (New York, 1993) pp. 174–189, cat. no. 8c. In another fragment, cat. no. 8b, a man on the left wears a cap on his head and holds his chaperon in his hands.

25. *Saint Eligius,* The Metropolitan Museum of Art, New York, Robert Lehman Collection, 1975.1.110; *Portrait of a Male Donor* and *Portrait of a Female Donor,* National Gallery of Art, Washington, D.C., Samuel H. Kress Collection, 1961.9.10–11.

26. Martens, "Artistic Patronage in Bruges," p. 259 and n. 512.

27. For example, a medallion, one of twelve, with enamelled gold and pearls on posts in Cleveland: The Cleveland Museum of Art, J. H. Wade Fund; see Prevenier and Blockmans, *Burgundian Netherlands,* pp. 90, 91, pl. 77. Ronald W. Lightbown, *Mediaeval European Jewellery* (London, 1992), mentions (p. 243) a foliate gold chain owned by Eléanore of Navarre in 1442, and points out that some chains were similar to what would later be called collars (p. 242). Another example of foliated treatment is found in a ring brooch of gold, onyx cameo, and rubies: Victoria and Albert Museum, London, 139—1879, illustrated in Lightbown, p. 496, cat. no. 18, color pl. 123. Lightbown identifies the brooch as Spanish, 14th or 15th century. The outer foliated ring frame of the brooch, however, is labeled at the museum as probably French or Burgundian, first half of the 15th century. Lightbown suggests that series of brooches, often of flower design with pendants and beads, may have been mounted on some material to form a collar (see p. 286). For foliage and gem settings, the pendant-brooch (silver, silver gilt, enamel, stones; W. Clemens Collection, 1919/20, inv. no. G 909 Cl) in the Cologne Museum für Angewandte Kunst (formerly the Kunstgewerbemuseum) is discussed in Anna Beatriz Chadour and Rudiger Joppien, *Kunstgewerbemuseum der Stadt Köln: Schmuck,* vol. 1 (Cologne, 1985), pp. 181–182, cat. no. 72, pl. V.. I want to thank Dr. Gerhard Dietrich of the Cologne Museum for his generous assistance. In addition, John Cherry, Deputy Keeper, Department of Medieval and Later Antiquities at the British Museum, brought to my attention the gold roundel found in the Fishpool Hoard. He believed that the arrangement of white enameled beads, set in a circle around a central gem, was comparable to the settings in Elisabeth's necklace. The items found in this hoard are considered to date from the mid-15th century and to be of Flemish workmanship or inspiration. See J. Cherry, "The Medieval Jewellery from the Fishpool, Nottinghamshire, Hoard," *Archaeologia,* 104 (Oxford, 1973) pp. 307-321. The roundel is discussed on pp. 315–316, no. 9, pl. LXXXVI b. Cherry examined the photograph of the Elisabeth Braderyck painting and expressed the opinion that her necklace was consistent in style and workmanship with Flanders in the mid-15th century (meeting of 22 July, 1994).

28. Engravings by Pieter de Jode the Elder that show figures with necklaces are found in the series of *The Temperaments* (F. W. H. Hollstein, *Dutch and Fleming Etchings, Engravings, and Woodcuts, ca. 1450–1700* [Amsterdam, 1949–], vol. 9, pp. 101–105) and *Fashions of Different Nations* (in ibid., pp. 237–246), as well as many of the portraits of women by Pieter de Jode the Younger in the books listed above in note 22.

29. I want to thank Dr. Elie and Esther Lowy for their assistance in reading the documents.

30. Lorne Campbell, *Renaissance Portraits: European Portrait-Painting in the Fourteenth, Fifteenth and Sixteenth Centuries* (New Haven/London, 1990) p. 14.

31. Maryan W. Ainsworth and Maximiliaan P. J. Martens, *Petrus Christus: Renaissance Master of Bruges,* exh. cat. (New York, 1994) p. 168.

32. Ainsworth and Martens, *Petrus Christus*, pp. 50, 93–94, 100.

33. Campbell *Renaissance Portraits,* pls. 104, 105, 80, 186, 22, 65, 72.

34. Lorne Campbell, "The Art Market in the Southern Netherlands in the Fifteenth Century," *Burlington Magazine* 118 (1976) pp. 192-194, and idem, *Renaissance Portraits,* pp. 140–141.

35. Martens, "Artistic Patronage in Bruges," p. 294

36. Ibid., p. 296 and n. 514.

Defining a Petrus Christus Group

J. R. J. van Asperen de Boer
University of Groningen

An Identical Contemporary Version of the Petrus Christus
Madonna and Child in an Archway

In 1976, when the author was examining some early Venetian paintings in the storeroom of the Dienst voor's Rijks Verspreide Kunstvoorwerpen in The Hague, his attention was drawn to a *Madonna with Child in an Archway* on one of the racks (Plate 7). The curator, the late Mrs. Brenninkmeyer-de Rooij, pointed out that the picture was a fake. Indeed, the reverse still carries a label to this effect.[1]

Examination with a stereomicroscope quickly showed that the picture was quite consistent with a fifteenth-century origin. The files of the Dienst voor 's Rijks Verspreide Kunstvoorwerpen revealed that Dr. H. Kühn of Munich (Doerner Institute) had previously examined the painting, as well as the Budapest version (Plate 8). In his unpublished report of 21 August 1967, Kühn could thus compare the two paintings. Not only are the dimensions almost identical, but the pigments identified in both paintings were found to be the same: natural ultramarine, azurite, vermilion, lead white, and lead-tin yellow (I)—a pigment that fell into disuse in the eighteenth century.[2]

The author independently examined the Hague picture and took some paint samples. He was able to corroborate Kühn's results. The new paint cross sections, moreover, showed a two-layer structure on top of a grayish intermediate layer (visible in X-radiographs as well) on the ground. This buildup is somewhat simpler than that found in Eyckian paintings and quite compatible with a genesis in the Petrus Christus group.

The panel was examined with infrared reflectography in 1976 and 1993; underdrawing was revealed only in the columns. The grayish intermediate layer also shows up in reflectograms.

In February 1994, Dr. Peter Klein of Hamburg carried out a dendrochronological examination. He was able to establish a felling date of 1432 .. /1434 /1438, with sapwood rings present. Taking into account an estimated ten-year storage period, we can estimate that the panel was probably used after 1444. The oak wood used for this panel is thus older than that in the Budapest painting, where Klein found a felling date of 1437 .. /1439 /1443 + x, suggesting the panel was used in or after 1449.[3]

Discussion

The Hague panel contains sapwood rings and its earliest dendrochronological date, therefore, cannot be shifted toward a later one, which would theoretically be possible for the Budapest panel, which has no sapwood rings. The close dendrochronological dates strongly suggest an origin in the same workshop, as do the virtually identical dimensions.

Urbach has suggested on stylistic grounds[4] that the Hague version might be a sixteenth-century copy. However, Klein has established that confusingly similar versions in the Rogier van der Weyden group are painted on panels contemporary with a later copyist, and not on earlier panels.[5]

Comparison between the Budapest and the Hague versions—a direct confrontation has so far not been possible—leaves no doubt that the former must have been created first. The arguments put forward by Ainsworth are quite convincing.[6] Idiosyncrasies, such as the use of a compass for constructing the arch (visible in X-radiographs)[7] and the changed architecture, support this.

Stylistic comparison of the painting technique also favors an attribution to Petrus Christus of the Budapest version. For instance, the modeling in yellow of the figures of Adam and Eve with thinnish, overlapping strokes is very similar to that in the small figures on the throne

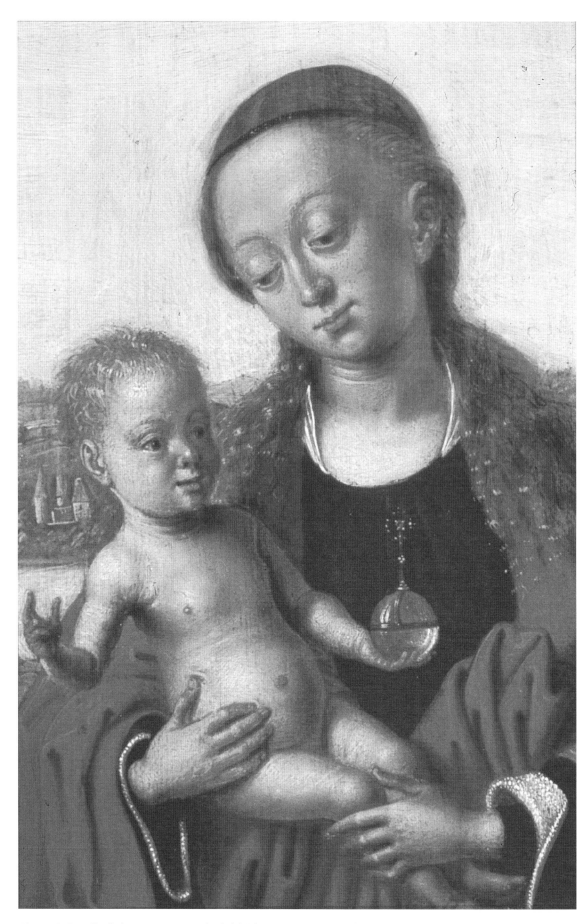

Figure 1. Detail of Plate 7, Virgin and Child (photo: Van Asperen de Boer)

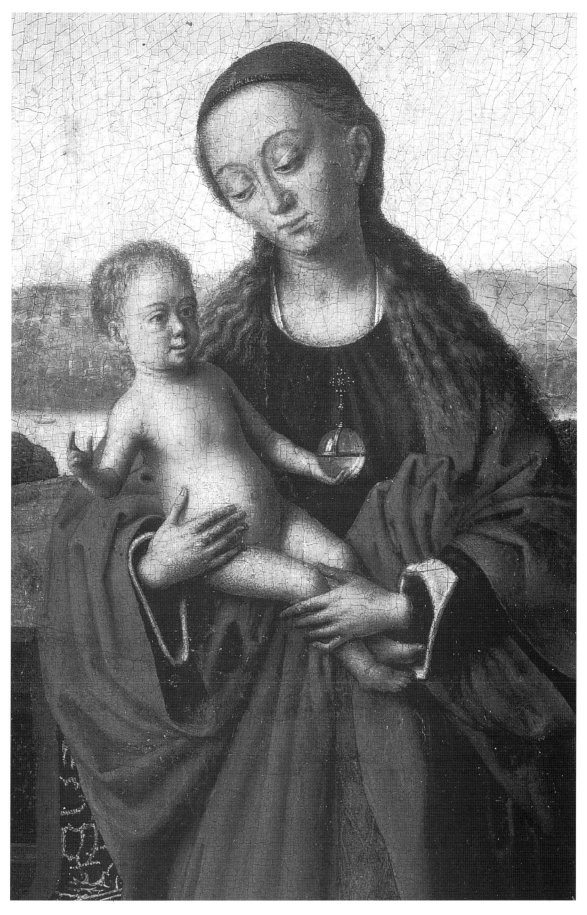

Figure 2. Detail of Plate 8, Virgin and Child (photo: M. Ainsworth)

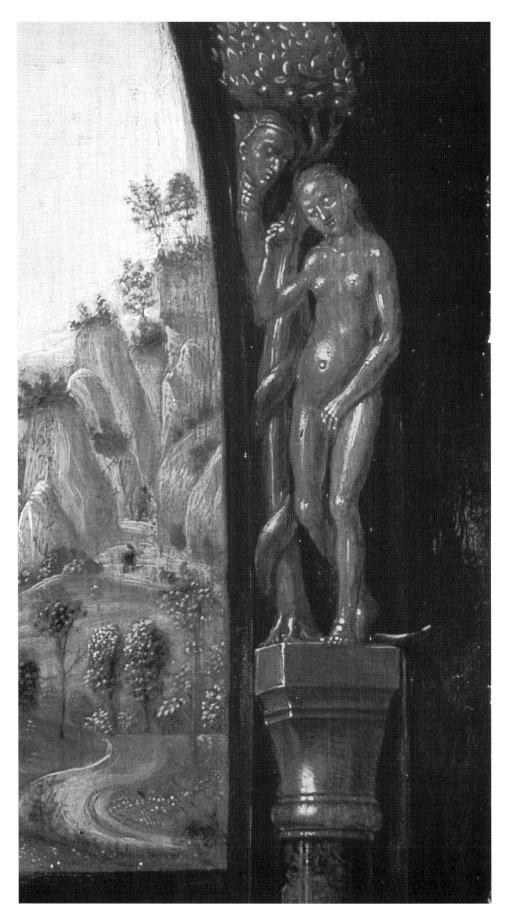

Figure 3. Detail of Plate 7, statue of Eve (photo: Van Asperen de Boer)

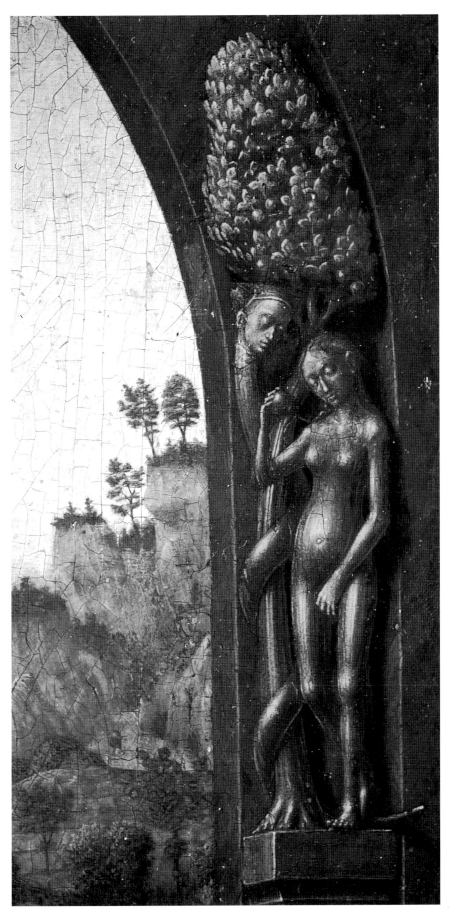

Figure 4. Detail of Plate 8, statue of Eve (photo: M. Ainsworth)

Figure 5. Detail of Plate 7, landscape (photo: Van Asperen de Boer)

Figure 6. Detail of Plate 8, landscape (photo: M. Ainsworth)

in the signed and dated Frankfurt *Madonna Enthroned with Saints Jerome and Francis* (cat. no. 13). In the Hague version, a rather thicker emulsion paint was used.

Another obvious difference is the presence in the Hague version of a streaky, grayish, flesh-colored intermediate layer, visible in both infrared reflectograms and X-radiographs.

Ainsworth considered the Hague version ". . . probably a weak though contemporary copy."[8] It would seem that the most interesting aspect is precisely that it is a *contemporary* copy. Petrus Christus is one of the few Flemish painters documented as having agreed to produce identical copies: "tres ymagines / ad similitudinem"[9] (now lost) were made of the Cambrai *Madonna.* In the two versions of the *Madonna and Child in an Archway,* we could well have a remnant of this practice. Judging from the technical evidence, it is likely that a different hand produced the Hague version in the studio of Petrus Christus (compare Figs. 1-2, 3-4, 5-6).

NOTES

1. It is unclear why the painting was considered a fake. It was included in the exhibition "Vals of Echt?" at the Stedelijk Museum, Amsterdam in 1952, and was subsequently shown in Basel (1953 as no. 38, "Fälschung nach Petrus Christus," in the category *Fälschungen ohne direktes Vorbild, im Stil einer Zeit oder eines bekannten Meisters* . . . and the United States ("True or False", Corning, Baltimore, New York, Boston, and Louisville, 1953-54). The painting returned damaged from the United States, and paint was fixed with wax. Further data on provenance and subsequent history in *Van Eyck to Bruegel, 1400 to 1550: Dutch and Flemish Painting in the Collection of the Museum Boymans—van Beuningen* (Rotterdam, 1994) pp. 40–43.

There is no doubt that the Hague picture is identical with the painting mentioned by Friedländer (*Early Netherlandish Painting,* trans. Heinz Norden, 14 vols., I [Leiden, 1967] p. 85) as sold in the Sellar auction, Paris, 1892. Germany returned the painting after World War II; it was at first taken for the now-lost larger (60.5 x 47 cm.) version, formerly in the Stroganoff Collection. It has been on loan to the Museum Boymans—van Beuningen since 1994.

2. The Budapest picture (Szépmüvészeti Museum, inv. no. 4324) measures 55.8 x 31.8 cm. The Hague painting (Dienst voor 's Rijks Verspreide Kunstvoorwerpen, inv. 1305, NK 1841) measures 56.6 x 31.6 cm. The Hague panel lacks a well-defined barbe and has no unpainted edge. This seems to be true of the Budapest picture as well. The original frame was probably sawn off closely in both cases. The original panel of the Hague version is thinned to c. 4 mm., and was transferred to another panel of similar thickness, and cradled.

3. Reports by Dr. Peter Klein, dated 7 July 1994 and 24 March 1992, respectively.

4. Susan Urbach, during discussion in the International Symposium Petrus Christus in Renaissance Bruges, New York, 10–12 June 1994.

5. For a survey and discussion, see J. R. J. van Asperen de Boer, J. Dijkstra, and R. Van Schoute, "Underdrawing in Paintings of the Rogier van der Weyden and Master of Flémalle Groups," *Nederlands Kunsthistorisch Jaarboek* 41 (1990) pp. 42–49.

6. Maryan W. Ainsworth and Maximiliaan P. J. Martens, *Petrus Christus: Renaissance Master of Bruges,* exh. cat. (New York, 1994) pp. 126–130. The Hague version was inadvertently printed on p. 127.

7. This could be deduced from the X-radiograph of the Budapest picture.

8. Ainsworth and Martens, *Petrus Christus,* p. 130, n. 18.

9. Maximiliaan P. J. Martens, "Petrus Christus: A Cultural Biography," in ibid., pp. 15–23 and Appendix 1, p. 195.

On the Technique of Two Lesser-Known Paintings of the Petrus Christus Group: The Amsterdam *Virgin and Child with Saints* and the Turin *Madonna and Child*

The Amsterdam *Virgin and Child with Saints* (Fig. 1) was attributed by Friedländer[1] to a contemporary follower of Jan van Eyck. Little is known about its provenance. It was sold at an auction of the von Nemes collection in Munich in 1928 and was acquired by the collector E. Proehl. It is still the property of his heirs.

Josua Bruyn has suggested that the picture may be reminiscent of the lost *Lomellini Triptych* by Jan van Eyck described by Fazio.[2] The panel is cradled and measures 54.6 x 72.7 cm. The original frame is lost, and the panel is slightly cropped.

The picture was examined with scientific methods by the author and Ariane van Suchtelen in 1985.[3] Dr. Peter Klein of Hamburg measured the tree rings of the three oak boards constituting the panel in June 1987 and established a dendrochronological felling date of 1446 .. / 1448 / 1452 + x. With a possible ten-year storage period, this suggests that it was painted from 1458 on. That would bring the panel within the time period of the Petrus Christus group.[4]

Infrared reflectography[5] revealed brush underdrawing without much detail; the hands are indicated in coarse contours (Fig. 2). Some shifts occurred during painting, notably in the face of the Virgin (Fig. 3), which inclined more to the right in the underdrawing. The clothing was underdrawn with firm contours and fold lines, which were generally followed in painting. Sparse hatching elucidates concave and convex shapes. This hatching is comblike or in the form of short, more or less parallel strokes across a fold line. Some crosshatching occurs as well.

Reflectograms show that the crossbeams of the roof are underdrawn with a ruler, but the diagonals are freehand. The capitals and arches are also underdrawn freehand. The circles of the window tracery were drawn with a compass (Fig. 4): dots can be observed in the reflectograms and corresponding holes in the X-radiographs.[6] Faries[7] has observed with infrared reflectography the use of a compass

and ruler in the Kansas City *Holy Family in a Domestic Interior* (cat. no. 20).

The tiles are apparently not underdrawn, but are reinforced by incisions in the paint—lines that appear dark in the X-radiographs. Such incisions are also visible in the horizontal edges of the crossbeams. Clearly the painter was striving for a certain rationalization of the interior space, but did not achieve it with a rigid perspective construction.

Comparison with Underdrawing in Some Petrus Christus Group Paintings

The signed and dated Frankfurt *Madonna Enthroned with Saints Jerome and Francis* (cat. no. 13) was first reflectographed in 1979 with the author's equipment.[8] Sander published his infrared reflectogram assemblies of the entire painting and the central part in 1993.[9]

The use of a ruler—especially in the horizontals of the steps of the throne which run underneath the carpet—is evident from reflectograms, but some diagonals appear to be drawn freehand.[10] Sander thought that the steps and tiles were incised freehand in the ground before painting began, many light lines being visible in the X-radiographs.[11] He concluded, therefore, that although Petrus Christus was trying to orient diagonals toward a common point, no perspective construction could be expected. In this respect, the two paintings have much in common.

Comparison of the underdrawing of the figures in the Amsterdam picture with that in other Petrus Christus group paintings turns out to be less convincing. Faces and hands in the Frankfurt panel and the Brussels *Lamentation* are also summarily drawn, but the robes are far more elaborately underdrawn, with great density and variety of hatching—in both the smaller and the large format paintings (see cat. figs. 50-51 and 142-145). The abundance of short, needlelike hatching in the Brussels *Lamentation* is certainly not encountered in the underdrawing of the Amsterdam panel.[12] Still, the comblike parallel hatching and cross hatch-

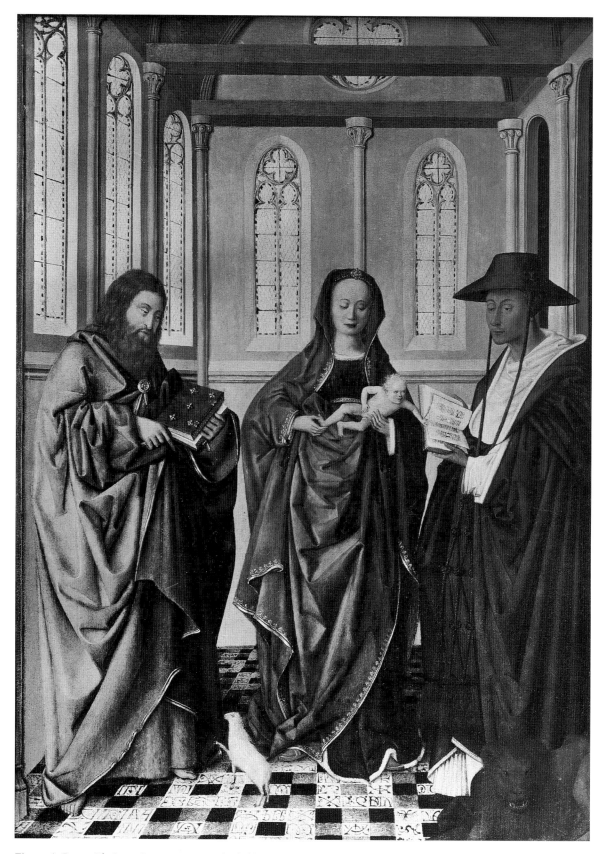

Figure 1. Petus Christus Group, *Virgin and Child with Saints.* Amsterdam, private collection

Figure 2. Infrared reflectogram assembly of a detail of Fig. 1 (photo: Van Asperen de Boer)

ing as it occurs could—with some hesitation—be associated with the Petrus Christus vocabulary.

Paint-Layer Structure and Composition of the Amsterdam Picture

Only five paint samples were taken during the 1985 examination, four of which were from the very edge of the painted surface.[13] The light blue robe of the Virgin contains natural ultramarine and lead white. Natural ultramarine is also used in the decorative tiles.

The red robe of Saint Jerome is composed of vermilion with a red organic glaze. Three samples show an intermediate layer of lead white with some black particles on the ground. It could not be ascertained whether the underdrawing is beneath or on top of this layer.

Comparative material from the Petrus Christus group seems not to have been published so far, but the author was kindly permitted by the Institut Royal du Patrimoine Artistique to consult a report by the late J. Thissen on the paint-layer structure and composition of the Brussels *Lamentation*.[14]

Paint cross sections—some of which were studied by the author—show that there is a white intermediate layer (with some black pigment) on top of the underdrawing. The blues in the sky are a single layer of azurite and lead white, and those in the blue robes are natural ultramarine on top of azurite with lead white. Reds are composed of vermilion with some bone black, and a red organic glaze on top.

Both the Brussels and the Amsterdam paintings have a slightly grayish intermediate layer.[15] In Eyckian paintings, this is an unpigmented oil layer. In the two paintings, there are normally only two paint layers—a simpler buildup than in most Eyckian paintings examined in this way.

This admittedly limited data of the Amsterdam picture would not seem to be incompatible with a Petrus Christus group origin.

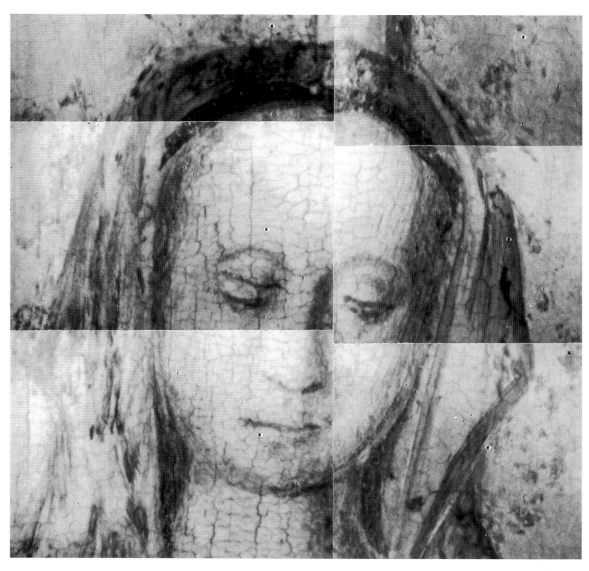

Figure 3. Infrared reflectogram assembly of the face of the Virgin in Fig. 1. The position of the head was changed. (photo: Van Asperen de Boer)

Figure 4. Infrared reflectogram assembly of the circular window in Fig. 1. The tracery is constructed with a compass: four circles are visible, with a clear dot in the center of the right-hand circle. (photo: Van Asperen de Boer)

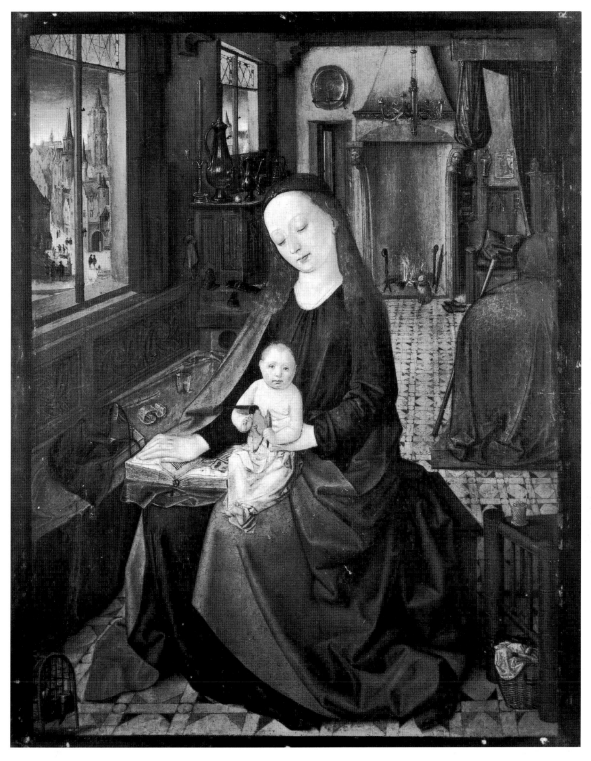

Figure 5. Petrus Christus Group, *Virgin and Child in a Chamber,* Galleria Sabauda, Turin (inv. no. 359).

The Turin *Madonna and Child*

The *Madonna and Child,* Fig. 5 (Galleria Sabauda, Turin, inv. no. 359) was examined in 1985 with infrared reflectography only.[16] A brief technical description was included, by Aru and Geradon,[17] in which they mention the existence of an X-radiograph, but that data were not consulted.

The architecture is mainly underdrawn by hand. The farther window originally extended downward to the sill, as the cupboard had not been planned (Fig. 6). Reflectograms show very straight horizontal and diagonal lines, which suggest the use of a ruler, laying out the lower tiles. The combination of freehand underdrawing and the use of a ruler is similar to the practice found in the Frankfurt and Amsterdam panels.

The face and hair of the Virgin are underdrawn with fine lines. There is a shift in the contour of the face and the position of her left eye. The Christ Child was underdrawn with a rounder head and bare legs. The sleeves of the Virgin are underdrawn with many fairly confused brushstrokes. The cloak shows rather straight, broadish fold lines and careful modeling with fine hatching. The shadowing of the bench and the lower right-hand corner with not very straight and overlapping hatching is reminiscent of the underdrawing near the foot of Saint Jerome in the Frankfurt panel.

It would seem that this limited evidence may well support the usual assignment of the Turin panel to the Petrus Christus group.

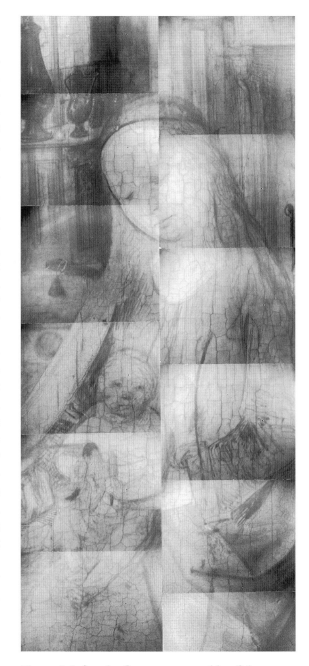

Figure 6. Infrared reflectogram assembly of the center of Fig. 5. The cupboard was not planned in the underdrawing; the window was underdrawn to the sill. The Christ Child was underdrawn with bare legs. (photo: Van Asperen de Boer)

NOTES

1. Max J. Friedländer, *Early Netherlandish Painting,* trans. Heinz Norden, 14 vols. (Leiden, 1967–76) vol. 1, p. 93, pl. 98.

2. J. Bruyn, *Van Eyck Problemen* (Utrecht, 1957) pp. 96–97.

3. Ariane van Suchtelen, Unpublished minor thesis on the scientific examination of works of art (Groningen University, 1987) 34 pp.; idem, "Vergelijkend natuurwetenschappelijk onderzoek van enkele schilderijen uit de Petrus Christusgroep" (unpublished manuscript, 1989) 15 pp. The author has frequently consulted this data in writing the present paper and is much indebted to Ms. van Suchtelen.

4. Letter by Dr. P. Klein, Ordinariat für Holzbiologie, University of Hamburg, to the owners of the painting, dated 24 August 1987.

5. Infrared reflectography was carried out on 21 August 1985 and 7 January 1986 with a Grundig FA 70 television camera containing a Hamamatsu N 214 infrared vidicon (1975). Reflectograms were photographed from the Grundig BG 12 monitor (875 lines) with a Nikon EL2 using Kodak Panatomic X film. The reflectograms are deposited with the author and carry the numbers AB 904–7, AB 925/11–36, 926, 927.

6. X-radiographs were made on 16 April 1985 by the Röntgen Technische Dienst of Rotterdam (40 kV, 4mA, 40 seconds).

7. Professor Molly Faries, Indiana University, personal communication, 27 March 1987. Ainsworth has interpreted two points in the Kansas City panel as part of a perspective system (Maryan W. Ainsworth and Maximiliaan P. J. Martens, *Petrus Christus: Renaissance Master of Bruges,* exh. cat. (New York, 1994) pp. 48-49, and the X–radiograph, fig. 61.)

8. By Professor R. van Schoute and W. J. Engelsman on 24 August 1979. Reflectograms AB 245/9–31.

9. Jochen Sander, *Niederländische Gemälde im Städel 1400-1550* (Mainz, 1993) figs. 91, 92. Ainsworth and Kasl examined the picture in 1989. These reflectograms are published in the catalogue of the Petrus Christus exhibition (Ainsworth and Martens, *Petrus Christus,* pp. 136–141.)

10. Sander, *Niederländische Gemälde,* p.167.

11. Ibid., fig. 94. For an extensive discussion of perspective in Petrus Christus paintings, see Ainsworth and Martens, *Petrus Christus,* pp. 43ff.

12. The Brussels *Lamentation* was first documented with infrared reflectography by the author in 1966, using the Barnes Infrared camera. Fifty-five Barnes reflectograms were made, covering the entire painting. Details were taken with the equipment specified in note 5 above in December 1977, some of which were published since (J. R. J. van Asperen de Boer, "A Scientific Re-examination of the Ghent Altarpiece," *Oud Holland,* 93 (1979) pp. 141–214, figs. 82 b, d) and again on 21 October 1991 (AB 1329/14–36a, AB 1330). Since I wrote the article on the Ghent Altarpiece, much more comparative material has been made available in the documentation of the 1994 Petrus Christus exhibition in New York, and part of it has been published (Ainsworth and Martens, *Petrus Christus*). The argument could thus be enlarged.

13. The five samples were taken by the author on 21 August 1985 and are numbered A 243/1–5. Paint cross sections were prepared by Ariane van Suchtelen.

14. The report by J. Thissen is dated 20 June 1962 and was consulted on 21 February 1977. Thirty-two paint cross sections were prepared in relation to the restoration in 1961-64 carried out at the Brussels Institute.

15. Paul Coremans et al., *L'Agneau mystique au laboratoire,* Les Primitifs flamands, III. Contributions à l'étude des primitifs flamands, no. 2 (Antwerp, 1953) p. 17; P. W. F. Brinkman et al., "Het Lam Godsretabel van Van Eyck: Een heronderzoek naar de materialen en schildermethoden, 1. De plamuur, de isolatielaag, de tekening en de grondtonen," *Bulletin de l'Institut royal du Patrimoine artistique,* 20 (1984/85) pp. 137–166, esp. pp. 155–157.

16. The panel was examined with infrared reflectography on 5 November 1985 by the author and Marigene Butler, Chief Conservator of the Philadelphia Museum of Art. This examination was made possible by the courtesy of the curator, Carlenrica Spantigati. The examination was facilitated by its position in the gallery, just above the Van Eyck *Saint Francis Receiving the Stigmata,* which had previously been reflectographed on that day. Reflectograms covering the entire panel are numbered AB 913/27–37, AB 914, AB 915/1–29.

17. C. Aru and É. T. de Geradon, *La Galerie Sabauda de Turin,* Les Primitifs flamands, I. Corpus de la peinture des anciens Pays-Bas méridionaux au quinzième siècle, no. 5. (Antwerp, 1952) pp. 1–5.

Recent Scientific Investigation of the Detroit *Saint Jerome*

Barbara Heller and Leon P. Stodulski
The Detroit Institute of Arts

The small Eyckian *Saint Jerome in His Study,*[1] (Plate 9) has been the subject of controversy since its acquisition in 1925 by The Detroit Institute of Arts (DIA). The painting was initially published as a work by Petrus Christus because of certain stylistic inconsistencies. In 1932, a date in cursive arabic numerals was discovered in the upper left of the panel between the chair and the curtain. Minuscule in size (0.1 x 0.4 cm) and in fragmentary condition, it was read as 1442, the year after van Eyck's death. Consequently William Valentiner, director of the DIA, proposed that the picture had been started by van Eyck and then completed by Christus.

A major cleaning and restoration was undertaken in 1956 by William Suhr. During this treatment, old varnish and extensive overpaints were removed, and the original red paint of the robe and a differently shaped hat were revealed. Beneath a blue cord with a tassel hanging from the cupboard shelf, a red paternoster, or rosary, was uncovered. Additionally, several pentimenti, or artist's changes, such as the first compass tracing of the astrolabe to the right of the instrument's present location, also became apparent. As a result of these discoveries, several scholars sought to reattribute the panel to van Eyck alone. Currently, however, opinion about the picture remains divided. The intervention of Petrus Christus, or even of some other second hand, now seems unlikely to many critics. The painting's Eyckian character is thus strengthened, but whether the *Saint Jerome* is from van Eyck's hand, or from that of some anonymous follower associated with his workshop, is still being debated.[2]

During Suhr's 1956 cleaning, Murray Pease, Curator of the Technical Laboratory of The Metropolitan Museum of Art, examined a cross section of the painting taken from the red robe near the barb. Three of the six layers were found to contain materials then considered unusual for a fifteenth-century Flemish painting: a layer of rag paper soaked with glue, a layer of bitumen, and a layer of minium.[3] To explain this atypical structure, Pease suggested that the painting had been transferred to a new panel. The idea of a transfer was apparently also supported by Dr. Paul Coremans, Director of the Technical Laboratory of the *Institut Royal du Patrimoine Artistique* (IRPA), Brussels, who saw the painting and cross section at Suhr's studio in 1956.[4]

In 1961, after the close of the "Masterpieces of Flemish Art: Van Eyck to Bosch" exhibition in Brussels, the panel was sent to IRPA for a more extensive technical examination by Coremans. The painting was studied using both visible and ultraviolet light, infrared photography, and X-radiography. Analyses were carried out using microscopic and microchemical tests on eight samples taken from the very edge of the pictorial field.[5] Despite an examination that he himself considered less than exhaustive, Coremans expressed the opinion that the painting had "some characteristics incompatible with what we know about Eyckian works and even those of the great Flemish masters of his epoch." He was particularly disturbed by the unusual structure and composition of the panel's preparation and paint layers, the crackle pattern, the lack of underdrawing, and the impossibility of obtaining a clear X-radiograph, as well as what were thought to be iconographic and stylistic problems.[6] These difficulties led Coremans to conclude that the *Saint Jerome* was "an imitation of high quality and of an age impossible to determine," and thus raised, for the first time, doubts about the painting's authenticity.

Since the time of Coremans's report, the study of early Netherlandish paintings has been revolutionized by new investigative techniques. An expanded database of comparative information, derived from the scientific examination of a large corpus of fifteenth-century paintings, now exists. These developments ini-

tiated our recent technical and scientific examinations of the Detroit *Saint Jerome,* which are the subject of this paper.[7]

Condition of the Painting, Paint Handling, and Technique

The painting is executed in oil on paper that is glued to a single piece of oak panel, measuring at its largest 20.5 x 13.4 x 0.7 cm. The unbevelled board is radially cut and has a very slight convex warp. The vertical grain runs parallel to the composition. The top and bottom of the panel are smoothed across the grain, while the right and left sides appear to have been split but not smoothed.

The painted front surface, 20.2 x 12.6 cm in size, ends in a raised, irregular, and slightly rounded *barbe.* The *barbe* appears to have been pushed in from all sides. A border, 0.20 – 0.35 cm wide and painted gray, extends from the *barbe* to the panel's edge on all four sides. The reverse of the panel is painted; the edges are not (Plate 10). Approximately one half of the reverse has been lost and repainted a lighter green. A pattern of yellow crosshatching marks is discernible over what remains of the original dark green paint on a white ground preparation. The lighter green paint is modern and contains chromium oxide (Cr_2O_3). Both the original paint and the ground layers, as well as the modern restoration paint, have flake losses that expose the panel.[8]

Optically, distinct and occasionally fairly large nonuniform granules of pigment can be clearly detected in the paint on the front under low magnification. Such texture is usually associated with early paint preparation and is the result of grinding pigments by hand. The condition of the paint surface ranges from very good to fair. (Fig. 1) The reds have suffered the most: they appear to have been subject to flaking as evidenced by the extensive losses in the cardinal's robe and hat. Passages containing white are in very good condition, such as Saint Jerome's face and hands and the still life details. Small losses occur in the tablecloth, the right edge of the lectern, the left side of the hourglass, the valance over the saint's head, and the underside of the top book. The window and the chair show signs of abrasion. Raking light reveals vertical tenting and the wrinkling pre-

Figure 1. Photograph after 1956, cleaning and overpaint removal by Suhr.

viously noted by Pease and Coremans. This may be due to the different expansion and contraction rates of paper, glue, and the wood panel induced by humidity changes, and is probably why the panel appeared to have an unusual crackle pattern. Inspection under ultraviolet light (UV) reveals Suhr's thickly applied natural resin varnish and wax polish, which conceal all the 1956 retouches. There are small inpainted areas around the perimeter that are presumed to be IRPA's sampling sites.

In general, the handling of paint corresponds with that in other early Netherlandish paintings, which were built up in thin paint layers or glazes from light to dark.[9] In some areas, such as the whites of the saint's sleeves, paint was applied all at once as a fluid paste, which allowed the folds to be built up into an actual low relief perceptible to the touch. Extremely fine details can be observed such as individual strands of fur, beard hairs, and the numbers on the astrolabe. The green squares of the valance fringe contain finely painted red threads. A

pinkish-tan underlayer, possibly the *primuersel* described in 1604 by Carl van Mander as a characteristic of early Netherlandish painting, is visible through the paint in several areas.[10] It can be seen through the hourglass, the lion's muzzle, and the compass incision of the first astrolabe. This layer is not observed underneath the tablecloth. Here, where the edges of paint along the cracks are worn, the underlying paint appears a light beige. A red discontinuous underlying stroke appears through the saint's hand.

The writing implements on the table, originally questioned in Coremans's report, have been the subject of subsequent debate (Plate 12). It has been argued that rather than depicting a fifteenth-century goose quill, the pen on the table has a hole in its tip similar to that of a modern steel pen.[11] Since there is a loss of paint from abrasion in this area, what appears to be a hole is actually restoration paint. Furthermore, the projecting object in the pen box is not a second pen but an erasing knife, commonly used for making corrections when writing on parchment. It has a wooden handle and a short knife blade, much like the one in Erhard Altdorfer's *Saint John on Patmos,* Nelson-Atkins Museum, Kansas City.[12]

Many Eyckian panels have marbling on the reverse.[13] For example, a marbleized green, black, and brown pattern is painted on the reverse of van Eyck's *Virgin of Chancellor Rolin* in the Louvre;[14] the *Annunciation* in the Thyssen-Bornemisza Collection has a pattern of red, white, and green veining on black;[15] the *Portrait of Margaretha van Eyck,* in the Musée Communal, Bruges,[16] has a red-brown marbleized layer; and the reverse of the Budapest *Portrait of a Man with a Ring* is painted red and black.[17] The pattern depicted on the reverse of the *Saint Jerome* can be identified as serpentine marble. Thus if, as we now believe, the painted layer on the reverse of the *Saint Jerome* is old, the oak panel is almost certainly part of the original construction.[18]

The Painted Wood Panel Support

In 1983, a dendrochronological study of the panel was undertaken by Dr. Peter Klein of the University of Hamburg. Klein determined that 1410 was the earliest possible felling date, which would have made the panel available for painting from 1420 onwards.[19] This strongly suggests that the painting's support is original.

The Paper Layers

Fibers, removed from underneath the edge of the *barbe*, were prepared as dispersed sample slides for study with polarized light microscopy in 1983 by Walter C. McCrone. The fibers appeared to be cellulosic and not proteinaceous, as would be expected if parchment or vellum had been present. Under crossed polars, the fibers exhibited traits characteristic of linen with respect to coloration, fairly thick cell walls, and visible nodes (Plate 11). The absence of calcium oxalate and the results of the Herzog twist test using a Red I compensator on fibers at extinction, plus the refractive index data, strongly indicated linen rather than hemp.[20] Most important was the condition of the fibers. Unlike modern paper fibers, which are bleached, heavily macerated, and full of tiny fibrils or projectiles, these fibers are rather large, irregular, and very much intact. Almost no fibrils were noted, a fact that was further confirmed by scanning electron microscopic images. These characteristics strongly suggest a very early handmade paper. The paper is attached to the panel with rabbit skin glue, identified by staining with amino black (which yields a blue color) and the presence of birefringent needles. Particles of a brown/black pigment appeared to be intimately integrated with the fiber network when observed at high magnification.

The presence of this paper layer in the structure of the *Saint Jerome* panel had greatly disturbed Coremans. However, parchment, leather, metal foil, and linen fabric have all been used as interlayers directly over panel seams or over entire panel surfaces since the thirteenth century.[21] There are several technical reasons for using an interlayer: to create a smooth transition across panel joins, to minimize wood shrinkage, to expedite the preparation of panels for painting, or to supply a new kind of ground layer with its own unique aesthetic properties.

Paper composed of linen fibers was commonly used in Europe since the fourteenth cen-

tury; the earliest authentically dated example is from 1249.[22] Known early examples of oil painting executed on paper on panel include the Master of Saint Gilles, *Virgin and Child,* third quarter of the fifteenth century, in the Robert Lehman Collection, The Metropolitan Museum of Art, and the Master of the Blue Crucifix, *Crucifixion,* Umbrian, late thirteenth century, in the Museum of Fine Arts, Boston. Paper interlayers are also found in the sixteenth century.[23] Furthermore, both the Philadelphia Museum of Art's *Saint Francis* and The Metropolitan Museum of Art's Petrus Christus's *Head of Christ* have been painted on parchment adhered to a wood panel.[24] Thus the presence of an intermediate support in the Detroit *Saint Jerome* is by no means unique.

Figure 3. Infrared reflectogram—detail of book and lectern region (photo: Paintings Conservation Department, National Gallery of Art, Washington)

Infrared Reflectography

Examination of the *Saint Jerome* by infrared reflectography (IRR), a technique unavailable to Coremans, has revealed new information about the artist's working procedure.[25] An underlying modeling or toning layer of pigment over the paper support appears as vertical streaks in the reflectograms. This is particularly notable in the chair. The piece of fruit, the albarello jar, and the date are completely penetrated and become transparent. There is no detectable underdrawing. The painting did not follow an underdrawing, but rather was executed in an additive process.[26] The lion is painted over the table, which itself is painted over the green drapery just to the left (Fig. 2).

Figure 2. Infrared reflectogram–detail of lion and table (photo: Paintings Conservation Department, National Gallery of Art, Washington)

The left edge of the strongbox door is visible through the body of the lion, as is the circular element through its left ear. The letter is painted over the sand shaker, which is painted over the lectern. The strap of the bookbinding clasp is painted over the reading stand and adjacent pen box. (Fig. 3) The left side of the curtain is painted over the books and the shelf. The cover of the albarello jar is painted on top of the astrolabe. The rosary was painted on top of the cupboard shelf.

Minor compositional adjustments were also noted. The fingers of Saint Jerome's right hand have been shifted slightly: the pages of the book are visible through the middle finger, which was originally somewhat more elongated, and the tip of the fourth finger was shortened as well. The hat may have been lower on the saint's head. The location of the flask on the right and of the hourglass, as well as the position of the saint's cushion, have been slightly changed. A rectangular shape appears below the central part of the astrolabe. The position of the pages of the open book and the lectern have been shifted. The first astrolabe tracing is visible through the flask.

Coremans, as well as others, considered it anomalous that no underdrawing can be detected in the Detroit *Saint Jerome.*[27] But no trace of underdrawing has been found in van Eyck's unquestionably authentic *Man in a Turban* (The National Gallery of Art, London) either[28]. It has been suggested that this is the case because the painting is a portrait, and thus likely to have

been painted from life or from a detailed drawing.[29] Likewise no underdrawing has been found in van Eyck's signed *Portrait of Jan de Leeuw* (Kunsthistorisches Museum, Vienna).[30] In a recent infrared reflectography study of the Turin-Milan Hours, elaborate underdrawing was found on some of the miniatures, but none, or very little, was detected for most of the "Eyckian" miniatures.[31] Finally, it should be noted that an underdrawing made with certain non carbonaceous brown inks, such as sepia, bistre, and iron-gall, cannot be detected using infrared vidicon systems.[32]

X-Radiography

Lack of precision in X-radiographs of the *Saint Jerome* has been a major reason in the past for casting doubt on the authenticity of the painting. In his 1961 report, Coremans expressed the opinion that this lack of precision was not caused by the paint on the reverse of the panel. That is now, however, known to be incorrect, since lead white, a pigment that very effectively absorbs X-rays, is a confirmed component of the original marbleized paint on the back of the panel. When a tracing of the original paint remnants on the reverse of the *Saint Jerome* is superimposed over an X-radiograph, a definite correlation is noted between areas of paint loss (which appear less dense) on the reverse and similarly shaped "dark spots" on the X-radiograph.

The X-radiograph, moreover, is not as imprecise as Coremans suggested (Fig. 4)[33]. Although some parts are indeed indistinct, still life details such as the hourglass, the glass flask, and the letter are very legible. Several changes are also visible: the right side of the blue curtain partially covers the books on the cupboard shelf; the robe may have been originally shorter and more open at the armhole, perhaps revealing the saint's tunic; the window appears to have been initially blocked out in a slightly different shape and location; the shelf on which the "tyriaca" jar and the tall-necked bottle stand can be seen through the top of the hourglass; and the top of the valance was originally lower. These compositional changes not only create additional density in the image but also clearly indicate that the composition actually evolved on this panel, rather than having been copied or forged.

Figure 4. X-radiograph of panel

Unusual X-rays are considered characteristic of Eyckian paintings. Well-known examples include the *Madonna with Canon George van der Paele* and the *Ghent Altarpiece*.[34] Van Eyck's technique of broadly blocking out shapes and his tendency to make shifts in composition produce X-radiographs that do not quite match the images of the painted surface. Fingerprints have been found in the glazes of the *Arnolfini* double portrait and in the Washington *Annunciation*, indicating that van Eyck blended the oil paint.[35] The softened modeling, with few discernible brushwork markings, which results from this technique can also produce imprecision in the X-ray image.

A "double density" theory has also been used to explain the lack of clarity in X-radiographs of van Eyck's work, since many of his panels have painted marbleized reverses. For example, according to the report of a technical examination of the *Portrait of Margaretha van Eyck,*

in Bruges, "the ghostly nature of the shadow-graph record is due in part to the imposition of two sets of pigment upon each other."[36]

Coremans did question the presence of red lead (minium) in the painting and suggested that the barb was only a bulge formed during the transfer process.[37] The *barbe* is clearly defined in the X-radiograph as a bright white border around the edges of the paint surface. In our recent cross sections, a red lead component is observed in the *barbe*, whereas only a very thin and diffuse red lead layer is present in the tablecloth. The number and location of specimens analyzed are insufficient to justify the assumption, made by Coremans, that the red lead layer is continuous throughout the painting. A more plausible explanation for the accumulation of red lead at the edge is its use in gilding. It is possible that the red lead is part of the bole preparation for the original engaged frame, whose inner molding was gilded, as in van Eyck's *Ghent Altarpiece.*[38]

Pigment and Cross-Section Analyses

Studies of the composition of the paint layers on the *Saint Jerome* panel were carried out at the DIA's Conservation Services Laboratory (CSL) using energy-dispersive X-ray fluorescence (XRF)[39] and X-ray diffraction (XRD).[40] Fifty-seven individual areas on the panel front and sixteen areas on the panel reverse were analyzed by XRF. A few specimens large enough for X-ray diffraction analyses were obtained from the panel edge in the barb region and from the panel reverse. Five specimens of white pigment and three specimens of red pigment from the panel front were analyzed. Two samples of white ground material taken from the reverse were also studied.

Two tiny fragments of paint layers were carefully removed from the front of the panel, at the barb in the vicinity of the blue valance and from the green tablecloth. One specimen of original dark green paint was removed from the panel reverse. These fragments were mounted in polyester resin, sectioned using an ultramicrotome, and studied under reflected visible light and ultraviolet fluorescence microscopes. The individual layers contained in these sections were subsequently analyzed using a scanning electron microscope fitted with an energy-dispersive X-ray analyzer.[41] Photographs of these sections may be seen in Plates 13, 14 and 15, accompanied by a brief description of the composition of each layer.[42]

Of particular interest in the tablecloth cross section is the gray-black paint (layer six), which is composed primarily of lead white with particles of madder, ultramarine, antwerp brown, and bone black. As a substitute for the discreet layer of chalk ground usually found in early Netherlandish paintings, this layer within the structure of the *Saint Jerome* may be the layer of drying oil with pigment, which, as described by Watrous, was used to prepare paper or parchment for painting.[43] The *Mystic Lamb* was also found to have a gray-black foundation layer under some of its colors.[44]

Polarized light microscopic analyses of pigment samples were also performed at the McCrone Research Institute in Chicago, with supplementary scanning electron microscopy and electron microprobe analysis done by McCrone Associates. About twenty minute samples were taken from the panel's outer border, from the barb, from within the image near losses, and also from the marbleized reverse, using a tungsten microneedle. The specimens were mounted in Aroclor 5442 and prepared as dispersed pigment slides. Generally, the size of the pigment particles was found to be fairly coarse and irregular. Impurities were routinely found in all color samples and consisted of various amounts of calcite, quartz, and silica, as well as grains of other colors. Pigment particles of nonuniform size, and impurities, are usually signs of early paint manufacture.

The pigments identified in the *Saint Jerome* are in keeping with a fifteenth-century Flemish palette,[45] and include lead white, red lead, lead-tin yellow, yellow ocher, vermilion, ultramarine, azurite, madder lake, bone black, and copper resinate. The copper resinate pigment is particularly interesting in that the green glasslike crystals are completely nonuniform and partly crystalline, traits that indicate an early date.[46] The only pigment that at first does not appear to be typical of the period is a brown-black pigment containing carbon. McCrone identified it as either antwerp brown or mummy, both of which consist of an asphalt-type material minus the volatile components.[47] The marbleized paint layer on the reverse consists of copper resinate, lead white, lead-tin yel-

MEAN parts per million (ppm)	Neterlands ★	DIA Saint Jerome ★★	Venetian ★	Modern ★ c.1820	Modern ★ c. 1950
Cu	64.4	52	183.2	20	<1
Ag	40.6	60	3.8	3.4	<1
Mn	7.1	17	22.7	1	2
Sb	123.1	50	22.6	695	85
Cu / Ag	1.59	0.87	48.2	5.9	~1
Ag / Mn	5.72	3.53	0.17		
Sb / Mn	17.4	2.94	1.00		
Range (ppm)					
Cu	5-136	42-62	8-104		
Ag	8-103	48-72	<1-9		
Mn	<1-16	14-20	6-82		
Sb	32-228	40-60	5-66		

Figure 5. Trace elements in lead white
★ Values from H. Kühn, "Trace Elements in White Lead and Their Determination by Emissions Spectrum and neutron Activation Analysis", Studies in Conservation, 11, no. 4, (November 1966) pp. 163-169.
★★ Values from John Gavrilovic, McCrone Associates, using the electron microbe, April 1984.

low, antwerp brown, and a copper-containing pigment, possibly azurite or verdigris. Underneath the marbleized paint is a ground preparation of chalk (or calcite) containing coccoliths.

Analysis of Lead Trace Elements

McCrone Associates analyzed the trace elements present in the lead white from the paint layers of the Saint Jerome with an electron microprobe in order to attempt to determine its geographical origin (Fig. 5). The values obtained for the trace elements in the DIA Saint Jerome closely approximate those from a Netherlandish source and do not correspond with those recorded for modern lead pigments.[49]

Media Analyses

In 1983, employing hot stage and staining methods, McCrone Associates identified the paint medium in the Saint Jerome as oil.[50] Two multilayer specimens were subsequently sent to the Getty Conservation Institute for media analysis in 1994.[51] Proteins were identified by ethyl chloroformate (ECF)—derivatization of acid hydrolysates followed by gas chromatography (GC). Drying oils were identified by Fourier transform-infrared spectroscopy and also by gas chromatography-mass spectrometry (GC-MS) analysis of samples prepared by acid-catalyzed methanolysis.[52] The cross section from the brown paint on the back of the chair, which contained only paint layers but no paper, had no significant quantity of protein. A drying oil is present in the sample, and it appears to be

based on either walnut oil or a mixture of linseed and poppyseed oils.[53] A marbleized paint cross section from the reverse has a very thick coating layer of modern varnish that fluoresces white under ultraviolet light. Protein identification by amino acid analysis gave a close match for animal glue, probably present in the ground. The oil analysis indicated that a drying oil is present and that walnut oil (or a linseed-poppyseed mixture) is the paint medium.[54] Gerard David's *Christ Nailed to the Cross* (c. 1480, National Gallery of Art, London) was also found to have walnut oil.[55] Other Flemish paintings that have undergone media identification compare favorably with these results.[56]

The issue of the authenticity of the panel's painted date has not been resolved by analytical means (Plate 16). Suhr's assessment that the "date appears old but may not be original"[57] is quite subjective. Although some portions of the date seem to be on top of the paint surface, it apparently was added before the crackle pattern had formed. It should also be noted that since the date was completely penetrated by infrared radiation, it is probably not composed of a carbonaceous material. Because of the minute size of the date inscription and the possibility of shattering the surrounding paint film, it is difficult to contemplate sampling this area of the painting. Until such time as the date's composition and age can be resolved, discussions regarding its authenticity will necessarily remain speculative.

Summary and Conclusions

The cumulative effect of the evidence derived from materials analysis and by other technical means indicates a fifteenth-century origin for *Saint Jerome in His Study*. The oak panel with its painted marbleized reverse is definitely of the fifteenth century, and the pigments are consistent with a Flemish fifteenth-century palette. The pigment particles are characteristic of an early paint manufacture, while the trace elements in the lead white suggest a Netherlandish origin. The presence of a drying oil medium, and the paint handling, are consistent with early Flemish painting techniques. While unusual, the use of paper as an interlayer in panel paintings is also documented in contemporary practice.

The technical research on *Saint Jerome in His Study* is still in progress. We would like to verify whether the paper extends from edge to edge on the front, to continue the investigation of the layer structure, and to further probe the use of walnut oil as a binding medium. We would like to discover if there are other contemporary examples of the brown-black carbon-based pigment, identified here as antwerp brown or mummy. It would be interesting to compare technical examinations of van Eyck's smaller compositions, such as the Antwerp *Virgin at the Fountain* to determine if similar materials were used. Further study of coccoliths in the chalk ground could prove worthwhile, since they have also been found in the *Ghent Altarpiece* and in Dieric Bouts's *Altarpiece*[58] *of the Last Supper* in Louvain.[59]

No determination of attribution is complete without stylistic interpretation, investigation of provenance, and discussion of iconography, which are not addressed here. The present condition and state of preservation need to be considered in any future assessment of the painting's stylistic strengths and weaknesses. We believe that the data presented in this paper help to explain the misconceptions responsible for some of the earlier conclusions about the authenticity and atypical technique of the Detroit *Saint Jerome*.

ACKNOWLEDGMENTS

The DIA would like to acknowledge the assistance of those who have participated in this project: Debra Kalish, who as Associate Paintings Conservator, DIA, conducted the 1983 portion of this study, supported by a grant from the Pfizer Corporation; Walter C. and Lucy B. McCrone, McCrone Research Institute; John Gavrilovic, McCrone Associates; Michael R. Schilling and Herant P. Khanjian, The Getty Conservation Institute; Jerry Jourdan, BASF Corporation; Dr. Peter Klein, University of Hamburg; David Bull, Sarah Fisher, Colin Fletcher, E. Melanie Gifford, Catherine Metzger, and Elizabeth Walmsley, of the Conservation Division, The National Gallery of Art, Washington. Special thanks to the staff of the DIA Conservation Services Laboratory and European Paintings departments, Maryan W. Ainsworth of The Metropolitan Museum of Art, Molly Faries of Indiana University, as well as to J. R. J. van Asperen de Boer of the University of Groningen for their encouragement, support, and suggestions.

NOTES

1. Jan van Eyck, *Saint Jerome in His Study,* 1442 (?), oil on paper on oak, (20.5 x 13.4 cm). Inscriptions: 1442 on wall behind saint, possibly a later addition; *Reuerendissimo in Christo patri et domino, domino Ieronimo, tituli Sancte Crucis in Iherusalem presbytero cardinali* (on folded paper on table). Provenance: Italy?; Pierre Stevens, Antwerp?; Paul Bottenweiser, Berlin; The Detroit Institute of Arts 1925, 25.4.

2. See *Flanders in the Fifteenth Century, Art and Civilization-Masterpieces of Flemish Art: Van Eyck to Bosch,* exh. cat., The Detroit Institute of Arts and The Centre National de Recherches Primitifs Flamands (Detroit/Brussels, 1960) pp. 69–72. The entry for the *Saint Jerome* was written by Jacqueline Folie, attaché, Institut Royal du Patrimoine Artistique (IRPA), Brussels. The statement on page 69, that the picture was transferred to a new panel in 1956, is incorrect. For a summary of more recent scholarship see also Maryan W. Ainsworth and Maximiliaan P. J. Martens, *Petrus Christus: Renaissance Master of Bruges,* exh. cat., The Metropolitan Museum of Art (New York, 1994) pp. 68–71.

3. William Suhr, conservation report, "Jan van Eyck, *Saint Jerome in His Study,*" 24 February—20 July 1956, Conservation Services Laboratory files (CSL), The Detroit Institute of Arts.

4. Suhr report, p. 3. See also Edgar P. Richardson, "The Detroit *Saint Jerome* by Jan van Eyck," *Art Quarterly,* 19 (1956) p. 237; and J.R.J. van Asperen de Boer, unpublished minor field thesis (1961), unpaginated manuscript, CSL files. By the time the painting was examined at IRPA, it was commonly assumed that the painting had been transferred to a new panel in the 19th century.

5. Paul Coremans, "Examen d'un tableau du Detroit Institute of Arts" (examination report, 25 April 1961, CSL files). The CSL file contains four black-and-white photographs of cross sections and three color transparencies of thin sections analyzed by IRPA. Special thanks to are owed to J. R. J. van Asperen de Boer for making arrangements with Liliane Masschelein-Kleiner to review IRPA's van Eyck file and their 1961 samples in August 1994. Leopold Kockaert, J. R. J. van Asperen de Boer, and Barbara Heller studied these samples microscopically.

6. Coremans report. The blue paint was identified as lapis lazuli, lead white, and an oil binder; the green as malachite (this is not correct; see below), lead white, and an oil blinder with a copper resinate glaze; and the brown as ocher, lead white, animal black, and an oil binder. The composition and structure, from the bottom to the top, were identified as 1) wood; 2) rag paper, "probably of modern fabrication"; 3) a thin layer of animal glue; 4) a layer between 15 and 30 microns thick of animal black with an aqueous binder that was neither chalk, gypsum, nor lead salt; 5) a thin translucent layer (?); 6) one to three whitish or gray-whitish layers containing lead white, animal black, and oil binder; and 7) layers of dirt and protection. No coordinate measurements are recorded for the sample sites. Portions of IRPA's analyses were published by Roger H. Marijnissen, "On Scholarship: Some Reflections on the Study of Early-Netherlandish Painting," *Mededelingen van de koninklijke Academie voor wetenschappen, letteren en schone kunsten van België, klasse der schone kunsten,* 40, no. 4 (Brussels, 1978) pp. 1–11; idem, *Paintings—Genuine, Fraud, Fake: Modern Methods of Examining Paintings* (Brussels, 1985) pp. 384–87; and idem, *Tableaux—Authentiques, maquillés, faux: L'Expertise des tableaux et les méthodes de laboratoire* (Brussels, 1985), pp. 384–387. Regarding the incorrect identification of malachite, see Pim W. F. Brinkman et al., "Het Lam Godsretabel van van Eyck, 2. De hoofdkeuren blauw, groen, geel en rood," *Bulletin de l'Institut royal du patrimoine artistique* 22 (1988/9) p. 45.

7. A complete study of the painting, including all materials analysis data, will be published in a forthcoming issue of the *Bulletin of the Detroit Institute of Arts.*

8. Examination and condition reports by Merrill Johnson, August 1976; Teri Hensick, March 1979; Debra Kalish, March 1983—April 1984; and Barbara Heller, 1994, CSL files.

9. Paul Coremans et al., *L'Agneau mystique au Laboratoire,* Les Primitifs flamands, III. Contributions à l'étude des primitifs flamands, no. 2 (Antwerp, 1953) pp. 16–122; Jill Dunkerton et al., *Giotto to Dürer: Early Renaissance Painting,* National Gallery of Art (London, 1991) pp. 166–168.

10. Carl van Mander, *Das Lehrgedicht des Karl van Mander,* trans. R. Hoecker (The Hague, 1916) vol. 3, pp. 271. Chapter 12, verse 17, translated into English, reads: ". . . fine graphite mixed with water [for the drawing]. On top of that they layered very neatly and carefully a thin imprimatura through which one could see everything, and this imprimatura was flesh colored." See also Dunkerton et al., *Giotto to Dürer,* p. 196.

11. Coremans report, p. 4; Marijnissen, *Tableaux,* p. 386.

12. See Molly Faries's comment elsewhere in this volume.

13. Further examples of panels with painted backs are van Eyck's *Portrait of a Young Man,* 1432, marbleized; *Portrait of Giovanni(?) Arnolfini and His Wife, Giovanna Cenami(?),* 1434, painted black; and *Portrait of Marco Barbarigo,* c. 1450, by the Follower of Jan van Eyck, painted brown over white preparation; all three are from The National Gallery of Art, London. The reverse of the *Crucifixion,* Galleria Franchetti, Ca' d'Oro, Venice, ascribed by Châtelet to the Hand H, is marbleized, as is that of *Saint John the Baptist in a Landscape,* attributed to Petrus Christus, c. 1445, Cleveland Museum of Art. A marbleized pattern, in brown-green and yellow, is used on a trompe-l'oeil frame on Christus' *Portrait of a Carthusian,* The Metropolitan Museum.

14. J. R. J. van Asperen de Boer and Molly Faries, "La *Vierge au chancelier Rolin* de Van Eyck: Examen au moyen de la réflectographie à l'infrarouge," *La Revue du Louvre et des musées de France* 40, no. 1 (February 1990) pp. 37–38.

15. Emil Bosshard, "Revealing van Eyck: The Examination of the Thyssen-Bornemisza *Annunciation,*" *Apollo* 136 (July 1992) p. 5.

16. A. Janssens de Bisthoven and Parmentier, *Le Musée communal de Bruges,* 4 vols., Les Primitifs flamands, I. Corpus de la peinture des anciens Pay-Bas méridionaux au quinzième siècle, no. 1 (Antwerp, 1951) vol. 1, p. 32.

17. J. R. J. van Asperen de Boer, Bernhard Ridderbos, and Manja Zeldenrust, "*Portrait of a Man with a Ring* by Jan van Eyck," *Bulletin van het Rijksmuseum,* 39 (Amsterdam, 1991) p. 10.

18. In the case of a transfer, it is unlikely that a 15th–century panel would have been used. There is no reason why someone would adhere paint that is consistant with a 15th–century palette to both the back and the front of an old panel. Though it is plausible that a painting could be removed and then reattached to its original panel, the deterioration of the support is usually the main reason for attempting a transfer. The possibility that the panel could be a very sophisticated forgery is remote, for the panel would have had to come either from an existing work of art with a known date, or from furniture known to have been constructed during van Eyck's lifetime.

19. Peter Klein, dendrochronological report, 28 October 1983, CSL files; John Fletcher, "Panel Examination and Wood Dendrochronology," *J. Paul Getty Museum Journal* 10 (1982) pp. 39–44; Peter Klein, "Dendrochronologische Untersuchungen an Bildtafeln des 15. Jahrhunderts," in *Actes du colloque VI pour l'étude du dessin sous-jacent dans la peinture: Infrarouge et autres techniques d'examen,* ed. Hélène Verougstraete-Marcq and Roger van Schoute (Louvain-la-Neuve, 1987) pp. 29–40; Ainsworth and Martens, *Petrus Christus,* pp. 213–215. Another technique for dating wood is ^{14}C determination by accelerator mass spectrometry (AMS), which we have not undertaken for this study.

20. Walter C. McCrone, McCrone Research Institute Analytical Report, 1 September 1984, p. 4. For fiber analysis in general see Dorothy Catling and John Grayson, *Identification of Vegetable Fibers* (London, 1982); Walter C. McCrone and John Gustav Delly, *The Particle Atlas: The Electron Microscopy Atlas,* vol. 3 (Ann Arbor, Mich., 1973) p. 609; and *Papermaking Fibers: A Photographic Atlas,* ed. Wilfred A. Côté (Syracuse, N. Y., 1980) pls. 71–72.

21. Christiana Herringham, *The Book of the Art of Cennino Cennini: A Contemporary Practical Treatise on Quattrocento Painting* (London, 1899) p. 230; *Arte nell'Aretino: Recuperi e restauri dal 1968 al 1974,* exh. cat. (Florence, 1974) pp. 15–28, pls. 1–32. An interlayer of linen was personally observed by the author Heller when treating Margarito d'Arezzo's *Madonna col Bambino in trono,* c. 1250 (Santa Maria, Montelungo) and *Madonna col Bambino in trono e quattro storie di Maria,* 1262 (Santuario di Santa Maria delle Vertighe, Monte San Savino). See also Janssens de Bisthoven and Parmentier, *Le Musée communal de Bruges,* vol. 1, p. 36. Van Eyck's *Madonna with Canon George van der Paele* in Bruges was found to have some fibers (wood?) embedded in the preparation, consolidating across the joins of the panel and of the frame. See Roger H. Marijnissen and G. van de Voorde, "Un Procédé enigmatique des primitifs flamands: Annotations concernant l'oeuvre de Joos Van Wassenhove, Hugo van der Goes, Roger van der Weyden et Hans Memling," in *Actes du colloque V pour l'étude du dessin sous-jacent dans la peinture: Dessin sous-jacent et autres techniques graphiques,* ed. Hélène Verougstraete-Marcq and Roger van Schoute (Louvain-la-Neuve, 1985) pp. 23–24. Marijnissen hypothesized that these paintings are executed on an independent support of parchment, paper, or a metal foil, then cut out and glued onto the panel (apparently on top of the ground preparation layer), and finally integrated into the pictorial layer by retouching.

22. Julius Grant, *Books and Documents: Dating, Permanence and Preservation* (London, 1937) p.9.

23. Hans Holbein the Younger, *Benedikt von Hertenstein* (1517, 06.1038); Workshop of Cranach the Elder, *Frederick III, Elector of Saxony* (46.179.1) and *John I, Elector of Saxony* (dated 1533, 46.179.2), all in The Metropolitan Museum of Art. Hélène Verougstraete, A. De Schrijver, and R. H. Marijnissen, "*Une Vierge et Enfant* du XVIème siècle dans le style de Gérard David peinte à l'huile sur papier," in *Actes du colloque X pour l'étude du dessin sous-jacent dans la peinture: Le Dessin sous-jacent dans le processus de création* (Louvain-la-Neuve, in press).

24. Ainsworth and Martens, *Petrus Christus,* pp. 86, 215. The Christus has been transferred to a new mahogany panel. Marigene H. Butler, "A Technical Examination of the Jan van Eyck Stigmatization of Saint Francis," in *Abstracts of Papers Delivered in Art History Sessions,* 71st annual meeting (College Art Association of America, 1983) p. 34; idem, "An Investigation of Two Paintings of the Stigmatization of Saint Francis Thought to Have Been Painted by Jan van Eyck," in *Actes du colloque VII pour l'étude du dessin sous-jacent dans la peinture: Dessin sous-jacent et copies,* ed. Hélène Verougstraete-Marcq and Roger van Schoute (Louvain-la-Neuve, 1991) pp. 95–101.

25. For IRR, see J. R. J. van Asperen de Boer, "Infrared Reflectography: A Contribution to the Examination of Earlier European Paintings" (Ph.D. diss., Central Research Laboratory for Objects of Art and Science, Amsterdam, 1970) and idem, "Examination by Infrared Radiation," in *PACT: Art History and Laboratory Scientific Examination of Easel Paintings,* ed. Roger van Schoute and Hélène Verougstraete-Marcq (Strasbourg, 1986) vol. XIII, pp. 109–130. Infrared reflectography was conducted by the CSL in 1983; by Molly Faries of Indiana University, 14 November 1984, as part of an infrared reflectography study supported by a National Endowment for the Humanities Basic Research Grant; and by Maryan W. Ainsworth of The Metropolitan Museum of Art, 18 March 1991. Subsequently, 23 August 1993, *Saint Jerome* was examined at the National Gallery of Art, Washington, using its IRR system, which was capable of penetrating more thickly applied paint. The infrared reflectogram images were captured with an Apple Quadra 700 equipped with a Perceptics Pixelbuffer frame-grabber card using the band from 1.2 to 2.0μ, with a Kodak 310–21X Thermal Imager. The camera contains a Pt:Si (platinum silicide) detector with a 640 x 486 focal plane array. See John K. Delaney, Catherine Metzger, Elizabeth Walmsley, and Colin Fletcher, "Examination of the Visibility of Underdrawing Lines as a Function of Wavelength," in *Preprints,* papers of the 10th Triennial Meeting, ICOM Committee for Conservation (Paris, 1993) pp. 15–19.

26. The additive method of painting has been considered by some to be alien to Van Eyck's oeuvre; see Ainsworth and Martens, *Petrus Christus,* p. 71, but also see E. Melanie Gifford, "Jan van Eyck's *Annunciation*: Development and Alteration," *Actes du Colloque X pour l'étude du dessin sous-jacent dans la peinture: Le Dessin sous-jacent dans le processus de création* (Louvain-la-Neuve, in press). The *Annunciation* was found to have the lilies painted over the Virgin's blue robe, and the vase was painted over the completed niello floor, "covering the fine details of the brown-block design."

27. Underdrawing has been found in other small paintings by van Eyck. See J. R. J. van Asperen de Boer, "Over de techniek van Jan van Eycks *De heilige Barbara,*" *Jaarboek van het koninklijk Museum voor schone kunsten Antwerpen* (1992), pp. 9–18; Bosshard, "Revealing van Eyck," pp. 4–11; and E. Melanie Gifford, "Jan van Eyck's *Annunciation.*"

28. Martin Davies, *The National Gallery of London* (London) vol. II, pp. 129–131. The only pentimenti noted were on the jawline and the nose.

29. Dunkerton et al., *Giotto to Dürer,* pp. 166–168; van Asperen de Boer, Ridderbos, and Zeldenrust, "Portrait of a Man," p. 10; Edwin Hall, in "Cardinal Albergati, St. Jerome and the Detroit Van Eyck," *Art Quarterly* 31 (1968) pp. 2–34, does propose that the Detroit painting is a portrait of Cardinal Albergati.

30. Van Asperen de Boer, Ridderbos, and Zeldenrust, "Portrait of a Man," p. 10.

31. Marigene H. Butler and J. R. J. van Asperen de Boer, "The Examination of the Milan-Turin Hours with Infrared Reflectography: A Preliminary Report," in *Actes du colloque VII pour l'étude du dessin sous-jacent dans la peinture: Geographie et chronologie du dessin sous-jacent,* ed. Hélène Verougstraete-Marcq and Roger van Schoute (Louvain-la-Neuve, 1989) pp. 71–76 and pls. 30–40.

32. Infrared reflectography is most successful in detecting underdrawing when the artist has drawn with a carbonaceous material, such as charcoal or bone black, on a white ground and when the paint layers above the drawing are relatively thin. As the paint structure becomes thicker or more complex, involving a number of layers, this analytical tool becomes less effective.

33. The CSL X-ray image with best contrast was taken at 5MA, 30KV, and 140 seconds.

34. Alan Burroughs, *Art Criticism from a Laboratory* (Boston, 1938) pp. 172–203, pls. 75, 76; Coremans et al., *L'Agneau mystique*, pls. 56, 57. Davies, *The National Gallery of London,* pls. 281, 301. J. R. J. van Asperen de Boer, "A Scientific Re-examination of the Ghent Altarpiece," *Oud Holland,* 93 (1979) pp. 141–214.

35. Dunkerton et al., *Giotto to Dürer,* p. 196; Gifford, "Jan van Eyck's *Annunciation.*"

36. Burroughs, *Art Criticism,* pp. 173–174: "X-rays are of some help, in spite of the fact that the panel is painted on the reverse to imitate stone, and hence has a double density."

37. Contrary to Coremans's assertion that red lead would not have been used, it was used in manuscript illumination, gilding, and panel painting. See Cennino Cennini, *The Craftsman's Handbook (Il Libro dell'Arte),* trans. Daniel Thompson, Jr. (New York, 1933) p. 86; Daniel Thompson, *The Materials and Techniques of Medieval Painting* (New York, 1956) pp. 101, 209–210. Red lead was also used as a "bulking agent" in bole for unburnished gilding. Charles Lock Eastlake, *History of Oil Painting of the Great Schools and Masters,* 2 vols. 1 (London, 1847) vol. 1, p. 270; M. Digby Wyatt, *The Art of Illuminating* (London, 1860) p. 67. The terms *red lead, minium, cinnabar* and *vermilion* are sometimes confused. *Red lead* and *minium* are used interchangeably. *Cinnabar* is the name used for the naturally occurring mineral, whereas *vermilion* is used for the chemically produced pigment, made from mercury and sulfur, which has been known from at least Egyptian times. Herringham, *The Book of Cennino Cennini,* p. 248. It is known that expensive pigments such as cinnabar and vermilion were frequently altered by the addition of red lead, red arsenic, and red earths.

38. Coremans et al., *L'Agneau mystique,* pp. 101–102. In each instance, red lead seems to be associated with lead white in a foundation layer that lies directly below gold or silver leaf on the painting and the frame; pls. 19 (layer 3), 24 (layer 3), 37 (layer 8), 67 (layer 2).

39. The analysis was performed with a KEVEX Model 0750A X-ray fluorescence spectrometer using both barium carbonate and molybdenum metal secondary targets.

40. X-ray powder patterns were generated using a Phillips X-ray diffraction spectrometer with a 114.6mm diameter Gandolfi camera.

41. An Amray 1830 I scanning electron microscope fitted with an EDAX PV 9800 energy-dispersive X-ray analyzer was used.

42. Because of the necessarily limited number of samples available, the identifications listed are the most reasonable ones and are based on SEM/EDS analyses of the materials in the cross-section layers themselves, and on polarizing microscopic and XRD analyses of similar materials taken from other sites on the panel.

43. James Watrous, *The Craft of Old Master Drawings* (Madison, Wisc., 1957) pp. 3, 4, 13. The material used in preparing parchment and paper for silverpoint drawing, which consists of a white lead preparation in oil, often contains other pigments.

44. Pim W. F. Brinckman et al., "Het Lam Godsretabel van van Eyck: Een heronderzoek naar de materialen en schildermethoden, 1. De plamuur, de isolatielaag, de tekening en de grondtonen," *Bulletin de l'Institut royal du patrimoine artistique* 20 (1984) pp. 158–160, 162–164, 166.

45. Coremans et al., *L'Agneau mystique,* pp. 79-88, 99–122, nos. 6–62; Paul Coremans, Rutterford J. Gettens, and Jan Thissen, "La Technique des primitifs flamands," *Studies in Conservation* 1, no. 1 (October 1952) p. 1–29; van Asperen de Boer, Ridderbos, and Zeldenrust, "Portrait of a Man," pp. 12, 14; Brinkman et al., "Het Lam Godsretabel van van Eyck, 1. De plamuur," pp. 137–166; "2. De hoofdkeuren blauw," pp. 26–29; Butler, "Two Paintings of the Stigmatization of Saint Francis," pp. 95–101; Gifford, "Jan van Eyck's *Annunciation.*"

46. "The green glass-like crystals are characteristic of the pigment which was made by dissolving copper salts into balsam, Venice turpentine or other resinous material. By the fifteenth century, both well crystallized verdigris and completely amorphous copper resinate were common. Therefore, it may be significant that the copper resinate found in the samples from the front and back and partly crystalline." McCrone report, p. 2, CSL files.

47. McCrone reports having "considerable difficulty" in identifying the "black" pigment found in the *Saint Jerome* samples. Microscopically, the individual particles are clear brown in color, isotropic with glassy fracture, and have variable refractive indices from just below 1.66 (for the light brown ones) to considerably above (for the dark brown ones). They strongly resemble Vandyke brown and burnt umber, except that they are clear glassy particles, and differ in this respect from most umbers and Vandyke brown. Microprobe analyses reveal the presence of only carbon and oxygen as major elements, no minor elements, and no significant trace elements. All the clear brown particles have the color of asphaltum, but unlike this pigment, are insoluble in organic solvents. Eastlake, in *History of Oil Painting,* vol. 1, p. 464, describes an "antwerp brown" pigment prepared from bitumen by strong heating, which removes the low-boiling volatiles and leaves a "cinder." McCrone prepared this product according to Eastlake's direction and ground the resulting "cinder" to a powder for comparison with the brown *Saint Jerome* pigment particles. He states that the shape and optical properties of the synthetic brown pigment particles were indistinguishable from the *Saint Jerome* particles. Furthermore, almost no other brown or black pigments are reasonable—bone black and umber are excluded by composition, and charcoal and Vandyke brown by their refractive index. Only mummy is a possibility—and it is, like antwerp brown, an asphalt minus its volatile components. Thus, the brown pigment is conclusively one that has an asphalt base but that, having been treated to remove volatiles, is insoluble in an oil medium (McCrone report, p. 2, CSL files). A similar pigment is discussed by Leopold Kockaert in "Note on the Green and Brown Glazes of Old Paintings," *Studies in Conservation* 24, no. 2 (May 1979) pp. 69–74. An unidentified dark brown resinous layer was found during the course of his study at IRPA of green and brown glazes in 15th– and 16th–century Flemish paintings, including *The Mystic Lamb,* or *Ghent Altarpiece,* by van Eyck.

48. McCrone report, p. 4, CSL files; H. Kühn, "Trace Elements in White Lead and Their Determination by Emission Spectrum and Neutron Activation Analysis," *Studies in Conservation* 11, no. 4 (November 1966) pp. 163–169. On the basis of earlier work by Ed Sayre, Kühn has reported trace element measurements on a large number of white lead pigments from Netherlandish and Venetian paintings. Differences in trace element concentrations can be used to distinguish modern white lead (post-1850) from older lead pigments.

49. A 20 percent margin of error, however, must be taken into consideration when interpreting these results.

50. Bromcresol blue was used to identify the binding medium as oil.

51. Michael R. Schilling, "Binding Media Analysis of *Saint Jerome in His Study* Attributed to Jan van Eyck, from the Collections of The Detroit Institute of Arts," Scientific Program internal memorandum report, The Getty Conservation Institute, 13 May, 1994, unpaginated, CSL files. The specimens were mounted in polyester resin (Bioplastic) and polished to a smooth finish using Buehler finishing paper ending with a 0.3μ grit.

52. Identification was based on the criteria established by Mills and White. See John S. Mills, "The Gas Chromatographic Examination of Paint Media, Part I. Fatty Acid Composition and Identification of Dried Oil Films," *Studies in Conservation* 11, no. 2 (1966) p. 92; idem, "Identification of Paint Media: An Introduction," and idem and Raymond White, "The Gas Chromatographic Examination of Paint Media: Some Examples of Medium Identification in Paintings by Fatty Acid Analysis," both in *Conservation and Restoration of Pictorial Art,* ed. Norman Brommelle and Perry Smith (Boston, 1976) pp. 69–71 and 72–77; Mills and White, "Analysis of Paint Media," *The National Gallery Technical Bulletin,* no. 3 (1979) pp. 66–67, no. 4 (1980) pp. 65–67, and no. 7 (1983) pp. 65–67. GSI research will be published in a forthcoming issue of *The Journal of the American Institute for Conservation.*

53. Since GC is a bulk analysis technique, the results given are for the sample as a whole and not for each individual layer. The azelaic/palmitic (A/P) acid ratio was 1.1, and the palmitic/stearic (P/S) acid ratio was 2.6. There is a mathematical chance that a P/S ratio of 2.6 could also indicate a mixture of linseed (P/S 1.6) and poppyseed (P/S 5.0) oil. According to the literature, however, a value of 2.6 is usually associated with walnut oil. See Mills and White, "Analysis of Paint Media" (1979) pp. 66–67; Carl van Mander, *Dutch and Flemish Painters: Translation from the Schilderboeck,* trans. Constant van de Wall (New York, 1936) p. 5. Mixtures of boiled linseed and nut oils were said to have been used by van Eyck.

54. The A/P ratio was 2.1, and the P/S ratio was 2.3.

55. Mills and White, "Gas Chromatographic Examination of Paint Media," p. 76.

56. Leopold Kockaert, "Note sur les émulsions des primitifs flamands," *Bulletin de l'Institut royal du patrimoine artistique* 14 (1973–74) pp. 133–139; idem and Monique Verrier, "Applications des colorations à l'identification des liants de van Eyck," *Bulletin de l'Institut royal du patrimoine artistique* 17 (1978-79) pp. 122–127; Kockaert, P. Gausset, and M. Dubi-Rucquoy, "Detection of Ovalbumin in Paint Media by Immunofluorescence," *Studies in Conservation* 34, no. 4 (November 1989) pp. 183–188; Bosshard, "Revealing van Eyck," pp. 4–11; Gifford, "*Annunciation.*"

57. E. P. Richardson, *Detroit Institute of Arts: Flemish Painting in the Fifteenth and Sixteenth Centuries* (Detroit, 1936) unpaginated; idem, "The Detroit Saint Jerome by Jan van Eyck," *Art Quarterly* 19 (1956) pp. 230–233.

58. Brinckman et al., "Het Lam Godsretabel van van Eyck, 1," pp. 148–149, 166.

59. Coremans, Gettens, and Thissen, "Technique des primitifs flamands," p. 28. Coccolithophoridal microorganisms were found in the ground preparation and are presumed to relate to the geographical origin of the chalk.

Discussion

Molly Faries
University of Indiana at Bloomington

All three talks in this session either point up, or test the limits of, attribution in one way or another, and all touch upon the issue of alleged forgery. The speakers' evidence differs, and is either historical or technical.

Response to Lola B. Gellman

Lola Gellman convincingly opened up the possibility of lost works by Petrus Christus in the very likely category of portraiture. As noted in the catalogue, a surprisingly small number of portraits by Christus survive, despite scholars' assumptions that Christus must have been one of the few important portrait painters, and perhaps the only one, in mid-fifteenth-century Bruges. Now that we know that the Metropolitan's *Portrait of a Carthusian* was painted soon after Christus established residence in Bruges, it is hard to imagine he would not have been sought out for portraits during the remainder of his long career in that city.

We, like Lola Gellman, eagerly await the reappearance of the two portraits presumed to depict Pieter Adornes and his wife, Elisabeth Braderyck. Without the actual paintings, it is impossible to deal fully with the issues of likeness, always a difficult matter, and authenticity. Lola Gellman logically pursued a thoroughgoing investigation of the costume to help establish that these portraits or the originals of the portraits were of Petrus Christus's time. In discussion, we were fortunate in having the corroborating opinion of Anne van Buren, who also clarified a few points of terminology. (The man's garment can be termed a robe, and the piece under the woman's robe is like a stomacher.) This type of basic research has to be done whether or not we will ever have the originals; and it already makes it clear that it is impossible to dismiss these "lost" works as forgeries, as several scholars have done in the past. But there are other important questions we will not be able to answer until the paintings resurface. The apparent slight difference in the size of the portrayed individuals will remain just a supposition. Without the results of an investigation by infrared reflectography, the presence —or lack—of underdrawing cannot be related to the various theories that have been put forth about the availability or absence of the sitter. Nor can any of the following permutations be clarified: whether the paintings are originals or copies, or whether they precede, follow, or are contemporary with the seventeenth-century prints. It is worth recalling that the late sixteenth to the seventeenth century was a time when earlier history was chronicled. Portraits of earlier Netherlandish nobles were often fabricated, and identities were assigned (such as Jan van Eyck's *Cardinal Albergati*).

Response to J. R. J. van Asperen de Boer

As usual, Dolf van Asperen de Boer has presented a paper with the full array of documentation necessary for today's technical connoisseurship. This, combined with a cogent selection of paintings, easily leads to the conclusion that the works discussed—the Amsterdam *Virgin and Child with Saints,* the Turin *Madonna and Child,* and the Hague *Madonna and Child in an Archway*—are all part of the Petrus Christus "group," a conclusion based on similarities in working procedure which would have been common knowledge in the studio.

This again brings up the larger question of attribution—and especially what the implications are of making attributions to the Petrus Christus "group," as opposed to making attributions to Petrus Christus, the individual artist. Approaches to attribution vary so much that they may seem to lack a conceptual basis. But the underlying assumptions or aims of attribution can be related to issues of method. One type of attribution can lead to what might be termed the "clean" Christus (to use a term that was making the rounds at the time of the 1991–92 Rembrandt exhibitions). Construct-

ing an artistic "group" supposedly brings in collaboration and the workshop, in an effort to link connoisseurship to the historical realities of making images in the fifteenth century. I am of course not suggesting that these approaches are mutually exclusive, nor am I implying that either has ever been practiced exclusively of the other. The two points of view can, in fact, inform each other.

As is well known, the concept of an artistic group is used in the Brussels series Les Primitifs flamands. As far as I can tell, the policy has never been fully explained, but it attempts to put paintings on an equal footing, and by so doing to allow previously unsuspected links between paintings to emerge without prejudice. The concept becomes unwieldy as soon as there are signed and dated works, citations in van Mander, and the like, which give weight to some paintings over others. The only true group, in fact, may be one like the Isenbrandt group, in which there are no signed and dated works, no descriptions in early sources, and more than five hundred equally plausible candidates for attribution. On the other hand, as Maryan Ainsworth has shown in the current catalogue, inscriptions and dates also require close scrutiny and cannot be used as an exclusive basis for attribution. Ultimately, the "group" concept has to be followed, and an across-the-board study of a critical percentage of works is unavoidable.

In the technical studies of groups, working methods are emphasized as the key to shared studio practice. Even here, however, general practices have to be distinguished from particular ones. The use of the compass as discussed by Dolf van Asperen de Boer may characterize Christus's workshop practice, but it is also a fairly routine procedure. The tool was used in other workshops as well (such as that of Stefan Lochner). For instance, it marks out a position for the astrolabe near the right edge of the Detroit *Saint Jerome*. The compass point can be seen in the X-ray. Although this was not noted in the catalogue or in Barbara Heller's talk, it was observed by van Asperen de Boer in his study of the Detroit painting some years ago. It is just one more piece of evidence that makes the *Saint Jerome* fit with the period, but not necessarily with Christus or even the Christus "group." An exacting layout of perspective, on the other hand, does appear to be more close-

ly restricted to Christus's shop; and this is one of the most interesting findings of the recent research on the artist. In the exceptionally well-preserved Kansas City *Holy Family in a Domestic Interior,* there are many clues to Petrus Christus's concern with precise geometric layout. Some are still not fully understood. The double compass points in the background may indicate only that the artist changed his mind about the position of the vanishing point. The incised arcs at the top of the panel and across the fireplace must have had a function beyond that of suggesting a different ceiling. Here, in what is a very individualized handling of geometry and tools, it is tempting to suppose that Christus was working with a method of proportional diminution of window and door openings in the oblique wall that dominates the composition and controls the recession into space.

In the effort to expand the boundaries of attribution, other notions of the "group" approach can be helpful. My impression now from reading the catalogue is that the workshop existed only to a very limited extent in the Petrus Christus group. Collaboration in the paint stage has been suggested only for the Paris *Lamentation* and background figures of the Timken *Death of the Virgin*. Perhaps Petrus Christus represents the type of small, one- or two-person enterprise mentioned by Wim Blockmans in his talk. Maryan Ainsworth has carefully described acceptable variations in individual style in the paintings: large versus small, for instance, with or without underdrawing, differing facial typologies, and response to patrons. But variations in the underdrawn layout can sometimes also be explained on a basis other than individual style development. The more schematic layouts of the large Washington and Timken panels might be conditioned by the need to direct portions of the execution of the paintings within the workshop. An attempt to reveal the differences between wing and central panels in an altarpiece is also fundamental, for it documents the degree of variance in the underdrawing or painting, or both, within the context of one commission. (Peter Klein has told me, in this regard, that his finding that the wood for the Washington donor wings and the Frankfurt *Madonna Enthroned with Saints Jerome and Francis* derives from the same tree should be taken more seriously.)

Replicas deriving from the same workshop yield similar information, which is why the Hague and Budapest versions of the *Virgin and Child in an Archway* are so important. As long as the Hague and Budapest standing Madonnas can be considered contemporary workshop versions, they will represent the range of style acceptable at the time. As such, they can give an additional historical grounding to connoisseurship and the subsequent refinements in attribution.

It is worth recalling that it is Dolf van Asperen de Boer's research that led to our current understanding that the two Mary altarpieces in the Rogier group (the *Miraflores* in Berlin and that in Grenada and New York), which are so similar in style and quality of execution, differ vastly in date. Now we have the opposite. These compositional replicas differ markedly in appearance but are close in date. Such are the ironies of technical connoisseurship.

Response to Barbara Heller

Previous to the Christus exhibition, the Detroit *St. Jerome* was included in the Stefan Lochner exhibition, and not a word was said there about technique or the possibility of any attribution other than Jan van Eyck. That is not the case here, and the exhaustive technical study by Detroit is most welcome. In this review of the findings, several points have to be stressed. First, the technical investigation of this tiny painting has been ongoing—from before the Christus exhibition to during and even after the Christus symposium—and will eventually culminate in a forthcoming technical study by Barbara Heller in the Detroit *Bulletin*. Secondly, some of the critical technical evidence is historical—gathered by Paul Coremans and Jean Thissen at Brussels when the painting was there in 1961. This is probably the first time technical material has been reinterpreted more than thirty years after the fact, and Dolf van Asperen de Boer's perspective on this matter has been invaluable. He graciously agreed, at my suggestion, to add his comments to the discussion.

As Barbara Heller has demonstrated, most of the problematic aspects of the *Saint Jerome*, taken singly, can be explained reasonably and related to comparanda. This still does not alter the fact that the painting has anomalous features.

The first is the paper layer, which is unusual as a support or interlayer. (Judging by the continuing doubts expressed about this point, notably by Roger Wieck, some double-checking is in order.) All the pigments identified by Detroit and by the McCrone laboratory are consistent with the period, and that applies even to the pigments that are a bit more difficult to explain, such as red lead (which is the same as minium, the red ubiquitous in manuscript illumination). This is where cross sections are more relevant than crushings, and everything should therefore be done to correlate the recent samples with notes and drawings of the earlier Brussels cross sections. (This was actually done by Barbara Heller and Dolf van Asperen de Boer after the Christus symposium; they found the original samples in Brussels.) If the red lead indeed appears only along the edges (as Heller argued about the X-radiograph, and as it appeared to me, too, when I studied the *Saint Jerome* under the binocular microscope in August 1994), then an argument needs to be developed about a possible frame. Van Asperen de Boer noted the same pigment in connection with the frame in van Eyck's *Saint Barbara* in Antwerp (*Jaarboek van het koninklijk Museum voor schone kunsten Antwerpen,* 1992). It would also be useful for Cleveland and The Metropolitan to confirm (by some nondestructive means) the presence of red lead which has been proposed in the catalogue for their Christus paintings. As Barbara Heller stated in her talk, more information about antwerp brown would be helpful. Asphaltum and mummy are old pigments; they are referred to in Leonardo's treatise on painting, for instance, and they are described by Plesters. We need other examples from the period, however; and as a rule, browns and blacks are not analyzed. Marigene Butler very kindly informed me that the brown in the Chicago Gerard David, described as a bituminous earth in her article, might be consulted again. Finally, lead-tin yellow has also been found in the *Saint Jerome* (seen by me during the same August 1994 study of the painting under the microscope, and confirmed by Barbara Heller in a phone conversation, September 1994). The presence of this pigment is just one more factor that fits the painting neatly into its time and makes the possibility of forgery even less likely.

In the forgery arguments, there has been a great deal of discussion about the objects in Jerome's study, and so I will restrict my remarks to one additional point having to do with the pens. One quill pen is on Jerome's table (along with some splatters of ink), and another so-called pen is in the box next to the lectern. This object has been identified as modern, with a metal nib. These details are minuscule, but they are in an unretouched section of the painting, if one judges by the ultraviolet photograph. If these instruments are compared with those in Erhard Altdorfer's *Saint John the Evangelist on Patmos* (Kansas City), another possibility arises. There the quill pen is used along with an erasing knife, which in this case consists of a short blade set into a wooden handle. If, as I believe, one can interpret the writing instruments in the *Saint Jerome* as a quill pen and an erasing knife, they would be perfectly in line with the practices of the period.

Pursuing the notion that the painting is a forgery, it seems to me, would be a fruitless task. To do so, one would have to reconstruct a context for an extremely clever forger who somehow had foreknowledge of dendrochronology, later research about Cardinal Albergati, the need for damages and overpaint, a date that would prompt controversies about attribution, and even the current art historical suggestion that places the painting in a period when small oils were created which looked like miniatures.

Response to Barbara Heller
by J. R. J. van Asperen de Boer

The *Saint Jerome* is a very important picture for me, because it was the very first painting whose scientific examination I was allowed to assist in, when I was studying for a minor under Professor Coremans in 1961. The painting had actually been to the exhibition in Bruges in 1960, and was illustrated on the cover of that catalogue. After those exhibitions in Bruges and Detroit, it came to the Institute (Institut Royal du Patrimoine Artistique) in Brussels. It was examined under strict conditions imposed by the museum. A gag rule was imposed on it. It was understood that we were not to speak about it until the museum (the Detroit Institute of Arts) agreed. Therefore today is a very important day, now that this embargo has finally been lifted after thirty-four years. I think the museum is really to be congratulated on it, because finally we can discuss the whole thing.

The point is that at that time the restoration and examination of the *Mystic Lamb* had been accomplished, but that is not to say that a great many Flemish primitive paintings had been examined at the Institute. Nor was the knowledge of every technical aspect as great as it is now. For example, little attention was paid to marbled reverses of panels. Today, if you see a marbled reverse you say, "Ah, that must be an old painting." I specifically remember thinking that the reverse of the *Saint Jerome* was damaged and not very interesting. And of course, dendrochronology of panels did not exist. In one report on the Ince Hall *Madonna*, Coremans actually states that there is no way of dating the panel. Thus, one must take into account that the idea of a transfer was not related to the fact that the panel was old. It was thought that it was due to damage, and no importance was attached to it. In the catalogue of the 1960 Detroit exhibition, it actually says "transferred to a panel in 1956." I have asked Jacqueline Folie, who edited the catalogue, how that came about, and the answer was that it was on the form the Detroit Museum filled out. So doubt crept in that way.

I was more or less responsible for systematically analyzing all the objects in the painting. Indeed, I suggested that one object was a modern pen: you see, the modern pen with the hole in it cannot be earlier than 1830. That again threw some doubt on it, and a lot of discussion ensued.

Roger Marijnissen actually lifted the silence, so to speak. He began publishing documents from the files of the IRPA. He also quite unjustly, I think, published documents in the handwriting of the late René Sneyers, and quoted them entirely out of context. That didn't help. Since the silence was not officially lifted, nobody could speak about it; and I was not allowed to, morally...

I am showing you on the screen the original report of Coremans of 1961 (a little after I left for Amsterdam, so I haven't seen this one, which has been translated into English), and you see the composition of the various paint layers here. It still is a very concise report, I think. A number of things were not understood

at the time, and are still difficult to understand, as Molly Faries said, because there are no other examples. Those two slides are taken from my minor thesis-students did not even have typewriters at that time. I made little drawings of the cross sections made by the late Jean Thissen. One thing I would like to point out is the green layers here. At the Brussels Institute, Thissen always concluded that a pigment that was green and had a positive chemical reaction for copper was malachite. But he did not make mounts, like the one you were shown, because it is optically easy to differentiate copper resinate from malachite, since the copper resinate is not birefracting. Thus, malachite is not the usual green pigment in Flemish primitive painting; ground copper resinate is. That is something we have to take into account as not incompatible with a fifteenth-century origin.

Then there is the problem of the paper, which is directly on the wood. The puzzling thing still is the red lead at the edges. The idea of the transfer was also explained to me by Richard Buck when he was in Brussels in 1961: that you sometimes find red lead in transfers. That is true, but if you think about it in retrospect, why should somebody transfer something that had first been painted on a panel onto a second panel that is perfectly compatible with an Eyckian origin? Nobody would do that. And nobody, as Molly said, would have this idea somewhere in the nineteenth century. The transfer idea distorted the whole question, because a transfer is a typical nineteenth-century thing to do. I think, at the present time, we must say, "Well, there are examples of different supports." The only thing that we have to explain is how the red lead came about. It may be that it had something to do with attaching small strips of wood or something. After all, nobody knew until a few years ago that *tüchlein* were provided with flat wooden supports, that they were actually tacked onto them. It is quite possible that in this particular case we have a paper support up to the edges, and that the red lead is a remainder of some sort of traditional framing that has been removed. It must be something like that, because there is no red lead on the gray edge. Molly and I discussed this almost the entire day yesterday, when there was an opportunity, and I must say that in retrospect, the idea of a transfer is ridiculous,

because I've never seen a real nineteenth-century fake of a Flemish primitive painting.

Therefore, I would like to end by putting into perspective, as it were, what the Institute did at that time. One must, of course, remember that Coremans was being harassed after the war because he had been asked by the Dutch government to sit on the committee in the van Meegeren affair, and those who believed that the van Meegeren pictures were really Vermeers were still actually making his life very, very bitter in a sense. So the word "fake" had a particular significance at the Brussels Institute. Today we know, I think, that fakes are rare. They are very easy to recognize. You usually have considerably damaged paintings that have been retouched or something – ruins that are original, but don't look very nice anymore. So I think we can discard the idea that the Detroit *Saint Jerome* is a nineteenth-century object.

Audience: Roger Wieck

I should state right off that I have always been suspicious of the Detroit *Saint Jerome*, so I will play my hand right away. The paper is very suspicious, as has been noted in the talk. It has been noted that paper was used in one late thirteenth-century panel as a support, but doesn't reappear again until the late fifteenth century. Illumination was brought up, and we know that Jan van Eyck was an illuminator. No illuminator would ever use paper as a support for what we would consider illumination. Manuscripts were made on paper in the West from the thirteenth century on, and though – especially in the fifteenth century – they were sometimes given wash drawings, they are never given what we would consider illumination. To me, as a manuscript person, it is inconceivable that Jan van Eyck would use paper as a support for a panel painting. The last thing I want to add is a rumor that I heard when I was a student in Brussels in the late 70s, which was that the Detroit *Saint Jerome* was painted by the restorer Phillipot, who painted the panel for the lost section of the *Ghent Altarpiece*. He was the one who was said to have painted the *Saint Jerome* in Detroit. I hear some tittering. But before I get a response, let me just finish: when you, Molly Faries, were thinking of who might be capable of painting such a panel, it clearly would

fall into the hands of someone like a conservator or a restorer. What perhaps started out as a practice piece has now been taken a little bit more seriously than it should have been.

Van Asperen de Boer:

First, about this rumor. The copy in the *Ghent Altarpiece* is by the restorer J. Vanderveken, who was actually related to Albert Phillipot. He could not have painted the *Saint Jerome*, because it was in a German collection before 1945. Then too, if you look at his copy in the *Ghent Altarpiece* panel, it is totally different. Nobody would have been able to paint it early in this century. He wouldn't have been able to paint it, because he really wouldn't have known how to make those pigments. That is like maintaining that van Meegeren knew Vermeer's technique so well that he could make those paints. But that is nonsense, because van Meegeren saw that Vermeer used natural ultramarine and therefore he used only natural ultramarine and not smalt and azurite. He used lead white and he used Kremnitz white and not the Dutch process globules you see sticking out in all the Vermeer paintings. At that point, in 1925 when the Detroit *Saint Jerome* turned up, nobody knew anything about van Eyck's technique and that's my answer to that particular question.

The Philadelphia *Saint Francis*—it is not a panel painting, it is parchment on panel, and the Detroit *Saint Jerome* is paper on panel. If you use oil paint, which is used in the Philadelphia painting too, it will soak into the paper, so you must do something. In Philadelphia, there is a thin lead white layer. The paper of the *Saint Jerome* was impregnated first and then covered with lead white. I find it very interesting that Barbara Heller reports that it is probably walnut oil, while the usual medium for a van Eyck painting seems to be linseed oil. (Some of the samples of the van Eyck in Rotterdam were analyzed and they are pure linseed oil.) Walnut oil may produce something with less tension in the crack pattern, and so would react better on the paper support.

Dendrochronological Findings of the van Eyck-Christus-Bouts Group

Peter Klein
University of Hamburg

Introduction

Dendrochronology is a discipline of biological sciences which serves the purpose of determining the age of wooden objects. This method of dating allows us to arrive at least at a *terminus post quem* for a painting by determining the felling date of the tree from which the panel was cut. The method involves measuring the width of the annual rings on the panels and comparing the growth ring curve resulting from this measurement with the dated master chronologies. A relatively precise dating of the panel can then be determined; it is based on the specific characteristics of the growth ring curve and on the geographic origin of the wood.

The analysis of a group of panels of a workshop is more helpful for determining questions of attribution and dating than the analysis of a single panel. Notwithstanding the statistical problems of estimating the number of growth rings of the missing sapwood and the time the boards were kept in storage, art historians may obtain supporting evidence for chronological distinctions from dendrochronological analysis.

By the evaluation of twenty-one panels from the van Eyck workshop, eighteen panels attributed to Christus, and thirty-three panels by Dieric Bouts and his workshop, it is possible to make certain chronological distinctions. Furthermore, it is clear that some boards originate from the same tree. Although the problems and limitations of dendrochronology were described in the catalogue for the Petrus Christus exhibition, it is essential to reiterate the basic elements of this method.

Limitation and Problems

In preparing oak panels for paintings, the panel makers usually cut the planks with a radial orientation to the cross section of the tree

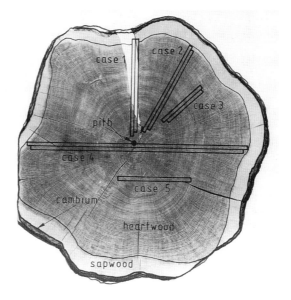

Figure 1. Various methods of extracting boards from an oak tree

(Fig. 1). The bark, and the light and perishable sapwood, were cut off, and as a result evidence of the latest growth rings was eliminated. Because of this, a determination of the exact felling year is not possible. Only the latest measured growth ring of the panel can be determined for the exact year.

The estimated number of sapwood rings to be added may be derived by statistical evaluation. The provenance of the oak is significant in establishing the statistical basis for sapwood analysis. In Europe, the number of sapwood rings varies: a range from seven to fifty can be found in western Europe, only nine to thirty-six in the eastern part. This information is especially important, as the wood used for Netherlandish panels generally originated from the Baltic region (Fig. 2).

The number of sapwood rings found in oak trees from northern Poland was analyzed and yielded a median value of fifteen: 50 percent of all the trees had thirteen to nineteen sapwood rings; the minimum was nine, the maximum thirty-six. The number of sapwood rings also

Figure 2. The areas of the natural distribution of oak. Distribution of *Quercus robur* L. (European oak) is shown as a heavy line, and of *Quercus petrea* Liebl. (sessile oak) as an interrupted line. European oak goes farther northeast than sessile oak. The source of oak timbers and the places of their utilization as panels are indicated by arrows.

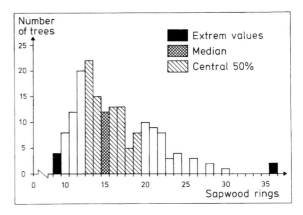

Figure 3. Distribution of the number of sapwood rings in oak trees from northern Poland

depends on the age of the tree: in general a tree three hundred years old has more sapwood rings than a tree one hundred years old (Fig. 3).

In order to determine the earliest possible felling date, at least nine sapwood rings must be added to the latest heartwood ring found on the panel. If some of the sapwood is still preserved, the felling date of the oak tree can be estimated with higher accuracy. If a panel is made exclusively out of heartwood, the estimated felling date of the tree cannot be determined as precisely. For an earliest felling date nine years must be added, and it must be considered that some heartwood rings may have been cut off during the preparation of the panel.

The next problem is to determine how much time elapsed between the cutting of the tree and the painter's use of the panel. Signed and dated panels of the sixteenth and seventeenth centuries show that most panels were used from two to eight years after the tree had been felled. The relative size of the panels apparently has no effect on the storage time; i.e., the wood used for a small panel need not be stored for a

longer or shorter period than that for a large painting.

Few signed and dated early Netherlandish paintings exist from the fifteenth century. On the basis of these few examples (Tables 1 and 2) it seems probable that the painters used the panels about ten years after the tree had been cut down—or even later. However, the estimate of ten years' storage time is also a statistical figure that can differ widely in particular cases.

Dendrochronological Results

For all analyzed paintings of the van Eyck-Christus-Bouts group, only oak wood was used. The wood was imported exclusively from the Baltic region. Altogether for this group 144 boards were analyzed; on only 3 boards could sapwood rings be detected:

Christus follower:
Madonna, The Hague
200 growth rings, incl. 7 sapwood rings

Bouts follower:
Mater Dolorosa, Ottawa
278 growth rings, incl. 5 sapwood rings

Bouts follower:
Christ, priv. coll.;
195 growth rings, incl. 2 sapwood rings

Through a comparison of all boards with each other, some boards from the same tree could be

Table 1: Dieric Bouts, *The Last Supper* (Louvain; St. Pieters Church dated 1464)

	Minimum	Median	Maximum
Sapwood	9 rings	15 rings	36 rings
Felling date	1445	1451	1472
Storage time	19 years	13 years	–

Table 2: Petrus Christus, *Saint Eligius* (New York, The Metropolitan Museum of Art, dated 1449)

	Minimum	Median	Maximum
Sapwood	9 rings	15 rings	36 rings
Felling date	1421	1428	1449
Storage time	28 years	21 years	–

Table 3: Jan van Eyck (1390–1441)

Painting/ Museum, Inv.-No.	Board	Number of growth rings	Youngest growth ring	Earliest felling date: 9 sapwood rings	Estimated felling date: 15 sapwood rings
Virgin in a Church B, 525 C	I	158	1307	1316	1322
Stignatization of St.-Francis TU	I II	87[1] 84[1]	1359 1365	1374	1380
Donor ASL, NGK 728	I	107	1366	1375	1381
Head of Christ B, 528 A	I	88	1377	1386	1392
Portait of a Man with a Ring BUC	I	123	1377	1386	1392
Stignatization of St.-Francis PHI, 314	I	83[2]	1307	1392	1398
Giovanni Arnolfini B, 523 A	I	177[2]	1382	1392	1398
Baudouin de Lannoy B, 525 G	I	179[2]	1383	1392	1398

Superscript numerals in "number of growth rings" column indicate boards that came from the same tree.

Table 4 : Jan van Eyck (1390-1441)

Painting/ Museum, Inv.-No.	Board	Number of growth rings	Youngest growth ring	Earliest felling date: 9 sapwood rings	Estimated felling date: 15 sapwood rings
Portrait of a Man PHI, 315	I	96	1391	1400	1406
St. Jerome DET, 25.4	I	86	1401	1410	1416
Virgin and Child priv. coll.	I	204	1404	1413	1419
Three Maries at the Tomb ROT, 2449	I II III	223[3] 136 213[3]	1407 1319 1408	1417	1423
Lucca *Madonna* FFM, 944	I II III	153 78 97	1366 1413 1408	1422	1428
Rolin *Madonna* PL	I II III	195[4] 134 198[4]	1417 1386 1416	1426	1432
Portrait of a Man NY, 32.100.41	I II	110 66	1422 –	1431	1437

Superscript numerals in "number of growth rings" column indicate boards that came from the same tree.

Table 5 : Follower of Jan van Eyck

Painting/ Museum, Inv.-No.	Board	Number of growth rings	Youngest growth ring	Earliest felling date: 9 sapwood rings	Estimated felling date: 15 sapwood rings
St. Christopher PHI, 342	I	159	1439	1448	1454
Christ priv. coll.	I	245	1451	1460	1466
Christ priv. coll.	I	220	1452	1461	1467
Man with a Pink B, 525 A	I	244	1459	1468	1474
Virgin and Child NY, 89.15.24	I II	168 171	1478 1469	1487	1493
Christ Bearing the Cross BUD, 2531	I II III	156[5] 181[5] 73[5]	1491 1491 1481	1500	1506

Superscript numerals in "number of growth rings" column indicate boards that came from the same tree.

Table 6 : Petrus Christus (1410–ca. 1475/76)

Painting/ Museum, Inv.-No.	Board	Number of growth rings	Youngest growth ring	Earliest felling date: 9 sapwood rings	Estimated felling date: 15 sapwood rings
St. John the Baptist CLE, 7980	I	61	1355	1364	1370
Exeter Madona B, 523 B	I	154	1387	1396	1402
St Eligius NY, 1975.1.110	I II III	180[1] 80 73[1]	1410 1413 1408	1422	1428
Portrait of a Lady B, 532	I	212	1415	1424	1430
Portrait of a Carthusian NY, 49/7.14	I	133	1415	1424	1430
Annunciation NY, 32.100.35	I II III IV	25[2] 121[3] 103[2] 108[3]	1334 1417 1411 1415	1426	1432
The Last Judgment B, 529 A	I II III	240[5] 97[4] 246[5]	1400 1419 1408	1428	1434
Annunciation and Nativity B, 529 B	I II III	231[4] 130[4] 215[5]	1416 1311 1398		
Virgin and Child in an Archway DH, NK 1841	I	200/7	1419	1428	1434
Female Donor WNG, 1368	I	129[6]	1391		
Male Donor WNG, 1367	I	148[6]	1412	1430	1436
Enthroned Madonna FFM, 920	I II	106[6] 181[6]	1421 1420	1430	1436

Superscript numerals in "number of growth rings" column indicate boards that came from the same tree.

Table 7 : Petrus Christus (1410–ca. 1475/76)

Painting/ Museum, Inv.-No.	Board	Number of growth rings	Youngest growth ring	Earliest felling date: 9 sapwood rings	Estimated felling date: 15 sapwood rings
Lamentation ★	I	246[7]	1414		
BMB, 564	II	257[7]	1412		
	III	393	1424	1433	1439
Virgin and Child in an Archway	I	176	1424	1433	1439
BUD, 4324					
Virgin and Child	I	161	1426	1435	1441
TU, 26					
Lamentation	I	207	1426	1435	1441
NY, 91.26.12					
Nativity	I	286	1431	1442	1448
WNG, 40	II	136	1433		
	III	177[8]	1431		
	IV	147[8]	1430		
Virgin and Child with	I	105	1407	1442	1448
Sts. John the Baptist and Jerome	II	190	1433		
priv. coll.	III	96	1399		

★ Measurement by J. Vynckier, Brussels (IRPA)
Superscript numerals in "number of growth rings" column indicate boards that came from the same tree.

Table 8 : Dieric Bouts (1410/20–1475)

Painting/ Museum, Inv.-No.	Board	Number of growth rings	Youngest growth ring	Earliest felling date: 9 sapwood rings	Estimated felling date: 15 sapwood rings
Virgin and Child FFM	I	223	1359	1368	1374
Virgin and Child NY, 30.95.280	I	97	1402	1411	1417
St. John the Baptist Preaching B, 533 C	I	184[1]	1423		
	II	180[1]	1425	1434	1440
Mater Dolorosa priv. coll.	I	93	1427	1436	1442
	II	154	1321		
Virgin and Child AN, 28	I	173	1431	1440	1446
Altarpiece of the Holy Sacrament LOH					
Abraham and Melchizedek	I	130	1424		
	II	100[2]	1415		
	III	60[3]	1422		
Feast of Passover	I	140	1423		
	II	140[2]	1417		
	III	100[3]	1426		
Gathering of the Manna	I	100[4]	1434		
	II	50[2]	1428		
	III	60[5]	1414		
Elijah in the Dessert	I	252[4]	1430		
	II	194[2]	1428		
	III	258[5]	1436	1445	1451
Jesus with John the Baptist and Donor MP, WAF BI 35	I	272[6]	1437	1446	1452
	II	170[6]	1432		
Pearl of Brabant center MP, WAF 76	I	126[7]	1419		
	II	126[7]	1421		
	III	143[7]	1402		
left wing	I	302[7]	1437	1446	1452
right wing WAF 77 and 78	I	140[7]	1435		

Superscript numerals in "number of growth rings" column indicate boards that came from the same tree.

Table 9 : Dieric Bouts (1410/20–1475)

Painting/Museum, Inv.-No.	Board	Number of growth rings	Youngest growth ring	Earliest felling date: 9 sapwood rings	Estimated felling date: 15 sapwood rings
Christ on the Cross B, 533 B	I	147[8]	1435		
	II	147[8]	1438	1447	1453
	III	262	1405		
Moses and the Burning Bush PHI, 339	I	178	1439	1448	1454
	II	139	1434		
Lamentation PL, RF 1	I	210[9]	1443	1452	1458
	II	189[9]	1436		
Lamentation FFM, 1268	I	106[10]	1445	1454	1460
	II	111[10]	1445		
Mourning Virgin LN, 711	I	167[11]	1448	1457	1463
Man of Sorrows LN, 712	I	156[11]	1448	1457	1463
Virgin and Child FFM, 1217	I	130	1451	1460	1466
Resurrection MP, WAF 74	I	101[12]	1461	1470	1476
	II	122[13]	1449		
	III	145[13]	1452		
	IV	102[14]	1436		
St. John the Evangelist MP, WAF 75	I	101[12]	1461	1470	1476
	II	122[13]	1449		
	III	145[13]	1452		
	IV	102[14]	1436		
St. John the Baptist CLE, 51.354	I	70[14]	1437		
	II	137[14]	1432		
	III	122[12]	1449	1470	1476
	IV	–			
Arrest of Christ MP, 990	I	144[14]	1432		
	II	150[14]	1437		
	III	130[12]	1456	1470	1476
	IV	20			

Superscript numerals in "number of growth rings" column indicate boards that came from the same tree.

table 10 : Follower of Dieric Bouts

Painting/ Museum, Inv.-No.	Board	Number of growth rings	Youngest growth ring	Earliest felling date: 9 sapwood rings	Estimated felling date: 15 sapwood rings
Mourning Virgin CHI, 1986.998	I	267	1468	1477	1483
Man of Sorrows OT`	I	273[11]	1473	1483	1489
Mourning Virgin OT	I	278/5[11]	1479	1483	1489
Man of Sorrows KA, 1138	I	154[12]	1489		
	II	191[12]	1491	1500	1506
Man of Sorrows NY	I	217	1491	150	1506
	II	97	1354		
Mourning Virgin	I	111	1500	1509	1515
	II	169	–		
Head of Christ priv. coll.	I	150	–		
	II	195/2	1507	1514	1520

Superscript numerals in "number of growth rings" column indicate boards that came from the same tree.

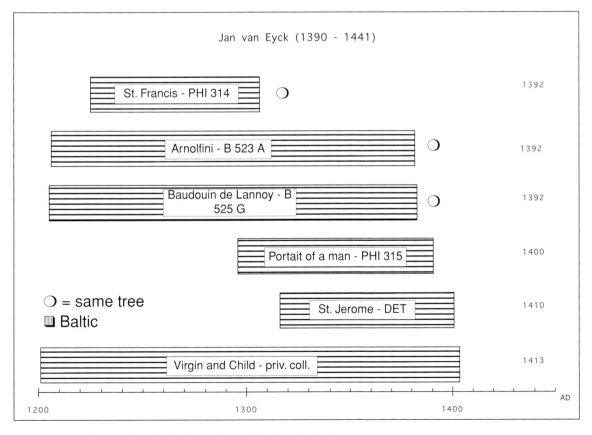

Figure 4. Examples for the dendrochronological dating of paintings

found in the same painting or in different paintings from the same workshop, but not in the different workshops. In general the following results could be obtained (Tables 3 to 10). Some results will be discussed in particular.

Jan van Eyck

All of the panels analyzed could be dated, but in some cases the dendrochronological results did not provide significant results for an art-historical attribution. For the panel *Virgin in a Church* (Berlin, inv. no. 525C), a board from the center of a tree was used. The earliest felling date of this tree differs by more than a hundred years from the art historical attribution. In the case of the *Stigmatization of Saint Francis* (Philadelphia, inv. no. 314), the measurement could be taken from an X-ray photograph. It is evident (Fig. 5) that the growth ring curve is identical with the last part of the growth ring curves from the wood used for the *Portrait of Giovanni Arnolfini* and the *Portrait of Baudouin de Lannoy* (Berlin, inv. no. 523 A and 525 G). (Fig. 5). As the wood of one single tree was not used in different workshops, the *Stigmatization of Saint Francis* must come from van Eyck workshop. Regarding the *Virgin of Chancellor Rolin* (Paris), whose latest wood growth dates from 1417, the earliest possible felling date is 1426, with the assumption of the median of fifteen sapwood rings and a ten-year storage time. That results in a presumed date of 1442, which is contradictory to the art historical dating and attribution to Jan van Eyck, who died in 1441 (Fig. 6). Under the assumption that the usual art historical date of c. 1435/36 is correct, fewer sapwood rings or less storage time must be taken into account.

Figures 7 and 8 show very clearly that these paintings were executed by followers of van Eyck. The wood planks for the Budapest *Christ Bearing the Cross* (inv. no. 2531) have an earliest felling date of 1500, which suggests that the painting was created in the beginning of the sixteenth century.

Petrus Christus

The dendrochronological analysis of a number of Petrus Christus's paintings has provided interesting results.

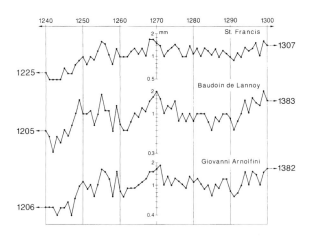

Figure 5. Section of the growth ring curves of the three paintings *St. Francis, Baudouin de Lannoy,* and *Giovanni Arnolfini*

As the latest heartwood ring of the Friedsam *Annunciation* dates from 1417, the tree cannot have been felled earlier than 1426. This results in a dating of the picture in the late 1430s or early 1440s.

Each of the Berlin wings is made out of three boards: boards I and II of the *Annunciation and Nativity* and board II of the *Last Judgment* derive from the same tree; board III of the *Annunciation and Nativity* and boards I and III of the *Last Judgment* were cut from another tree. For the middle boards of the wings, one single thick board was split vertically into two pieces. The part that originated from the tree's center and thus showed only very early growth rings was used for the *Annunciation and Nativity,* and the part with the younger growth rings was the source of the middle board of the *Last Judgment*. When the board was split, 5 mm of wood got lost, as can be determined from the missing growth rings (Fig. 9).

The grouping of the boards has nothing to do with the panel's stability. If boards come from one tree, one might only conclude that the panel makers bought a whole trunk that had already been cut into boards. Further conclusions can hardly be drawn, as the trade of wood within the cities needs further research. When wood from the Baltic region was transported, the trunks were usually cut; one does not, however, yet know if the boards of a single tree were kept and sold together once they arrived at their destination.

Like the boards of the Berlin wings, the two boards of Petrus Christus's Frankfurt *Madonna*

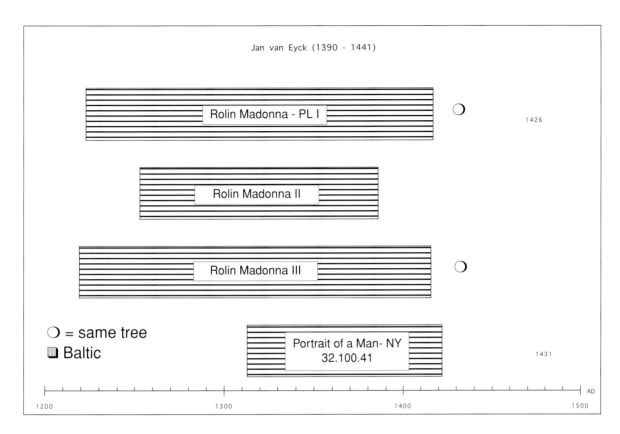

Figure 6. Examples for the dendrochronological dating of paintings

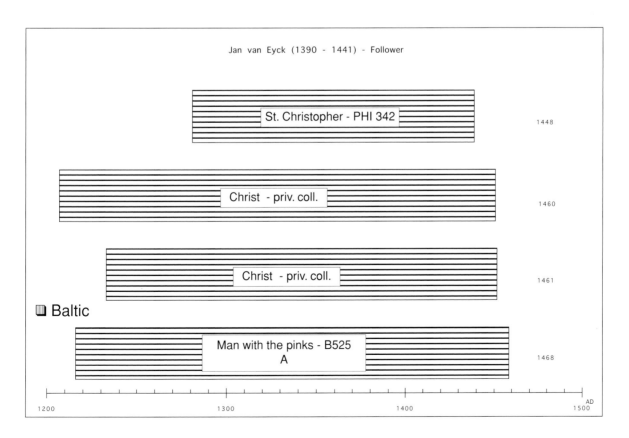

Figure 7. Examples for the dendrochronological dating of paintings

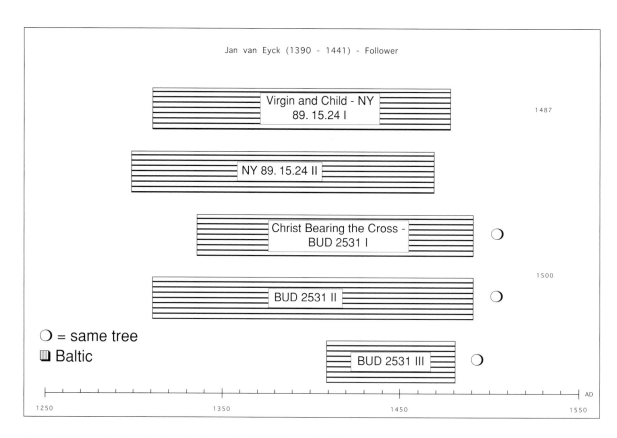

Figure 8. Examples for the dendrochronological dating of paintings

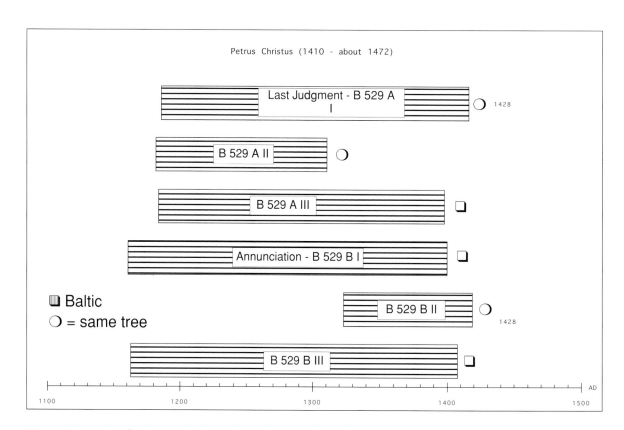

Figure 9. Examples for the dendrochronological dating of paintings

were cut from the same tree. The last growth ring that can be measured dates from 1421, and so the tree cannot have been felled before 1430. That year must also be accepted as a *terminus a quo* for the donor panels in Washington (Fig. 10), whose boards come from the same tree as the Frankfurt painting.

Boards of the same tree can frequently be found in the center panels and the wings of altarpieces from the fifteenth century. This information points to a possible connection between Christus's Frankfurt *Madonna* and the Washington donors as parts of one altarpiece, although all data have not been evaluated statistically.

The analysis of the *Virgin and Child in an Archway* (Budapest, inv. no. 4324) shows an earliest felling date of 1433 for the tree that provided the panels (Fig. 11). The copy of this painting in The Hague, Rijksdienst, has a board with two hundred growth rings, including seven sapwood rings, and an earliest felling date of 1428. The creation of this painting in the middle of the fifteenth century is plausible from the view of the dendrochronology.

Dieric Bouts

Editor's Note: Comparative material on Christus's contemporary Dieric Bouts has been included here to contribute to and underscore the reliability of this method of research.

On each wing of Dieric Bout's *Last Supper* altarpiece (Louvain) two scenes from the Old Testament are represented. As the paintings were kept in different collections until they were rejoined to the centerpiece, the reconstruction of the correct sequence is open to debate. The present position of *Abraham and Melchizedek* over the *Passover* on the left wing, and the *Gathering of the Manna* over *Elijah in the Desert* on the right, cannot be proven through dendrochronology.

A total of twelve boards were used in making the wings; three boards were used for each of the four paintings. All four central boards were cut from the same tree (Fig. 12); since the inner and outer sides of the central boards of the upper and lower scenes of each wing do not conform in their specific tree ring characteristics, the scenes need not have been in their current configuration. In addition, the combination of boards from the same tree (board I: *Elijah* and *Manna*) and boards from different trees (board I: *Abraham* and *Passover*) proves that the four panels were produced individually, not as pairs in an entire wing.

The central painting and the wings of the *Pearl of Brabant* (Fig. 13) consist of five boards, all originating from the same tree. Given the estimated felling date of 1452, an execution date in the second half of the fifteenth century seems likely; this dendrochronological result has to be considered art historically.

Four paintings of the Bouts group in Munich and Cleveland are *Arrest of Christ,* the *Resurrection, Saint John the Evangelist* (Munich, inv.-no. 990, WAF 74, and WAF 75) and *Saint John the Baptist* (Cleveland, inv. no. 51.354). The *Resurrection* and *Saint John the Evangelist* as well as the *Arrest of Christ* and *Saint John the Baptist* were originally the front and back sides of the same panel. As the tree cannot have been felled before 1470—probably even as late as ca. 1476 —the creation of the paintings during the lifetime of Dieric Bouts seems unlikely, since he died in 1475.

Dendrochronology cannot prove that the attribution to Dieric Bouts himself is impossible, but it does make it seem very improbable statistically.

The dendrochronological analysis provides important evidence in considering the differentiation between an original and copies. Of the pair *Man of Sorrows* and the *Mourning Virgin* (private collection; Fig. 14 and 15) only the *Mourning Virgin* could have been made during Bouts's lifetime. None of the other paintings studied in this group can be by the master himself.

The dendrochronological data of the paintings by van Eyck, Christus, and Bouts or their followers show in an exemplary way the use of dendrochronology for art history as well as the restrictions of this method:

1. Dendrochronology can provide information in questions of attribution; *e.g.* the Friedsam *Annunciation* cannot have been painted by Hubert van Eyck, who died in 1426, because the tree from which the panel was made could not have been cut down before that year. The dendrochronological data also exclude an attribution of the Friedsam *Annunciation* to the ear-

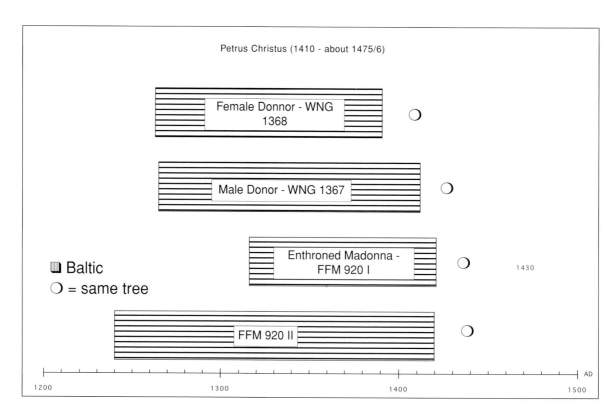

Figure 10. Examples for the dendrochronological dating of paintings

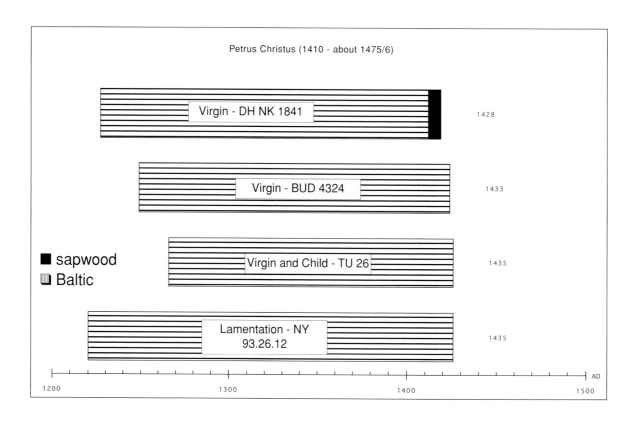

Figure 11. Examples for the dendrochronological dating of paintings

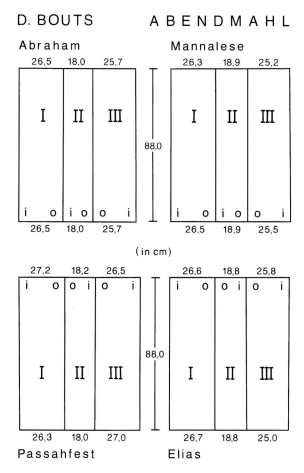

D. BOUTS ABENDMAHL

Abraham Mannalese
26,5 18,0 25,7 26,3 18,9 25,2

I II III I II III

88,0

i o i o o i i o i o o i
26,5 18,0 25,7 26,5 18,9 25,5

(in cm)

27,2 18,2 26,5 26,6 18,8 25,8
i o o i o i i o o i o i

88,0

I II III I II III

26,3 18,0 27,0 26,7 18,8 25,0
Passahfest Elias

Figure 12. *Last Supper,* Louvain. Reconstruction of the
four wings; i = towards the pith; o = towards the bark

ly oeuvre of Jan van Eyck, *i.e.,* before the *Ghent Altarpiece* from 1432.

2. The method also gives valuable information about the function of panels that are separated today but might have originally belonged together. The context of Petrus Christus's Washington donor portraits and the Frankfurt *Madonna* should be discussed again art historically as dendrochronology provides the same date for the panels and proves that boards for the center and the wings were cut from the same tree.

3. The Rolin *Madonna* by Jan van Eyck serves as a brilliant example to show that dendrochronology cannot provide an accurate *terminus post quem* for the execution of a painting, because the method is based on statistical data that give only probable dates for the felling of the tree and for the storage time of the boards. Statistical dendrochronological data suggest a

date for the execution of the Rolin *Madonna* as late as 1442; thus Jan van Eyck could not have painted one of his most characteristic works. As that is for stylistic reasons impossible, the dendrochronological date must be reconsidered. Either the tree was cut down earlier or the boards were stored a shorter than average time. The dendrochronological data for Bouts's panels in Munich have to be interpreted differently. Here dendrochronology supports already existing art historical doubts about the attribution; a date within Bouts's lifetime is very unlikely as the earliest possible felling date is 1474, one year before the artist died.

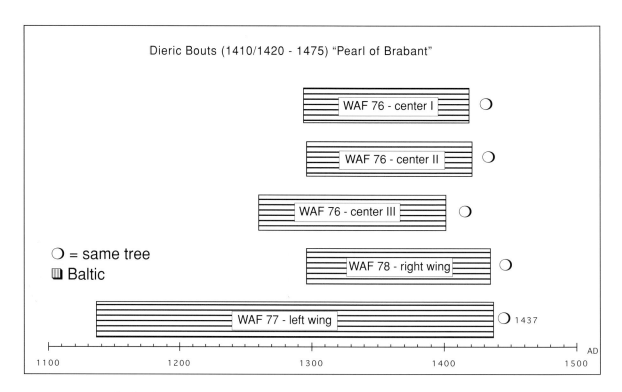

Figure 13. Examples for the dendrochronological dating of paintings

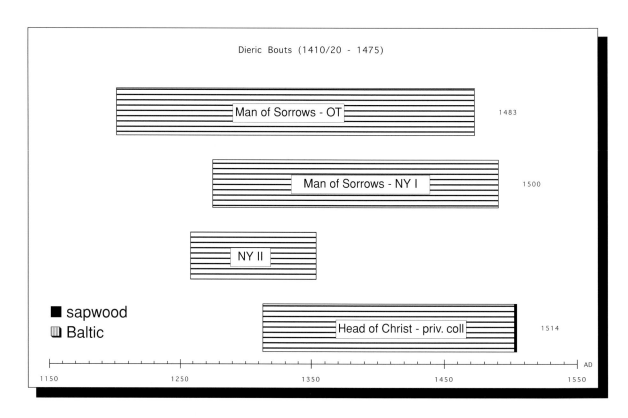

Figure 14. Examples for the dendrochronological dating of paintings

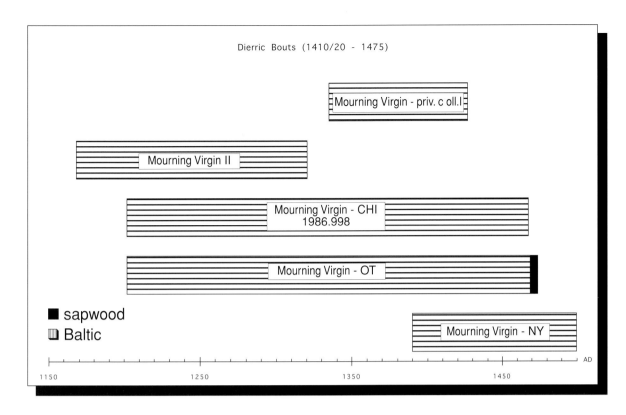

Figure 15. Examples for the dendrochronological dating of paintings

Museum abbreviations used in the following charts and figures:

AN Antwerp, Koninklijk Museum voor Schone Kunsten
B Berlin-Dahlem, Gemäldegalerie
BMB Brussels, Musées Royaux des Beaux-Arts
BUC Bucharest, National Museum
BUD Budapest, Szépmúvészeti Múzeum
CLE Cleveland, Museum of Art
CHI Chicago, Art Institute
DET Detroit Institute of Arts
DH The Hague, Rijksdienst Beeldende Kunst
FFM Frankfurt am Main, Städelsches Kunstinstitut

KA Kansas City, Nelson-Atkins Museum
LN London, National Gallery
LOU Louvain, Sint Pieterskerk
MP Munich, Alte Pinakothek
NY New York, The Metropolitan Museum of Art
OT Ottawa, National Gallery
PHI Philadelphia Museum of Art
PL Paris, Musée du Louvre
ROT Rotterdam, Boymans-van Beuningen Museum
TU Turin, Galleria Sabauda
WNG Washington, National Gallery of Art

The Washington *Nativity*

Catherine Metzger
The National Gallery of Art, Washington, D.C.

The complex iconography and sophisticated conceptualization of space and color in the Washington *Nativity* (cover illustration) are devised to engage the viewer in the contemplation of its message of sin, redemption, and sacrifice.[1] The discovery, during the recent restoration, of alterations to both the picture's color and its iconography illuminates Christus's artistic methods and the subsequent efforts by others to reinterpret his painting.

The earliest record of the *Nativity* is from 1930.[2] The Duveen Archive contains two documents relevant to the condition and treatment of the picture: a cable and a telegram, both from Armand Lowengaard, Duveen's representative in Paris, who wrote "condition good, but the Virgin's dress entirely new and there is a little damage at the right due to a fire," and "This picture will be sent to the German restorer in Berlin in five or six days. In the meantime we are working as hard as we can on it so that the principal parts will be restored except the dress, when the picture goes to Germany."[3] It is presumed that the German restorer was Helmut Ruhemann.

Part of the original Mellon bequest of 1937, the *Nativity* was conspicuous in the Northern Renaissance galleries for its darkened varnish. Simply reducing the varnish layer revealed the subtle color variations Christus had introduced in painting the carved stone portal. By means of these variations, the arch, the figural groups, and the pedestals on which they are presented appear to be made of three distinct materials. The impression of depth in the recess of the façade was made stronger, and the relief of the carvings more pronounced. The revelation of color harmonies and enhancement of spatial recession is a characteristic result of varnish reduction. The revelation of the full extent of damages is likewise an expected result of cleaning. Judging by its size and shape and the surrounding browned and blistered paint, a loss in Joseph's right shoulder was probably caused by a candle flame (the fire referred to by Lowen-

Figure 1. Petrus Christus, *Nativity*, before inpainting, detail (right side)

gaard). There is a second, smaller burn just to the right of the porphyry column at the right side. The glazes in the green lining of Joseph's mantle are abraded, as are those of his pattens and of much of the earth beneath his feet, quite possibly a result of heat and splattered wax from the candle that caused the flame-shaped losses (Fig. 1). The heat and flame damage extends upward through the flock of sheep into the cliff beyond. Some of the darker green glazes in the landscape at the right side are also damaged.

Figure 2. IIR of small figure at lower right of arch (digital file)

Close inspection of the X-radiograph, together with stereomicroscope examination of the Virgin's attire prior to commencing treatment, suggested that the original paint was largely missing in this area. In some instances the study of the underdrawing through infrared reflectography assists the restoration in much the way that the underdrawing originally aided the workshop assistant – as a guide to the artist's composition. In infrared reflectograms of the Washington *Nativity* (cat. fig. 159), overpaint masks the underlying drawing of Mary's robe, except where it is revealed by slight changes in the outer contours of her form, and by the compositional change in the placement of the angels' wings.[4] Christus made a second compositional change from the underdrawn to the painted version in the small figure that supports the right-hand column. In the drawing the figure is seated on a large, plain rectangular block. These two paint-stage changes, the only major compositional changes in the painting, were

made during the first lay-in of paint, as evidenced by the reserve left for the angel's wings and the lack of one for the block beneath the small sinner (Fig. 2).

We decided to make a cleaning test just below the angel's wings to determine how much underdrawing lay beneath the overpaint, as the presence of underdrawing in adjacent areas was apparent. When the overpaint was removed from the portion of Mary's mantle lying behind her, the damage to the drawing was found to be extreme. No continuous lines remain, and it is not possible to state whether the uneven gray tonality was once part of a wash layer or is merely the result of the damage. In the figure of Mary, only the head, hands, fur trim, and strands of hair are intact, as well as the area occupied by the Child and his radiance. There are some residues of original paint between the strands of hair and scattered along the perimeter of the mantle and robe. The hat in Joseph's hands, the forward section of the yellow-clad angel's left wing, and the shepherds' blue hats are likewise lacking the original paint and underdrawing. These large losses in important areas of the composition, which would have been revealed when the picture was restored in 1930, probably prompted sending it to "the German restorer" following the restoration of the "principal parts ... except the dress" in Paris.

Only one deep blue in the picture—the robe of the shepherd leaning on the wall behind Joseph—is original and intact. Although particles of bright blue pigment are visible under high magnification in the paint of this robe, it now appears deep blue-black and is disfigured by multiple open drying cracks, which reveal the white ground and create a distracting web of pale lines over the deep folds of the garment. Complete loss of blue elements in paintings is not a unique occurrence,[5] and different explanations of the phenomenon have been offered. The precise boundaries of the damage imply that the cause must be inherent in the formulation of the blue paint (*e.g.,* use of an aqueous binder) or the result of deliberate and careful removal by a later hand. Samples from the remains of the original paint between the strands of Mary's hair, which have a slightly purple cast,[6] and under the fur trim at the hem of her robe revealed a difference in the hue of the two garments. The paint for the mantle is composed of layers of azurite and red lake[7] (Plate

17), and that of the robe of almost pure azurite. In a cross section taken from an area under the gold leaf of the radiance, the robe has an extremely thin glaze of red lake and azurite (only one pigment particle-thick in some places; Plate 18).[8] It can be concluded that Christus painted an underlayer of azurite in the robe, adding the fur trim over this layer, then completing the glazing of the body of the robe with a delicate layer of purple. This thin red-purple glaze over the green-tinged azurite base layer would have adjusted the color of the robe closer to ultramarine, in a subtle harmony with the rich purple of the mantle.[9]

Christus used a similar mixture of azurite and red lake[10] for the blue mantle of the figure entering through the door at the right of the *Death of the Virgin* (Timken Art Gallery, Putnam Foundation, San Diego; cat. no. 15), which is currently very dark. The practice, however, cannot be said to be characteristic of Christus alone. Paint composed of azurite and red lake in works from Gerard David's studio has darkened to the point of appearing black.[11] Such a paint, if it was formulated without a drier and required a great deal of oil to form a tractable material, will with the darkening of the oil become quite obscure and badly cracked. It seems probable that once the darkening and crackle had disfigured the Washington picture, someone removed the discolored areas to prepare them for the application of repaint. The point at which the paint removal was carried out is illuminated to some degree by investigation of another major alteration to Christus's composition: the addition of gold leaf.

With a binocular microscope it can be seen that Mary's halo and the solid radiance around the Child lie on a substantial gray mordant. The cracks in the leaf and mordant follow those of the paint and ground below, with perhaps one or two deviations. There are no instances of mordant or gold crossing the fissure formed by an open crack in the original paint, as they would if the mordant had been added after a substantial period of time, during which the original paint had dried and developed cracks. Inspection of a lacuna in the radiance suggests that the thin rays emanating from the solid radiance around the Child lie under the mordant for the solid radiance, apparently having been applied directly on the paint below.

Three paint samples for cross–section analysis were taken: one from the halo, one from the radiance, and one from the thin radiant lines under the solid radiance surrounding the Child. Examination of the cross sections revealed that all three gold elements, and the mordant beneath the radiance and halo, lie over two layers of unpigmented medium or varnish that, in turn, are over the intact original paint. The thin radiant lines surrounding the Child lie directly on the second unpigmented layer under the mordant for the solid disk. The solid radiance lies on a gray mordant, identical to the mordant under Mary's halo (Plate 19).[12] There is no dirt between the paint and the first clear layer. Between the two translucent layers there is only a slight indication of dust that has become caught up into the second layer. The technical evidence, therefore, suggests that the rays emanating from the Child were applied prior to the plaque and Mary's halo. The aged, cracked mordant and gilding and the formulation of the paint used as the mordant argue for an early date of application. Since the radiance and halo share an identical construction, these elements are by the same artist.

It is difficult to interpret the presence of the two translucent layers between the paint surface and the gold leaf and mordant. Such a layer is not uncommon in paint cross sections, and is usually taken to indicate the presence of either varnish or paint medium. A thin layer of unpigmented paint medium at the interface between the mordant and the paint film was found to be present in every sample of supposed oil mordants in the National Gallery, London, study of early Italian paintings.[13] A translucent layer is diagrammed between the mordant and the underlying paint in the two samples of Eyckian mordant-applied leaf in the *Ghent Altarpiece*.[14] The composition of these unpigmented layers has not been analyzed, but the association of an unpigmented layer with the technique of oil mordant gilding is strongly indicated. In the case of the Washington *Nativity*, coupling the uppermost translucent layer seen in the samples with the oil mordant lying over it is complicated by the presence of the thin gold rays beneath the larger mordant-gilded radiance. Were these thin lines applied by the same artist as the mordant-gilded elements? If so, the translucent layer may represent a first stage of the gilding process. This explanation

Figure 3. X-radiograph (photo: National Gallery of Art, Washington, D.C.)

Figure 4. Detail of Mary's head (photo: National Gallery of Art, Washington, D.C.)

does not address the rather incongruous concept of utilizing two dissimilar methods of gilding in related pictorial elements.

Perhaps, on the other hand, the unpigmented layers signify the presence of varnishes. We know too little of early varnishing practices to reconstruct the circumstances that led to the complicated layering found in these samples. The exact origin of varnishing paintings is not known, but records of varnishing pictures prior to installing them as altarpieces date from the fourteenth century.[15] It may have been customary to protect the surface of an altar with a varnish, but we do not have conclusive evidence of the practice, nor of the point at which it would have been carried out—in the painter's studio prior to shipment or at the point of receipt. In the absence of a secure provenance and history of treatment, analysis of the translucent layers would not yield substantive information.[16] In summation, the two translucent layers may be interpreted in several ways: as the original varnish overlaid with a translucent layer associated with the application of the oil mordant; as the original varnish covered by a second varnish; or finally as two nonoriginal varnish layers.

By any of the above interpretations it is highly unlikely that Petrus Christus applied the mordant gilding, especially when one considers his painting technique. Mary's robe and its fur trim are brought to a finished stage under the large oval of gold leaf. Such a large form would have been left in reserve from the beginning paint stages, so that it would not have been necessary to paint in the robe beneath the area to be filled with gold leaf. The X-radiograph registers the band of fur encircling the Child, showing his body resting on a corner of Mary's mantle and his head resting directly on the ground, in the manner common to Nativities from the Netherlands in the fifteenth century (Fig. 3)[17]. The shading on the underside of his limbs is distinctly blue, with a thin line of light paint defining the limit of the flesh. Christus frequently places a thin line of light paint between adjacent shaded forms, as may be seen along the right, shaded side of Mary's face and neck, which are made to stand out against the stone wall behind her by the optical device of a thin highlight along the extreme right side of her form (Fig. 4). The combination of the blue shadows and light lines on Christ's limbs and torso are inconsistent with the presence of a bright radiance, but correspond perfectly with Christus's typical method of depicting shading and the limits of a form where it would be seen against the deep blue of Mary's robe. The possibility that Christus himself changed the composition after having completed it, perhaps in response to the request of a patron, is almost certainly negated by the presence of the two unpigmented layers between the paint and mordant. In addition,

although the thin lines of the rays beneath the aureole are believably subtle for Christus's hand, especially in the light of the painted rays in the Berlin *Nativity* (Gemäldegalerie, Staatliche Museen Preussischer Kulturbesitz; cat. fig. 9), the rather broadly brushed strokes of red and green on the solid radiance are not plausibly his.

Having established beyond a reasonable doubt that the halo, rays, and solid radiance are later additions, we must understand, as exactly as possible, when and by whom they were added. Several factors argue against a Netherlandish origin for the radiance. From a stylistic perspective, the solid radiance, tilted on a plane out of alignment with Christus's carefully rendered perspective, disrupts the meticulously constructed space. This organization would have been understood by his contemporaries and by later Netherlandish artists, whose use of leaf respected the naturalistic representation for which they were renowned. From an iconographic viewpoint, northern painters more commonly place the Child on the Virgin's mantle or directly on the earth, and a radiance is more often indicated by rays rather than by solid gold leaf.[18]

In default of other indications, if one begins with the rather limited provenance, it has been suggested that the completed painting was delivered in Spain. It is well established that Christus had links with Spanish patrons. Although the use of gold leaf elements continued throughout Europe in the fifteenth century, it was generally much reduced from earlier centuries, except for Spain and Germany. In fifteenth-century Spain, where the Flemish precedent toward naturalism was not followed,[19] the gold was applied without regard for the depiction of spatial progression. A trend toward greater opulence and ostentation during the fifteenth century was complemented by the view that wealth was synonymous with godliness.[20] Therefore the addition of gold would have increased the devotional value of the painting.[21] Of eleven fifteenth-century Nativity scenes from the Castilian region illustrated by Silva Maroto, six depict the Child surrounded by a gold radiance, five show gold halos on the Mother and Child, and only one is without gilding.[22] Even in the Catalan school, where the Flemish influence is most evident and one might expect a diminished use of gold leaf in

favor of a more naturalistic, human expression, a review of published images reveals that half of the Nativity scenes show gold leaf halos, 36 percent show the Child surrounded by rays or a radiance, and 7 percent show Christ on a solid radiance. Only 1 percent lack gold. The preference for heavy, solid gold halos and radiances began to wane in sixteenth-century Spanish art, where they appear more rarely, and halos and radiances take the form of rays rather than solid forms.[23] By mid-century, Italianate forms from the Renaissance predominate, and gold leaf is no longer prominent.

The technical evidence places the addition of the gold leaf elements sometime after the painting left Christus's studio and before the advent of machine-ground paints, or roughly the nineteenth century. Stylistic analysis suggests that the first added radiance, in the form of widely spaced rays, may have been influenced by the Berlin *Nativity*, which was in Spain. The large solid radiance and the halo, united by their identical mordant structure, are closely associated with the traditions of fifteenth-century Spanish painting, and are clearly religious, rather than decorative, additions. The argument that the gold disk represents a paten need not be dismissed, but must be attributed to a tradition, patron, or artist other than Petrus Christus.[24] It is probable that the gilded elements were added in the belief that they augmented the religious purpose of the image.

The appearance of the Washington *Nativity* as it was displayed for over fifty years in the National Gallery of Art did not reflect Christus's concept in the representation of the figures most central to the image—Mary and the infant Christ. The delicate balance of color, the sculptural modeling of form and of rhythmic, undulating drapery folds, and the spatial relationships of the figures to one another were interrupted by the heavy presence of the nearly monolithic, unmodulated form of Mary's overpainted mantle and robe. Adding to the spatial distortion, the clumsy presence of the solid radiance destroyed the carefully constructed natural progression from the foreground ledge to the exquisitely graduated sky, and distorted Christus's subtle iconography by coarse overstatement. The distortion of the composition rendered the central figural group illogical in the context of the picture, most notably in the discontinuity of the Child to his surroundings.

The usual course of action with regard to later additions is to remove them, if it is possible to do so without endangering the original work of art. Although the location of the two translucent layers between the original paint and the gold leaf additions promised to facilitate the process of removing them, our research suggests that the religious function of the painting within the community for which it was created could be compromised by such an act. Our research has not provided a specific date, author, or reason for these additions, but it has linked them with a fifteenth-century Spanish religious tradition. We concluded that it would be prudent to leave the gold leaf intact, but that the present function of the painting as a representation of the oeuvre of the artist Petrus Christus would be facilitated by painting over the gilded elements.[25] The missing blue robe, mantle, wing, and hats had been present at the time the gold leaf elements were added, as evidenced by the presence of original paint under the leaf. Their repainting is attributable to problems with the picture's condition and in no way alters the original devotional purpose or aesthetic appeal of the painting. Rather, the restoration of these areas with colors suggested by an analysis of the remaining original paint renewed Christus's color relationships. The interwoven quality of image and iconography as Christus conceived it is once again the dominant theme of the painting.

NOTES

1. A thorough listing of the bibliography up to 1984 can be found in John Oliver Hand and Martha Wolff, *Early Netherlandish Painting*, The Collections of the National Gallery of Art Systematic Catalogue (Washington, 1986) pp. 47–49. See also Ainsworth and Martens, *Petrus Christus*, cat. no. 17, pp. 158–162.

2. The provenance is as follows: Señora O. Yturbe, Madrid; F. M. Zatzenstein (1930); [Duveen Brothers, London and New York, 1930–37]; A. W. Mellon Educational and Charitable Trust, Pittsburgh (January 1937); National Gallery of Art, Washington, D.C., Andrew W. Mellon Collection.

3. National Gallery of Art conservation files, citing Armand Lowengaard to Joseph Duveen, 25 April 1930, in Duveen Archives, Metropolitan Museum, New York, quoted by Martha Wolff, memorandum, 8 May 1980, to Kay Silberfeld. The treatment record at the National Gallery dates from 1941 and chronicles the laying down of blisters, retouching, refinishing the surface, and "wiping," which presumably refers to some sort of surface cleaning. The wiping was carried out four times between 1941 and 1944, interspersed with a refinishing of the surface in 1943. No further work was done until 1956, when the painting was retouched. In 1963 the picture was cleaned "superficially with turpentine." After the painting was retouched in oils, a dammar varnish was sprayed on, followed by a coat of Acryloid B–72 (an acrylic polymer varnish). The treatment notes from 1973 through 1992 discuss the discoloration of the varnish and white spotting, which was frequently treated by buffing the surface.

4. In the underdrawing the angels' wings are folded, but in the painted version they are fully extended. For an illustration of this see Ainsworth and Martens, *Petrus Christus:* p. 160, fig. 159. Examination of the painting with a Kodak 310–21X thermal imager configured to operate in the 2.0– to 2.5–micron spectral region and in the 3.0– to 5.0–micron spectral band did not improve the penetration of the repainted blue elements. The use of the imager configured to operate in a spectral band from 1.5 to 2.0 microns revealed underdrawing throughout the composition, including the layout of the architecture, the landscape, and the indications of shadow under the trees at the right.

5. María Pilar Silva Maroto, *Pintura hispanoflamenca castellana* (Valladolid, 1990) vol. 2, p. 439. An excellent example is illustrated in a *Crucifixion* by Maestro Salomón de Frómista, in which the Virgin's robe is almost entirely missing (fig. 111A). See also Kenneth Bé, "Conservation Treatment of the Pintoricchio *Madonna and Child*," *Bulletin of the Cleveland Museum of Art* (December 1991) pp. 360–373.

6. Barbara Berrie, conservation scientist at the National Gallery of Art, noted the purple cast in preparation for sampling (personal communication).

7. Berrie, analysis report, 3 November 1993, National Gallery of Art conservation file. The layer structure of the paintings was studied by using microscopic paint samples taken from the edges of existing paint losses. These were mounted in polyester, and then ground and polished to expose the layers in cross section for microscopical examination by reflected light.

8. Author's identification, confirmed by Barbara Berrie. The cross-section sample was mounted in polyester then ground and polished for microscopical examination by reflected light.

9. In these and other areas, the painting technique revealed in the cross sections is a building up of multiple thin layers of paint, from light to dark except in the small figures in the carved portal. These are depicted by using a middle-value gray, onto which shadows and highlights are brushed. One unusual feature is found in the use of a yellow underpainting for the purple mantle, a layer which is not present in the sample from the robe. The presence of black pigment and ocher in the underpainting of the dark parts of the red, purple, and blue of the Brussels *Lamentation* (Museés Royaux des Beaux-Arts) is reported by Jan Piet Filedt Kok, "Underpainting and Other Technical Aspects in the Paintings of Lucas van Leyden," *Nederlands Kunsthistorisch Jaarboek* 29 (1978) p. 160.

10. Author's identification, confirmed by Barbara Berrie, from microscopical study with reflected light of a cross-section paint sample embedded in polyester resin.

11. Two examples of severely darkened paint containing azurite and red lake are known to the author: the *Marriage of Saint Catherine* (National Gallery, London) and the *Saint Anne Altar* (National Gallery of Art, Washington).

12. The gray mordant is composed of white, black, blue, and a very few red pigments in a mixture with the appearance, particle-size variation, and consistency of hand-ground, hand-mixed paint.

13. David Bomford et al., *Art in the Making: Italian Painting Before 1400*, exh. cat., The National Gallery (London, 1989) p. 46. The authors report that the layer can be variously interpreted as medium from the mordant that has separated out, as an oil or varnish applied in the intended locations of the mordant gilding, or as an application of varnish that predates the mordant gilding.

14. Paul Coremans et al., *L'Agneau mystique au laboratoire*, Les Primitifs flamands, III. Contributions à l'étude des primitifs flamands, no. 2 (Antwerp, 1953) p. 110, fig. 10, and p. 113, fig. 11.

15. Jill Dunkerton, Jo Kirby, and Raymond White discuss the San Pier Maggiore Altar in "Varnish and Early Italian Tempera Paintings," in *Cleaning, Retouching, and Coatings: Technology and Practice for Easel Paintings and Polychrome Sculpture*, International Institute for Conservation, Preprints of the Brussels Congress, Sept. 3–7, 1990, ed. John S. Mills and Perry Smith (London, 1990) pp. 63–65.

16. Two kinds of traditional picture varnishes were used, those composed of resin and oil *(vernice liquida)* and those containing resin (spirit varnish) alone. The former are believed to have been in common use before the 17th century, after which time the use of spirit varnishes was customary. The use of *vernice liquida* did not die out completely, however. Information from Michael Swicklik, "French Painting and the Use of Varnish, 1750–1900," *Conservation Research*, 41, National Gallery of Art Studies in the History of Art Monograph Series 2 (Washington, D.C., 1993) p. 157.

17. Henrik Cornell, *The Iconography of the Nativity of Christ*, Uppsala Universitets Årsskrift (Uppsala, 1924) p. 44.

18. Wolff, memorandum, and idem, *Early Netherlandish Painting*, p. 46, n. 4, cites two examples of solid mandorlas in Netherlandish Nativity scenes.

19. Chandler Rathfon Post, *A History of Spanish Painting*, vol. 4 (Cambridge, Mass., 1930) p. 63.

20. Silva Maroto, *Pintura Hispanoflamenca*, pp. 18, 55.

21. Ibid., cites, on pp. 49–50, n. 119, Victor Nieto, *La Luz, símbolo y sistema visual* (Madrid, 1978) p. 53.

22. Silva Maroto, *Pintura Hispanoflamenca*, passim.

23. I thank Teresa Guevara for her work in checking about 125 examples of Renaissance Spanish Nativities in the Witt Photographic Index; in the National Gallery of Art photo

archives; in Judith Berg Sobré, *Behind the Altar Table: The Development of the Painted Retable in Spain, 1350–1500* (Columbia, Mo., 1989); in Post, *History of Spanish Painting;* and in Silva Maroto *Pintura Hispanoflamenca;* and for compiling statistics by region and type of ornamentation. She also provided immeasurable assistance in tracking down publications and scanning them for relevant information.

24. Joel M. Upton, *Petrus Christus: His Place in Fifteenth-Century Flemish Painting* (University Park/London, 1990) p. 99.

25. The gold leaf was painted over with reversible synthetic paint.

Painting Techniques, Their Effects and Changes in the Los Angeles *Portrait of a Man* by Christus

Joe Fronek
Los Angeles County Museum of Art

For much of its recorded life in the Holford Collections in England and in the Los Angeles County Museum of Art, *Portrait of a Man* (cat. no. 16) has been known as a rather murky, over-restored picture, somewhat larger and more spacious than it is today. During a recent restoration to correct these inaccuracies, the materials and techniques used by the artist of this painting were studied. The findings compare closely with analyses of studies of other Christus paintings.

The sitter in *Portrait of a Man,* close to life-size, wears a red velvet jacket with a dark collar and lined with fur over a white chemise. On his head sits a greenish hat that is difficult to see. The background appears to be almost black and flat. Photographs from the first half of the century show that the painting then had an extremely discolored surface coating, so that the flesh appeared quite yellow (Plate 20).[1] The hat was even more difficult to see than it is today, and the red jacket appeared to be completely overpainted. The design of the painting extended to the very edges of the panel, so that the picture was larger and proportionally wider than it was originally.

Fifteen years ago the painting was cleaned for the first time in its recorded history.[2] After restoration the flesh, jacket, and background were much easier to read; an orange tone from an earlier restoration, however, still covered the flesh, and old restorations remained on the hat. While the extensions of the red jacket were removed, the dark paint was still present on the edges.

After the 1979 cleaning, a very thick acrylic varnish was applied to the surface of the painting to compensate for the rough texture of the hat. Unfortunately, after a few years this coating began to crack and blanch. As a result, it was recently removed along with the earlier restorations on the flesh and hat. The perimeter of the panel was completely cleaned to regain the original dimensions.

Physical Aspects of the Painting

The materials used in *Portrait of a Man* are typical for northern paintings of the fifteenth century. The support of the painting is a single plank of oak with four vertical cracks. The panel was thinned at some time, probably to aid in mending the cracks and flattening the board. It was then set onto a slightly larger secondary panel, which carries a cradle. Strips of wood were appended to the edges of the original panel to extend the dimensions (Plate 21).

Since the ground forms a lip at the edges of the picture, the panel must have been prepared with an engaged frame. Small holes along the unprimed edges would suggest that the frame was nailed to the panel, and it probably would have been glued as well.

The wood is prepared with a chalk and animal glue ground that is rather thin.[3] In fact, raking light picks out the grain of the wood coming through the thinner paint layers.

The underdrawing, in brush and dark-colored paint, is partially visible under normal viewing conditions. This is true for the area of the lips, for example, or the left side of the face. The infrared reflectogram shows up the drawing almost entirely (cat. fig. 68). While the picture was being examined with infrared, it was discovered that the drawing material did not exhibit the degree of contrast expected for a carbon black. And, in fact, the pigment is a dark brown one with a high organic content, something like Cassel earth (Van Dyck brown).[4]

The underdrawing for the face is more finished than any other part of the picture. The shading on the right side of the face is worked up to a fine degree with hatching and cross-hatching, while on the light side the hatching is more widely spaced. The eyes are outlined with a firm line that varies only slightly from the final paint, but the ear is drawn with much heavier lines.

There is also underdrawing in the red jacket and the hat, but to a lesser degree than in the face. It is difficult to see the hatching indicating folds of the jacket in the infrared reflectogram, but it is similar to the shading of the jacket in the silverpoint *Portrait of a Man with a Falcon* (cat. no. 24), though more plastic.

The infrared reflectogram of the earlier *Portrait of a Young Man* (cat. figs. 66 and 67) by Christus in London shares some similarities with that of the Los Angeles portrait, as Maryan Ainsworth has shown. The direction of the strokes and the configuration of the areas of shading are comparable (*e.g.*, the throat). The drawing of the later portrait, however, is more delicate and plastic, which, as Ainsworth suggests, is typical of Christus's later works.

As was the practice at this time, an imprimatura lies over the ground.[5] A cross section from the edge of the red paint shows the layer quite clearly (Plate 23). The imprimatura appears ocher in color and contains charcoal and yellow and red earth pigments all bound in linseed oil.

Paint application in the Los Angeles portrait follows a definite system. First, a flat layer of color was applied within a form. For example, the red jacket was laid in with a light red color, primarily a mixture of vermilion and lead white pigments. Highlights were worked up with a slightly lighter mixture of the same pigments. Pure lake or lake mixed with vermilion was brushed over the base layer to create the shadows and textures of the fabric. Several layers of the lake paint were built up to achieve the deepest tones. The textural effect is achieved totally by brushwork and the thinness or thickness of the red glaze (Plate 25). As one might expect, the upper glaze of red is oil (poppy seed), but the medium of the base color appears to be egg tempera.

While the jacket was worked from light to dark, the flesh was built up in a different way. Similarly, there is a flat underlayer. The base tone for the flesh is a mixture of lead white, vermilion, black, and earth colors, yielding a pinkish tone found elsewhere in Petrus Christus's oeuvre. Shadows, however, are applied on top of this underlayer first, followed by the lighter flesh colors. Since the paint is very thin at the junction of the shadow and light colors on the forehead (Plate 22,24), the pinkish underlayer is more perceptible there than elsewhere.

The dark shadows of the flesh are not necessarily glazes. The warm brown color does allow the underlayer to show through to some degree to give a sense of translucency. This brownish paint is, however, fairly opaque and contains lead white mixed with black vermilion and earth colors. Its transparency may be largely attributed to the thinness of the application. For deeper shadows, a second layer of dark paint containing less white and more black was applied. Finally, for the deepest shadow, a glaze of red lake was used.

Similarly, on the left side of the face, shadows were first laid in, followed by the lighter tones. In the end some shadow color was added on top of the lighter colors. This sequence becomes quite clear if one looks at the shadow under the left eye (Plate 22).

Though more visible today, the underdrawing must have played a role in the final painting. Around the eyes, it adds depth to the shadows, for example. On the left side of the face, the parallel strokes of the drawing create a bluish cast for the beard.

The lighter colors of the flesh are relatively thick, show brushstrokes, and can be very subtly blended. Where a pink comes up to a yellowish flesh tone (to the left of and below the left eye, for example), the blending, wet in wet, is so successful that one cannot tell where one color ends and another begins. The medium of these lighter colors is either walnut or a mixture of linseed and poppy seed oil.[6]

The way that the flesh has been laid in can be read in an X-radiograph of the painting (Fig. 1). Because of the thin underlayer containing lead white, the form of the face appears quite clearly in the X-radiograph. The eyes and mouth of the man appear as dark holes, so that the face looks like a mask. Obviously the underlayer skips or goes around these forms.

The X-radiograph of the Los Angeles man compares rather closely with those of some other Christus paintings. *Portrait of a Young Man* in London or the *Portrait of a Carthusian* in New York, for example, obviously uses the overall initial application of body color for the flesh, but the color skips around the eyes and mouth in each portrait, giving the appearance of a flat mask (cat. figs. 73 and 111). The jacket of the *Young Man* is handled similarly to that of the Los Angeles man as well, in that there seems to be an initial underlayer that is then worked up.

Figure 1. X-radiograph of Plate 20

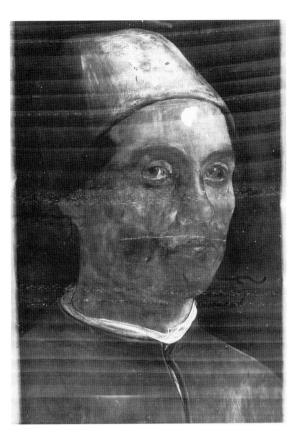

Figure 2. X-radiograph, Antonello da Messina, Portrait of a Man, London, National Gallery (photo: Trustees of The National Gallery of Art)

Since the Los Angeles portrait is often compared to Antonello da Messina's *Portrait of a Man* (cat. fig. 87) in the National Gallery in London, it is interesting to compare the X-radiographs of these two paintings (Fig. 2). Antonello is said to have used a pinkish underpainting for the flesh of this portrait, and we can see it in the X-radiograph. In the Antonello, however, there is more of a sense of what is shadow and what is highlight. Consequently, it would seem that Antonello constructed the shadows using glazes more than semi-opaque paints, with the result that there is greater contrast between light and shadow, making the modeling and volume of the face more obvious.[7]

The sequence of painting in the *Portrait of a Man* is highly systematic: the base flesh tone was applied first. With low magnification it is clear that the initial layer of the background, a medium gray, falls over the underpainting for the flesh. The base colors for the jacket and hat were applied after the underlayers of the flesh and background.

In the photomicrograph of the collars, a bit more information can be gotten about the build-up of the paints (Plate 26). Both collars are painted over the base flesh layer. In fact, the white collar is completely underlain by the base flesh tone. Between the lighter flesh paints and the dark collar the underlayer is visible as a middle tone. In the final stages of painting, the shadow, which is the one thrown by the collar onto the flesh, was painted with a dark gray. These translucent shadows, which include the ones thrown by the hat and hair onto the flesh and by the fur onto the white collar, were painted after the major light and dark areas, and they are among the last strokes of paint to be applied to the picture.

Condition

The techniques and paints that the artist used for this portrait were, for the most part, quite solid. Some forms have, however, changed considerably. The hat is the most obvious and disturbing change. It is the technique used here that is at fault. The form of the hat was initially laid in with a red lake. Over this rich red one finds a thick greenish layer. The unusual sequence of lean over rich paint has been

Figure 3. IRR, detail of hat

Figure 4. IRR, detail of collar

responsible for severe cracking and flaking in the uppermost layer.

As a start to reconstructing something here, we can say that the hat was originally purple, with the deepest shadows perhaps being entirely of red lake. The now greenish layer contains mostly azurite with some red lake mixed in. The cross section from the hat shows the azurite and lake mixture in a now discolored medium, with a possibly original red lake glaze and the thin red lake underlayer (Plate 27). Because of interference from past restorations, the medium was not analyzed.

There is a precedent for this use of an azurite and red lake mixture. For example, the purple dress in the *Portrait of a Woman* by Robert Campin in the National Gallery, London, contains the same pigments, but the paint layer is glazed with ultramarine. In addition, the Strasburg Manuscript recommends this mixture of azurite and red lake with a little lead white for use with oil paint, and goes on to say that the color can be shaded with red lake or indigo.[8] And Christus used the red lake—azurite mixture to paint the now discolored and damaged robe of the Virgin in the Washington *Nativity*. (cover illustration).[9] There is, however, no example of the layering sequence that we find in the Los Angeles portrait.

The underdrawing that we see in the infrared reflectogram gives a bit more information about the original form of the hat (Fig. 3). There is some hatching indicating ripples in the fabric. At the upper left of the hat some lines of drawing would seem to indicate either that there was a shadow representing an indentation, or perhaps that there was to have been a tassel.[10] There is a narrow brim that is turned up on the backside of the hat, again detailed in the underdrawing. The brim is only barely visible in the actual painting.

The collar of the jacket has also changed. What appears to be a black collar was not originally black. The pigments used here are actually red lake and azurite, placed side by side to create a design. Infrared reflectography picked out a design in the collar, which is probably meant to represent a two-color damask (Fig. 4).[11]

There are other details that simply do not appear to our eyes any longer under normal viewing conditions. The dark brown strands of hair springing out from under the hat on either side of the head, for example, go almost undetected, since they are painted very thinly on top of the dark background color. The same can be said for the brown fur lining where it bristles out over the dark background.

Conclusion

There has, of course, not been an opportunity to look as closely at the other Christus portraits, but even from a more superficial examination, it is clear that the other portraits in the Petrus Christus exhibition do relate in terms of the structure of the paint layers. All of the available radiographs of the portraits that this writer has seen show the flat, masklike effect, indicating the use of an underlayer for the flesh. This is also true for the faces in The Metropolitan Museum's *Saint Eligius* (cat. fig. 45).

Paint layering seems very similar in the *Portrait of a Young Man* in London, which was superficially examined there. Thick, light flesh tones are applied after the shadows, and the shadows of the flesh seem to have been laid in first with opaque or semi-opaque paint. It also appears that underpainting for the flesh was applied first, and then the base color for the background. The same can be observed in the Berlin *Portrait of a Lady* (cat. no. 19), where the shadows are quite clearly opaque or semi-opaque paints applied before the lighter flesh tones. The paint type and structure are easy to read in this portrait because the surface paints integrating the lights and shadows are unfortunately missing.

The build-up of the jacket in the *Portrait of a Young Man* is also similar to the Los Angeles portrait in that there is a lighter underlayer with darker glazes on top. The strokes of the surface glazes in the London painting, however, are much more careful and less brushy, probably because of the smaller scale. The same comparison can be made with the red dress in the *Portrait of a Female Donor* (cat. no. 12) from the National Gallery of Art, Washington, D.C. The brushwork of the application of the glazes over a lighter red underlayer creates the texture of the fabric, and glazes are built up in several layers to create rich and very deep shadows. It is only by the build-up of dark translucent paint that such deep colors could be achieved (Plate 28).

In contrast, none of the other portraits seem to have used the type of layering that is found in the hat of the Los Angeles painting, though the pigment mixture of azurite and red lake was fairly common and used at least one other time by Christus, as we have seen. Perhaps the layering for the hat in the Los Angeles painting represents a change of color made by the artist, or an experiment, for it would not make sense for an artist to continue using such an obviously faulty technique.

One of the biggest obstacles to comparing the Los Angeles painting to the other portraits in this exhibit is scale. It is unfortunate that the *Saint Eligius* is not in better condition, since the figures are closer in scale. The *Portrait of a Man* is a good deal larger than the other portraits, and there have to be differences in the handling of the paint, if only by the use of larger brushes or thicker paint. A comparison of the brushy application of the red surface glazes of the jacket in the Los Angeles portrait to the technique used for the same color in the dress worn by the Washington, D.C., donor illustrates this point. Consequently, since there are no works of this scale in good condition and of similar date, the *Portrait of a Man* will probably always present some difficulties in the oeuvre of Petrus Christus.

NOTES

1. Photographs in LACMA curatorial files.

2. In 1979–80, by William Leisher at LACMA.

3. All media analysis was done by Michael R. Schilling, Associate Scientist, and Harant P. Khanjian, Research Assistant, Getty Conservation Institute. Oil analysis was done with gas chromatography—mass spectrometry and protein analysis with gas chromatographyflame ionization detection. Analysis of the ground in this and other paintings has been submitted by the investigators for publication to the *Journal of the American Institute of Conservation* as "Gas Chromatographic Analysis on Amino Acids as Ethyl Chloroformate Derivatives: II. Effects of Pigments and Accelerated Aging on the Identification of Proteinaceous Binding Media." Pigment analysis was done with a polarized light microscope by John Twilley, Senior Research Scientist at LACMA, or Michael Schilling. A very small sample was taken from the red at the edge of the painting for analysis of the ground, imprimatura, and red layers.

4. In the course of infrared reflectography examination, it was noted by John Twilley that the underdrawing material did not exhibit the degree of contrast expected for carbon black in the region of 1.6 and 1.8 microns. A bandpass filter of 1.4 microns was more successful in imaging the underdrawing. As a result, the analysis of the pigment used for the underdrawing was conducted by polarized light microscopy.

5. Karel van Mander, in his *Elements of Painting,* refers to such a layer in use by northern painters. According to van Mander, this layer was a "flesh-coloured" oil application that would have been applied after the drawing was in place. Sir Charles Lock Eastlake gives a translation from van Mander's *Elements of Painting* in *Materials for a History of Oil Painting* (London, 1847; reprint, New York, 1960) vol. 1, pp. 379–380.

6. A tiny sample from the crack in the upper part of the forehead was analyzed for pigments and media. The strict limitation of material prevented analysis of the medium of the underlayer.

7. Joanne Wright, in "Antonello da Messina, The Origins of His Style and Technique," *Art History* 3, no. 1 (March 1980) p. 49, presents important comparisons of X-radiographs of Italian and northern paintings. She fails to contrast the X-radiographs of Christus and Antonello paintings, however. Maryan Ainsworth reports various similarities in technique between the portrait by Antonello and the one by Christus, including the use of a pink underpaint for the flesh. (Ainsworth and Maximiliaan P. J. Martens, *Petrus Christus: Renaissance Master of Bruges,* exh. cat. (New York, 1994) p. 62.) This writer has not had the opportunity to closely examine the painting by Antonello.

8. Lorne Campbell et al., "The Virgin and Child before a Firescreen: History, Examination and Treatment," *National Gallery Technical Bulletin* 15 (London, 1994) p. 33; *The Strasburg Manuscript: A Medieval Painter's Handbook,* trans. Viola and Rosamund Borradaile (New York, 1966) p. 57.

9. As reported by Catherine Metzger at the Petrus Christus Symposium, Metropolitan Museum of Art, 10–12 June 1994.

10. Ben Johnson, when Conservator at LACMA, indicated that he might have found an "insignia" on the hat. Perhaps he was referring to this underdrawing. (Kenneth Donahue to Joel M. Upton, 22 July 1970, letter in conservation file, LACMA).

11. Cara Varnell, Associate Conservator of Costumes and Textiles, LACMA, suggested the fabric type.

Discussion

Hubert von Sonnenburg
The Metropolitan Museum of Art

Reponse to Peter Klein

Thank you, Peter Klein. I think this was all very interesting, and I would just remind you that, of course, many of these dendrochronology results were received with great suspicion. There have been very controversial opinions about the method, and some art historians have simply dismissed this kind of information or wouldn't even mention it. The same kind of results can also be found with works from later periods. One of the most notable ones, early on, was the *Sea Storm* by Jan Bruegel the Elder at the Vienna Museum. It took years until the art historians finally resigned themselves to accepting this date, which was later than had previously been thought—no longer in the lifetime of Pieter Bruegel.

Question from Audience:
How can we be so absolutely sure that we can pinpoint a date within ten to fifteen years?

Klein:
We can date or we cannot date. We have only this chance. When we measure the rings, we compare the rings with the master charts and then we find the date that is absolutely sure— or there can be no dating. When I say that the last ring comes from the year 1475, for example, I have compared this curve with the different master charts in Europe for oak wood. One master chart gives me the exact dating for the last ring. In some cases, I cannot obtain a result at all. I cannot say perhaps 1407 or 1408; I can only say that the last ring was grown in the year 1475, not more. All other things are helps for the interpretation of this last ring.

Von Sonnenburg:
Of course the method has been improved very much during the last twenty years. Even so, it's a very young research method. Perhaps Mr. Klein could say something about how the method developed? Of course, in order to establish a chronology, you also need dated paintings.

Klein:
Dendrochronology was invented in the United States at the beginning of the century with the use of different trees of the Arizona desert. We have pines 4,500 years old, so we can establish a very good chronology for the United States. We must also establish chronologies for Europe. That was begun after the Second World War. We must take our trees in Europe, and we must make an overlapping system for a chronology for every kind of wood and for different regions in Europe. Therefore, you need a chronology, not only for oak wood but also for other kinds of woods. We can date oak wood, conifer wood, and also beech wood, but not poplar wood, because poplar grows too fast and does not have enough rings.

Von Sonnenburg:
Do we already have an extensive chronology for beech wood, for instance?

Klein:
Beech wood was used by Lucas Cranach the Elder. Perhaps 50 percent of all his panels were made of beech wood from the period 1522–35. He used this beech wood only in a very narrow time period. At other times he used lindenwood.

Audience:
Have you ever worked on sculptures?

Klein:
Yes. We can use the method for oak sculptures, but the problem is with large sculpture, where the back side is often hollowed out. When that is the case, we have only small pieces of wood on the base, and sometimes there is not enough to make a measurement. But when I have wood that shows rings from about a hundred years, there is no problem. It can be shown that the sculpture, for example in northern Germany, was made of wood from the region. Wood for the shrines, however, was oak wood imported from the Baltic. We can date conifer wood for sculptures, but not lime wood. That is not possible.

Audience:

I have a question regarding your assumption that—as it appeared from the diagram—they always cut radially to the sapwood. Can you make that assumption?

Klein:

We found sapwood only three times in this particular group; you can recognize sapwood directly with the microscope or magnifying glass. It is possible to differentiate sapwood and hardwood rings, but normally sapwood was cut off because it is very much damaged by insects or fungi, and therefore was not useful. The panel makers cut the planks directly on the border between sapwood and hardwood. Was that your question?

Audience:

Yes. It addresses it, but what if one begins to make one's cut short of the sapwood? You were showing transverse cuts extending to the sapwood that far out . . .

Klein:

No. That is only hardwood. On the diagram I show the last or first felling date with nine separate rings. The bars of the diagram show the last growth rings, or the latest growth rings and the earliest growth rings. When I have two hundred years of oak board, the beginning is, for example, 1250, and the end is 1450. To this you must add the sapwood. The horizontal bars represent only the hardwood that was found.

Audience:

Have you accumulated evidence about the average storage time?

Klein:

For the fifteenth century, I have examined only five or six exactly dated paintings. For these, we found out that we have an average storage time between ten and fifteen years. But it is not possible to give statistical values based on five or six paintings. Therefore, we always say a minimum of two years must be allowed for storage time, but in the fifteenth century it was usually longer. We cannot say precisely how long.

Audience:

But for example, I'm thinking about the Eyckian painting. The wood was felled in the early fourteenth century. Does that make a storage time of eighty years?

Klein:

For this first painting, we cannot say whether that is only storage time, or whether the board was cut from the center of a tree with forty year-rings cut off. When you examine a narrow panel, the other half of the panel may have been used for another painting. I demonstrated that for the Petrus Christus *Annunciation and Nativity* and *Last Judgment* in Berlin: each painting had a wood panel divided into two pieces; one was used for one wing, and one for the other wing. When you look at only the narrow board used for the *Annunciation and Nativity*, you find a very early felling date; but when you combine it with data from the board from the same tree found in the *Last Judgment*, you can get a later, exact felling date.

Audience:

Is this process applicable to any Italian wood panels at all?

Klein:

For poplar wood, it is not possible, though it may be so in some years, if we have some new information. We need a chronology for poplar woods. For the statistical values, you need about fifty to a hundred years. Normally I found the Raphael panels of 25 centimeters had only twenty rings, and that is not enough to determine a date.

Audience:

Can you use wood from other sources, like demolished houses, for the chronology?

Klein:

Yes. The chronology has been established from wood from houses, from church roofs, and also from instruments—from all things. It is not from paintings alone.

Von Sonnenburg:

Because, obviously, a lot more wood was used for those purposes. Does one have any idea whether the trees—the trunks—were cut up when they were shipped, let's say from the Baltic region?

Klein:

The trunks were felled in the Baltic, then were transported by river to Gdansk. In Gdansk the trunks were cut into boards, and the boards were shipped by the Hanse to the other Hanse towns. We didn't find beams that originated in the Baltic region. We have looked with colleagues in the Netherlands at many roofs and many houses in the Netherlands. We couldn't find wood that originated in the Baltic in the houses. Baltic wood was found only in paintings, panels, reliefs, and also in panels in houses. Two years ago, a sunken ship of the Hanse was found in the port of Gdansk; it was full of boards, all 22.7 centimeters thick.

Von Sonnenburg:

So these boards could be used directly by the panel maker, who would assemble them, glue them together . . .

Klein:

Because, for transport, you have enough drying time for a board of 2 centimeters, and then when you split this board into two of 1 centimeter each, you would dry it about six months outside or some months less in the house. That is enough for the technological examination.

Von Sonnenburg:

I think that it is important now to add that the panel makers, who prepared the panels, also grounded the panels at the same time. This was probably done in the same or a neighboring workshop. All these early panels received moldings that were actually attached —glued on with pegs or nailed to the original panel—and then everything was grounded. Even the frames were finished. As we know from the unfinished painting of Saint Barbara by van Eyck in the Antwerp museum, the actual framing was finished before the painter began his painting.

Response to Catherine Metzger

Von Sonnenburg:

Thank you, Ms. Metzger. That was a very good example of excellent documentation of a restoration, and perhaps we have some questions on this score?

Audience:

I wonder if you could comment on the fact that you have chosen to paint out the halo, but The Metropolitan Museum has removed the halo from the *Carthusian* and the *Saint Eligius.* How do you decide?

Metzger:

I would point out immediately that they are very different cases. That's why I stress that it's very important to understand when and by whom things were added, because neither the *Carthusian* nor the *Eligius* was intended to be part of a religious altarpiece. So the addition of the halo changes their original function, which is not the case in Washington. I've tried to point out that the addition of gold may well have been done in adherence to and for the furtherance of the religious function in the destined location for which the painting was created.

Audience:

So I'm curious, if you were faced with the same paintings as The Metropolitan Museum, would you have chosen the same solution?

Metzger:

If I found the halos were later additions on secular portraits, I would take them off.

Audience:

The varnishes that are being used to replace the former varnishes—are they now entirely synthetic?

Metzger:

On this altar, I used a synthetic varnish that is called MS2A, and it is quite easily removable.

Von Sonnenburg:

Of course, there are different varnishes being used in different parts of the world, in different museums and conservation workshops. There is a general trend in the Anglo-Saxon countries toward using synthetic varnishes, whereas on the Continent there is a general preference for natural resin varnishes. These varnishes have been examined in great detail and there are some signs that they have been stabilized. Varnishes have always been a problem. There have been whole conferences devoted solely to varnishes. Of course, it is a very impor-

tant issue, because varnishes cover enormous surfaces. It is most important that the varnishes don't change prematurely, so that they don't have to be taken off, because usually with the varnishes the restorations also have to come off. Then the painting has to be restored again. So it is best if the gap between these interventions is as wide as possible.

Audience:
What about cross-linkage?

Von Sonnenburg:
I remember when I came to this country first, it was in the late 1950s and I was working at The Metropolitan Museum of Art; I found that there was an enormous amount of methyl methacrylate used, which indeed cross-links. So I spent a lot of time in the following years trying to take some of these varnishes off. Even the cross-linked ones could be removed relatively easily when they had been applied over existing older varnishes. But if they had been applied directly after cleaning, removing them with certain solvents proved to be quite an operation. They can be quite harmful to paintings.

Audience:
Is there underdrawing under the halo and radiance on the Washington *Nativity?*

Metzger:
There is original paint under the gold leaf, but the gold leaf obstructs the infrared reflectography because the light reflects off the gold leaf.

Von Sonnenburg:
It was interesting to see, when looking through Maryan Ainsworth's catalogue, that there is an illustration of a painting by Dieric Bouts that shows the Christ Child in almost exactly the same position, lying directly on the earth, not even on the mantle of the Madonna. So that was frequently the case.

Audience:
Unclear question.

Metzger:
The reason I was talking about dust and dirt was that we look in cross sections for accu-

mulations of dirt, which show that the picture existed in that state for a period of time and accumulated a layer of dirt that was then covered over by the subsequent layers. That's one of the ways that we can tell something is a distinctly later addition. So that was what I was looking for. The small amount of dust that I found between the two varnish layers—I wasn't really able to illustrate it, it really needs to be seen through the microscope—wasn't sufficient to prove that point. It simply showed that a sticky varnish had perhaps caught a bit of dust in the studio and had been immediately gone over with another layer.

Audience:
Question asked concerning the advisability of removing the falsely added haloes on the *Carthusian* and *Eligius.*

Von Sonnenburg:
The halo of the *Eligius* was really not much of a problem as far as I was concerned. When I examined it closely, I saw that it was really of very poor workmanship. It was not in keeping with the rest of the painting. So I don't think it was a very dramatic decision. The *Carthusian* is a much more delicate painting. The interference on it was more critical from an aesthetic point of view. There was a lot of discussion about the *Eligius;* even the trustees of the Lehman Collection had a say in that. Everybody got into the act. Finally, we were convinced that it was the thing to do. Above all, there was no cleaning done on either picture. It is a misconception that they have been recently cleaned. It was perhaps two days' work in each case, and it did not involve the rest of the paintings at all. Otherwise, I would not have undertaken it.

Audience:
Why didn't you adopt the same technique as the National Gallery?

Von Sonnenburg:
Actually, the surface on the *Carthusian,* when you saw it close-up, was very uneven; it wouldn't have looked good to add yet another layer on top of this. And unfortunately somebody had scratched in an arc for the halo first as a guideline. I think such a discussion can go too far—being more concerned about the addi-

tions that were made to these old pictures than about the original.

Metzger:

I might also add that the fact that the entire robe of the Virgin had to be repainted made it an easy decision to repaint the radiance under the Christ Child.

Von Sonnenburg:

It is, more or less, something of a general practice that conservators wouldn't simply remove any old reconstructions; they would see whether they could retain them. If there is an entire area, such as the mantle of the Madonna, that was known to be a later addition, why remove it altogether if it's still aesthetically acceptable? Because it can be adjusted. That is obviously what happened in this case.

Reponse to Joe Fronek

Von Sonnenburg:

Thank you, Mr. Fronek. I would like to say something initially. In the Los Angeles *Portrait of a Man,* which has particularly beautiful and very regular underdrawing, one can see in the infrared photograph that there is an extraordinary modeling, more than in any of the other pictures, particularly the one in London that was used for comparison. Not only is the underdrawing finer, there is sometimes not even much of a discrepancy between the length of the parallel strokes. It appears almost as if the underdrawing, at least in the face, has been very calculatedly applied, so that it would also play a role in the actual modeling of the finished product. The very fine modeling that you see in the infrared is a little disturbed on the left section of the face, because that is too light, in comparison with the other images. So immediately, you are losing this kind of subtlety of the modeling. I am only pointing this out because it is very difficult to reproduce it in any documentation. Obviously, it was impossible to have the same perfection for all these images, because they were done at different times. I was also surprised to hear what you had to say about the medium.

Fronek:

I was a bit surprised. Again, this was done under an arrangement we had with the Getty

Conservation Institute, who did the analysis. To be quite honest, when I was looking at it—just with magnification at the painting—I sort of had an idea that the medium of the lower layers was different. I can't really say why, but that's why I pursued the analysis. Unfortunately, because of the restrictions on sampling, we haven't been able to take a sample from the flesh or the underlayers of the flesh, but in the case of the red, the underlayer was definitely egg tempera, and then oil was on top. Actually, they felt that the upper layers of the red glazes were poppy seed oil. There was no certainty about the face—in fact, I thought perhaps walnut, or a mixture of linseed and poppy seed oil. It seemed rather ambiguous, which is why I didn't mention it in my talk.

Von Sonnenburg:

Of course, as you all know, there are many theories. Now we also have some new results concerning the media used by these painters, particularly among the followers of Jan van Eyck. I would just like to draw attention to a dissertation that I found gave very thorough documentation, at least of all the material that has ever been published on it and also of modern lab examinations. It is a dissertation by Pim Brinkman, a Dutchman, and unfortunately it has only appeared in Dutch. There is a summary in English, *The Secret of van Eyck*—a very fetching title. It is an extremely elaborately worked out book, which gives you all the literature—everything. It deals with all the different approaches. I think it might be quite helpful. It will probably be more widely read once it is available here in this country.

Audience:

A question was asked about the Antonello da Messina *Portrait of a Man* in London compared to the Los Angeles *Portrait of a Man.*

Von Sonnenburg:

It is also an interesting point—well, actually quite obvious; it was mentioned by several authors—that the face, for a portrait, is really a little blown out of proportion. That is very important because that is something that you find more in Italian painting in the circle of Antonello da Messina. One wonders what this could have been—there is no change in the underdrawing, no obvious change—whether it

was a portrait directly done from life. It could even have been something that was copied after an existing work. Who would get such specifications to do something that is so different from the rest? I think the comparison with the *Saint Eligius* is perhaps not very helpful, because the face of the goldsmith is anyway somewhat inferior, when you speak of the modeling in particular and is about fifteen to twenty years earlier in date. There is a problem in the works of Petrus Christus when it comes to the different sizes. There is quite a difference in quality. I regret a bit, now that we come to the end of this symposium, that there was no mention of—that nobody would really go into— some of the more obvious problems of attribution. The Friedsam *Annunciation*—this debate has been going on for so many years, so many generations – was once attributed to Jan van Eyck, of course, which is completely out by now. Is it really by Petrus Christus? Of course, it is under "Attributed to," but not the Los Angeles portrait—that is "by Petrus Christus." So I am more addressing the art historians among the audience who want to say something about this.

Audience:

The question I have, and the thing that struck me again about the painting you have just shown, is that the color of the modeling of the face is very different, I feel, from the modeling color used on other faces. If you would comment on that? On the fact that this is black, whereas the other paintings, and Flemish paintings in general, tend to have modeling in darker color rather than in black.

Fronek:

Actually, in the face it is more of a brown color. I find it quite close to something like the Berlin portrait that I showed, as well as to the *Portrait of a Young Man* in London, as far as coloration goes. That is, if we are talking simply about pigments and the layering, and the fact that is it somewhat opaque paint. I found it fairly similar. As for the modeling and the modulation, I don't think I feel up to addressing that. As I pointed out with the Berlin painting, much of the surface has been lost there. I didn't bring up the Metropolitan's *Carthusian,* because I found it so hard to even think about comparing our painting technically. The *Carthusian*'s condition is so spectacular, in the flesh at least, that I found it a difficult comparison to make. But when looking at the less well-preserved Berlin or the National Gallery (London) painting, I can make some connections. I kept bringing up the National Gallery *Portrait of a Young Man*—well, for one reason because I had studied it closely and spoken to some people at the National Gallery about it. But also because it is fairly similar in the sense that the man is facing the same way, the light is rather similar, the same coloration is found in the clothes. I found some points of comparison—things I could compare fairly easily.

Von Sonnenburg:

But I think it should make comparisons a little easier, because Petrus Christus had such an individually formed expression, a very individualized style. So that you can without any hesitation immediately name sixteen pictures out of the collection that are not very problematic as far as the attribution is concerned. But then there are several that don't quite fit in with the rest. This is exactly what this investigation was all about. We are quite a step further now in the research, having all the documentation. I am someone who is always extremely interested in the technique of painting. The technique of painting is to me not just one aspect of underdrawing; it is the whole thing, it is how the picture was conceived, how it was prepared, how the paint was applied, and how it was finished. This is something that I think we might have to pursue somewhat further. This exhibition is a great opportunity to do that. But everything is made more difficult by all the protection. As you can imagine, we have these loans, and in some instances we are not even supposed to remove the protective glass from the painting. All the same, one should go to the exhibition as often as possible—at least we, working here in the Museum, are going—in order to form a more coherent picture. I don't think it is a final picture that we have right now, and nobody would expect that.

General Questions

Susan Urbach (from the audience):

I am a great admirer of Peter Klein and van Asperen de Boer, and I believe totally in their exact dating and their dates; but as a curator, as an art historian coming more or less from

connoisseurship, I still have many questions. I knew the Hague *Virgin and Child in an Archway*. I have all the detail photos and the color slides, and I did the comparisons. The Virgin is painted in a very traditional way with glazes, but the landscape background, the trees, the architecture, and the Adam and Eve are painted in a very heavy, thick paint layer with thick glazes, which is not typical of Petrus Christus, or of any fifteenth-century painter. What we have seen on the slide—the blue trees, which are not a little bit like Joos de Momper—that goes too far. I think if we can date the painting according to its technique, I would tend to date it to the middle of the sixteenth century. My way of thinking is the following. In the sixteenth century, there were many artists who were trained to revive the style of the great early Netherlandish painters—they imitated, they were the archaic painters. In Budapest, we have a beautiful Colyn de Coter where the Virgin is totally Campinesque. De Coter imitated the painting technique, not only the motif. But the landscape background of this *Crucifixion* reveals its true date in de Coter's style—it is sixteenth century, very spontaneously drawn. I think something similar might have happened. But we have here now the felling date and the date of the panel, which are earlier than the original. What to do with that? I don't know exactly. Were artists using old panels for paintings? As you see in the Budapest painting, which is here on view, there is a date of 1537 and a monogram that is fairly visible and is mentioned in old catalogues. All this only proves the fact that the Budapest *Virgin* belonged to somebody in the middle of the sixteenth century: the painting was used, he was proud of it, he put his monogram on it, and he put a date on it. Why couldn't a copy have been made of it in the middle of the sixteenth century, when somebody was so proud to possess the painting? One document is still missing, the X-ray of the Hague panel, and I am waiting for that. When we see it, I think there will be perhaps some other conclusions. I hope the Hague-Rotterdam exemplar will be compared directly, face-en-face.

Von Sonnenburg:

Thank you, Mrs. Urbach; I just can't say very much with regard to the picture in The Hague because I haven't seen the original. But I would ask Mr. van Asperen de Boer a question: What do the edges look like? Was that panel stripped of its moldings, or can one see at least how it was made or get some idea of the Hague one.

Van Asperen de Boer:
Both paintings have lost their frames. The actual dimensions are almost identical.

Von Sonnenburg:
And it is made exactly the same way—the lip is still there and everything?

Van Asperen de Boer:
No, there is not an unpainted edge, because that is cut off. I think that is true of both paintings. I never examined [the Budapest] painting, so I don't know. I've never seen it out of the frame, but that is certainly what we ought to do.

If I may try to reply to Mrs. Urbach—I hope Dr. Klein will join me—but those panels are so similar in dendrochronological dating. It is fairly significant because he has found that wherever a copy was made, notably in the van der Weyden group, it is a later copy that looks exactly the same as the original. The copyist would generally use the wood available to his carpenters at that particular moment. I think that is a very strong argument in favor of supposing that the Hague painting was also made in Petrus Christus's studio. I never said that this is Petrus Christus the painter—not at all—but I think it very, very likely that it is from his studio, because the pigments are the same, or probably the same (we don't know that), and the panels are so close.

Von Sonnenburg:
Well, maybe it is a hesitation on our part to accept differences in the execution within a workshop. It is mainly our role to establish the age of the painting.

Van Asperen de Boer:
May I just say this: I believe that in early Netherlandish painting, we are not used to the German situation. If you take the *Herlin Altarpiece,* in Nördlingen—this is the middle of the century—it says "Friederich Herlin hat mir gemacht," and that is particularly untrue: we know he didn't do the sculpture, he didn't do the painting, and he certainly didn't do the case.

So he was the entrepreneur who undertook to do it; he subcontracted the work on various parts of the altarpiece.

Martens:

I would like to add something to the discussion from the point of view of the documents. A very interesting case is the copies that the count of Etampes commissioned from Petrus Christus of the miraculous Madonna of the Cathedral of Cambrai. He made several copies of the same work, that is for sure. Another point: the memory, from the point of view of the documents, of Petrus Christus had died out completely by the sixteenth century in Bruges. I think that has something to do with the impact of Memling and his school. He only appears in Italian documents after his death. That makes it in my mind improbable that in the sixteenth century copies would have been made after works by Petrus Christus.

Audience:

It strikes me that one doesn't have to know who painted a beloved original to want to have a copy of it—particularly if the copy is made for some pious, personal purpose. I mention this only as a very small point in our attempts to figure out the logic and probabilities concerning those standing Madonna paintings. It did strike me, as it did Susan Urbach, that they were painted really quite differently. The one in The Hague really might have some relation to early sixteenth century German painting.

Von Sonnenburg:

Well, thank you. I think that was a very good point. It may not have been commissioned because it was by Petrus Christus, but because it was a Madonna and the people who wanted it commissioned it for that reason. Thank you very much.

Problems Concerning the Brussels *Lamentation* by Petrus Christus

Leopold Kockaert
Institut Royal du Patrimoine Artistique

Summary

Prior to a conservation treatment in 1961, a series of samples were taken from the Brussels *Lamentation* (see Verougstraete and Van Schoute essay, Plate 33), principally in order to elucidate the question of a hypothetical transfer. The examination revealed an anomaly in the stratigraphy of the green areas, namely an inversion of the traditional Flemish structure.

The present article reports a reexamination of the cross sections taken in the 1960s, with complementary analysis, leading to a different interpretation of the painting technique used in the *Lamentation*. A comparison with Jan van Eyck's technique is also made.

Introduction

When the *Lamentation* by Petrus Christus from the museum in Brussels came to the Institute Royal du Patrimoine Artistique (IRPA) for conservation treatment, a canvas was found under the paint layer—a circumstance that suggested it has at some time been transferred to a new panel. To obtain evidence about this hypothesis, a series of samples was taken and cross sections were made to detect any anomaly in the preparation layers. The examination of these cross sections raised a new question concerning the structure of the greens. Indeed, the first layer directly on white priming was supposed to contain copper resinate, which meant that the stratigraphy was inverted, relative to the tradition of Flemish painting. As this anomaly appeared in seven samples out of ten, it must have been systematic, and our predecessor (J. Thissen) even wondered if this *Lamentation* was really Flemish. When the painting came back to the IRPA for restoration in 1969, a few more samples were taken in hopes of finding material proof of a transfer, but the effort was in vain.

The pigments have been sampled in an effort to solve only two problems; no complete view of Petrus Christus's palette has been attempted. The samples of 1961 were analyzed by J. Thissen, who interpreted the stratigraphy together with P. Coremans, but no report seems to have been published. The subject of the present article is a re-examination and a reinterpretation based on the former analysis, but also on new microscopic information. Several cross sections were made into transparent sections, and others were stained so as to determine the binding media.

Structure and Composition of the Original Paint Layer

All the paint samples contain a preparation layer of chalk (coccoliths) and an animal glue. The ground tone (imprimitura) is almost pure lead white with an oil and protein medium. The following colors have been examined:

Violet
– Highlight on the mantle of the Virgin:
3. Lead white, azurite, red lake, and ultramarine, all with oily medium
2. White priming
1. White to ivory-colored ground

– Same mantle in a depressed fold:
Similar structure and composition as the light tone, but with an oily glaze of red lake with a few particles of azurite. A thin black layer on top might be an accent of the fold.

– Grayish violet mantle of the holy women on the right:
Light and dark tones have a structure and a composition similar to the former ones, but with some black in the opaque layer.

Blue
– Blue from the sky near the upper edge:
3. Lead white, azurite, and sometimes traces of yellow ocher; oily
2. White priming
1. Chalk ground

– Deep blue gown of the Virgin (Plate 29):
5. Ultramarine particles in protein tempera
4. Ultramarine (and azurite?) with a little white lead; oil base
3. Azurite, lead white, and traces of ocher; oil base
2. White lead
1. Whitish chalk ground

– Gown of the Magdalene:
4. Ultramarine with little lead white; protein tempera
3. Azurite and lead white; oil base
2. White priming
1. Chalk ground

– Mantle of man standing at right:
5. Ultramarine in tempera (?)
4. Ultramarine with oil
3. Lead white, azurite, and a few grains of ocher; oil with proteins
2. Lead white
1. Chalk ground

Green
– Mantle of Joseph of Arimathea (?) (Plates 30 and 32):
5. Dark transparent green without particles (copper resinate?)
4. Lead white and copper green; oil base
3. Partially transparent copper green, few green particles, traces of red; oily
2. Lead white
1. White chalk ground

– Deep green of the same mantle, in fold:
7. Transparent brown (varnish?)
6. Transparent brownish green (copper resinate?)
5. Copper green particles, lead white; oil with a little protein
4. Partially transparent copper green, few green and white grains, traces of black and red; oil
3. Lead white; oil base
2. Black particles (drawing?)
1. Grayish white ground

– Grass on the left side:
6. Grayish brown (varnish?)
5. Transparent brownish green (copper resinate?)
4. Light copper green with green and white grains; oil base and proteins
3. Partially transparent copper green, few green and white particles, traces of black and red; oily
2. Lead white; oil with proteins
1. White to yellowish ground

– Grayish green rising background:
10. Transparent fluorescent gray varnish
9. Dark fluorescent brown (varnish?)
8. Grayish dark green
7. Olive green
6. Dark copper green with few lighter particles
5. Copper green and white lead
4. Dark copper green with traces of red and black; oily
3. Lead white; oil base with proteins
2. Black line (drawing?)
1. Whitish chalk ground

Red
– Deep red mantle of man holding Christ:
4. Red lake; oily
3. Vermilion (with charcoal in darker parts); oil base
2. Lead white
1. White chalk ground

– Mantle of Saint John (Plate 31):
5. Red lake; oily
4. Vermilion (with charcoal in shadows); oily
3. Lead white, red lake (?), and traces of vermilion; oil base
2. Lead white; oil with proteins
1. Light gray ground layer

Brown
– Lower part of the cross:
4. Red earth and charcoal; oily
3. Yellowish with scarce red particles
2. Lead white; oil with protein
1. Whitish chalk ground

White and Gray
– Pinkish white shroud:
4. White lead, traces of red and yellow; oil

3. White lead, red lake (?), traces of vermilion; oily
2. Lead white, traces of red ocher; oily
1. Light gray ground

– Gray foreground:
4. Lead white, few particles of yellow ocher and black; oily
3. Ocher, charcoal, and a little white; oil base
2. Oily lead white
1. Whitish chalk ground

The Painting Technique

The panel was prepared with the usual mixture of chalk and animal glue; the average thickness is about half a millimeter. No isolating coat has been observed, but the tint of the ground, grayish to yellowish, as well as the staining tests suggests it was impregnated with a fat medium. The black drawing lies directly on this chalk ground and is covered by a pure white priming, 5 to 20 microns thick, with oily medium always containing some protein. Only in the case of Christ's shroud does this white layer contain traces of red pigment.

Over this white imprimatura, the colors are then applied in the following layering structure:

Violet
– Garments
Lighter parts: a mixture of lead white with red lake, azurite, and ultramarine
Shadows: on the same basic layer, a glaze of red lake containing some azurite

Blue
– Garments
On the white ground tone: lead white with azurite, followed by ultramarine with white (optional) and a glaze of pure ultramarine
– Sky
On the white ground tone: one layer composed of azurite and lead white

Green
– Garments and Vegetation
A first layer of dark copper green, more or less transparent, with few green particles and traces of red and black. Next, a layer of white and copper green, generally followed by a brownish green glaze, probably copper resinate.

Red
– Garments
Over the imprimatura, a layer of white with red lake and eventually some azurite, covered with vermilion containing charcoal in the shadows. Finally, a glaze of red lake.

Binding Media

Overall, the medium can be considered oily or, more particularly, emulsions with a constant presence of oil with some proteins dispersed in it. The red glazes and the transparent green layers seem to be oil, pure or mixed with some resin. On the other hand, the blue glazing with ultramarine reacts like protein tempera.

Discussion and Conclusion

The present reexamination brings more precise answers to the problems of the *Lamentation*. Neither the cross sections nor the X-radiographs reveal any traces of a transfer. On the contrary, the panel is made according to Netherlandish painting tradition: quartersawn oak with butt joints reinforced with dowels. Moreover, dendrochronological dating by J. Vynckier estimates that the felling date of the tree cut for the panel was about 1439. Areas of lighter density, seen on the X-rays along the joins, suggest that strips of canvas were glued over the joins before the panel was primed. It was probably in these areas that the restorers discovered the textile, leading to the hypothesis of a transfer.

A second question, raised by J. Thissen and P. Coremans, is the inversion of the structure of the greens, inferred from the fact that glazes of copper resinate had been found beneath the opaque layers. Our reexamination revealed that more or less transparent green was indeed situated on the white priming; but whereas usual green glazes are of pure, homogeneous resinate, the basic greens in Christus's *Lamentation* often contain green or blue particles, and always traces of red and black. It thus seems reasonable to admit that this first dark green layer was not intended as a glaze, but that it resulted from a chemical reaction between the oily or oil-resin medium and the copper salt (verdigris?), yielding a copper oleate or resinate.

On the other hand, the final green layer looks like a dark and brownish glaze, probably discolored copper resinate. The inversion of Petrus Christus's greens thus appears to have resulted only from an accidental chemical reaction of the pigment.

Comparing Petrus Christus's and van Eyck's techniques, the following points may be put forward. Overall, the construction of the paint layers in this *Lamentation* corresponds to Flemish tradition. None of the samples shows the typical isolation layer of van Eyck, appearing as a grayish to brownish continuous coat on the chalk ground. It is evident, however, that Petrus Christus applied a fat medium less viscous than the lead–boiled oil of van Eyck, and that it was then absorbed by the preparation layer.

The light priming was generally applied over the whole surface, but whereas van Eyck modulates it from whitish to dark gray, Petrus Christus always keeps it pure white.

Van Eyck's greens generally lie on a light gray priming. Since Petrus Christus started with a pure white ground, in order to achieve a similar green he might have been forced to darken it with the grayish green oily layer. The blues, too, are very similar to those of van Eyck, with a final glaze or pseudoglaze of ultramarine with protein tempera. Unfortunately, no samples of flesh tints were available, but the X-rays reveal that the faces in the *Lamentation* have a lower overall density than those generally found in van Eyck's paintings. Thus, they were painted with less lead white.

Petrus Christus's reds are also close to those found in the *Ghent Altarpiece,* except for the addition of black to the vermilion in the darker tones. Indeed, van Eyck's reds may be darkened either by the use of a gray to blackish ground tone, or more generally, by thickening the final glazes, to which some black may be added in exceptional cases.

As far as is known, the binding media seem to correspond fairly well, but if the green pigment has been altered chemically, it could mean that Petrus Christus used pure oil or an oil-resin mixture, instead of the oil-protein emulsions that are usual in van Eyck's green opaque layers.

In conclusion, we may state that the technique of Petrus Christus in the Brussels *Lamentation* is close to that of van Eyck, but with some different features that make a collaboration between the artists most improbable.

References

Coremans, P., et al., *L'Agneau mystique au Laboratoire,* Les Primitifs flamands, III. Contributions à l'étude des primitifs flamands, no. 2 (Antwerp, 1953)

Kockaert, L., "Note sur les émulsions des primatifs flamands," *Bulletin de l'Institut royal du patrimoine artistique* 14 (1973–74) p. 135.

Thissen, J., Unpublished notes and remarks.

La *Lamentation* de Petrus Christus

Hélène Verougstraete et Roger Van Schoute
Université catholique de Louvain–la–Neuve

Vers 1450, huile sur panneau de chêne, 101 x 192 cm. Bruxelles, Musées Royaux de Beaux-Arts de Belgique, inv 564. Provenance: acquis du marchand A. Lucq en 1844.

Documents et examens: dendrochronologie par J. Vynckier (mai 1993), cité dans P. Klein, "Dendrochronological Analysis of Panels Attributed to Petrus Christus," Appendix 2 of *Petrus Christus: Renaissance Master of Bruges,* Maryan W. Ainsworth and Maximiliaan P. J. Martens (New York, 1994) p. 215.

Nombreux clichés ACL ensembles et détails en noir et blanc et en couleurs illustrant l'état avant, en cours de et après traitement (1961–1964). Avant le même traitement de 1961, clichés en lumière réfléchie et rasante, clichés infrarouges et ultraviolets. Prélèvements et rapport de J. Thissen (non publié). L'Institut royal du patrimoine artistique (IRPA) réalise une première radiographie de détail (têtes de la Vierge, saint Jean et Sainte femme) en 1961, puis, en 1970, 21 radiographies qui couvrent l'ensemble de la surface. Prélèvements par L. Kockaert en février 1994 (non publiés). Réflectogrammes à l'infrarouge (J. R. J. Van Asperen de Boer, 1966 et 1978, et M. W. Ainsworth, 1993).

La Conservation

Entré une première fois à l'IRPA le 27 octobre 1961, restauré entre 1961 et 1964. Sorti en juin 1964. Les clichés en lumière rasante avant la restauration de 1961 montrent d'abondants soulèvements dans la couche picturale. Ces soulèvements sont concentrés principalement dans les zones de couleur blanche, couleur qui présente les plus forts empâtements. Dans le linceul du Christ, les soulèvements dans les zones peintes sont surtout importants sur la planche inférieure, qui, selon le rapport de J. Vynckier, est la planche la plus récente (voir plus loin: le support).

En 1969 le tableau présente de nouveaux soulèvements et retourne à l'IRPA (12 mars 1969). Une imprégnation à la cire est faite par A. Philippot et R. Guislain-Witterman. Le tableau réintègre le musée en 1970. Le rapport de restauration est établi le 8 mars 1970.[1]

La radiographie révèle des lacunes dans la partie supérieure de l'oeuvre à droite de la tête de saint Jean et des usures concentrées le long du joint supérieur. La robe rouge sombre de saint Jean comporte de nombreux petits écaillages superficiels, liés à la technique picturale adoptée à cet endroit (une superposition de deux couches qui semblent mal adhérer entr'elles). Un peu partout dans le tableau, des trous d'épingles ont été pratiqués par les restaurateurs pour assurer des voies de pénétration à l'adhésif à la cire. Malgré les lacunes et les problèmes d'adhérence, l'ensemble de la surface picturale et les glacis originaux sont bien conservés.

Le Support

Trois planches de chêne sont disposées à l'horizontale; elles mesurent de haut en bas: A: 31.1–33.4 cm; B: 32.9–34.7 cm; C: 34.4–34.9 cm. Il s'agit de chêne de la Baltique qui ne comporte pas d'aubier. Les planches A et B proviennent du même arbre. Le plus jeune anneau de croissance est formé en 1424 sur la planche C. Tenant compte d'une moyenne de quinze anneaux d'aubier, l'arbre avec planche C peut être considéré avoir été abattu au plus tôt en 1433, probablement vers 1439 pour un usage possible en 1449.[2] La barbe a été poncée. Le bord non peint est de 2 cm. Le revers comporte un large chanfrein (±6 cm) des quatre côtés. Le cadre original est perdu.

La Signature

L'emplacement et la forme inaccoutumées de la signature sous l'aspect d'un monogramme expliquent qu'on lui ait accordé peu d'attention jusqu'à ce jour (Fig. 1). Sur la chute du

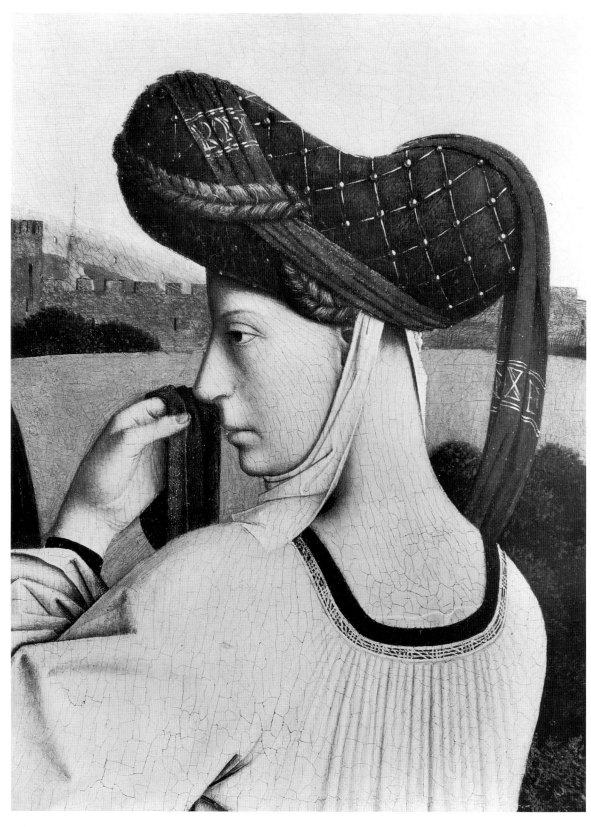

Fifure 1. Détail de Plate 33: les lettres PXF pour *Petrus Christus Fecit* sont visibles dans la chute du turban. D'autres signes dans la partie haute du turban n'ont pu être déchiffrés. (Copyright A.C.L.)

Figure 2. Détail de Plate 33: Manche de la robe de Véronique. Les stries créant des ombres légères sont visibles en diverses zones. (Copyright A.C.L.)

turban de la femme à droite, trois lettres sont brodées en fil d'or sur le tissu rouge *P. X. F.* (soit l'initiale latine de *Petrus,* l'initiale grecque de *Christos* et l'initiale latine de *Fecit*). Plus haut dans le turban, le motif brodé au fil d'or se répète et forme des caractères fantaisistes (ou des lettres et chiffres que nous n'avons pas pu déchiffrer).

La Manière striée

L'examen au microscope révèle une couche picturale travaillée avec soin. L'artiste s'aide d'instruments divers et a recours à des artifices variés pour assurer une belle finition des surfaces. Une des techniques utilisées mérite une attention particulière. Il s'agit d'une technique assez répandue dans la peinture flamande ancienne. Adoptée très localement dans de nombreuses peintures à des fins précises, elle s'écarte de la technique généralement en usage, celle de couches superposées lisses et de glacis. Il s'agit de "la manière striée." R. Marijnissen avait relevé des "hachures très fines" dans certaines zones de la *Lamentation* de Bruxelles et y voyait les traces d'un outil.[3] La "manière striée" a été décrite ailleurs.[4] Le procédé consiste à appliquer localement une couche picturale claire fortement striée au moyen d'un pinceau à poils durs (?), plus ou moins large. On dispose ensuite, sur cette couche structurée en relief, une matière picturale sombre et diluée qui se loge uniquement dans les creux. Il n'y a pas de doute que les stries sont volontaires. On ne peut pas les confondre avec de l'usure. L'observation de la radiographie permet de voir que les zones destinées à les recevoir sont localement structurées à cet effet et plus fortement chargées de matière. Aux quinzième et seizième siècles ces stries sont adoptées principalement à deux fins. Dans un premier cas, elles servent à réaliser les ombres dans les zones de couleur blanche et dans les carnations. L'effet obtenu est celui d'une

Figure 3. Détail de Plate 33: Arbres dans le fond au centre de la composition. Les stries à la brosse dure ont structuré la ligne d'horizon; les arbres y sont posés légèrement. (Copyright A.C.L.)

Figure 4. Détail de Plate 33: Tête du personnage masculin de droite. Le contour du crâne se détache avec légèreté grâce aux stries réalisées sur le fond. (Copyright A.C.L.)

ombre légère. Dans un second cas, les stries servent à estomper les contours. Les stries évitent que certains détails n'aient un caractère trop sec ou trop découpé. Elles créent des effets de lumière par exemple pour des éléments qui se profilent sur l'horizon ou sur le ciel.

La première utilisation des stries—celle de créer des ombres légères—est illustrée dans la *Lamentation* par la manche (Fig. 2) et le voile de Véronique, le voile de la Vierge et le linceul du Christ. Ces zones claires sont structurées à la brosse dure, puis délicatement ombrées avec une matière sombre qui se loge dans les creux. Ce n'est qu'une fois réalisé ce travail de stries et d'ombrage, que le peintre pose les accents finaux de lumière et les traits d'ombre profonde.[5]

La seconde utilisation des stries, qui vise à atténuer les contours, est illustrée dans la *Lamentation* par la ligne d'horizon, structurée à la brosse dure de manière à pouvoir y superposer des éléments légers. Certains petits arbres (Fig. 3) et le contour de la tête du personnage masculin de droite sont exécutés de la sorte. Ce contour se détache sur le fond par le moyen de cette zone légère et striée qui assure la jonction entre le ciel et le crâne d'un gris opaque (Fig. 4). La radiographie[6] permet de voir à cet endroit que la tête est comme "auréolée" de matière. L'artiste, après avoir réalisé le ciel, ajoute la matière picturale striée qui permettra un contour estompé. La manière striée décrite ci dessus nécessite une technique d'*impasto* locale, qui contraste avec le caractère généralement lisse des couches picturales des Primitifs flamands.

Le procédé n'était pas neuf.[7] On le retrouve déjà dans la peinture de Melchior Broederlam. Les carnations sont ombrées à la manière striée dans les volets peints du *Retable de la Crucifixion* (Musée des Beaux-Arts, Dijon). Jean van Eyck aussi avait adopté ce procédé pour marquer les ombres dans les visages de la Vierge et celui de l'Enfant de *La Vierge au Chanoine van der Paele* (Groeningemuseum, Bruges). Memling l'adoptera également pour ombrer le menton de Giles Joye (Sterling and Francine Clark Art Institute, Williamstown) et Colyn de Coter pour strier la barbe de Dieu le Père dans la *Trinité* (Louvre, Paris). Ce ne sont que des exemples. D'autres artistes ont estompé la ligne d'horizon en la striant, par exemple Albert Bouts, dans une *Vierge et Enfant* (Worcester). Parfois le ciel entier est strié pour que les arbres

peints par dessus paraissent plus légers. C'est le cas dans un panneau anonyme représentant les martyrs des saints Crépin et Crépinien (Musée National, Varsovie).

Dans certains cas les stries sont réalisées dans la couche de préparation et ne sont alors pas visibles à la radiographie. Ces stries dans l'enduit sont régulières et semblent faites avec un instrument métallique denté. C'est le cas dans la *Communion des apôtres* de Juste de Gand (Palais Ducal, Urbino). Plus tard, au seizième siècle, la structure striée provient parfois de l'imprimitura blanche ou colorée, brossée à larges traits, que l'on peut souvent observer sur les radiographies et que l'on a fréquemment identifiée dans les coupes. Tributaire de la tradition, Rubens au dix-septième siècle, couvrira des surfaces entières d'une imprimitura striée et fortement colorée. Dans ses esquisses il la laisse largement apparente.

Autres procédés pour structurer les surfaces

Petrus Christus utilise d'autres procédés pour la finition de sa peinture. A l'aide de divers instruments, il structure ou tamponne localement les glacis. Parfois une ombre légère est estompée avec un plumeau ou un pinceau souple. Certaines ombres dans le manteau de la Madeleine ou celui de Marie sont ainsi faites. Ailleurs un pointillé serré est réalisé sur l'ensemble d'un tissu, peut-être avec le dos du pinceau, dans la couche de glacis. C'est le cas de la robe rouge de la Sainte femme qui soutient Marie (Fig. 5). Les points clairs ne sont pas en relief, comme on pourrait en avoir l'illusion à l'œil nu. Le procédé, tel qu'on peut l'observer au microscope, consiste à réaliser un pointillé dans la laque de garance fraîche, sorte de travail en *sgraffito*. La laque, repoussée vers les bords, encercle le point vermillon sous-jacent mis à nu. Une fois la surface ainsi pointillée, l'artiste s'applique à peindre les plis. Un travail analogue s'observe dans la robe verte de Joseph d'Arimathie. Le glacis de résinate de cuivre a été structuré de la même façon, mais les points sont plus petits et moins perceptibles. Cette manière de faire s'observe également chez van Eyck. Dans le pavement de *La Vierge au Chanoine van der Paele,* un carrelage rouge à proximité du bâton du saint a reçu le même traitement.[8] M. W. Ainsworth a

Figure 5. Détail de Plate 33: Dans le coin supérieur gauche: robe rouge de la Sainte femme qui soutient Marie. Sur une base de vermillon, un pointillé réalisé dans la laque de garance fraîche donne l'illusion de points clairs en relief. (Copyright A.C.L.)

relevé d'autres analogies de facture pour les brocarts et des objets métalliques entre le même tableau de van Eyck et d'autres oeuvres de Petrus Christus.[9] L'auteur présente le galon doré de la robe verte de Joseph d'Arimathie de la *Lamentation,* où l'effet de la dorure est obtenu par une multitude de petits traits rectilignes entrecroisés et courbes, puis des pointillés, en général jaunes, et quelques accents ocre rouge. La comparaison établie avec le brocart de saint Donatien dans *La Vierge au Chanoine van der Paele* est frappante. M. W. Ainsworth souligne a juste titre que Petrus Christus n'a pas nécessairement reçu une instruction chez van Eyck (par exemple, le parallélisme entre les dessins sous-jacents respectifs est limité) mais qu'il a peut-être eu accès au fond d'atelier. Il n'y a pas de doute à notre avis que Christus a observé très attentivement et de très près certains tableaux achevés de van Eyck, pour s'inspirer des procédés raffinés auxquels le grand maître avait eu recours.

Notons encore que d'autres vêtements de la *Lamentation* sont structurés avec les empreintes digitales (ou un fin tissu?), comme la pèlerine et le bonnet de Joseph d'Arimathie. Ailleurs le glacis est "tamponné" (avec un tissu?), comme dans le haut de la colline sous la croix.

Facture et style

Quelques autres éléments de la facture picturale ont pu être observés au microscope. Certains sont traditionnels. Dans le manteau pourpre de la Vierge la construction des ombres se fait de la manière suivante: le ton général est d'abord appliqué, soit le blanc ou le pourpre moyen. Les ombres sont construites progressivement: d'abord un fin glacis étalé de manière régulière, puis les ombres de plus en plus sombres, tantôt bleues, tantôt pourpres, souvent en hachures ou retravaillées avec une brosse fine pour les "structurer." Vient ensuite le trait final de l'ombre profonde, en accumulation de matière. Souvent un reflet clair jouxte cette ombre.

Pour réaliser le manteau mauve de la femme à droite, l'artiste met d'abord en place une couche de glacis de garance fixée, à laquelle il superpose, dans les zones plus claires, une très fine couche bleutée, plus ou moins chargée de blanc de plomb. Au microscope la couche rouge

transparaît abondamment, surtout dans les ombres. Cette disposition d'un glacis sous une couche en principe plus opaque mais très diluée, est assez inhabituelle. Quand deux zones d'ombre se jouxtent, l'artiste les sépare souvent d'un accent clair.

La barbe du Christ est faite d'une matière brune qui s'étale avec difficulté (elle présente une sorte de coagulation de la matière picturale; Plate 34). S'agit-il d'une couche à liant aqueux ou d'une émulsion qui se laisse mal étaler sur la base huileuse? Ce phénomène a été souvent observé dans la peinture ancienne. Il nous semble tout aussi délibéré que les stries. Le brun est tamponné, puis repassé avec la pointe ou le dos d'un pinceau ou une fine petite plume pour enlever de la matière.

Certains bleus des vêtements sont devenus opaques et ont perdu toute leur structure. C'est le cas pour la robe de Marie, celle de Marie-Madeleine, et celle du personnage à droite. Par contre le caractère uniforme, avec des nuances subtiles, des étendues herbeuses est voulu dès l'origine. Les objets, étoffes, personnes et les rochers s'en détachent nettement, entourés d'ombres légères. La facture des rochers est très particulière: deux couleurs ton sur ton; l'une claire, l'autre sombre, créent les premières structures (Fig. 6). La structure finale est organisée par des lignes très appuyées brun-noir posées indépendamment du premier ombrage.

Souvent les contours des personnages se superposent à la couleur environnante du fond. Le fond peut alors être repris pour améliorer les raccords. Cela peut trahir le fait que l'artiste a peut-être une tendance à amplifier les contours. Mais les superpositions sont aussi révélatrices de l'ordre suivant lequel s'est effectué le travail: l'artiste commence par peindre le fond, puis les vêtements et termine par les carnations.

Le dessin sous-jacent de la *Lamentation* a été publié et commenté ailleurs[10] et jugé généralement assez différent de celui de van Eyck[11], même si certains auteurs perçoivent des similitudes.[12] Notons que dans le dessin très abondant des vêtements, la mise en place des plis est progressive. De petites modifications interviennent encore au stade de la couleur. Les mains sont parfois maladroites. Dans le dessin de la main droite de la Vierge, le poignet est à peine marqué.

Figure 6. Détail de 1: Rochers sous le pied de la croix à gauche. La facture des rochers est d'abord constituée de deux couleurs ton sur ton, l'une claire, l'autre sombre. Des lignes brun-noir déposent comme un filet, indépendamment du premier ombrage. (Copyright A.C.L.)

Conclusion

Dans la *Lamentation* de Bruxelles, Petrus Christus apporte un grand soin au travail des surfaces, à la structuration des matières et à la superposition des couches. Les effets coloristiques sont raffinés, surtout dans les vêtements blancs aux ombres bleutées et dans les violets. Certains procédés semblent empruntés à van Eyck. Il y a un équilibre et un raffinement très grand dans la composition. A partir du modèle de van der Weyden, la scène est réorganisée selon une vision géométrique particulière au maître. Cette vision géométrique (à laquelle on peut rattacher l'intérêt que l'artiste éprouve pour la perspective dans d'autres oeuvres) et abstraite (détachée du réel) fait la qualité spécifique et attachante de la *Lamentation* de Bruxelles.

En effet la *Lamentation* ne se fonde pas sur une observation de la réalité. Le pan du manteau de Nicodème ressemble à un papier froissé. Le manteau rabattu de saint Jean, qui appuyait le mouvement du personnage dans la *Descente de Croix* (cat. fig. 10) de van der Weyden au Musée du Prado, n'est pas adapté au personnage qui a ici une attitude figée. En général les bras des personnages ne sont pas réalisés proportionnellement au reste du corps. Certains visages sont trop grands par rapport aux mains. Les mains sont très petites avec les phalanges trop bien alignées (les mains du Christ), des poignets peu marqués, des paumes gonflées (les mains de la Madeleine). Elles sont même parfois escamotées (comme la main gauche de la Vierge). Les attitudes ne recherchent pas le naturel. La composition est disposée dans une nature imaginée. Les plans ne cherchent pas à créer une illusion de profondeur (on part plus vite dans les lointains à droite du tableau qu'à gauche). Le "réel" que reconstruit Petrus Christus, est celui qu'il imagine, dont il a le souvenir ou qu'il a vu chez d'autres. L'oeuvre nous semble représentative d'un stade antérieur par rapport à la petite *Lamentation* (cat. no. 8) du Metropolitan Museum of Art, New York (vers 1450, huile sur chêne, 26.1 x 35.9 cm; pour autant que les dimensions très différentes des deux oeuvres permettent une comparaison). Dans cette dernière œuvre, les personnages, détachés de l'influence de van der Weyden, sont plus personnels à l'artiste. Les mains sont mieux maîtrisées. Le paysage harmonieux évoque—malgré ses petites dimensions—des espaces plus vastes. Les rochers ne découpent plus les étendues herbeuses de manière abrupte et artificielle; ils sont plus naturels et la croix y est mieux implantée.

NOTES

1. D'après A. Philippot (témoignage oral) le tableau aurait été transposé. L'étude au microscope d'un prélèvement par J. Thissen révèlerait un reste de fibre qui correspondrait à une bande de toile ayant existé à l'origine à hauteur du joint. L'emplacement primitif de la toile correspondrait à une bande de moindre densité visible à hauteur des joints sur la radiographie. Après examen nous estimons que l'hypothèse de la transposition ne doit pas être prise en considération. On est en présence du support original de l'œuvre.

2. L'étude dendrochronologique du support a été réalisée par J. Vynckier le 12 mai 1993. Les anneaux d'aubier du bois de la Baltique sont en général au nombre de 15 (minimum 9 et maximum 36); dans 50% des cas ils fluctuent entre 13 et 19 (P. Klein et al.,"New Findings for the Dendrochronological Dating of Panel Paintings for the Fifteenth to the Seventeenth Century." Icom Committee for Conservation, Sidney, Australia, 6-11 sept 1987, *Preprints* [Los Angeles, 1987] p. 51–54).

3. R. H. Marijnissen, *Tableaux – Authentiques, maquillés, faux: L'Expertise des tableaux et les méthodes de laboratoire* (Zaventem, 1985) p. 197, 262 et 263.

4. H. Verougstraete, "L'Imprimitura et la manière striée. Quelques exemples dans la peinture flamande du quinzième au dix-septième siècle," *Actes du colloque VI pour l'étude du dessin sous-jacent dans la peinture: Infrarouge et autres techniques d'examen* (Louvain–la–Neuve, 1987) p. 21–28.

5. Chez Christus, comme chez d'autres maîtres, les ombres sur les blancs et les carnations ont été également réalisées par d'autres moyens que par les stries, par exemple par la superposition de couches légères ou de multiples petits traits sombres. Les différentes manières d'ombrer ont souvent coexisté dans une même œuvre.

6. Le détail de la tête de l'homme à droite de la *Lamentation*, en lumière ordinaire et en radiographie, est publié par Marijnissen, *Tableaux,* p. 197.

7. Cette technique peut être observée dans de nombreuses macrophotographies publiées dans les *Corpus de la peinture des anciens Pays-Bas méridionaux au quinzième siècle. . . .* En particulier, pour les oeuvres citées dans ce paragraphe, voir M. Comblen-Sonkes, avec la collaboration de N. Véronée-Verhaeghen, *Le Musée des beaux-arts de Dijon: Les Primitifs flamands. I. Corpus,* XIV (Bruxelles, 1986) pl. *xliii, lxv, lxxxi*; A. Janssens de Bisthoven (avec la collaboration de M. Baes-Dondeyne et D. De Vos), *Le Musée communal de Bruges: Les Primitifs flamands. I. Corpus,* I (Bruxelles, 1983) pl. *ccxxxiv*; C. Eisler, *New England Museums: Les Primitifs flamands. I. Corpus,* IV (Bruxelles, 1961) pl. *lxxv, lvi*; J. Bialostocki, *Les Musées de Pologne: Les Primitifs flamands. I. Corpus,* IX (Bruxelles, 1966) pl. ***xxii***; J. Lavalleye, *Le Palais ducal d'Urbin: Les Primitifs flamands. I. Corpus,* VII (Bruxelles, 1964) pl. *x, xi, xii.*

8. Voir le détail en macrophotographie dans A. Janssens de Bisthoven et al, *Le Musée communal de Bruges,*, pl. *ccxxxvi.*

9. Maryan Ainsworth and Maximiliaan P. J. Martens, *Petrus Christus: Renaissance Master of Bruges,* exh. cat. (New York, 1994) p. 55, 58, 59 (pl. 76, 77, 78 et 79).

10. M. Sonkes, "Le dessin sous-jacent chez les primitifs flamands," *Bulletin de l'Institut royal du patrimoine artistique,* 12 (1970) p. 201–202.

11. Ainsworth and Martens, *Petrus Christus;* J. R. J. Van Asperen de Boer, "A Scientific Re-examination of the Ghent Altarpiece." *Oud Holland,* 93 (1979) p. 210–212.

12. C. Périer d'Ieteren, *Colyn de Coter et la technique picturale des peintres flamands du XV^e siècle* (Bruxelles, 1985) p. 24, ill. 17 a–b, 18.

Afterthoughts and Challenges to Modern-Day Connoisseurship

Maryan W. Ainsworth
The Metropolitan Museum of Art

To compleat our ideas of the masters it is necessary to take in their whole lives, and to observe their several variations so far as we possibly can The mischief is, men are apt to confine their idea of the master to so much only as they know, or have conceived of him; so that when any thing appears different from this, they attribute it to some other, or pronounce it not of him.

Jonathan Richardson
"Essay on the Art of Criticism," 1773

The experiences of mounting an exhibition and of coordinating a related symposium inevitably provoke new thoughts on the subject in question—about the very process of reaching conclusions, about changed priorities of the issues, about new discoveries, and about changing one's mind. Numerous interesting observations were made during the course of the Petrus Christus exhibition and symposium by specialists in the field and casual visitors alike, some of which I will include here in my "afterthoughts" and many more of which I hope will be developed into new articles on Christus or on related themes. In this way, an exhibition serves not as the last word, but as the stimulus for new thoughts and varying points of view. The resulting dialogue is what enriches the discipline of art history.

What I want to address here is the fundamental question of methodology, or more specifically the revision of traditional art historical assumptions which is necessitated by the obvious inconsistencies in Christus's œuvre. What makes the study of Christus at once so fascinating and so puzzling is the inhomogeneity of his paintings relative to the more consistent stylistic traits and logical chronological development found in the works of Christus's contemporaries, such as Jan van Eyck or Rogier van der Weyden. In fact, the diversity of the five paintings attributed to Christus in The Metropolitan Museum of Art alone initially prompted the comparative study that

evolved into the exhibition. A conventional developmental progression like that generally taken for granted for the works of most Netherlandish painters—taught to us by earlier connoisseurs such as Max J. Friedländer and Erwin Panofsky—is a construct not so easily applied to the œuvre of Petrus Christus. This methodological conundrum has led to widely disparate views about the attributions and chronology of Christus's works.[1] One way to solve the problem might be to take an ultimately restrictive view, and exclude all but the signed and dated paintings from Christus's œuvre. However, as the confrontation of paintings in the exhibition made abundantly clear, even those works that are signed and dated to within a few years of each other appear to represent the poles of Christus's style rather than any self-evident homogeneity.

Take for example the juxtaposition in the exhibition of the *Portrait of a Carthusian* (cat. no. 5), signed and dated 1446, with the *Saint Eligius* (cat. no. 6), signed and dated 1449. The *Carthusian* easily assumes a place among the great portraits of early Netherlandish painting. But what characteristics link it to the *Saint Eligius*, which although painted on a larger scale and admittedly abraded, shows a reduction of form to simple types, completely devoid of the attention to verisimilitude that imbues the Carthusian with life? Friedländer must have been thinking of the *Saint Eligius*—certainly not the *Carthusian*—when he formed his opinion that Christus's figures ". . . look as though they had been turned out on a lathe."[2] Other signed and dated devotional paintings, such as the Berlin wings of 1452, the *Annunciation and Nativity* and the *Last Judgment* (cat. fig. 9), further emphasize the disparity in treatment and handling. Here again are the geometrically conceived figures—cones, cylinders, and spheres—with summary modeling and no sense of bone structure beneath their voluminous robes. Although the works of other Netherlandish artists, Jan van Eyck, Rogier van der Weyden,

and Hans Memling among them, show some qualitative differences between the execution of portraits and that of figures inhabiting devotional scenes, the contrast between modes of representation is never so great as it appears to be in Christus's œuvre.

If Christus's paintings were considered without knowledge of the signed and dated works, the portraits no doubt would be accepted on the basis of what most consider to be their superior aesthetic qualities, and the devotional paintings would be excluded from the corpus. But because both types of works are signed and dated and because we have no clear evidence of workshop participation in Christus's earlier production (the years of the dated works fall prior to the period of the 1460s when Christus's son, Bastyaen, might have been an assistant), the "less esteemed" paintings may not be summarily dismissed. To do so would be tantamount to placing a straitjacket on the production of the artist by imposing stylistic consistency as the methodological premise, instead of allowing the art works themselves to help define a suitable method. The considerable differences in approach between the execution of Christus's portraits and that of the figures in his devotional paintings, therefore, must be taken into account as characteristic of his production.

A close examination of the technique and execution of the paintings reveals some of the contributing factors to these apparent visual differences. The key factor is the varied level of finish to which works were brought. That is to say, Christus's portraiture in general benefited from considerably more lavish attention to final modeling glazes and finishing touches than did the figures of his devotional paintings. Furthermore (as noted in the exhibition catalogue and in the essay by Joseph Fronek in this volume),[3] Christus prepared the flesh tones of his figures with a broadly painted flat, pinkish tone, not the selectively applied, more three-dimensionally suggestive white strokes found in the paintings of Christus's contemporaries, such as Rogier van der Weyden or Dieric Bouts.[4] For Christus, then, the uppermost layers of glazes and scumbles provided the essential modeling of the faces and hands. As a result of Christus's painting technique, when these thin upper layers are abraded or lost because of accidents of time or overzealous cleaning, it is more or less the preparatory layer that remains, further accentuating a feature of Christus's paintings which causes so much objection— the flatness of form. But this represents only one explanation for the conspicuous differences found among the paintings, one that relies chiefly on issues of painting technique and the state of preservation of the works.

Christus's adaptability in terms of style and representation can perhaps be understood as a result of the influence of his clients and the art market. In the exhibition catalogue this was given as the explanation of Christus's development of perspective,[5] and for his nod to certain Italian conventions in paintings like the *Madonna Enthroned with Saints Jerome and Francis* (cat. no. 13). I would like, however, to reconsider this question of Christus's adaptable style —or chameleonlike nature—in view of laying the methodological groundwork for solving certain attribution questions, which for some visitors to the exhibition proved troubling— for example, the Los Angeles *Portrait of a Man,* the Friedsam *Annunciation,* or even the Cleveland *Saint John the Baptist* (cat. nos. 16, 10, 3).

One way of rethinking this problem of diversity within the bounds of one artist's œuvre is by considering the nature of copies as the quintessential examples of adaptability and by asking what allowances can be made for seemingly incongruent stylistic features of an artist's works when that artist is deliberately suppressing his own creative identity in order to copy in the manner of another artist. Less than might have been was made in the exhibition and its catalogue about the issue of Christus as a copyist. We know from documents that Christus was commissioned to paint three copies of the so-called Cambrai *Madonna* in 1454 and was paid rather handsomely for the task.[6] Unfortunately, these copies do not survive, which makes it impossible to judge any correlation between the prototype and Christus's copy of it.[7]

We can only discern Christus as a copyist from his remaining works. These show a range from exact copies after Jan van Eyck (the *Madonna and Child with a Donor,* drawn after the Maelbeke *Madonna;* cat. no. 22 and cat. fig. 95), to partial copies (the Exeter *Madonna,* which assimilates all the figures except the Saint Elizabeth from the Frick *Virgin and Child with Saints Barbara, Elizabeth, and Jan Vos;* cat. nos. 7 and 2), to inspired versions (as in the Budapest

Virgin and Child in an Archway, after Jan's *Virgin at the Fountain*, or the Berlin *Last Judgment* after the right wing of the Eyckian diptych in The Metropolitan Museum of Art; Fig. 2 of first essay by van Asperen de Boer and cat. fig. 134, cat. figs. 9 and 20). In these cases Christus more or less assimilates the composition or motif, but not always the details of handling and execution of the artist he imitates. In the Brussels *Lamentation* (cat. fig. 11), Christus absorbs not only the essence of the composition, but also figure types, style, and even color harmonies of his models. As Friedländer already noted, it departs markedly from all other Christus works in its "enhanced expression of sorrow, the surprising types and the brittle folds of the drapery."[8] Although some of the stylistic anomalies in terms of Christus's norm are perhaps due to the influence of Rogier's Prado *Deposition* (cat. fig. 10), certain hints of paintings attributed to Robert Campin are also evident. These are found in the ovoid face of the Virgin and the ice-blue and purple draperies of Mary Magdalen and the Virgin Mary respectively. Examples such as the *Virgin and Child Before a Firescreen* (National Gallery, London) or *Mérode Triptych* (The Metropolitan Museum of Art, New York) may have provided models for the particular color harmonies and remarkably subtle transitions in value and hue that Christus never again attempted after the Brussels *Lamentation*.

That Christus demonstrated his abilities as a copyist more than once and had commissions for copies is important to keep in mind. This may well explain the artist's departure from his habitual manner in order to approximate that of another artist, not only for the Brussels *Lamentation,* but also for the Friedsam *Annunciation* and the Los Angeles *Portrait of a Man* (see exhibition catalogue discussions, pp. 117-125 and 154-157). The common denominator for the works inspired by the paintings of other artists is found in the underdrawing. For despite the anomalous character of these paintings on their surfaces, their preliminary stages and working methods indicate the same artistic identity at work.

What accounted for Christus's rather distinctive stylistic adaptability? What were the motivating forces for the chameleonlike nature of his art? It is important to remember that Christus was not a court painter, as was Jan van Eyck, nor the designated city painter, as were his contemporaries Rogier van der Weyden in Brussels and Dieric Bouts in Louvain; he therefore had to attract commissions on his own instead of having them guaranteed by virtue of an official position. As a result, Christus may well have seen the advantage of adjusting his production to the demands of the art market and his prospective patrons. Making copies and producing art for export were a large part of that business. As recent studies have shown, exact or very close copies of another artist's work (as in the case of the Metropolitan Museum of Art *Christ Appearing to His Mother,* formerly given to Rogier van der Weyden, or the San Francisco *Virgin and Child,* now attributed to a follower of Dieric Bouts) at best cloud or may even fully obscure a painting's attribution, since the artistic sensibilities or habitual manner of the copying artist is necessarily suppressed.[9] The question raised here is the extent to which an artist's identity may be hidden as he assimilates the characteristics of another artist's works, and how we may eventually identify his hand therein. To answer the question requires an adjustment to traditional methodologies.

Another factor contributing to the distinct stylistic range evident in Christus's works was far easier to comprehend in the exhibition than in any illustrated monograph on Christus. It is the difference that the size of individual paintings made for Christus, who appears to have been more adept at small-scale rather than large-scale paintings. This observation led to the investigation of whether Christus might have begun his training and career as a manuscript illuminator, rather than a panel painter. This hypothesis needs further investigation and corroboration through more in-depth study of illuminated manuscripts from Utrecht and Bruges in the second and third quarters of the fifteenth century. In particular, a search should begin for other illuminations that, like the *Trinity* miniature in the exhibition, may be reliably attributed to Christus.

In general, the identification and study of manuscript illuminators who were also panel painters warrants further attention. I had already found it a particularly intriguing problem in the case of Simon Marmion, whose works, like those of Christus, benefited from a close technical examination, which revealed the com-

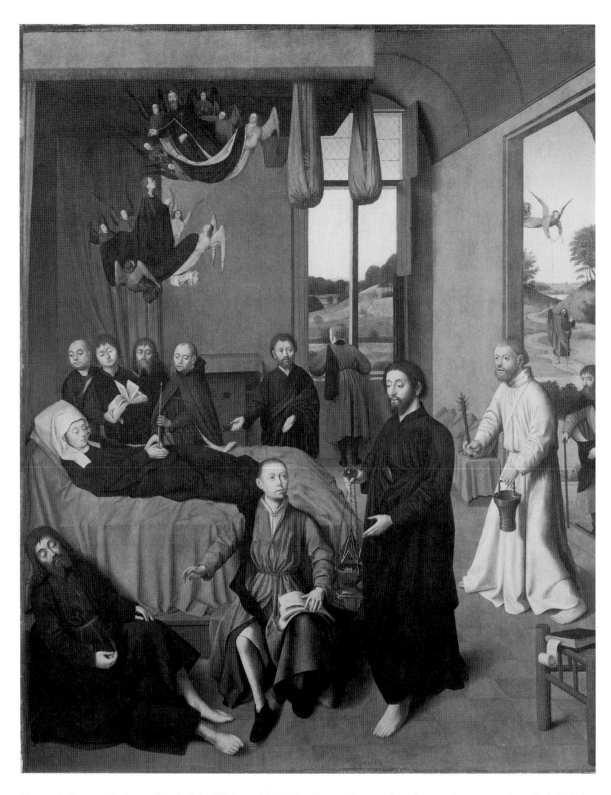

Figure 1. Petrus Christus, *Death of the Virgin,* c. 1460-65, oil on oak, transferred to mahogany and cradled, 171.1 x 138.4 cm, San Diego, Timken Museum of Art (photo: Timken Museum of Art)

Figure 2. Master of Catherine of Cleves, *Hours of Catherine of Cleves, Death of the Virgin*, MS 917, folio 180, New York, The Pierpont Morgan Library (photo: The Pierpont Morgan Library)

mon characteristics of handling and execution between the artist's panel paintings and manuscript illuminations.[10] The recent exemplary exhibition *Les Manuscrits à peintures en France 1440-1520* curated by François Avril and Nicole Reynaud at the Bibliothèque Nationale in Paris also touched on the question of panel painters who were manuscript illuminators, such as Jean Fouquet, Jean Perréal, Enguerrand Quarton, or Barthélemy d'Eyck, to name a few.

In Bruges, compositions and motifs appear to have circulated freely between the ateliers of panel painters and those of manuscript illuminators. In addition, there are strong indications that a number of Bruges painters also practiced manuscript illumination, either on a regular basis or only from time to time. These included Jan van Eyck, Christus's son Bastyaen (who joined both the painters' and illuminators' guilds), Gerard David, and possibly Juan de Flandes. As the exhibition catalogue discusses, there is striking visual evidence found in Christus's works that points to his activity in both arts.

Since the exhibition, some additional thoughts have come to mind over this issue. In terms of palette, Christus's frequent dependency upon an unusual color scheme of Indian reds, brownish purples, and acid greens may directly reflect the color preferences of the Utrecht School of manuscript illumination, particularly as the Master of Catherine of Cleves employed them[11]. A study of M. 945 and M. 917 (together forming the Book of Hours of Catherine of Cleves) in the J. Pierpont Morgan Library demonstrates this point well. The same book of hours also offers additional sources for some of Christus's spatial conceptions, compositional solutions, and figural motifs. For example, the composition of the Timken Museum's *Death of the Virgin* (Fig. 1), which is rarely found in northern panel painting before this time, appears to have been derived in part from two death scenes by the Master of Catherine of Cleves.[12]

The illumination of the Death of the Virgin (Folio 156, Fig. 2) shows general similarities to the Timken painting through the arrangement of figures around the deathbed and the position of the bed on a tile floor, parallel to the picture plane. The three apostles seated in front of the bed, two of whom are asleep, are echoed in Christus's slumbering apostle at the lower left corner of the Timken painting. Even more directly related is the death scene (folio 180, fig. 3) from the same book, which may have provided a model for the spatial organization of Christus's painting with its corner space room, open window on the back wall, and receding wall at the right with a doorway through which a figure enters into the room. The female figure with a book in her lap in the foreground of the miniature may well have inspired a similarly positioned apostle in the center foreground of the Timken painting.

The study of another book illuminated by the Masters of Zweder van Culemborg with the participation of the Master of Catherine of Cleves reveals additional links between Petrus Christus and these Utrecht masters. In the Missal of Eberhard von Greiffenklau (Ms. W. 174 in the Walters Art Gallery, Baltimore) the flesh tones of the figures are underpainted in the kind of flat pinkish application that is so distinctive and characteristic of Christus's technique, and highlights are daubed on in unblended white strokes in the manner found in the Exeter *Madonna* (see cat. no. 7 and discussion in Stephanie Buck's essay in this volume).[13]

Other, more general evidence that supports the likely connection of Christus with Utrecht book illumination includes the established network of relations between Utrecht and Bruges illuminators at the time,[14] and Christus's origins near the present-day Dutch-Belgian border, as recently confirmed by Wim Blockmans (see his essay in this volume). Furthermore, the suggested association of Christus's signed and dated (1449) *Virgin and Child* (Bentinck-Thyssen Collection; cat. fig. 12) with the patronage of Eberhard von Greifenklau, prebendary at Utrecht from 1446 and owner of the missal mentioned above, may document a direct link between Christus and Utrecht early on in his career.[15]

The issue of the importance of manuscript illumination for the art of Bruges and especially for Petrus Christus is closely related to the question of the post-Eyckian workshop, which at the time of Christus's arrival in Bruges was still involved in both panel painting and manuscript illumination. Any further resolution of the attribution of the Cleveland Museum's *Saint John the Baptist* ultimately depends upon unraveling the complicated matter of the

Figure 3. Master of Catherine of Cleves, *Hours of Catherine of Cleves, Death Scene,* MS 917, folio 180, New York, The Pierpont Morgan Library (photo: The Pierpont Morgan Library)

shop's activities. The *Saint John* is an example *par excellence* of the intermingling of stylistic traits of manuscript illumination and of panel painting, and of the use of stock patterns of figures and landscape motifs probably available in the Eyckian workshop. In order to support an attribution of this painting to Petrus Christus, one would have to agree with my proposed identification of Christus's hand in the preliminary stages of the work (particularly in the underdrawing) and accept that the deviations from Christus's usual style are a result of his copying stock patterns out of the Eyckian workshop. Not only for the sake of this work, but for the confusion remaining about a number of paintings and drawings which float semi-connected to the Eyckian workshop, I would urge the assembly of the pertinent works for an exhibition and discussion. This may be a case where the definitive catalogue should be written *after* rather than before the exhibition.

In regard to another work in the exhibition, perhaps the painting of Christus's that most resembles manuscrcipt illumination, the Exeter *Madonna,* I am inclined to reconsider its date. Having more recently studied the Book of Hours of Catherine of Cleves, I find its illuminations, with their ribbonlike clouds and particular color harmonies, close to similar effects in the Exeter *Madonna.* Furthermore, in the modeling of the Virgin and Child (see cat. figs. 91 and 117), with the impasto dots for highlights and unblended strokes particularly in the flesh areas, the Exeter *Madonna,* more than any of Christus's other paintings, approximates the technique of manuscript illumination. Its date is probably closer to 1445, just after Christus's arrival in Bruges, than to 1450 as I suggested in the catalogue. Jan Vos need not have waited to commission a copy of the *Virgin and Child with Saints Barbara and Elizabeth and Jan Vos* (Frick Collection) until 1450, when he left Bruges for the monastery at Nieuwlicht. He could have ordered it for his personal use anytime after Christus arrived in Bruges in 1444.

Some amendments also might be made to the list of Christus's signed paintings. The suggestion offered by Hélène Verougstraete and Roger Van Schoute (see their essay in this volume) that the letters on the red scarf of the blue hat worn by the woman in the Brussels *Lamentation* are "PXF," signifying "Petrus Christus Fecit," is most intriguing. If

this is indeed an abbreviated inscription on the painting, then another possible instance of a semi-hidden signature should be considered.

I briefly called attention to the Greek letters "xpi" for "Christ" in the otherwise Latin text of the *Salve sancta facies* prayer found mounted as a trompe-l'oeil illumination on the back wall of the London *Portrait of a Young Man* (see the exhibition catalogue, pp. 59-60 and cat. fig. 66). A recent consultation of printed and illuminated books including this popular prayer reveals that the "xpi" substitution for the word "Christi" is not unique or uncommon.[16] However, certain stanzas of the traditional prayer have been omitted on Christus's trompe-l'oeil page, and those chosen have been arranged so that the verse featuring the "xpi" in its last line falls in the prominent position at the lower left of the first column. Furthermore, the "xpi" letters (cat. fig. 82) appear to be slightly larger and more legible than those of the rest of the text. Is Christus's incorporation of this particular prayer in his painting with its face of Christ and emphasized "xpi" in the text a deliberate one, meant as a visual pun on the artist's own name? There is no clear evidence that this is Christus's self-portrait, but the idea that it may contain a reference to its author is well worth considering.

A final question—that of followers of Christus or evidence of a workshop—was inadvertently addressed in the exhibition. By error, the Hague copy after the Budapest *Virgin and Child in an Archway* was printed in the catalogue (p. 127), which gave visitors to the exhibition the opportunity to compare original and copy. J. R. J. Asperen de Boer's essay in this volume offers additional details about the technical investigation of the Hague version. Although pigment identification and dendrochronology suggest that the Hague version could well have been painted in the late fifteenth or early sixteenth century, the details of handling and execution of the two paintings are markedly different (see van Asperen de Boer's first essay, Figs. 1-8). These observations indicate that, although the Hague painting was copied after the Budapest *Virgin and Child,* it need not necessarily have been produced under the guidance of Christus himself in any workshop situation. The same is true of a contemporary copy in Spain produced after Christus's *Virgin*

and Child Enthroned on a Porch (cat. no. 14) in the Prado.[17]

Other paintings that reside today mostly in Italian or Spanish collections are reminiscent of the art of Christus in one way or another – usually in composition—but rarely show the hallmarks of his handling and execution.[18] These works would seem to have been copied after paintings by Christus which found their way into southern collections, and are not the direct products of a Christus workshop. Furthermore, the small number of works in this category is not indicative of any significant workshop activity, as is implied by the considerable number of remaining works assigned to Rogier van der Weyden, Dieric Bouts, or Hans Memling, for example.

Although Christus presumably trained his son, Bastyaen, as a painter, no extant work by his hand may be identified. All we know is that Bastyaen became a free master in the corporation of image makers on March 13, 1476. He, in turn, must have trained his son, Petrus Chris-tus II, who took over the workshop of his father at Bastyaen's death on 5 May 1500. Thereafter, Weale reports, Petrus II had established himself in Granada by 1507. The division of Christus's œuvre into groups of paintings assigned by Weale and Durand-Gréville to Christus, to Bastayen, and to Petrus Christus II was long ago dismissed as untenable, but no clear identification of works attributable to Bastayen and Petrus Christus II has filled the void left by their unsuccessful attempts.[19] Perhaps a fresh starting point for the consideration of a Christus workshop might be the closer examination of the paintings by the Master of the Baroncelli Portraits. What must be said, however, is that by all appearances, the activities of a Christus workshop were relatively minimal. The demonstrable interest in Christus through copies made after his paintings, or works inspired by them, particularly in Italy and Spain, may turn out to have been equally significant as local production, or even more significant, in terms of ensuring the artist's legacy.

NOTES

1. See Maryan W. Ainsworth and Maximiliaan P. J. Martens, *Petrus Christus: Renaissance Master of Bruges,* exh. cat. (New York, 1994) pp. 24–27 and individual entries for the widely varying dates on individual paintings provided in dissertations and monographs on Christus.

2. Max J. Friedländer, *Early Netherlandish Painting,* trans. Heinz Norden, 14 vols. (Leyden, 1967–76), vol. 1, *The van Eycks – Petrus Christus,* p. 89.

3. Ainsworth, *Petrus Christus,* especially pp. 33-36, 41, and 53.

4. Ibid., cf. figs. 73 and 74.

5. Ibid., p. 60. One question raised during the exhibition was whether perspective development may be accurately used as a method for dating paintings. In terms of Christus's œuvre, perspective can only be used as one of the determining factors for dating. The fact that Christus developed the under-drawing and the figures themselves into progressively more volumetric forms hand in hand with the greater understanding of perspective (which in itself is a gradual development) seems to support the determining factor of these stylistic traits insofar as chronology is concerned.

6. Ibid., pp. 195-196, docs. 3–6.

7. For suggestions of what these copies may have looked like see Catheline Périer-d'Ieteren, "Une Copie de Notre-Dame de Grace de Cambrai aux Musées royaux des beaux-arts de Belgique à Bruxelles," *Musées royaux des beaux-arts de Belgique bulletin* 17 (1968) pp. 111–114.

8. Friedländer, *The van Eycks,* 1967, p. 88.

9. For a discussion of this issue see Maryan Ainsworth, "Implications of Revised Attributions in Netherlandish Painting," *MMJ* 27 (1992a) pp. 59-76, and idem, *Facsimile in Early Netherlandish Painting: Dieric Bouts's "Virgin and Child,"* exh. cat., Metropolitan Museum of Art (New York, 1993).

10. Maryan W. Ainsworth, "New Observations on the Working Technique in Simon Marmion's Panel Paintings," in *Margaret of York, Simon Marmion and "The Visions of Tondal,"* ed. T. Kren (Malibu, 1992) pp. 243–255.

11. For further on this matter see the essay in this volume by Stephanie Buck, to whom I am indebted for a number of interesting observations during our study together of the Morgan Library Books of Hours.

12. Charles Sterling, in "Observations on Petrus Christus," *Art Bulletin,* 53 (1971) p. 3, suggested a link with Franco-Flemish book illuminations by the Bedford Master and with the Turin-Milan Hours.

13. I am grateful to Stephanie Buck for this observation resulting from her firsthand study of the missal.

14. Maurits Smeyers and Bert Cardon, "Utrecht and Bruges —South and North: 'Boundless' Relations in the Fifteenth Century," in *Masters and Miniatures,* Proceedings of the Congress on Medieval Manuscript Illumination in the Northern Netherlands, 10-13 December 1989, ed. K. van der Horst and J.-C. Klamt (Utrecht, Doornspijk, 1991) pp. 89–108

15. See F. T. Klingleschmitt, *Mainzer Goldgulden auf dem Eligiusbild des Petrus Christus in der Sammlung Baron Albert Oppenheim, Köln* (Wiesbaden, 1918).

16. I very much appreciate the efforts of Roger Wieck, Associate Curator of Medieval and Renaissance Manuscripts at the Pierpont Morgan Library, in this search.

17. The copy in Spain is illustrated in Jacques Lavalleye, *Collections d'Espagne,* 2 vols., Les Primitifs flamands, II: Répertoire des peintures flamandes des quinzième et seizième siècles, I, 2 (Antwerp, 1953-58) vol. 1, pp. 29–30.

18. Examples may be found in the following publications: Georges Hulin de Loo and Édouard Michel, *Early Flemish Paintings in the Renders Collection at Bruges Exhibited at the Belgian Exhibition, Burlington House, January, 1927* (London, 1927) pp. 83–84; Giovanni Carandente, *Collections d'Italie,* I: *Sicile,* Les Primitifs flamands, II: Répertoire des peintures flamandes du quinzième siècle 3 (Brussels, 1968) pp. 18–19, p. 7 no. 10, and p. 20, pl. 16, no. 20; Jarmila Vackova, *Collections de Tchécoslovaquie* (Brussels, 1985) pp. 66-69, pl. 30 no. 24, and pp. 85–89, pl. 41 no. 34.

19. W. H. J. Weale, "Les Christus," *Annales de la Société d'é-mulation de Bruges* 59 (1909) pp. 97–120, 363–364; E. Durand-Gréville, "Les Deux Petrus Christus," *Revue de l'art ancien et moderne* 30 (July, August, September 1911) pp. 43–54, 129–142, 195–208.

Plate 1. Jan van Eyck, Detail of *Crucifixion* (the head of the Erythrean Sibyl), New York, The Metropolitan Museum of Art (Photo: M. Ainsworth)

Plate 2. Assistant of Jan van Eyck, Detail of *Last Judgment* (head of Saint John the Baptist) (Photo: M. Ainsworth)

Plate 3. Assistant of Jan van Eyck, Detail of *Last Judgment* (apostles on the right sitting on the bench) (Photo: M. Ainsworth)

Plate 4. Assitant of Jan van Eyck, Detail of *Last Judgment* (left angel holding the cross) (Photo: M. Ainsworth)

Plate 5. Petrus Christus, Detail of *Last Judgment* (the two hellmouths) (Photo: M. Ainsworth)

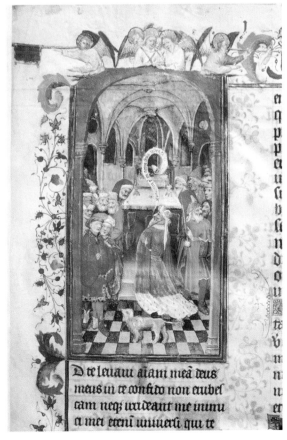

Plate 6. Master of Zweder van Culemborg, Missal of Eberhard von Greiffenklau. Baltimore, Walters Art Gallery, MS W. 174, fol. 8 (unpublished)(photo: Walters Art Gallery)

I

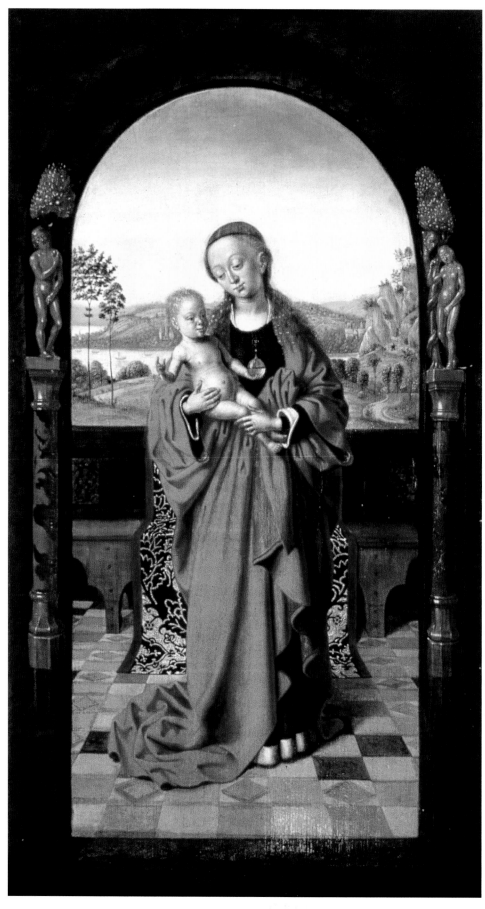

Plate 7. Anonymous, *Madonna with Child in an Archway,* The Hague, Rijksdienst voor Beeldende Kunst
(photo: Rijksdienst voor Beeldende Kunst)

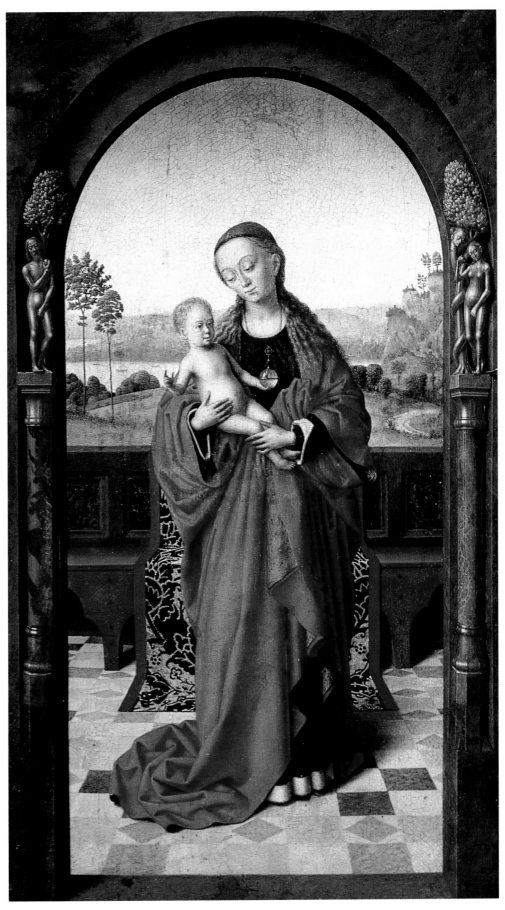

Plate 8. Petrus Christus, *Madonna with Child in an Archway,* Budapest, Szépmüvészeti Múzeum
(photo: Szépmüvészeti Múzeum)

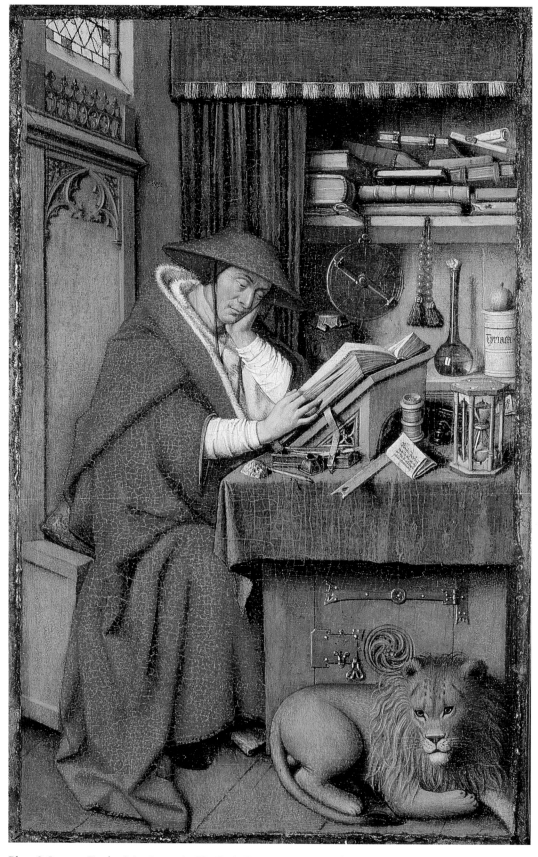

Plate 9. Jan van Eyck, *Saint Jerome in His Study.* Detroit Institute of Arts, 25.4 (photo: The Detroit Institute of Arts)

Plate 11. Photomicrograph of linen fibers taken under crossed polars at 100X magnification (photo: McCrone Research Institute)

Plate 10. Panel reverse with serpentine marbling pattern (Photo: The Detroit Institute of Arts)

Plate 12. Detail of Plate 9 (pen, erasing knife, and pen box) (photo: Detroit Institute of Arts)

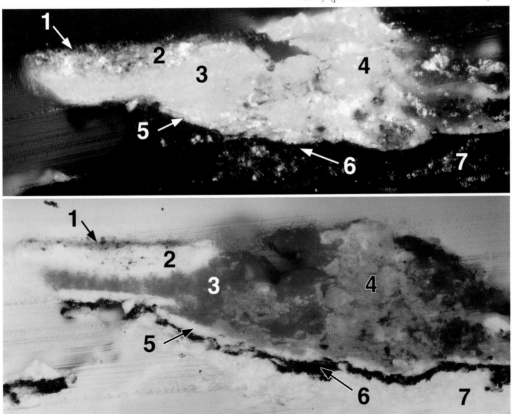

Plate 13. Cross section of barb and blue valance from panel front, under visible and ultraviolet light at 160X magnification

Layer (L) 1: incomplete top glaze: transparent medium, very few pigment particles

L2: blue paint: ultramarine, lead white

L3: red layer: red lead, lead white

L4: yellow/tan layer: lead white, clay, yellow ocher

L5: off-white layer: lead white

L6: black layer: antwerp brown

L7: linen paper layer

V

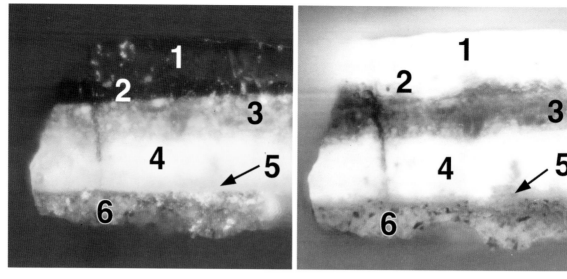

Plate 14. Cross section of green tablecloth, panel front, under visible and ultraviolet light at 160X magnification

L1: modern varnish layer

L2: thin brown layer: copper resinate (darkened)

L3: yellowish-green layer: lead-tin yellow, azurite, lead white

L4: white layer: lead white, lead-tin yellow (trace)

L5: red layer: red lead

L6: dark gray/black layer (incomplete): lead white, ultramarine, madder lake, antwerp brown, bone black

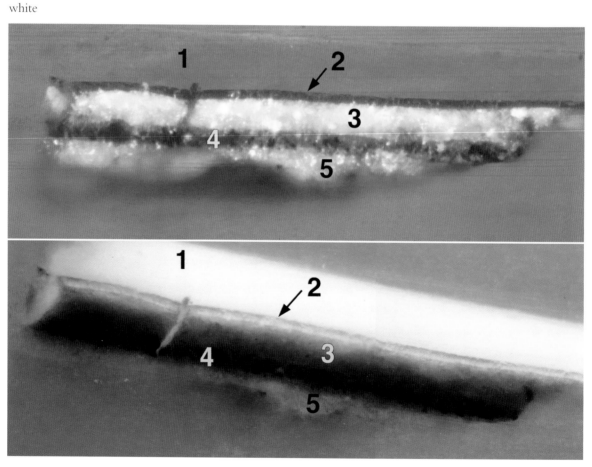

Plate 15. Cross section of original dark green paint from panel reverse, under visible and ultraviolet light at 160X magnification

L1: modern varnish layer

L2: thin brownish-green layer: copper resinate (darkened)

L3: yellow layer: lead white, lead-tin yellow, possible verdigris

L4: dark brown layer: copper resinate (darkened), with white, orange, brown, and black particles

L5: white ground layer: chalk

Plate 16. Photomicrograph of date at 40X magnification (photo: The Detroit Institute of Arts)

Plate 17. Cross section, hair over mantle (photo: National Gallery of Art, Washington, D.C.)

Plate 18. Cross section, robe (photo: National Gallery of Art, Washington, D.C.)

Plate 19. Cross section, rays, mordant, and solid radiance (photo: National Gallery of Art, Washington, D.C.)

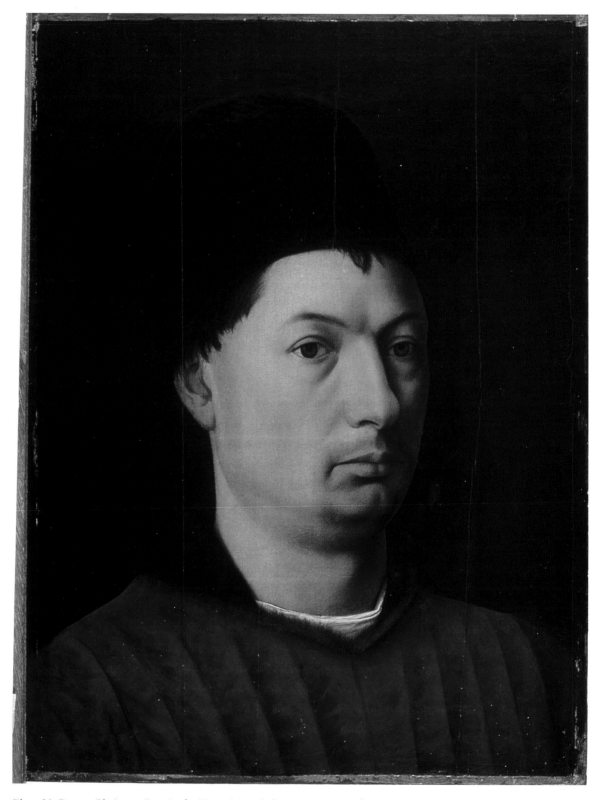

Plate 20. Petrus Christus, *Portait of a Young Man*. Color transparency from c. 1950 in LACMA curatorial files

Plate 21. Detail of edge of painting showing lip of ground and added strip of wood

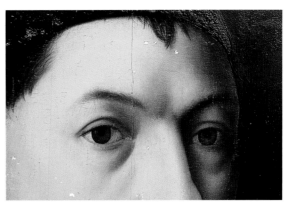

Plate 22. Detail of Plate 20 (face)

Plate 23. Cross section from red jacket (left edge), 125x

Plate 24. Photomicrograph of right side of forehead, 10x

Plate 25. Detail of Plate 20 (red jacket)

Plate 26. Photomicrograph of white and dark collars, 6x

Plate 27. Cross section from hat (right edge), 125x

Plate 28. Petrus Christus, *Portrait of a Female Donor*, Detail (red dress). Washington, D.C., National Gallery of Art (photo: M. Ainsworth)

Plate 29. Transparent section through a typical blue, showing the ultramarine glaze over the lighter azurite

Plate 30. Cross section through a typical green, showing the dark green layer on the white ground

Plate 31. Deep red mantle of Saint John. Starting from the white ground: red lake with some white and traces of azurite; followed by vermilion containing charcoal. On top, a glaze of red lake. The dark line on the chalk ground may be the drawing.

Plate 32. The same green in transmitted light, revealing that the deep green underneath is fairly translucent, and that the brownish to green layer on top looks like discolored copper resinate

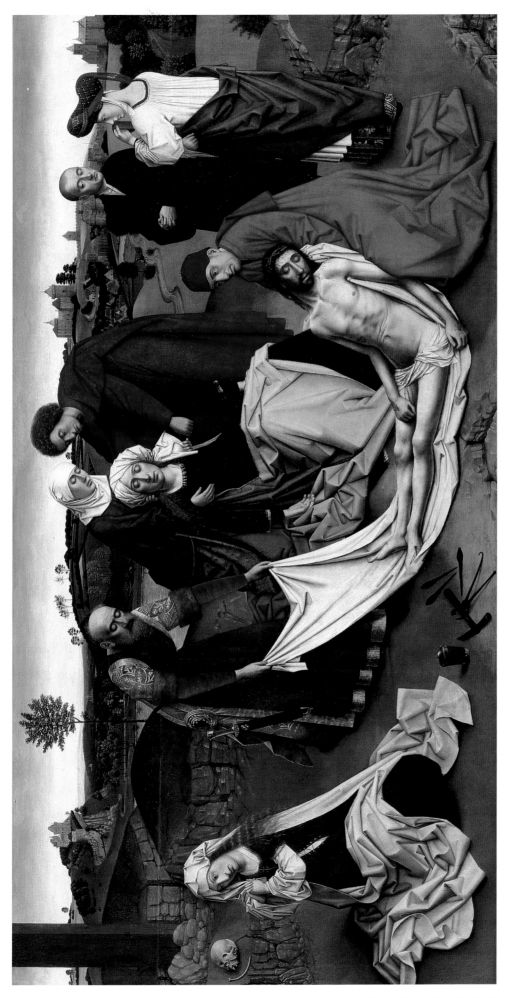

Plate 33. Petrus Christus, *Lamentation,* ca. 1450. Huile sur chêne, 101 x 192 cm, Bruxelles, Musées Royaux des Beaux-Arts de Belgique (Copyright A.C.L.)

Plate 34. Détail de 1: Les cheveux du Christ. Dans la barbe, utilisation de la strie. Dans la chevelure, sur le cou, matière brune coagulée. A noter, les trous d'épingles pratiqués lors de la restauration. (Nég. Lab art, U.C.L.)